Hopi Kachinas
HISTORY, LEGENDS, AND ART

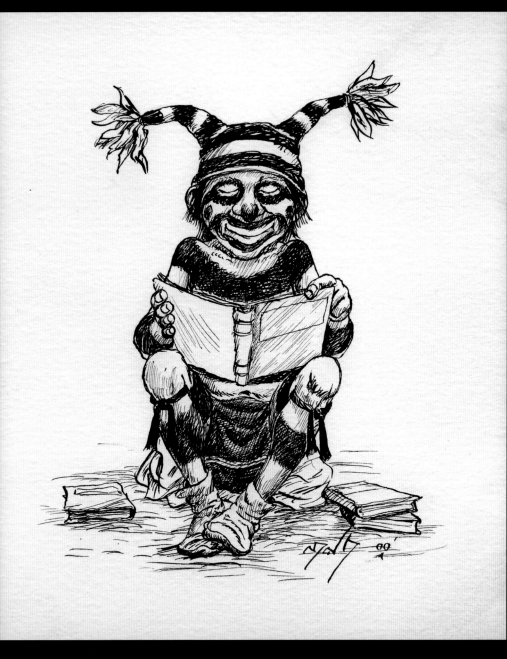

By Ron Pecina and Bob Pecina

Schiffer Publishing Ltd®

4880 Lower Valley Road • Atglen, PA 19310

Other Schiffer Books by the Author:
Neil David's Hopi World, 978-0-7643-3808-3, $29.99

Other Schiffer Books on Related Subjects:
Kachinas and Ceremonial Dancers in Zuni Jewelry, 978-0-7643-4167-0, $24.99
Contemporary Hopi Kachina Dolls, 0-7643-1848-9, $39.95
Hopi Kachina Dolls and their Carvers, 0-88740-373-5, $59.95

Type set in Zurich BT

ISBN: 978-0-7643-4429-9
Printed in China

Published by Schiffer Publishing, Ltd.
4880 Lower Valley Road
Atglen, PA 19310
Phone: (610) 593-1777; Fax: (610) 593-2002
E-mail: Info@schifferbooks.com

For our complete selection of books on this and related subjects, please visit our website at
www.schifferbooks.com. You may also write for a free catalog.

This book may be purchased from the publisher.
Please try your bookstore first.

We are always looking for people to write books on new and related subjects.
If you have an idea for a book, please contact us at
proposals@schifferbooks.com

Schiffer Publishing's titles are available at special discounts for bulk purchases for sales promotions or premiums. Special editions, including personalized covers, corporate imprints, and excerpts can be created in large quantities for special needs. For more information contact the publisher.

In Europe, Schiffer books are distributed by
Bushwood Books
6 Marksbury Ave.
Kew Gardens
Surrey TW9 4JF England
Phone: 44 (0) 20 8392 8585; Fax: 44 (0) 20 8392 9876
E-mail: info@bushwoodbooks.co.uk
Website: www.bushwoodbooks.co.uk

Contents

Foreword

On a fortuitous day in the mid 1980s, Ron Pecina made a right instead of a left turn in his travels through the Southwest and arrived at Hopi for the first of many visits. On his sojourns Pecina developed close relationships with a number of Hopi painters and sculptors, and the art that he and his family commissioned reflect these interactions, the personal connections that result when an artist is aware of the recipient. This book celebrates the associations that grew from the excursions.

When the Pecinas approached this book focusing on Hopi Katsinam their intention was to amass a number of Hopi vignettes encompassing histories, supernaturals, ceremonies, legends, and contemporary Hopi artists to provide detailed backgrounds for some of the remarkable paintings and sculpture that emerged from their time at Hopi. The Pecinas' text and their subjects became intertwined as they sought out the artworks that would illustrate their writing. They were particularly alert to representations not often depicted in books about Hopi art: carvings by Ron Honyouti of Third Mesa that include complex stories or legends on the base, detailed representations of ceremonies by Neil David of First Mesa, and other forward-looking artists became central to the endeavor. These artworks, most never before published, are the book's core and strength.

The flexible organization of the text provides the Pecinas with opportunities for fresh and unusual entries. Valuable for novice Hopi observers as well as scholars and collectors is the chapter on four artists whom the Pecinas call Hopi documentarians, artists who have recorded the historical and legendary aspects of the Hopi people. The Pecinas include personal information about these prominent creators, and about their own relationship with them, along with descriptions of their studios and carving styles; this is illuminating information, not easily found elsewhere.

Equally worthwhile is a chapter that provides in-depth histories and examinations of two of the many hundreds of known Katsinam—*Tseeveyo* and Cold-Bringing Woman. Hopi collectors and visitors often know a little about a number of Katsinam, but these detailed portfolios are novel as readers are given a substantial understanding of two supernaturals. The essays illuminate both the complexities woven into the meaning of each Katsina as well as the wide range of interpretations available to artists.

The Pecinas have given their readers both traditional and unusual pictorial windows to the Hopi world through Hopi eyes. Their selection of original and outstanding artworks allow the abstraction of Hopi legends, ceremonies, and history to spring to life. The book provides a staple resource for anyone with an interest in Hopi life and art.

Zena Pearlstone
Professor Emerita
California State University, Fullerton

Preface

There is no single way to learn of a race or tribe of people. We have chosen the creative expression of the beliefs, knowledge, and experience of a set of renowned Hopi artisans to express, through their art, the public image of the Hopis' Katsinam along with accounts of the Hopis as seen through the eyes of outsiders, generally termed ethnologists.

Our goal is to expand the understanding of the Katsinam as part of the Hopis' beliefs and culture. The Hopi people have a proud history and have developed a beautiful life against all odds of nature. They have survived the intrusions from militant and religious outsiders and government regulators who with intent, or inadvertently, have molded the culture to the world surrounding them—by chance or choice, eventually to extinction.

We begin with a review of the history of the Pueblos, the efforts of historians, reporters, and recorders of oral history, and the work of the archaeologists and anthropologists that has cast a scholarly light on the Hopi people of Northern Arizona, to provide a foundation for students and aficionados of traditional Hopi art. We hope to illuminate the stage for scholars and edify students through a portrayal of kachina art as created by Hopis who live on Hopiland and are dedicated to their culture.

The opportunity to develop this manuscript started by chance almost three decades ago. Driving north from Flagstaff we decided to bypass a visit to the Grand Canyon and headed east into the unknown Hopi Reservation. A quick stop at the Cultural Center on Second Mesa turned into a delightful exploration of the shops, museum, and the Arts and Crafts guild. We decided to spend the night in the appealing pueblo style motel. A number of Hopi we met asked if we had come to see the dance at First Mesa. Not until next morning, with continued reminders at the restaurant, we decided to stop on First Mesa on our journey eastward. Fortunately, as we neared the village of Polacca, a number of cars and trucks filled with excited passengers on route to the dance saw the plight of the lost Bahanas from out of state looking for the dance. They called out to us to follow them up the trail to the mesa summit. Quite a trip, and then a spectacular view of the Hopi Buttes and San Francisco Peaks to the southwest. We parked at the mesa top and stayed for several rounds of the dance. In summary, this day was the highlight of our visit to the Southwest. We shall always remember our introduction to Hopi and those who urged us to see their dance.

We give special thanks to our many Hopi friends for opening their world to us. Above all we acknowledge the many Hopi artists and traders who for many years have patiently helped us gain understanding of the Hopi Katsinam and Hopi celebrations, and made thoughtful and valued contributions to this work.

Ron Pecina

Chapter 1: Introduction

For more than four hundred years Hopis' life plans have suffered aggressive infringement by a host of intruders: Navajo, Apache, and Ute raiders; Spanish missionaries; U. S. Government agents; army surveyors; gold seekers; anthropologists; writers; artists; and tourists. Yet Hopi religious convictions and beliefs have remained unbroken. The Hopis' spirit beings, the Katsinam, have been a unifying force giving strength to the Hopi people and providing them the ability to keep their values separate from outside forces. Threats to their cultural survival have ranged from innocent probing from tourists and belligerent curiosity from ethnologists to a cruel and purposeful effort to abolish practice of the Katsina religion by Spanish missionaries and, even until the last century, certain factions of the American bureaucracy. While these forces have dominated the Hopi society, the Hopis continue to brave the odds and their beliefs survive. Rather than diluting their religion, the intimidation and coercion have merely served to harden the Hopis' religious life and the Katsina culture—and the Hopis remain Hopi.

Evolution of the Hopi society began with the gathering of Native Americans who had been forced to migrate because of climate changes, insufficient natural resources, and inadequate food supply. The indigenous people living in New Mexico's Rio Grande Valley, and the Hopi and Zuni region located on the Colorado Plateau, gathered in settlements the Spaniards called *pueblos*. Today we would call them condominiums. The Puebloans survived wars in which they defended their homes and crops from marauding tribes, and their culture was influenced by living in the unpredictable, high-country environment that challenged their skills for survival. The unexpected intrusion of the Spanish conquistadors, Christian missionaries, and the Americans intent on their manifest destiny, were not easily accepted. The Hopi people are still adjusting to the change from oral conveyance of tribal legends and history in their native language to the written form, the change from an agricultural subsistence economy to the venture of a cash economy, and to the bitter memory of forced schooling and attempts to eliminate their traditional religion. A major step towards a symbiotic relation with the descendants of the Euro-American intruders began at the closing of the nineteenth century when the entrepreneurial Native American left the reservation and traveled into towns at the railroad stops on the route to California, and then in the 1930s to crossroads along the continental highway, route U.S. 66, to sell arts and crafts to tourists. Today, reservation Hopi artists and craftsmen sell their creations through art galleries and their own websites. Sacred ceremonies are scheduled for weekends to accommodate the Hopis who live and work in off-reservation cities as distant as Phoenix and Santa Fe.

To gain a solid understanding of the Hopis, one must assemble data from a variety of sources. Archeological studies set the background for describing the life and activities of the people by gathering fragments of information from the era long before their history was recorded. In the case of the pueblo Native Americans, this prehistoric period ended with the first appearance of the Europeans. Credit the sixteenth-century Spanish explorers and Catholic missionaries for the first written reports of the Native Americans of the Southwest. In addition to the nineteenth-century ethnological investigations and archeological findings, the best resource on early Hopi life and history is gleaned from the oral teachings passed on by Hopi elders to succeeding generations.

Like any civilization, the Hopis' is complex and deserves further study for greater appreciation. Much of the Hopis' cultural and religious life is held in secret, partially resulting from the attempts of the Spanish missionaries to eradicate the Native Americans' beliefs and convert the people

to Christianity. A review of the initial meetings between the Native Americans of the Southwest and the Spanish conquerors helps to understand the impact of this intrusion and gives a background for understanding the current relations between the white man and the Pueblo Indians. The justification and rationale for the Spanish fortune hunters and colonizers ventures were: "To serve his majesty in the discovery, conquest, pacification and settlement of the provinces of New Spain." (Diaz, 1963, 15). The Native Americans would suffer, and many would die. The white man's domination would bring great changes. In some regions the native culture was either assimilated or destroyed. In others, the Spanish influence would be tolerated to some degree. The Hopis have survived intrusions from militant and religious zealots and government edicts to conform the culture to the world that surrounds them. Even now, Hopi prophecies include the eventual demise of Hopi culture.

This book reviews the efforts of historians, anthropologists, and reporters who captured Hopi oral history; it presents the background for the students and aficionados of Hopi art and supports the study of the Hopi culture through the use of Katsina art.

The approach taken here is to present historical writings and artistic interpretations. Historical observations of the Hopis made by early ethnologists Voth, Stephen, and Fewkes are commingled with the creative work of Hopi artists and kachina doll carvers. Our aim is to extend the understanding and awareness of the Hopis, who have a proud culture and maintain a beautiful life philosophy against heavy odds.

Walter Hough wrote:

Every visitor to the Hopi pueblos is attracted by the carved wooden figures painted in bright colors and decorated with feathers, etc., that hang from the rafters of the houses. "Dolls," they are usually called, but the Hopi know that they are representations of the spiritual beings who live in the unseen world, and a great variety there is of them. The carvers of these strange figurines must be granted the possession of much skill and ability to their art, which is carried out with a few simple tools.

–Hough, 1915, 86

Over the years, the interest in the Hopis' art has not diminished but instead has drawn worldwide interest, and as a result, Hopi kachina carving has grown into a fine art form. The artworks pictured were created by individuals who were born in Hopiland, live the Hopis' ceremonial life, and are steeped in their culture and beliefs.

History is the foundation of legends which in turn are integral to Hopi beliefs and culture. The Hopis' rich cultural development and exciting religious ceremonies continue to thrive; however, as outsiders we have limited opportunity to witness the festivities and customs of the Hopi except through artistic expressions in word, color, and wood.

Chapter 2: The New World

Two centuries of Spanish rule and overzealous Spanish Catholicism attempted to eradicate what the Spaniards called idolatry, the Katsina culture, and its rituals. Although the Katsina culture predates Spanish rule in the Southwest the intrusion by the Spaniards and their search for Eldorado, the legendary and illusive "Lost City of Gold," had significant effects on the culture and religion of the Pueblo Indians. The pueblo dwellers were forced to adjust to Spanish rule and Christianity. In some cases village culture was lost or assimilated, while other Pueblo settlements outwardly accepted Christianity and Spanish authority's attempts to change tribal social systems. This subjugation drove the traditionalists to increased secrecy and clandestine religious activities in *kivas*[1], and has contributed to the survival and strength of the Hopis' Katsina cult.

The era of Spanish domination and conquests in the Southwest are part of Hopi history. Its effects have infiltrated the Hopi world and Hopi legends. Selected events of this period of intrusion are presented in the following section.

Spanish Mission

From the first appearance of Spaniards in the New World, on their quest for new lands, there had been conflict. Settlers from Tierra Firme, a settlement in Panama, and those who had come to Cuba seeking grants of Native Americans and land, planned to make an expedition to mainland America to seek new lands and to try their fortunes. Their encounter with the Native Americans of Yucatan at Cape Catoche in 1517 appeared openly friendly, but the Spaniards were ambushed. In the skirmish that resulted, warriors on both sides were killed, but the Spaniards won. Bernal Diaz (1963, 19) wrote, "Whilst we were fighting the Indians, the priest Gonzalez took possession of the chests, the idols and the gold, and carried them to the ship." This incident was a preview of the coming centuries of struggle between the Spaniards and the Native Americans of Mexico and the American Southwest.

In 1518, another Spanish fleet landed in the Yucatan. After many battles and surrender of their gold and treasures, the Yucatan Indians pointing to the west repeated the call: "Mexico, Mexico" distracting and diverting the greedy Spaniards to supposed riches in the province of Mexico.

The governor of Cuba, who believed the lands of Mesoamerica were rich in gold, ordered a new fleet to trade with the natives and conquer the new land. The land would be shared with the explorers and settlers. By political accident Hernando Cortés won out as leader of the expedition. His expedition's first landing was at Cozumel in February 1519. As his exploration and battle campaigns moved from coastal settlements into the province of Mexico, Cortés' conquest in New Spain brought the intruders face to face with the indigenous of Mexico. Speaking of the agility and vigorous attacks of the Spanish horsemen in battle, Diaz (1963, 76) reported, "The Indians thought at that time that the horse and rider were one creature since this was their first encounter under battle conditions of the soaring image of horse and rider." These myths persisted and influenced the unwary Native Americans on their strategy in dealing with the intruders until they faced them in battle. Fear and awe of the intruders burdened and confused the defending Native Americans whose ancestors had prophesied that men with beards would come from the direction of the sunrise and rule over them.

By the end of the second decade of the sixteenth century, Spanish invaders lay waste to the pre-Columbian culture of Mesoamerica as they searched for gold and riches. With the plundering of Mexico completed by 1533, the Spaniards turned to the north, still searching for El Dorado. Stories of cities of gold encouraged the Europeans to search deeper into the pueblo regions for riches. Unfortunately, reports sent to the Spanish rulers were embellished

to gain support to continue the expeditions in the New World.

Intertwined with the fear of the aggressive intruders and the age-old legends of the coming of their white brother from the East, the Native Americans were divided in their position—resist the invaders or accept the prophecy. This struggle continued from the first meeting with the Spaniards on the Yucatan peninsula until the middle of the eighteenth century when the Spaniards were dominating the Rio Grande pueblos and the province of Tusayan.[2] Throughout the nineteenth century, the Hopi settlements still accepted the legend of the returning white brother. However, they rejected the Spaniards as their prophesized brother arriving from where the sun rises, and for a brief period looked to the Americans from the East.

They Didn't See It Coming

Unknown to the Hopi, the world around them was changing. Waves of intruders in the New World followed Cortes' conquest of Mexico. Francisco Vasquez de Coronado led the first organized exploration of the American Southwest in the search for the fabled Seven Golden Cities of Cibola.[3] After an eighteen-month journey from Compostela, west of Mexico City, his entourage of more than three hundred horsemen and foot soldiers, more than twice that number of Native Americans as well as workhorses and livestock arrived at Zuni in 1540. Disappointed when the reported golden cities were merely the adobe villages of Zuni glistening in the sun, the Spaniards fought and defeated the Native Americans in a brief battle and looted the villages. Continuing his march eastward, Coronado established his headquarters in the Rio Grande region in the pueblo of Tiguex, north of today's Albuquerque. Here in the fertile river valley, he found the Pueblos easy prey and forced them to feed and house his expedition. Coronado did not hesitate, following the methods of the conquerors of Mexico in upsetting the native culture searching for wealth in the name of the Spanish throne.

For the next two years, Coronado sent out small expeditions to explore the Southwest. Pedro de Castañeda[4] recorded the events of the exploration of the territory that would eventually become Arizona and New Mexico. Unfortunately, Castañeda's account of the encounters between the Spaniards and the Pueblos is from the viewpoint of the Spaniards. He failed to record many of the details of exploitation and atrocities they committed. Reports of some of the tragic events were recovered from other Spanish documents and confirmed through the oral history of the Pueblos.

Still searching for the rumored seven cities, Coronado promptly sent a party of soldiers led by Pedro de Tovar to travel northward to Tusayan.[5] Tovar's first meeting with the Hopis took place on the eastern reaches of the province, below Antelope Mesa, at the place now called Keams Canyon. When the natives came out to meet the exploring force, they were armed with bows and arrows and wooden clubs—without confusion they stood in a defensive line. As interpreters spoke with them, the Hopis drew lines on the ground insisting the Spaniards not cross.[6] The face-to-face meeting between the intruders and the villagers protecting their homes brought a predictable conflict. A sudden movement by a horseman was countered with a Native American striking a blow to the cheek of the horse. The mounted soldiers ran down many natives; the remaining Hopis retreated to their mesa village.

The village was probably Awatovi, the closest Hopi settlement to the Spanish headquarters in the New Mexico territory. Reports of the recent capture of Cibola "by very fierce people, who traveled on animals which ate people" subdued the Hopi defense force (Castañeda, 1990, 21). Hoping to maintain peace and safety from the overpowering force, the Native Americans offered gifts and accepted the expedition in their village. When the Spaniards left, they continued further west across the Hopi mesas until they reached Oraibi, the westernmost town located on Third Mesa. Finding the Hopi settlements scattered over the three mesas were not the fabled cities of gold, Tovar returned to Coronado's base camp.

Tovar was told of a large river further west of Tusayan. When he brought the news to Coronado, he sent an expedition led by Don Garcia Lopez de Cardeñas back to Tusayan to see this river. With Hopi guides, Cardeñas and his troop traveled west for another twenty days before they were stopped by an overwhelming chasm that blocked their path of travel. They found it impossible to travel to the bottom of the gorge by horseback. Continuing on foot, they descended only part way into the canyon. Even then, they could not grasp the true magnitude of the obstacle blocking their path. Cardeñas returned to Coronado's base without locating the fabled Eldorado. He reported he had reached an impenetrable gorge that had a stream of water at its bottom that looked like a fathom across. This trickle of water was in reality the raging river now known as

the Colorado. The chasm, which blocked his route, we now call the Grand Canyon.

Coronado returned to Mexico in 1542, his exploratory mission ended. He reported the New Mexico territory lacked mineral wealth and was of little importance to Spain. Meanwhile, word of the atrocities the Spaniards committed spread throughout the pueblo world and would be long remembered by the Native Americans. In years to follow, Spanish missionaries and settlers would be burdened with the tales of the first meetings between the white men and the Native Americans. The Spaniards would be feared and mistrusted from then on, and the Pueblo Indians would protect their culture with a shroud of secrecy.

The Zuni people and the Eastern Pueblos located along the Rio Grande valley suffered the greatest oppression by Coronado and his army throughout their two-year occupation. Conflict between the Pueblos and intruders was common. Early during the occupation, Native Americans from a village near present-day Albuquerque rebelled in reaction to the burden of feeding, housing, and serving the Spaniards. The rebellion was quickly suppressed, the natives severely punished, and sadly, over one hundred were executed. Meanwhile, the Hopis, who lived in the remote region to the northwest, were spared the terror of conquest and burden of domination for another 40 years.

By1580, Spanish interest in the Province of New Mexico prompted a new wave of exploration. Plans to convert the Native Americans to Christianity masked the objectives to search for gold and silver and open the territory to colonization. Three Franciscan priests accompanied a military party led by Captain Francisco Sanchez Chamuscado to the Eastern Pueblos along the river valley. When the soldiers returned to Mexico the priests remained to begin missionary work among the Native Americans.[7]

An expedition led by the ambitious Antonio de Espejo returned to the region in 1583 and learned the Pueblos had killed the three padres. Espejo traveled throughout the pueblos telling the people he was looking for three missing priests. In reality, still captivated by the legends of mineral riches, he continued his hunt for gold. Natives tell of an episode where his savage behavior added to their fear and hatred of the foreigners. Enraged by the response of a Rio Grande settlement of Tiwa-speaking people who denied his demands for food and supplies, Espejo burned their village. Dwellers were burned alive in the pueblo, and a number of others were executed.

Focused on the drive for riches, the Spaniards had little understanding and tolerance for the beliefs of the natives they encountered. Espejo reported, "In each one of these pueblos they have a house to which they carry food for the devil, and they have small stone idols which they worship. Just as the Spaniards have crosses along the roads, they have… grottoes, like shrines, built of stones, where they place painted sticks and feathers (*pahos*)[8], saying that the devil goes there to rest and speak with them." (Bolton, 1916, 177-179). A further account attributed to the Coronado expedition stated, "Their rites and sacrifices are somewhat idolatrous, but water is what they worship most, to which they offer small painted sticks and feathers and yellow powder (pollen) made of flowers, and usually this offering is made to springs." (Castañeda, 1990, 107).

Fortunately, the Hopis had little contact with the European explorers until 1583, when Espejo and his soldiers, still in search of the elusive Golden Cities of Cibola, passed through Tusayan. Once again, Awatovi, the eastern most Hopi town, was the first settlement entered. Because the Hopis had gotten word of the exploitation of the Eastern Pueblos and Zuni, they warned the soldiers not to enter their village. However, Espejo did not heed the warning. According to his account, his party was welcomed and the Hopis provided food and lodging for their visitors until they continued on. It was a brief, but suspiciously friendly contact between the alien horse-mounted soldiers and the Native Americans.

The conquest of the Province of New Mexico was formalized in 1598, when King Philip of Spain commissioned Juan de Oñate as governor, and authorized him to give land grants and colonize the territory. Oñate and a large force of soldiers, missionary priests, and colonizers traveled the Camino Real to settle in the Spanish province they named Nuevo México. Their first governing center was established near San Juan Pueblo, 25 miles north of Santa Fe. Oñate traveled to the Hopi region late in 1598 also claiming the Hopi land for Spain.

Early during Oñate's rule, the people of Acoma killed thirteen soldiers who tried to take grain from the pueblo storehouse. The Spaniards took brutal revenge, killed hundreds and nearly destroyed the village. Even today tour guides, working at the mesa top village, report the episode to visitors. They add the appalling fact that more than five hundred Native American men were found guilty of rebellion and punished by amputation of their right foot. Two Hopis who were present at the time the soldiers

were killed were also punished. Each had his right hand cut off and was sent to the Hopi villages as an example and warning to those who would rebel against the Spaniards. This vivid display of brutality was long remembered and foremost in the minds of the Hopis when facing Spanish movement into Tusayan. After years of raids by neighboring Navajo, Ute, and Apache groups, and continuing threats of Spanish intrusions, the Hopis relocated their villages to the strategically safer mesa summits.

Spanish domination brought more missionaries and settlers to the fertile Rio Grande valley already occupied with pueblos. Spanish land grants for the new settlers had to come from the common land of the Native Americans. The Hopi territory, lacking moisture to grow crops and barren of minerals, was not of any value to the colonizers, but still the Franciscan priests were determined to include the mesa dwellers in their missionary work. However, future attempts to Christianize the Hopis would meet with mixed results. Outwardly the Native Americans were converted to Catholicism, but many secretly maintained their traditional beliefs.

The tenets of purification the Hopi practiced in the seventeenth century are still followed today. Don C. Talayesva of Oraibi said in order to purify hearts and bring rain the old men advised, "Think rain when you dance." He continued, "I expected the Whipper Katcina to come and flog them in order to purify their hearts and bring rain." (Simmons, 1942, 137, 229). Now in the twenty-first century, days of fasting and abstinence from sex remain essential elements of purification and preparation for the sacred ceremonies. Katsinam, using yucca leaves, perform individual flogging of the spectators as part of the public portion of the Katsina dances.

At the opening of the seventeenth century the Spaniards were in control of the New Mexico Province and the capital was moved to Santa Fe. Paradoxically, at the same time they worked to persuade the people to cease their pagan ways and adopt Christianity, overzealous Catholic missionaries used Native American labor to build missions. The first mission church, St. Augustine, was built in the pueblo of Isleta in 1612. The missionary movement continued and in 1629 a contingent of Franciscan missionaries arrived from Mexico and established San Esteban del Ray Mission in Acoma. Completed in 1640, the church, with walls sixty feet high and ten feet thick, still stands. Tour guides describe the suffering of the people forced to carry building materials to the summit of the 400-foot mesa, and then build the massive structure (Stoddard, 1898, 46).

Our Lady of Guadalupe Mission was built in 1629 in the heart of the Zuni village. Murals of ancestor Katsinam were painted on the early church walls as a reminder to the people they must attend mass and lead lives according to the Church and Zuni teachings. Following Mexico's independence, the Spanish priests were recalled and the mission was abandoned in 1820s. The mission ruin was excavated and rebuilt starting in 1966. Based on the oral legends and history of Zuni handed down from his father, Zuni artist Alex Seowtewa began to reproduce a scene of Zuni Katsinam on the church walls above the Stations of the Cross in 1970. Alex, now assisted by his son Ken, continues the project to paint the church walls with larger-than-life size figures in scenes from their traditional dramas.[9] Enchanting artwork covers the church walls, creating a permanent history of the Zuni, and reinforcing the Zuni way of life as it is now intermingled with Catholicism.

Zuni as well as the eastern pueblos enjoyed a religious heritage that included the Katsina cult. When the Spanish tried to eradicate the spiritual beliefs and convert the Puebloans to Christianity, traditional rituals either ceased or were celebrated in secret. The isolated Hopis were not subjected to the same extent of this religious suppression as their neighbors. In Tusayan, the Katsina cult survived, and in fact grew. During the Spanish occupation, many Native Americans moved from the Eastern Pueblos to the Hopi mesas, and they brought their religious legacy and their Katsinam with them. When a Katsina performance was credited with bringing rain, bringing ample crops, or curing the sick, it was accepted and became an additional resource the people would call upon in special celebrations. On occasion, the Zuni would perform a dance at Hopi, and likewise the Hopis would dance at Zuni with popular Katsinam being borrowed. Stephen (1936, 153) was told, Katsinam could be borrowed but entire ceremonies could not—that would be evil. It was not uncommon for the Hopi to add to their universe of masked supernaturals through exchange with other pueblos[10]. Barton Wright's writing of the Hemis Katsina noted: "The Hemis is presumed to have come from Jemez, a Rio Grande Pueblo. However, at Jemez Pueblo they have a ceremony in which the Hemis Katsina appears, and they refer to it as a Hopi Dance." (Wright, 1973, 214).

The Spaniards had a problem with control in the Southwest. With tribal rule and a large native population scattered in more than one hundred

villages, brutal tactics used by the small army of conquerors were devastating but not truly effective overall. Franciscan missionaries demanded the Pueblos accept Christianity or else face severe discipline. By the closing of the seventeenth century, the Spanish king eased the policies of ruthless control over conquered people in the Americas. Hoping to reduce the hostilities, each pueblo was allowed to have its own governing body. In turn, it was under control of the Spanish civil and church authority. However, attempts by the Spanish king to reduce the severe control over the pueblos were not practiced in the remote areas of the province. The New World Spaniards recognized conversion to Christianity would require eliminating the Native Americans' traditional beliefs and replacing them with Christian doctrine and ceremonies. Missionaries tried to end the "demon" worship and Pueblo celebrations by raiding the kivas and destroying figurines, altars, and sacred relics linking the Native Americans to their religious beliefs. Native religious leaders were punished, tortured, and some executed. The Spaniards believed once their church established a behavior pattern, the Native Americans would follow political authority.

The villages of Tusayan were not excluded from the Franciscan missionary plan to convert the Native Americans. In 1629, the Mission of San Bernárdo de Aguátubi was planned and built on Antelope Mesa—where, in the twelfth century, Anasazi ancestors of the Hopi had settled—at Awatovi, the Hopi village closest to the Spanish center at Santa Fe. Over the next two centuries the settlement of Awatovi grew to a population of about eight hundred, approaching the population of Oraibi. Oraibi was considered the capital of the Tusayan province and was looked on as the center of Hopi culture. Isolated and protected from the outside world by its location in the remote western part of Tusayan, it was the most conservative settlement. At the same time, Awatovi was the most progressive village since it was the most accessible to the outside world and had the closest relations with the Eastern Pueblos and Spanish colonizers and authority. The higher level of acceptance of the Spanish culture and religion would eventually lead to the destruction of Awatovi—not by the foreigners, but by the hands of the tradition-minded Hopis of Tusayan.

By the mid-seventeenth century, Franciscan missionaries established (and the Hopis built) the Missions of San Bartolomé on Second Mesa at Shungopavi and San Miguel on Third Mesa at Oraibi. When visiting Oraibi today, Hopi people will point

out ruts in the windswept mesa capstone caused by dragging logs from distant forests to construct the church the people would call the "slave church." The priests continued the methods they imposed on the Eastern Pueblos by using forced labor to build the missions and demand the people cease their religious and traditional celebrations—one reason the Catholic Church has little hold on the Hopis today.

The missionaries had some success in converting the people of Awatovi to Christianity. However, not all the people of Tusayan were willing to give up their traditional religion and accept Christianity. The isolated Second and Third Mesa villagers were more conservative and resistant to conversion. With a marginal environment for growing crops and a period of drought, poor crops were blamed on those who abandoned the traditional Hopi ceremonies and adopted Christian rituals. Adding to the problem, the forced tax-like payment of food and labor demanded by the priests reduced the ability of the villagers to support themselves. The Hopis were ready to return to their old ways.

In *Traditions of the Hopi,* Voth (1905, 268-270) recorded a story as it was told and retold as part of Hopi oral history. This story, *The Early Spanish Missions at Oraibi*, brings out reasons for the conflict between the Hopis of Oraibi and the missionaries. They kept the Native Americans at work and at first were not bad to them. The Franciscan priest said the water from the Oraibi springs was no good, and sent the men to the distant settlement of Moenkopi for his water. When the men got tired of this arduous trip for special water they went to Tuhciva, a spring south of the mesa, for water. The priest caught them in this deception and forced them to dig new cisterns. This was better than the travel to Moenkopi and the Hopis also benefited. However, after several years of plentiful rain, a dry period caused poor crops. The missionaries continued their demands for food even though the people had little for themselves. The padres forbid the Hopis to return to their traditional ways to pray for rain by making *pahos* and celebrating the Katsina rituals and dances. The oppression continued and some of the people wanted to kill the padres, while others feared the Spaniards would come and punish them.

Word of the heavy-handed rule over the pueblos of New Mexico alarmed the Hopis. Fear of punishment, loss of freedom, and forced changes in religion drove the Native Americans to feign cooperation and accept the demanding Spanish rule and conversion to Christianity. When the hard

driving Franciscan priest who established the mission church of San Bernárdo de Aguátubi died suddenly in 1633, the church hierarchy believed the villagers of Awatovi poisoned him (James, 1974, 47). The friars, eager to establish their mission and put an end to the ancient religious rituals, used physical punishment and torture, even to death, when the Native Americans were discovered practicing their ancient rituals. James (1974, 48) cites a hearing before church authorities in Santa Fe of a most brutal act committed by a Franciscan priest. A man from Oraibi was accused of an idolatrous act and was severely beaten as punishment before the villagers. He was beaten a second time then doused with turpentine and set afire. The man died from the unforgivable acts. James asks the question, "Was his act of idolatry merely the making of a kachina doll?"

Traditional Hopi cultural and religious ceremonies were conducted in secret and resistance to the missionary work continued. Hostilities were not diminished when the site selected for the mission convent at Awatovi was directly on top of one of the main Hopi kivas, "as a symbol that the Catholics had been victorious over the pagans." (Yava, 1988, 96). The priests were hoping to abolish the pagan rituals once the altars and religious paraphernalia were destroyed and the underground chamber buried. This was not the first or last time in history when an oppressor tried to eradicate an indigenous culture by burning artifacts and religious relics, and destroying sacred temples. The Hopis had no books to burn; their recorded history was in the relics, kiva murals, and figurines that were handed down to succeeding generations. The destruction of the kiva served to confirm the stories of Spanish tyranny and brutality.

The Awatovi ruins were rich in relics, including the finest of kiva murals and pieces of pottery belonging to the Hopis' ancestors. These antiquities remained buried until the 1930s when archeologists uncovered the ruins. Yava (1988, 96) reported when archeologists excavated the ruins, they found skeletons of young men. Hopis who were knowledgeable about Awatovi said the young men were killed so the padres could get their women.[11] In the 1980s a similar story of evidence of abuses at Awatovi was told to the author by a renowned Hopi/Tewa potter who often visited the ruins searching for pottery shards decorated with long forgotten designs she could reestablish in her creations.

Missionaries believed by destroying the kiva, along with its altars, the "devil worshipping" ceremonies would cease. They believed inflicting severe punishment for continuing ancient traditions would hasten the acceptance of Christianity. This intolerant plan backfired and would eventually bring the Eastern Pueblos, Zuni, and Hopis into a unified force to revolt.

The Last Knot

For many centuries the people who lived in the pueblos in the Rio Grande valley and Acoma, Zuni, and Hopi gathered and lived in densely populated settlements where they developed a stable, unique social system. Without a written language, history was orally transferred to succeeding generations and contributed to the legends which evolved to accommodate the communal culture. In a village-centered lifestyle, the Native Americans developed religious and cultural ceremonies that were conducted in kivas and outdoors in village plazas. At the same time, the Hopis had an ongoing struggle for survival in an agricultural society because they lived on the most arid part of the Colorado plateau. This continuing conflict with nature explains why for hundreds of years the Hopis have sought assistance from their spirit ancestors, the Katsinam, to bring the winter snow and rain to replenish the earth with moisture in preparation for the spring planting and summer growth of crops. It seems impossible to farm and harvest adequate crops in the northern plateau region of the Southwest where spring is the driest season, opposite to the weather conditions sought by the Euro-Americans who farm when moisture is available for seeds to germinate and plants to establish roots before the approach of summer sun and heat.

Puebloan way of life changed abruptly with the intrusion of the Europeans. For more than a century the Pueblos suffered under Spanish tyranny. The Franciscan priests were hated and feared for their tactics of using forced labor to build the missions, their ruthless policy of destroying kivas, burning sacred altars, and punishing religious leaders, even to death, in their drive to end the Native Americans' religion and ceremonies.[12] In difficult times, due to natural causes as well as adversarial relations with the Spanish factions, crop failures were blamed on the abandonment of the traditional religion. Smallpox, bubonic plague, and other infectious diseases brought to the Americas by the foreigners caused many deaths and weakened the village structure.[13] Many villages were reduced to less than a critical size and the survivors were forced to abandon them and move to other settlements. Many revolts developed in individual villages from

the time of Coronado's expedition and increased when Spanish settlements were establishment and encroached on Native American land. Village by village the Native Americans rebelled against the Spanish authority and taxation, but in each encounter the revolt was quashed in short order. Meanwhile, the Hopis were spared the unrelenting control and severe restrictions because their province had the least potential for colonization and exploitation.

The scattered settlements proved difficult for the Spaniards to control and govern; however, tribal rule and independent leadership in each pueblo proved a weakness of the Native Americans. The village chief was the highest governing authority. Each pueblo acted independently when fighting against the Spaniards. A Native American nation strong enough to resist the Spanish force was impossible without a central authority. The never-ending conflict with the Euro-American settlers, soldiers, and missionaries resulted in sporadic uprisings throughout the New Mexico Province. The unified Spanish force quickly suppressed each uprising and severely punished the insurgents. By the middle of the seventeenth century, rebelling villages sought assistance from neighboring pueblos, but without a strong leader to unite the various tribes in a common revolt, each uprising failed.

In the last quarter of the seventeenth century, the demands of the Spanish government, the dogmatic position of the Franciscan friars to eliminate the Pueblo religion, and the movement of colonizers onto communal Native American land reached a level where the inevitable dangers and pain of rebellion were acceptable to the native population. Native American leaders were flogged and many were imprisoned in the palace in Santa Fe for their pagan actions. Popé, from the San Juan pueblo, had been one of the Native American leaders imprisoned in the Governor's Palace. Upon release, he united the Pueblo Indians and organized a rebellion against the intruders. The underground kivas, the traditional meeting places for religious ceremonies, were an ideal place to plan, perfect, and coordinate the Pueblo Revolt of 1680.

According to pueblo legends, as the day of rebellion came near, the fastest runners carried a knotted cord from village to village. One set of knots represented the days until the uprising. Each knot corresponded to one day in the countdown, and one knot was untied each day. At the same time, a second cord with a set of knots was offered at each pueblo. Each pueblo would untie one knot, showing it agreed to join the effort to overthrow

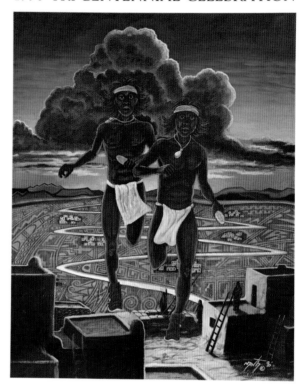

1990 TRI-CENTENNIAL CELEBRATION

1680 - 1980
"NEW DAWN - OUR INDEPENDENCE"

Taos to Hopi Relay • Hopi Agricultural Fair
Hopi Arts and Crafts Festival • Miss Hopi Pageant
Hopi Cultural and Education Fair • Tewanima Foot Races

Fig. 2-1: **New Dawn—Our Independence,** by Neil David. This poster commemorates the 1680–1980 anniversary of the Pueblo Rebellion.

the Spanish rule. Even the distant Hopi villages would join in the revolt. A Hopi delegation brought back a buckskin thong with a number of knots on it representing the number of days until the rebellion would begin (Yava, 1988, 90). Unfortunately, the secret of the uprising was uncovered and the Native Americans in Santa Fe were forced to begin the war two days earlier than planned. Because the Hopi followed the plan, their revolt started several days later. The decision was made to kill the resident priests at the time of the Rebellion. Members of the Badger Clan agreed to perform the deed. Crane (1925, 166) presented the Hopi history according to Yukioma; when the Spaniards came to Oraibi their "black-robes" wanted to baptize the Hopis. "It was against the traditions.... Finally, the Badger Clan killed the Spanish black-robes." They were driven into Skull Flat, a place named for the heads piled there. According to Third Mesa legends, two warrior

Katsinam from the Badger clan killed the priest and threw him into a ravine at the mesa edge. One of the warrior Katsinam was *Tseeveyo* (Cha'veyo, the Giant Ogre) (Pearlstone, 2005, 27; Pecina, 2011, 16-17; Waters, 1961, 254).

The Spaniards suffered the same war crimes they inflicted when they conquered the New Mexico pueblos a hundred years earlier. Churches were burned, images and crosses destroyed, priests were killed and the Spanish rule was ended. With the Native American population overwhelming the Spanish force, the Spaniards were defeated and driven from the New Mexico Province.

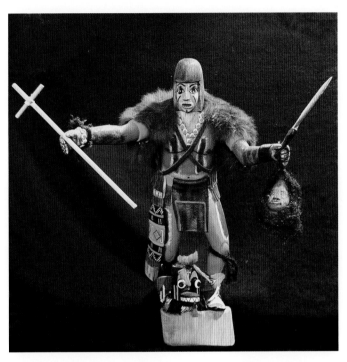

Fig. 2-2: **Priest Killer kachina,** *Yo-we*. This is a rare carving showing the performer with his mask removed. He carries his victim's head. *Courtesy Brian Hill.*

Unfortunately, carefully recorded, detailed Spanish accounts and missionary records of the period of occupation were destroyed during the revolt. As a result, records from the period of Spanish occupation are limited. In Tusayan, the missions of San Miguel, San Bernardo, and San Bartolome were destroyed and the resident priests were killed. The Spaniards were now gone from the Hopis' land, but Christian influence remained. Today the Hopis celebrate Christmas and Katsina dances are held at Easter.

Following the rebellion, many refugees from the Rio Grande pueblos migrated to Hopi land to avoid future encounters with the Europeans. The distant lands were of little interest to Spaniards and would provide a safe retreat for the oppressed people.

Tewa-speaking people, from the Northern Pueblos, established the village of Hano (Tewa Village)[14] on the northeast trail as it rises to the summit of First Mesa. Even today, their descendents proudly tell the history of their move to the Hopi mesas. According to Hopi-Tewa legend the Tewa were noted for their warring ability and were recruited by the Hopis as a forward guard to help protect the Walpi settlement on First Mesa from marauding parties of Utes, Navajo, and Apaches. Irving Pabanale,[15] whose ancestors came from a village near San Juan, presents the story as told to him by his Tewa elders about the recruiting of Tewa people, their relocation, and battles they fought on behalf of the Hopis. He learned about Hopi-Tewa history the same way Hopis have handed down their history for centuries: from family elders through the oral tradition of storytelling to the next generation.

Seeking the greatest protection possible from their enemies, and fearing the return of the Spaniards, the people of Walpi moved their village to the most defendable location on the remote narrow tip of First Mesa. For the same reason, the village of Shungopavi moved to a more secure site at the summit of Second Mesa.

Second Mesa is about sixty miles north of Winslow, Arizona, at the northern termination of state route 87. The one-hour drive from Winslow presents a variety of desert landscapes ending with a captivating view of Second Mesa.[16] About thirty miles north of Homol'ovi Ruins, the Hopi Reservation begins, and in the distance, the stark mesa breaks from the horizon. Continuing the drive northward the mesa grows larger and its details take form. A sheer wall extending from the mesa escarpment appears like a protective barrier of a fortified city. The mesa-top villages are not prominent because they are built of the native sandstone and blend into the slab-faced cliffs. Imagine what the first Spanish expedition thought when approaching the Hopi region from this direction— what riches they might find, what battles they might face. Driving further, the pueblo of Shungopavi now takes form as an impenetrable fortress perched on the mesa. However, today's paved highway climbs and winds up the mesa approaching the settlement from its vulnerable backside. Here, on still higher elevations of Second Mesa, are Shungopavi's younger sister settlements of Shipaulovi and Mishongnovi.

The Spaniards were determined to return to the Rio Grande region and were quick to respond to the Pueblo Revolt of 1680. Within a year the former governor of the New Mexico Province, Antonio de Otermín, returned with his forces and found the Native Americans who had united to rid themselves of the ruthless domination had returned to prehistoric

ways (Weber, 1999, 91). Unity to fight a common enemy was no longer essential. Rivalry and conflicts between villages and tribes returned to a more typical level. Intra-village differences once again resulted in groups of villagers breaking away and establishing new settlements. By 1692, the Spanish reconquest of the New Mexico Province and the Tusayan villages was underway.

During the revolt of 1680, some Hopis at Awatovi remained committed to Christianity, while those loyal to Hopi traditions destroyed the church and buildings that had been built over the kiva. Awatovi, a border town between two cultures, had lived divided in allegiance for more than two generations. To the east, the Spanish authority would demand submission and tribute, and the Christian priests would seek conversion to Christianity. To the west, the Hopi nation, firm in its culture, religious beliefs, and village sovereignty expected the people to live the traditional Hopi life.

Awatovi

By 1700, Spanish missionaries had returned to Awatovi and baptized a number of the Native Americans. Many of the people were receptive to the changes the Spaniards brought and accepted the missionaries and their Christian teachings. Tapolou, the traditionalist chief of Awatovi, was troubled with the changes in his people and their acceptance of the Christian beliefs. He decided to take action and went to consult with the chiefs of the more conservative Hopi villages for assistance in resolving the dissension and division in his village. Accusing the people of abandoning their religion, he wanted them killed.

The Hopi always prepared for upcoming ceremonies with fasting, abstinence, prayer, and meditation to achieve pure thoughts. Their leaders feared participating in Christian rituals would cancel the benefits of positive spiritual behavior needed in preparation for the Hopi's sacred ceremonies. Assimilation and conversion to the Christian beliefs was not acceptable to the people of Tusayan. Supporting Tapolou, the chiefs and their warriors from Oraibi and Walpi attacked Awatovi. The village was destroyed. Men were trapped in their kivas and massacred. Surviving women and children were divided between the conquerors and sent to live among the villages of Oraibi, Walpi, Shungopavi, and Mishongnovi. To this day, the reprehensible act of annihilation of Awatovi is regrettably the biggest black mark on the Hopis' proud history of being people of peace.

Summary

The Spanish invasion and conquest of the New World changed the way of life of the Native Americans of Middle America and the Southwest. The domination, forced labor, and economic burdens lasted for almost three centuries. The cruel and intolerant treatment and attempts to convert the Native Americans to the Catholic religion left them prejudiced and suspicious of outsiders. As a result, the Pueblo Indians built a protective shell of secrecy around their religion and ceremonies. Although the Hopis were subjected to Spanish domination during the hundred-year period when the missions flourished, they were spared the continuous rule the Spaniards had over the Rio Grande pueblos and the Zuni. Nonetheless, they constantly feared the Spaniards would oppress them with the same firm rule and cruel practices.

Early Spanish explorers provided the first written accounts of the life of the Native Americans. Unfortunately, their diaries and journals were written with the cultural bias of the authors and presented daily life as a story of Spanish adventure and conquest. These first writers had little interest in preserving the native history. Little detail of their understanding of pueblo life and religious practice was recorded. Up to the late 1800s, survival of the Hopis' traditional celebrations and legends was dependent on oral instructions and enactments of complex rituals by clan elders as they handed down their religion and ceremonies to the next generation. It remained for the American traders and missionaries who lived with the people on the mesas in the mid 1800s to record the life of the Hopis. These amateur ethnologists bridged the gap until the more formally trained investigators arrived, rushing to collect information on the rich Hopi culture before outside influence would change it.

The European intruders' presence and domination influenced and changed the culture and behavior of the native people of the Southwest. Assimilation in the white man's culture was not achieved, but a blending of cultures became an active process. Isolation protected the ancient Hopi civilization until the coming of the railroad brought travelers who wanted to see performances of the intriguing Katsina dances. By choosing the desert of the Colorado plateau and selecting the fortress like mesas of Northern Arizona as a refuge, the Hopi culture has survived and thrived in the twentieth century with limited awareness by outsiders. Hopefully in the twenty-first century, with a more sensitive and culturally tolerant America, the Hopi people will thrive with their beliefs and culture intact.

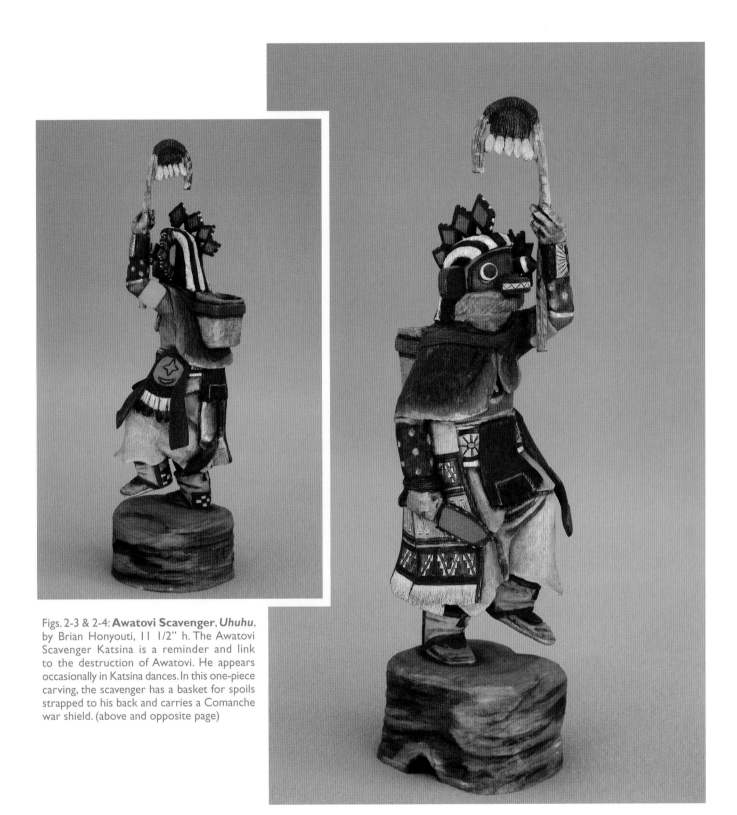

Figs. 2-3 & 2-4: **Awatovi Scavenger**, *Uhuhu*, by Brian Honyouti, 11 1/2" h. The Awatovi Scavenger Katsina is a reminder and link to the destruction of Awatovi. He appears occasionally in Katsina dances. In this one-piece carving, the scavenger has a basket for spoils strapped to his back and carries a Comanche war shield. (above and opposite page)

Chapter 3: The History Gatherers

With the close of the Mexican War and the treaty of 1848, this nearly forgotten tribe came under the nominal guardianship of the United States.... In 1882 an Executive Order set apart...[3863 square miles] of land for the Moqui Reservation.... At that time someone with a ruler drew on a map a parallelogram which represented an area, approximately 75 by 55 miles, for a reservation, without the least regard to topographical and ethnological conditions, and misnamed it the "Moqui Reservation."

–Crane (1925, 197, 298)

A significant part of Hopi history is the story of the individuals who first recorded the daily life, culture, and religion of the Hopi Indians. The pioneer ethnologists worked without knowing the value of their research not only for the outside world, but more importantly to produce a written history for the Hopis. These legendary history gatherers documented all aspects of the culture of the exotic pueblo dwellers who practiced strange religious rituals and lived in small communities in multi-storied houses secluded in the core of the bold new American nation.

Fortunately, the dedicated effort of these historians to collect and record the activities of the Katsina cult and the life and legends of the Katsinam preserved a snapshot in time of the Hopis' Katsina society. Cultural and economic changes of the nineteenth century were being forced on the Hopis by the surrounding dominant American society. These rapid changes, coupled with the limitations of transferring Katsina history and rituals to succeeding generations through oral teachings, would have influenced the structure and rituals of the Katsina cult. However, these first writings preserving the established rituals have been accepted by the Katsina society and they are still referred to as guidelines to settle disputes in preparation and performance of traditional Katsina celebrations.

Museums and research institutes saw a ground floor opportunity to study an aboriginal society secluded in our own Southwest. This was a chance to compete with the illustrious European expeditions who had explored ancient civilizations in Africa and the Middle East. Using men who gained their expertise by living with the Native Americans as their field observers, intermediaries, and interpreters, the Museums rushed to gather collections of Native American artifacts and crafts and establish ethnological studies of the pueblo tribes. Urgency was based on the well-founded fear that rapid expansion of the United States into the lands gained after the war with Mexico would destroy this ancient and still thriving civilization before it was studied. It presented a unique opportunity to study a prehistoric society living in the midst of the expanding nation. Museums and research institutions saw the need to document the life of the Pueblos before it changed; or worse, suffered the same fate as many Eastern tribes—extinction.

With the extremes in treatment of Native Americans by the Spaniards and then the Americans who swarmed over the West, one wonders why the Hopis would tolerate the intrusion of historians who came to write about their culture, their beliefs, and capture the images of the people even while their oral teachings showed harsh treatment from outsiders. Fortunately, a small number of sincere and dedicated historians won the trust of the Hopi people. Alexander Stephen (1936, 311) told the story of an open minded Hopi: "Siky'ahona'va tells me he is glad I am writing of all these things that occur in the kiva and making drawings of all

their *wi'mu*. It must please the Washington chiefs and all the good Americans: and the prayers of the Americans being united with their own, such intensity of unison must bring much rain, etc."

On The Western Front

Long before the coming of the white man, Moenkopi was a seasonal farming satellite of Oraibi. The fertile Moenkopi valley possessed the only dependable year-round water source available to the Hopis of Oraibi. During the farming season, farmers would run the forty-mile commute on a daily basis. In 1847, the Mormons began their exodus from Illinois and settled in the Salt Lake valley of Utah. Extending their colonizing movement, Brigham Young, "the Great Colonizer," called for settlers to go southward into Arizona territory. Over the next twenty years the Mormons established farming communities at Moenkopi and, five miles to the west, a trading center that in time would become Tuba City.[1] Committed to the duty of religious conversion, they started temporary missionary work with the Hopis who lived on the western extremes of Tusayan. Initially, the missions were seasonal and the Mormons stayed for only a few months each year. Meanwhile, the other missionary attempts were short-lived. The Mennonite Mission Board initiated plans to open a permanent mission among the Hopis, and in 1891 Heinrich R. Voth was chosen to lead the effort.

Voth was born in Russia in 1855 and moved to the United States in 1874. By 1890, Voth had completed ten years of missionary work among the Arapahoe Indians in Oklahoma Territory, and was on leave visiting his homeland in Russia when the Mormon Mission Board offered him new work living with the Hopis. On his return he made a brief visit to Arizona to plan for the mission and report his findings to the Board for approval and initial funding. In 1892, Voth married Martha Moser, also a missionary. They moved to Kansas and began the study of the Hopi language, knowing they had to understand the language of the Native Americans before they could accomplish their goals as missionaries. With the Church's authorization to establish a mission, they moved to Arizona in 1893. They traveled by railroad to Holbrook, and then by wagon to Keams Canyon. The seventy-five mile trip took a whole day and night; at times the trail was so sandy they had to walk.[2] They stayed at Keams Canyon as guests of government agent Ralph Collins for several weeks while Voth traveled throughout the three mesas to select a site for their home and mission (Voth, 1923, 3).

Voth decided to build his home on Oraibi, the largest Hopi community with a population of more than eight hundred. Oraibi, the pueblo settlement on the southeastern tip of the westernmost mesa (Third Mesa or Oraibi Mesa), has the distinction of being the longest continuously occupied settlement in the United States. From the time of the first Spaniards' visit, it had been looked upon as the principal Hopi settlement. Since the sixteenth century, the population range has been estimated between 500 and 2400. It remained the largest of the Hopi villages until the opening decade of the twentieth century.[3] Since its founding, wide swings in population were endured due to disasters such as famine, caused by drought, and outbreaks of small pox. For example, following an outbreak of smallpox in 1780, the entire Hopi population fell to less than eight hundred (Crane, 1925, 198).

In August of 1893, Voth, his wife, and a child from his first marriage moved to Oraibi to begin their work and build the Mission Station. To communicate effectively with the Hopis, they continued to study and practice the native language. Within three years, Voth knew enough of the language to serve as an interpreter between government agents and the Hopis. Living a frontier standard of living,[4] accepting the daily hardships of life in Hopi, planting a garden, and building a home in the inhospitable environment did not go unobserved by the Hopis. These were all plus factors in being accepted. Voth wrote that the route from Oraibi to the trade center at Flagstaff was one hundred miles. Lumber and building materials were hauled at the rate of $1.25 per hundred pounds. The cost of material plus freight charges consumed most of his allowance for housing. Little was left for labor costs. His wife's diary described the difficulties in completing their home and in shipping lumber from Flagstaff: "...at last [they] came with the lumber. As the road had been covered with sand they had several times lost their way. Were nine days on the road from Flagstaff and had to leave two loads behind although they had hitched up 20 horses and only brought two loads." (Voth, 1923, 4; James, 1974, 148-157).

The missionary couple used every opportunity to spread the teachings of Christianity while establishing their home. They opened their home to the Hopis and also made many visits to Hopi homes. Voth believed the people were deeply interested in his teachings. Meetings for the school-age children were held in his home and in public in the village

plazas. The Mennonite missionary knew the Hopis' rituals and ceremonies were held in their kivas, and the priests kept their religion a carefully guarded secret. To preach his religion and convert the Native Americans he needed to understand their traditional beliefs and religious ceremonies. "What little I could 'pump out' of the priests was, as I soon found, misleading, distorted, unreliable." (Voth, 1923, 5). They were perceptive and recognized his plan to replace their religion with his.

Although not a doctor, Voth's willingness and experience gained in aiding the sick while working among the Arapahoe Indians was frequently put to use when living with the Hopis. They had confidence in the man who helped them when they were sick, and who treated their religion with respect (not as told in the stories of the Spaniards and more recent actions of other missionaries who intruded). Voth (1923, 5) noted the episode of a missionary (of another denomination) entering a kiva, and kicking sacred objects with his feet.

While Voth wrote of the incident, could this be the event as recalled from a Hopi's point of view some thirty years later? Based on his oral teachings, Don Talayesva recalled the time when in an exceptionally dry year, even the late summer Snake Dance failed to bring rain. The first thoughts were of the participants. Were they not pure in thought, or did they fail to pay proper attention to the rituals and performance? Searching for the cause of the drought, the people remembered Reverend Voth. He had taken many sacred images and altars and set them up in the white man's museum. He had written of the Oraibian's ceremonial secrets and sold them. Talayesva recalled when he was a boy (he was born in 1890), Voth had worked at Oraibi. The people were afraid of the reverend and feared punishment if they harmed him. "During the ceremonies this wicked man would force his way into the kiva and write down everything he saw. He wore shoes with solid heels, and when the Hopi tried to put him out of the kiva he would kick them." (Simmons, 1942, 252). Years later, Voth returned to Oraibi, and Talayesva had heard Voth was in his mother's home. Now grown and taught in the government schools he no longer feared this man. He called Voth a thief who stole Hopi images and broke the commandments of his own God (Simmons, 1942, 252). Neil David's pen and ink drawing portrayed the story he was told of Voth's forced entry into the kiva, with nails protruding from his shoes, while the priests were preparing for their sacred ceremonies (Pecina and Pecina, 2011, 22-23).

Voth saw this aboriginal culture rich in traditions and myths of their migrations, and with an abundance of deities they called upon for assistance. He recognized the Hopis' religion was not recorded in books but was evident in visual form on pottery, in altar decorations and kiva paraphernalia, in masks worn by the performers during sacred rituals, in their songs and prayers, and in gifts the performers gave the children. With particular interest in the intriguing Katsinam he began collecting *tithu* (hand carved kachina dolls) given to the children by the Katsina dancers. For the next decade he observed Hopi life, customs, and religion and conducted a systematic study of their ceremonies. To help understand the culture and religion, he collected Hopi artifacts and used them as his library of reference material. He would discuss with the Hopis and with their priests the meaning of the pictorials and symbols and compare them to elements in his religion. In his writing, Voth affirmed this introduction to the Hopis' ethnological life remained second in importance to his missionary work.

Voth (1923, 6) wrote he was not allowed to attend the major religious ceremonies until he gained the confidence of the conservative society members. Only after several years of sincere effort in helping the people, was he permitted entry into the kivas during the preparations for the sacred ceremonies. Since many are held annually, and some only every two years, it took a number of years before he accumulated a relatively definitive set of notes for publication.[5] It is no trivial task entering a foreign culture, not speaking the native language, and studying cultural and religious activities that have been kept secret from outsiders for hundreds of years. Voth only hinted at the challenge to his endurance to observe the almost continuous performances that only recognized each day's new dawn as the beginning of the next ritual when he wrote: "Of course, during the nine days that these religious performances were in progress I had to spend many a night hour in the kivas...." His publication, *The Oraibi Powamu Ceremony*, remains *the* report of this major Hopi celebration—never surpassed in depth and detail. Mischa Titiev, in his account of the Powamu recorded: "The fullest and best description of Oraibi's Powamu celebration is given in Voth, 1901. Although I was present at Oraibi during the 1934 performance, I was not allowed to witness the esoteric rites. The summary here given is taken largely from Voth, but is supplemented by interviews with Powamu members." (Titiev, 1944, 114, n. 29).

Dr. George Dorsey had directed the collecting of Hopi material for the Columbian Exposition of 1892 and 1893. Several years after the Chicago World's Fair, Dorsey, who was Curator of Anthropology, met Voth while on a field trip for Chicago's Field Columbian Museum. Impressed by the missionary's knowledge of the Hopis, his collection of specimens, and his thorough documentation of the collection, Dorsey planned to use Voth as a collector for the museum. He also proposed Voth come to Chicago to develop several exhibits based on his observations of the Hopis' elaborate ceremonies, and at the same time write a series of related articles. Voth's wife died in 1901, and Voth, still primarily a missionary, deferred his work with Dorsey. He resigned his position as the Missionary of Oraibi, remaining in place until his successor arrived later the same year. However, he continued his studies of the people of Oraibi and in 1901 published *The Oraibi Powamu Ceremony* and coauthored with Dorsey *The Oraibi Soyal Ceremony*.

Based on his observations and photographs collected in the ten years he lived in Oraibi, Voth prepared reproductions of kiva and sacred altar displays relating to various Hopi rituals for the Field Museum, and for the Fred Harvey tourist house in Albuquerque. The accuracy of these reconstructed kiva exhibits raised serious concerns with the Hopis. They appeared so authentic the Hopis said they were not replicas, and they asked for their return.[6] From 1900 to 1915, Voth wrote a number of papers on Hopi customs and sacred multi-day ceremonies. Eleven were published under the banner of the Field Columbian Museum, funded by and under direction of the Stanley McCormick Hopi Expedition. He also gathered a number of major collections of Pueblo antiquities and artifacts for clients including the Field Museum, Carnegie Museum of Natural History, and the Fred Harvey Group.

Over the years many Hopis accused him of stealing their relics. Some Hopis (Titiev, 1972, 72) who had visited Chicago during the Fair of 1933 also visited the Field Museum to view the exhibits initially developed by Voth. They claimed they saw the image of Ned, Titiev's interpreter and principal informant for the ethnological field study, in an exhibit portraying a sacred rite of the Soyal ceremony. They accused him as the model for the image and of revealing secret ceremonial information to the white man.[7] In his autobiography *Sun Chief* (Simmons, 1942, 252), Don Talayesva remembered Voth, "...who had stolen so many of our ceremonial secrets and had even carried off

sacred images and altars to equip a museum and become a rich man."

Fred Eggan's essay on Voth the ethnologist (Wright, 1977, 3) provides an assessment of his missionary activities. He quotes from Alfred Siemen's article "Christ and Culture in the Mission Field" (*Mennonite Life*, April 1962), an assessment of the Mennonite's missionary activities. He saw Voth as an "...aggressive evangelist and anthropologist. He gathered many Hopi artifacts, made intensive studies of their customs, vocabulary and religion, and wrote carefully and voluminously about them. But he, as had the Catholic fathers before him, also antagonized them."

Titiev, in reporting Voth's disregard for the privacy of kiva rituals, noted Tawaqwaptiwa, the Oraibi Chief, said Voth had come into the kiva while a secret rite was taking place. The warrior Katsinam, "carried Voth up the ladder and dropped him outside, but Voth promptly came in again." He was then allowed to remain in the spectator's area behind the kiva ladder. He preached in Hopi throughout the ritual saying the participants would "be burned in a big fire." (Titiev, 1972, 361, n. 4).

Because of government edicts in this last decade of the nineteenth century, the people of Oraibi were splitting into two factions—friendly and hostile. Friendlies, or progressives, accepted the plans for "civilizing" them and schooling the Hopi children, while the conservative Hostiles were dedicated to following the traditional life. Their decisions had separated the two groups in everyday life and traditional celebrations. Voth found the religious rituals were performed as they had been for hundreds of years but now were being celebrated separately by the groups. About this time, government agents were directed to survey and allot the limited farmable land into plots. The plan was to allot these parcels—land that had traditionally been clan owned for generations—to individuals. All the Native Americans were against this form of land distribution. Adding to the conflict, the missionary Voth was given a plot of their land for a home, a mission, and to farm. Not an ideal way to introduce the Christian doctrine to the people.

Some have blamed Voth for the Split of 1906; others find the negative memories of Voth were caused by the internal conflict between the Hostiles and the Friendlies, and the federal government's aggressive operation to assimilate the Hopis. The settlement following the war with Mexico (1845–1848) and the Gadsden Purchase of land extended the American territory to include

the Southwest and California. The opening of the American West accelerated with the discovery of gold in California and with army expeditions conducting reconnaissance and surveys of the newly acquired lands.[8] At the same time, an ever-increasing number of white men intruded into the world of the Hopis. These encounters and the new government's control of Pueblo Indians forced the Hopis to a defensive preservation mode.

In 1882, a decade before Voth arrived, Major Powell, who at this time was Director of the Bureau of Ethnology and Geology of the Smithsonian Institution, sent an expedition of scientists to Tusayan "to make as large an ethnological collection as possible at Oraibi." (Cushing, 1990, 403, n. 36). Powell instructed his secretary to write Frank Cushing[9] and the Oraibi expedition, led by Victor Mindeleff, to secure their cooperation to "'clean out' Oraibi—ethnologically speaking." (Cushing, 1990, 247).

The expedition reached Oraibi in December 1882. They traveled across the Hopi mesas from the east with two six-mule teams and one four-mule team. In his journal, Willard Metcalf (Cushing, 1990, 256-259) recorded the events of the expedition's brief stay at Oraibi. He believed theirs was the first team that had ever visited Oraibi. On reaching their destination, the men unloaded the wagons at the governor's house. That evening their spokesman, Cushing, went to several council meetings, and then reported to his fellow travelers things were not going well. In the middle of the night he woke the men. Cushing said the village council, bending to the wishes of the people of Oraibi, had given him an ultimatum to leave Oraibi promptly or they would "pierce us."[10] The group packed, remained on guard with weapons at ready, and left Oraibi as soon as their teams could be brought up to the mesa. Before they left Oraibi, Cushing wrote a letter to Mindeleff reporting the incident at Oraibi and the expedition's failure. He concluded, "They like me, they say. My mission they do not like." (Cushing, 1990, 260).

Less than a year later, the first Mennonite missionary arrived at Oraibi. Even with the resentment from the orthodox Hopi, Voth approached his assignment as a true missionary. Years later after the loss of his wife, he resigned from the mission to care for and educate his four children. While the number of Hopis he converted to Christianity was few, he made many Hopi friends over the ten years he lived in Oraibi. Voth had the personal satisfaction of gaining the confidence of the conservative element to a degree he was permitted to attend their ceremonies.

Fred Eggan (Wright, 1979, 6) wrote of Voth the ethnologist: "Voth excelled as an ethnologist. The details fascinated him and he was never content until he had everything in place." In his study of Hopi life, "he had no peers but the task of interpretation had to be carried out by others." In 1947, the chief of the Badger Clan died without training a successor in the rituals of the Powamu (James, 1974, 158; Titiev, 1972, 342). The chief's younger brother took the lead and performed the complex ceremony. As a last resort, he was forced to use Voth's definitive publication, *The Oraibi Powamu Ceremony*, to assist him in conducting the elaborate ceremonial.

On the East Mesa

While Heinrich Voth was working as a missionary and broadening his understanding of the Hopis, who lived at Oraibi on Third Mesa, the story of the Hopi-Tewa Indians of First Mesa was already being written. During the last quarter of the nineteenth century, word of a fascinating Native American ritual brought curious travelers and scientific investigators to Tusayan. One of the first, John Bourke, on special leave from the army, toured the pueblos along the Rio Grande and planned his leave so he would reach the Hopi village of Walpi in August 1881 to witness the spectacular Snake Dance, a dramatic ceremony where the Native Americans perform with "live rattlesnakes!"[11] To reach the Native Americans in the desert wilderness of Arizona, Bourke and artist Peter Moran traveled on the newest segment of the Atlantic and Pacific Railroad westward from Albuquerque (Bourke, 1984, 54), and continued on to the terminus at Wingate Station.[12] Bourke then walked the three and a half miles in a severe night-long rainstorm finally reaching Fort Wingate. The next day, guided by Thomas Keam, a Native American trader, they traveled on the ancient trail linking the pueblos of Zuni, Acoma, and Laguna to the Tusayan villages, to Keam's ranch and trading post.[13]

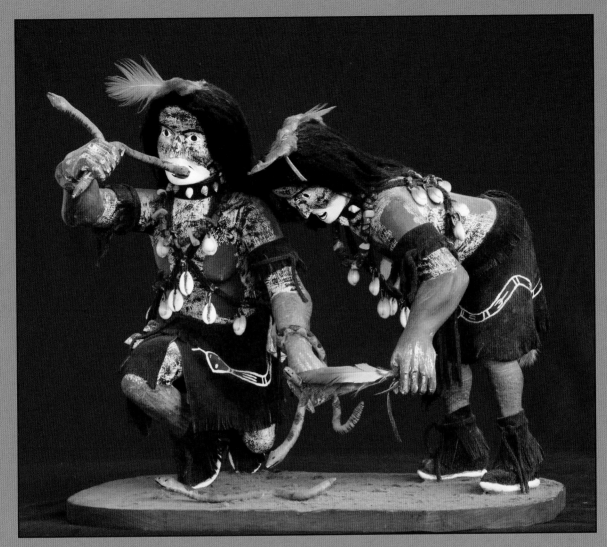

Fig. 3-1: **Snake Dancers**, *Chusona*, c. 1970, 16" h.

This carving of Snake Dancers was made about 1970 and documents the details as the ritual was performed on Second Mesa. The "carrier," with a snake held in his mouth, makes a circuit around the village plaza while guided by the "hugger" who uses a feather to distract and sooth the snakes. The dancers' chins are painted white and their faces are painted to simulate the micaceous hematite used to create a sparkling effect. Their leather bandoliers are decorated with shells and turquoise. Both performers wear coral and turquoise necklaces, and their leather kilts are marked with zigzag figures of the plumed serpent. This carving was made in an era when few carvers were bold enough to carve the Snake Dancers. In later years, the carver said he would not carve this figure again.

Bourke's published account of the Hopis' Snake Dance brought widespread attention to the pueblo dwellers that lived on the narrow mesa summits in the extremes of Northern Arizona. By 1911, Leo Crane, Superintendent of the Hopi Agency, was concerned tourists numbering in the thousands descending on the sparse desert settlements could bring a potential for disaster. There was no commercial lodging and a limited water supply to support the influx of outsiders that swarmed over the mesa to see the Prayer for Rain ceremony with live snakes. During the ceremonies, the crowds were deeply packed along the mesa's unguarded open ledge. Spectators jammed the pueblo rooftops and there were concerns the house rafters would collapse under the burden. Further cause for concern, they crowded the small dance area, distracting the performers who were handling poisonous snakes. Some of the crowd even tried to participate in the handling of snakes. Crane wrote:

The place of dance is a narrow shelf at the very edge of the mesa. The houses of the people, tier on tier terraced into little balconies, form a backdrop. Through these houses, and leading from the shelf, a tunnel gives to another street. The ledge is simply a continuation of the rock roadway that skirts the brink of the village overhanging the wide First Mesa Valley.... The ground-area available to spectators and dancers measures about ninety feet in length and not more than thirty feet in width...[By 1911 moving pictures of the Snake Dance were prohibited; however, individuals were still allowed to take still pictures. Crane clarified the order:] No moving-picture film of the Hopi Snake Dance should be made unless by permit of the Secretary of the Interior; and it had been further decreed that such permission should be granted to representatives of State and National museums only.... The reason for such an order against movies? Some of the mildest of the Hopi are members of the Snake clan, and go their peaceful ways at Walpi; but they zealously enact their parts in the pageant every second year; and to see those fellows painted ferociously, garbed in savage dress, with snakes held in their mouths—yes, in their mouths: and two or three active snakes can weave a revolting mask for a painted face—I

can conceive of no more terrible close-up than that of a Snake Priest, coming toward one with eyes glaring, cheeks and chin painted black, his mouth a huge white daub, and snakes, some of them with rattles, feeling about his ears, through his hair, and about his face and neck.

–Crane (1925, 248-255)

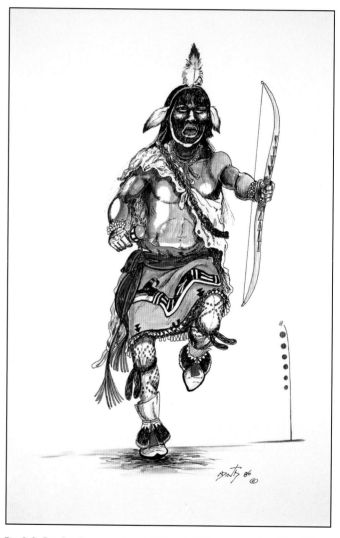

Fig. 3-2: **Snake Dancer**, by Neil David, 1986, watercolor, 8" x 12"

Keam's trading post was twelve miles east of First Mesa in the canyon that would in time be officially recognized by his family name and called "Keams Canyon."[14] At the time of Bourke's visit, the Indian Agency for the Hopi was administered from Fort Defiance. A permanent agency was established at Keams Canyon in 1878.[15]

The Navajo and Hopi trusted Keam, and called upon him as their spokesman on affairs with the federal government. Although he was recognized as a well-educated, honest, and competent individual who understood the Native Americans, the government bureaucracy held it against him because he defended the rights of the Native Americans. Anthropologists studying the Hopi culture sought his door-opening introduction to the conservative Hopi leaders who were reluctant to let outsiders see and record their religious ceremonies.

On arriving at Keam's home, Bourke reported, "At Keams' ranch we met Mr. Alexander Stevens [Stephen], a bright Scotchman who, during the past twelve years, had considerable experience as a metallurgist and mining prospector in Nevada and Utah." (Bourke, 1984, 80).

Alexander M. Stephen was born in Scotland and graduated from the University of Edinburgh with a degree in mineralogy. He moved to America and served in the Union Army during the Civil War. Afterward he migrated to the Southwest seeking his fortune in prospecting.[16] At this time, Stephen resided at Keam's house. Laura Graves astutely noted, "Alexander M. Stephen, a man whose studies of the Hopi would equal any of the ethnographies by Bourke, Matthews, or Cushing and whose knowledge of the Hopi would be unrivaled." (Graves, 1998, 145).

Living among the Native Americans and working as traders brought Keam and Stephen in daily contact with people who wanted to barter. Native Americans eager for trading would discuss the designs on their artifacts or explain the legends depicted in the designs, knowing the value of each piece increased by providing details of its provenance. As a result, the two white men gained an understanding of the Hopi culture and history greater than any outsider had ever achieved. Keam's wife was a Navajo, and in 1881 Stephen married a Hopi woman and moved to her home on First Mesa. Both men were trusted and accepted by the Hopis since they spoke the language and lived the lifestyle expected by the Hopis. They helped the people when in need, unlike visiting tourists and scholars who came, took pictures, and frequently violated cultural and religious protocol for their own gain.

Elsie Clews Parsons noted Stephen was "a careful recorder," and that his manuscripts were a "very systematic recording of the ceremonial and daily life" of the inhabitants of First Mesa. Showing his meticulous attention to details, she added, "The notebooks are written in pencil so clearly that seldom is a word illegible." (Stephen, 1936, XXI-XXII). In 1893, from early January through the final Powamu celebration, a multitude of rituals was conducted throughout the day and night in all the settlements on First Mesa. Stephen was busy observing these and documenting the preparations for the elaborate ceremony. The ethnologist noted his frustration in not being able to attend many of these simultaneous activities. Stephen's Hopi Journal includes meticulous detail of Hopi day-to-day life during the years when he lived at First Mesa. He presents a detailed account of kiva layout, altar preparations, and daily activities. His journal includes accounts and drawings of prayer sticks being made, masks repaired and refinished, and gifts being made to be given in the final public Bean Dance (Stephen, 1936, 162-184). As a noteworthy aside, confirming his diligence, he also recorded a detailed account of the seed planting and bean plant growth. On January 29, he measured the height of the new bean plants in five kivas on First Mesa. The heights varied from 3 to 5 inches in one kiva, up to 14 inches in another. His analysis showed the growth of plants was 25% less in kivas without stove heat (Stephen, 1936, 210). Fifteen days after planting, the growing plants were plucked and the following day distributed to the women to be cooked for feasts during the Bean Dance celebration.

Keam, the knowledgeable trader and talented public relations man, and Stephen, disciplined in engineering methodology and foremost of those who documented the Hopi culture and religious ceremonies, complemented each other—the ambassador, and the scholar. Anthropologists and museum collectors sought their collective service as consultants and in gathering artifacts for their studies of the Hopis.

Each year an increasing number of tourists, writers, artists, and researchers attended the Hopi ceremonies—especially those when the natives performed with snakes. Short-term visitors such as government surveyors and military expeditions, and more permanent residents including missionaries, teachers, and government agents upset the demographic balance of the Hopi settlements. Outsiders seeking lodging, food, and

labor assistance from villages of 100 to 200 people had a significant impact on the economy and social balance of the community. In the last quarter of the nineteenth century, ethnographic scientists rushed to preserve a record of the Hopi culture and ceremonial activities before they changed because of outside forces. Coupled with the influx of outsiders, major problems threatening change and causing conflict included: movement from a subsistence economy to a cash economy; forced schooling; controlled allotments of reservation land; and attempts to convert the Hopis to Christianity. Stephen lived with the Hopis and was called on as an interpreter, and to assist the people in their dealings with the outsiders. His income was partially derived as a purchasing agent collecting artifacts and contemporary crafts for institutions and visitors (Schaafsma, 1974, 148). At the same time, visiting researchers sought his expertise and introduction to Hopi leaders and paid him for his assistance in their field studies.

In 1882, Stephen assisted Victor Mindeleff in his study of Hopi buildings that resulted in the publication *A Study of Pueblo Architecture: Tusayan and Cibola*.[17] Stephen's interest in the Hopi people and their culture continued to grow. He was initiated into three Hopi societies, on First Mesa the Flute and Lakon, and on Second Mesa the Snake society in the Shipaulovi ceremony (Stephen, 1936, XXII, 579).

About this time he began recording Hopi legends as told by chiefs and priests most knowledgeable of Hopi tales (Stephen, 1929, 1-72). Between 1883 and 1893 he collected twenty-eight stories that were published in *The Journal of Folklore* in 1929. Parsons believed, "Compilers of these stories as recorded by Stephen, notably Mindeleff and Fewkes, attempted to give them historical verisimilitude by omitting features that could not but be taken as legend and by emphasizing topographical and archaeological description." (Stephen, 1929, 2). As Stephen worked with and observed ethnologists in their field studies at Hopi, he developed an understanding of the Hopis far beyond any research scientist who had been sent to accumulate data on the mesa dwellers. It took several years of close observation of the daily life of the Hopi to be able to isolate and describe the major ceremonies of the friendly people who spoke a foreign tongue, had no written language, and had learned to be suspicious of outsiders who in the past had tried to eradicate the Hopis' way of life and their religion. Stephen, an anthropologist in the making, quickly rose in ability to report as an independent researcher.

By far, Stephen's most important work was the journal he kept on the daily life, religious ceremonies, and festivities of the Native Americans of First Mesa. After his death, his observations recorded from 1891 until his death in 1894 were sold on behalf of his estate by Thomas Keam to Stewart Culin of the Boston Institute Museum (Stephen, 2, XXI-XXII; Graves, 1998, 304 n. 7). These were passed to Elsie Clew Parsons in 1922 and published as edited by Parsons in 1936 and titled *Hopi Journal*.[18] Stephen's account is indeed the most credible of early written descriptions of Hopi rituals as they were performed on First Mesa. In 1893, Stephen, using his notes and sketches, pointed out some errors in designs in the preparation of the Antelope altar for the Snake assembly, and the Antelope chief corrected the altar layout (Stephen, 1936, 671). Even now, over one hundred years later, a Hopi leader who has a treasured copy of Stephen's Journal said, "It is used as the main reference when memories of the ceremonial arrangements are unsure, and also used to confirm the altar configurations are in the traditional form."

Stephen had lived on First Mesa for nearly ten years when in 1890, Jesse W. Fewkes, Director of the Smithsonian's Hemenway Expedition, came to Tusayan. He recruited and paid Stephen to assist him in gathering information on Hopi ceremonials, cultural structure, and life; and he bought Keam's collection of prehistoric relics gathered from remote digs as well as older pottery, baskets, and crafts Keam had acquired from Hopi families (Graves, 1998, 160). Stephen was given credit for his contributions in Fewkes' publications. However, in later years after Stephen died, only some of his observations were credited in Fewkes' monographs.[19]

Fewkes was born in Massachusetts in 1850, graduated from Harvard, and earned his Ph.D. in zoology. He gained several years experience in fieldwork in Europe. Returning to Harvard he worked as curator at the Museum of Comparative Zoology until 1887. After a trip to the Southwest and California, on which he was introduced to the aboriginal cultures of the Southwest, he was appointed Director of the Hemenway Expedition, replacing Frank H. Cushing. Following his visit to the New Mexico Territory in 1890 he wrote:

Visits to Zuni Pueblo in the summer of 1889–90 opened my mind to the great field for research which the study of religious ceremonials among the sedentary Indian

tribes of the Southwest presents. Although the article on the Zuni summer ceremonials, which was published as a result of those visits, was confined to descriptions of the public celebrations, I knew when my observations were made that there were still more important secret ceremonials going on simultaneously with those which I described, in the estufas (kivas), to which I was denied entrance.

The novelty of the work, my ignorance of the Zuni tongue, and other circumstances combined to make my maiden ethnological publication more or less fragmentary and incomplete. Finding the task of winning the confidence of the Zunis to such an extent as to enable me to witness their secret celebrations was a very difficult one, and learning that possibly a more primitive representation existed in the neighboring Tusayan pueblos, I concluded to make an effort, if opportunity presented itself, to study the ceremonials of these people, about whom less was known than the Zunis. I resolved to make my home with the Tusayan people for a considerable time, and to endeavor, by winning their confidence, to study the ceremonial side of their religion.

–Fewkes (1892, 1)

Fewkes visited Zuni five years after ethnologist Frank Cushing had left. He found Cushing's writings, reputation, and his legendary status with the Zuni would be difficult to match.[20] Cushing had set the pace for ethnological research by living with the Zuni for several years and felt he had become a Zuni. Fewkes would have a difficult time gaining their confidence and willingness to discuss sacred ceremonies. Study of the Zuni would have to extend from Cushing's work. Cushing, the pioneer, had achieved the first harvest knowledge of the Zuni culture, religious beliefs, and customs. Scholars following him could only refine his observations. The fundamental ethnological study of this pueblo tribe was complete.

Before 1880, Spanish and American colonizers had surrounded the Eastern Pueblos. They had influenced the culture and economy of the Native Americans to a level where they were beyond research value as an aboriginal civilization. Meanwhile, the culture of the isolated Tusayan settlements remained secure. The Hopis were the last of the Pueblos left lightly studied. Fewkes knew gathering information and performing research centering on the people of Tusayan would be work on *terra incognita*. At the same time impressed by the relations between Cushing and the Zuni, Fewkes saw the benefits of the closeness between the ethnologists and his subjects. On his second visit to Tusayan he reported:

We went through the initiations, following their directions, and attended kib-va (estufa) ceremonies to which the uninitiated were debarred entrance. From the chiefs we received explanations of the meaning of the ceremonies at the time they were going on. We became well acquainted with the people, and shared their festivities and sorrows. We attended their feasts, and when invited partook of their food, although it was not to our liking, rather than insult their generosity. We did not ridicule their ceremonies.

–Fewkes (1892, 3)

When Fewkes went to Tusayan he won the approval of the priests and elders, and in 1891 he was initiated into the Fraternity of the Flute Priests. Then he was allowed to observe kiva ceremonies to which the uninitiated were barred.

On a return to Hopi in 1895, Fewkes visited Oraibi to gather more exact details of the ceremonials of the pueblo most resistant to ethnologist's prying. Reporting the incident and at the same time displaying *ka-Hopi* behavior, he wrote:

The Antelope priests at Oraibi were not over genial to strangers wishing to pry into their secret rites, and the Snake priests positively refused to allow me or any white man, except the missionary, Mr. Voth, to enter their kiva. I entered the Antelope kiva uninvited, but my presence there was not welcome and most of the half hour which I spent there was occupied in reasoning with the priests. I succeeded in making a sketch of their altar, but was several times ordered out, and was therefore not loth to leave the kiva when I had finished. There was some little satisfaction in being able to tell the priest of Oraibi in their own kiva

that my studies of Antelope altars in other pueblos enabled me to interpret about every object which theirs possessed, since they were so similar.

–Fewkes (1894, 290-291)

Over the next thirty years Fewkes' field investigations resulted in the publication of more than twenty reports on the people of Tusayan. He served as the Chief of the Bureau of Ethnology at the Smithsonian Museum from 1918 until 1928. His publications on the Hopi Indians are the most comprehensive reference observations of their religious rituals and festivities, and the Katsina culture. His research was definitive and provides a baseline of Hopi life from the beginning of its recorded history. For example, in his ambitious goal of compiling descriptions and drawings of the Katsinam, his *Codex Hopi* (a manuscript of all the known Hopi Katsinam), has survived the test of time.[21]

During the last years of the nineteenth century Fewkes commissioned several Hopi men, skilled in drawing, to paint the series of pictures of the Hopi spirit beings as they appeared in public celebrations. He took special care to select artists who had not been trained in the white man's way of painting to ensure the paintings reflected the purest Hopi image possible. This pictorial record shows the Katsinam in their aboriginal dress and at the same time preserves the native artistic style of drawing—without Euro-American influence. The drawings, created by talented Hopi, who were experts in painting the masks and symbolic characteristics of the Katsinam, portrayed them in traditional regalia. The initial paintings documented not only the Hopis' supernatural ancestors, but also their paraphernalia and the symbolic designs associated with their traditional role. Fewkes credits several Hopi artists by name. The first, *Kutcahonauu,* or "White Bear," had a slight knowledge of English gained from attending school at Keams Canyon. The second, White Bear's uncle *Homovi*, had never attended school and did not speak English. Fewkes credits him with drawing some of the best pictures. A few pictures were drawn by *Winuta*, whose work, like that of Homovi, was unbiased by outside influence.[22]

Fewkes provided the artists with paper, paints, and brushes. As the paintings were completed, other Hopis were asked to identify the pictures to verify the artist's interpretations:

This independent identification was repeated many times with different persons, and the replies verified one another almost without exception. The talks about the paintings elicited new facts regarding the symbolism and the nature of the beings represented which could not have been acquired in other ways. Several men made critical suggestions which were of great value regarding the fidelity of the work and embodied information which is incorporated in the exposition of the collection. At one time the reputation of these pictures was so noised about in the pueblos that visitors came from neighboring villages to see them. At first the collection was freely offered to all comers for inspection, on account of the possibility that new information might be gathered, until some person circulated a report that it was sorcery to make these pictures, and this gossip sorely troubled the painters and seriously hampered them in their work, but the author was able to persuade the artists and the more intelligent visitors that no harm would come to them on account of the collection.

–Fewkes (1900, 14)

His meticulous reporting, and attention to details are evident in the final report, "Hopi Katcinas Drawn by Native Artists," published in the *Bureau of American Ethnology Annual Report 1903*. It has become the primary reference for Katsina aficionados and students of the Katsina culture. Dockstader (1954, 87) speculates many Katsinam documented in Fewkes' *Codex Hopi* that ceased to appear might have been forgotten just as many older ones had already become extinct and lost to history. Mischa Titiev told Dockstader he had requested a Hopi to paint some Katsina portraits. The paintings were well done and Titiev then asked him to paint a specific Katsina. The artist returned with a number of pictures for Titiev to select the one he wanted painted. "The pictures were colored illustrations clipped from the study by Fewkes (1903), made thirty years earlier!" (Dockstader, 1954, 87).[23]

Summary

Our history gatherers set the groundwork for further study of the Hopi people. They were leaders among the productive ethnologists who gave us the first manuscripts of the traditions and religious ceremonies of the Hopi people and the Katsina cult before their frail civilization was distorted by the infringing outsiders. Frail in the sense that an ancient civilization of less than five thousand individuals, living on mostly arid land surrounded by the American land mass 750 times larger, were in danger of being absorbed and losing their cultural identity. Tripling their population to over seventy million between 1800 and 1850, the Americans were froth with manifest destiny. Exploratory expeditions, traders, and trappers had already scarred the Hopis' memories with the white man's abrasive attitude, hostility, and intrusive behavior as they encroached on the homeland of the Hopis. Ethnologists were not fault free; they carried more than their share of blame. They took copious notes of the religious kiva rituals and took photographs capturing Hopi images—from the conservative Hopis' point of view, stealing their ritual secrets and images—which to some were suspicious signs of witchcraft. The outsiders were there during periods of drought, poor crops, and deadly outbreaks of smallpox. Their presence gave reason for the disasters and misfortunes, and they personified the stereotypical white men guilty of thoughtless intrusions, greed, and overzealous attempts to change or eliminate the Hopis most sacred rituals. Voth, Stephen, and Fewkes helped the Hopi people, and were generally accepted. However, at times even these investigators violated the Hopi priests' request for privacy when they intruded on secret kiva ceremonials.

The careers of these pioneer historians present a unique story. Far from scholarly writing in a secure environment, our field ethnologists worked among people from an ancient and foreign society who spoke an unknown, undocumented language. These history gatherers accepted the hardships of living with the Native Americans, accepting living accommodations far different from their past experiences. Working with the stolid, suspicious, and secretive factions presented abundant opportunities to hone the people skills needed to learn of the Hopi way of life. Their work was the founding effort in preserving many elements of traditional Katsina rituals. Life threatening situations like Cushing's encounter at Oraibi were not uncommon. Frustrations in gathering the fine details of a major ceremony were the norm. Stephen, intent and in good humor, wrote of the preparations for the traditional drama of the Horned Water Serpent (*Palulukonti):* "Damn these tantalizing whelps to the devil with all of them! I have been bamboozled from pillar to post all day, have received no scrap of information. Nor will they give me a glimpse of the 'drop curtain' in *Nasha'bki* [Walpi kiva] they tell me to wait till it is shown." (Stephen, 1936, 294).

Armin W. Geertz credited Fewkes, Stephen, and Voth as the pioneer scientists who worked diligently among the Hopis, publishing objective descriptions of their observations. "It took a missionary to realize that songs, prayers, and myths when they are recorded in the original language—and published as such—add depth to otherwise lifeless behavioristic descriptions." Crediting Voth, who spoke the Hopi language, "he knew the Hopi as people" and further, he observed Stephen's journal "provided glimpses of the Hopi as people." (Geertz, 1987, 9).

In 1876, Fred Harvey and the Santa Fe Railroad began to offer travelers adventure tours in the Southwest. This opened a new market for Hopi artisans to satisfy the demands of travelers and collectors. Museum ethnologists and anthropologists were already in a competitive hunt for kachina dolls, pottery, and weavings that reflected the Pueblo culture. Now the influx of visitors seeking souvenirs of their travels to the Southwest would force the change from traditional styles to market-oriented products, and at the same time influence the lives of the Hopis and cause cultural changes the early history gatherers anticipated.

Chapter 4: Powamu

During the ceremony, beans are planted and grown in almost all the kivas...the people they may now plant beans in the kivas, which planting seems to symbolize the corn, beans, etc., etc,, of the coming season.

–H.R. Voth (1901, 72,83)

With the Powamu's multitude of complicated rituals, the community-wide planting of beans, harvesting, and consuming the young bean plants in the final feast led to the final dance celebration to be commonly known as the Bean Dance.

Voth noted "...planting of beans is symbolic of the corn planting in spring, and the main object of the Powamu ceremony is to consecrate the fields and evoke the blessing of the deities for the approaching planting season and the coming crop..." He also questioned why beans and not corn, "because corn does not grow as well in the kivas" and it is not as palatable as the young bean plants (Voth, 1901, 157).

Powamuya or Pure Moon Ceremony

Today the Hopis live by two calendars. For economic and legal purposes the Gregorian calendar is used. However, the calendar that their ancestors have used for hundreds of years is of greater cultural significance. The lunar calendar along with the solstice and equinox events determines the schedule for planting and timing of the traditional ceremonies. Solar observances are made and announced by the Sun Watcher (Sun chief or priest) from locations called Sun houses.[1] In particular, the annual visit of the Katsinam begins after the winter solstice and ends when they leave at the midsummer closing of the Niman ceremony (Home Dance).

From early winter to late August, the Katsinam—spirit relatives of the Hopis—are personified in sacred dances and rituals. Fewkes (1897, 268) classified the "Hopi Katcina celebrations" as either abbreviated or elaborate. The abbreviated are performances in which the masked dance in public is the most significant part. Kivas are used for preparation, practice, and mask regeneration, but no altar is prepared nor related kiva ritual performed. The elaborate are those where the altar and kiva ceremonials are formal and extensive, and the religious activity extends for nine or more days with periods of fasting before the final performance. Two of the most significant elaborate ceremonies are the Powamu and the Niman. Both conclude with an outdoor celebration and Katsina dance. The colorful Katsina dances give outsiders a misleading view of the Hopis' religious rituals. In general, the public dances and festivities are merely the concluding celebrations of the religious ceremonies. Just as with the proverbial iceberg, the Katsina dances are just the tip of the Hopi religion and beliefs.

Powamuya, which literally means "Pure Moon," is the time of the purification of life ceremony.[2] It takes place during the *Powamuy'iyawu* (Powamuya moon), which corresponds to the month of February. The opening of this elaborate ceremony is set relative to the new moon. However, the leaders of the Powamu society and the Powamu priest, assisted by the Katsina chief, begin their preparation and preliminary rites days earlier. Much of the week-long preparations and rituals are held in the kiva. Some men make *pahos*, prayer sticks or prayer feathers, while others are preparing the Katsina masks by scraping off old paint then repainting them.

For the concluding public festivities, the Katsinam appear in the village plaza, where they

perform their unforgettable dances and the traditional presentation of gifts. In general, children are the recipients of the treasured handmade presents including moccasins, dance rattles, bows and arrows, painted lightning sticks, and kachina dolls. Beginning in the last half of the twentieth century, with the Hopi economy changing to a cash economy, some of the public ceremonies were scheduled to take place on weekends to accommodate the Hopis who live and work off the reservation.

The Pure Moon Dance is also referred to as the Bean Dance from the ritual of planting beans in the kiva. Early planting, growing, and harvesting of the beans are a central part of the annual germination and fertility rituals essential to assure the growth of ample crops. Secretly, in the opening phases of the Powamu, the men bring bean sand (earth) and planting containers into the kivas. Bean seeds are planted, watered, and kiva fires are kept burning to generate additional heat to allow the beans to sprout and grow rapidly into young plants. The plants are carefully attended to allow good growth. It is believed their condition when harvested and the manner of handling the plucked young sprouts have a direct relation to the growth and condition of field crops in the coming season. This symbolic harvest is part of the ritual announcing the new season of growth.

Loftin (1991, 33) observed, "The Powamu has become the most significant winter ceremony for the Hopi, performed on all three mesas." He determined the Powamu on Third Mesa remains basically as it did when compared to the journal writings of the nineteenth-century ethnologists, the first white men to live among the Hopis who studied their culture and observed their sacred celebrations. These ceremonies have survived despite the intrusions and pressure from many outsiders. Today, however, in some of the Hopi villages, the public Katsina dances have been closed to non-Native Americans in order to protect their veracity.

Exclusion of outsiders is suggestive of the Native Americans' fear when Spanish intruders tried to eradicate the Puebloan cultural celebrations. In recent times, further reason for closing the outdoor ceremonies is traffic control in the rugged terrain and narrow streets in the mesa villages. Centuries old, multi-level adobe dwellings are crowded together separated by lanes intended to carry pedestrian traffic. By keeping out non-Native Americans, the cultural sensitivity of a large segment of the population is respected, and distractions during sacred performances are avoided. Many elements of the Hopis' religion are sacred and traditionally kept secret from nonmembers of the religious society.[3] At the same time, the Hopis are open to discussion of their Katsinam, and they are willing to provide introductory overviews of their Katsina dances. Proper behavior is expected when the Hopis' spirit beings are present. No pictures or electronic recordings are to be taken, and spectators are expected to be quiet during the performance. It is common for the Katsinam to appear—when they are ready. Questions like: "When are the Katsinas coming?" should not be asked. Just as in church, everyone dresses appropriately and is on his or her best behavior. If it rains during the performance, it is expected the spectators will not contradict the purpose of the dance and will not use umbrellas to ward off rain.

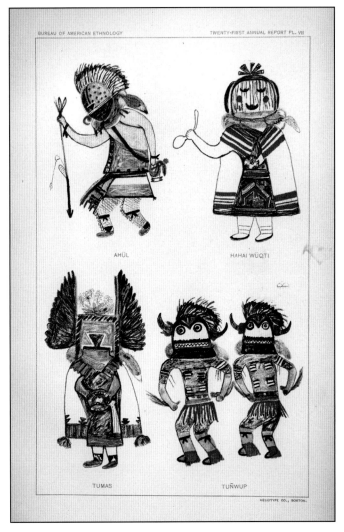

Fig. 4-1: Katsinam drawn by Hopi artists from J. W. Fewkes' *Codex Hopi (top: left to right)*: Ahul (Ahola), a chief Katsina, leads the Katsinam in their return to First Mesa and Hahai Wuqti (Katsina mother) travels with her children the Natackas during the Powamu, and is known as "Tongue always going"; *(bottom: left to right)*: Tumas (Crow Mother) is the mother of the Tunwup (Hu) who flog the children during their initiation (Fewkes, 1903, pl. VII).

Initiation

Two momentous rituals of the Powamu are the initiations into the Powamu and Katsina societies. Initiation into the Powamu society takes place on the first day, and initiation into the Katsina society takes place on the sixth day. In general, candidates for initiation into the Katsina culture are children between the ages of six and ten. Each has ceremonial parents, not their relatives, who bring their candidate to the kiva. The children have been forewarned of the initiation whipping they will endure. Voth who witnessed the initiations wrote:

The dreaded moment which the candidates have so often been told about and which they stand in such great fear has arrived.… Presently a loud grunting noise, a rattling of turtle shells and a jingling of bells is heard outside. The two Ho Katcinas and the Hahai-I have arrived at the kiva. They first run around the kiva four times at a rapid rate, then dance on each side of the kiva a little while, beat the roof of the kiva with whips, jump on it constantly howling the word u'huhuhu and finally enter the kiva.… The children tremble and some begin to cry and scream.

–Voth (1901, 103)

It is not difficult to visualize the excitement of a child as the central performer in a special ceremony, and then the added expectation and anguish of the whipping from their super-natural ancestors, the Katsinam. The ceremonial parents are told to protect their children, to gather and hold them in their laps—hold them close. "But now this time open your hands to these people that this yucca may enlighten their hearts…" (Voth, 1901, 101).

Each child is brought individually before the Katsinam. Crow Mother stands at the base of the kiva ladder holding a bundle of yucca leaves and hands a whip made of several leaves to one of her two sons. The Hu[4] will alternate in whipping the initiates while the ceremonial father holds his child. Generally, four lashes are given. At times, the sponsor may intercede if the whipping is too aggressive and take one or more of the lashes in the child's place. In 1893, the First Mesa initiation and flogging of the children took place in the village plaza. Fewkes (1897, 284) reported, "The man who personified Tunwup (Hu) exercised considerable discretion in performing his duty. In the case of a little girl who showed more than ordinary fear, he simply whirled his yucca whip over her head without touching her, and then motioned her away; but on the arms and legs of the adults he laid his whip without restraint."

Don Talayesva recalled his painful initiation into the Katsina society when he was given four extra lashes. Don, admittedly a mischievous boy, suffered the extra flogging because his father had instructed the Katsina to give his son a double thrashing, and the ceremonial father not to protect the boy (Simmons, 1942, 83). Today the initiation flogging still takes place but it is more ceremonial.[5] However, the Katsinam, just as people, do not always adhere to the rule. Several years ago as spectators at the Fest Parade on First Mesa, we received several lashes as a blessing from the passing Katsinam who applied various levels of energy in carrying out their duty. Along with many Hopi spectators who also received the blessing, we were surprised to receive an exceptionally vigorous lash from one of the whipper Katsinam.

The Powamu society is responsible for conducting the initiation into the Katsina culture. Prior to the ceremonial whipping of new candidates, the Powamu chief priest in the role of Muyingwa, the God of germination, tells of the coming into this Fourth World from the Underworld. He relates stories of the emergence from the *sipapu*, the place from which mankind climbed out upon the earth, and describes in great detail their meetings with their supernaturals, the migrations of the people, and migration convergence from the four directions to their present home (Voth, 1901, 98-102). Following the oral teachings, the ritual of whipping takes place. Yucca leaves are brought into the kiva and prepared in small bundles of six to eight leaves. These will be used to lash the initiates. In concluding the rites, each child is sworn to maintain the secrets they have learned and observed in the kiva; if not, the Katsinam will return and whip them again. A Hopi story recounts that at one time a boy who had just been initiated into the Powamu society told of the kiva rites during his initiation. Society leaders met and decided the boy must be severely punished for his indiscretion. Further, they believed by adding the ceremonial whipping to the initiation rites, it would also serve as a warning to future novices to keep secret what took place in the kiva. The initiation is concluded with a final statement from the Powamu chief:

You have now seen these things here; you are not to reveal them to anybody when you now go home; even if your own father or mother should ask you, you must not tell them anything; if they ask you about the Chowilawu,[6] tell them there was no fire in the kiva and you could not see him; you will later, sprinkle the Katcinas with corn-meal when they dance; you will sometimes not eat any salt or salted food; if you reveal any of these things the Katcinas will punish you.

–Voth (1901, 93)

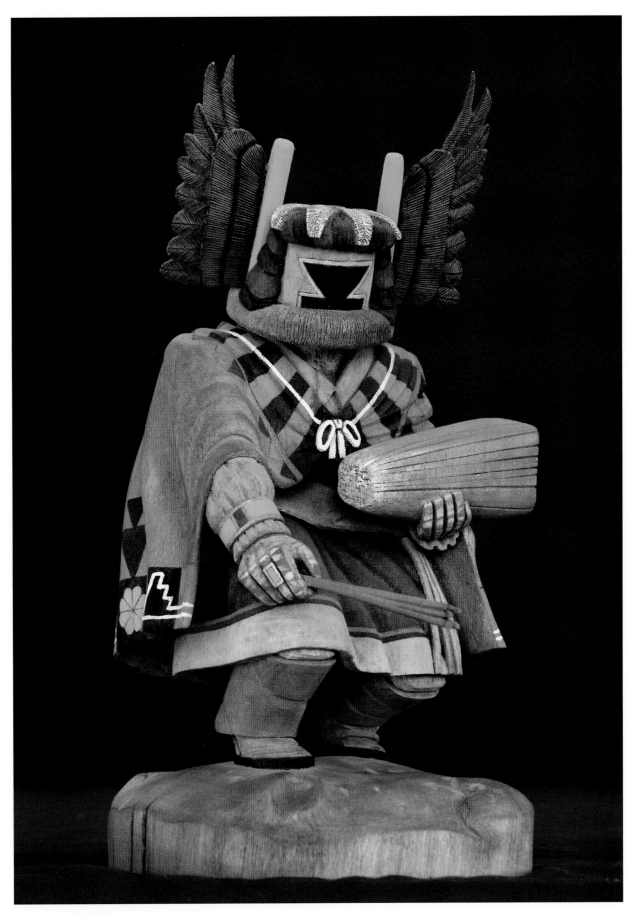

Fig. 4-2: **Crow Mother**, *Angwusnasomtaka*, by J. Seckletstewa, 11 1/2" h. This mother kachina carries a bundle of yucca leaves and in her right hand a yucca whip ready to be handed to the Hu whippers.

After the new initiates receive their lashes, the whippers flog each other and also Crow Mother. Needless to say, the children have a degree of satisfaction to see the three Katsinam get a thorough whipping. The harrowing event is over and the memory of lashing is still vivid, but a more unforgettable event is in store for the newly initiated. Meanwhile, for the next four days, while abstaining from salt and meat, the novices are instructed in Katsina history. They will now be permitted to participate in the religious rituals (Fewkes, 1897, 284).

Fig. 4-3: **Eototo**, late-nineteenth-century carving, 11 1/2" h.

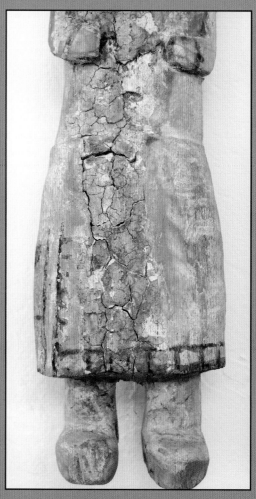

Fig. 4-4: Detail of Eototo carving. Natural hollows and cracks in the rough cottonwood root are filled with *kaolin* clay, and then the figure is painted with mineral paints. Cracks and loss of the clay base reveal the natural character of the wood.

Sandpaper and wood finishing tools were generally unavailable to the Hopi at the time this nineteenth-century kachina doll (*tihu*) of Eototo was carved. In order to fill in the flaws in the cottonwood root and to smooth out the rough carved surface, the figurine was heavily coated with *kaolin* clay. With age, the thick layer of *kaolin* across the front cracked and bits have broken away. Traces of the chalk-like pigments remain on the moccasins, the fringe of the kilt on the right side, and the bandolier. Geometric black designs are visible on the kilt edge. Black pigment designs are seen on the neck and sleeve ends of the shirt.

Stephen (1936, 160) wrote the Powamu chief Intiwa, "understands the omens of the coming season concerning the growth of corn, etc. as indicated by the height of the beans planted in the kivas." Good bean growth means good crops and the person farming has a "good heart." During the last days of Powamu, Stephen observed, "all hands" were busy preparing figurines (*tithu*), children's moccasins, bows, and other gifts to be distributed on the final day. "When they finished carving a figurine," he wrote, "they rub it smooth with a bit of sandstone." Pigments are brought into the kiva along with selected seeds to be chewed and mixed with saliva to be used for painting the figurines. Several individuals are specialized in grinding paints to be used in decorating the carvings. They are coated with white clay (*kaolin*), and when dry they are painted using yucca fiber brushes (Stephen, 1936, 210-212).

Ninth Day, *Tiikive*

In all the kivas and also in the houses, preparations are being made for a feast in which the beans that were pulled in the kivas early in the morning and have since been cooked form the principal dish.

–Voth (1901, 116)

A multitude of rituals take place on the ninth day, *Tiikive* (the day of the dance). Activities in the kiva begin before dawn. First the bean plants are harvested. They are pulled, complete with their roots, carefully bunched, and prepared for distribution to each household and given to the women to make stew. Handmade gifts and small bunches of plants are tied together with yucca leaves. These will be given to each family where the uninitiated children are told the Katsinam brought the gifts and greens. Everyone welcomes the hint of spring—the out-of-season plants that magically appear in late winter, in color that contradicts the omnipresent dormant desert vegetation, and lends credibility to the fact they are from the Katsinam.

In each kiva, one or more Katsinam will gather the presents and instructions from each kiva member for delivery to the appropriate houses and specific individuals.[7] Several trips must be made to carry and distribute the abundant collection of traditional gifts. Later, the Powamu priest sends someone to the village to tell the Katsinam to drive the people into their houses while the bean sand is secretly carried from the kiva and buried.

No ceremony is associated with the dispersal of the sand; however, Geertz (1987, 72) was told the sand is to rejuvenate so it may produce again. His informant, following the Powamu leader's instruction, removed the sand from the kiva, brought it to the place of dispersal, prayed, and threw cornmeal with the moist sand and said, "As we have borrowed it we must give back what we borrowed."

Midday is dedicated to feasting. In each household the young bean plants are included in a special stew prepared for the afternoon meal. Afterward, a variety of Katsinam parade through the village. Although they appear to travel randomly along the streets, they are reenacting the wanderings of the Hopi ancestors that Muyingwa described in his speech to the children during the initiation ritual. Meanwhile, Eototo and Aholi put on their masks and prepare for their door-to-door walk performing sacred rituals.

Eototo, the spiritual equivalent of the village chief, and Aholi, who is referred to as Eototo's lieutenant, are the principal Katsinam appearing during the Powamu. They have greater leadership duties and are among the *mong* (chief or more important) Katsinam that descend from old deities with traditional ties to clans and phratries. Families hereditarily own the *mong* masks, and only certain individuals or priests may impersonate the *mong* Katsinam.

Eototo and his lieutenant appear several times during the Powamu and again on the last day when their public rituals begin. At dawn they travel through the village, stopping at sacred shrines to perform their annual liturgy. During one ritual Eototo sprinkles sacred cornmeal on the ground in a symbolic cloud pattern (Simmons, 1942, 193).[8] Aholi places his staff on the symbol and in a high-pitched voice utters the traditional response. Circling his staff over the pattern, he claims ownership of the village for Eototo and himself. Continuing their performance in a ritual to bring rain, they approach the kiva and Eototo rubs a small handful of sacred meal to the north of the kiva hatchway. Then he pours water from his *mongwikuru* ("netted water gourd"), down into the kiva. As part of this annual ritual at Oraibi, Voth observed a man stands on the kiva ladder below the view of spectators and catches the water in a bowl. Eototo repeats this rite from all four sides of the kiva. Aholi then takes his

turn repeating the solemn ritual (Voth, 1901, 113-115). As the two move through the village, Eototo sprinkles a trail of cornmeal for his companion. They stop at selected homes, repeating a blessing and the performance of forming symbols with sacred meal. Aholi confirms the rite by positioning the lower end of his staff over the symbols and moving it in a prescribed pattern.

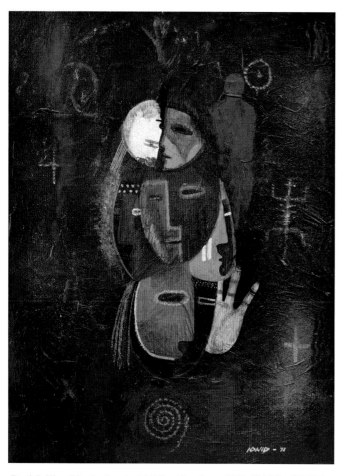

Fig. 4-5: **Kiva Mysteries**, by Neil David, collage, 1971, 17 1/2" x 23 1/2".

The Hopis' underground kivas serve many functions ranging from a meeting room to a chamber for ceremonial performances and sacred religious rituals conducted by various Hopi societies. The formal ceremonial entrance is through the roof by means of a ladder. The kiva is most remembered for the suspenseful initiations into the Katsina society and especially the enlightening moment for young initiates when they learn of the Katsina secrets.

Stephen (1936, 170) reported on the First Mesa activities centering around Chief kiva, "In'tiwa prays later at night, but as I have to be up at daylight to see the Ahu'l [.] I think I will creep home to sleep...." The next morning he confessed, "I made a grievous

mistake in not remaining in Chief kiva last night. They held a formal ceremony consecrating the Ahu'l Kachina." Stephen lamented it was impossible to gain details; merely, songs were sung and the pipe smoked, then kiva members gathered around the *sipapu* and its plug was removed and the ritual completed before daylight.

After the bean plants were pulled and blessed, they were given to Ahola. At daylight Ahola and the Katsina clan chief visited sacred shrines and springs where they deposited prayer sticks and prayer feathers, and offered prayers for warm early spring winds to melt the snow. Ahola carried a squirrel-skin pouch with prayer-meal and his *mongkoho* ("chief's badge of office") in his left hand, his staff in his right. As the Katsina procession walked through the three villages, Hano (Tewa), Sichomovi, and the mother village Walpi, the Katsina clan chief marked their path with sacred corn meal. Ahola, assisted by the chief and several principal society members, approached a kiva and performed special blessings. He continued with a sacred ritual where he holds his staff vertically and moves the upper end in a meaningful pattern. His performance may be compared to Aholi's on Third Mesa. After visiting all kivas and appropriate houses, Ahola completed his annual blessing and deposited prayer feathers at a last visit to a holy shrine. He then prepared for his return to his home—not to be seen again until next year (Stephen, 1936, 171-3).

Fewkes presented a succinct account of Stephen's observation made during the First Mesa celebration in January 1893:

Just as the sun rose the two [Ahul and the chief] visited a kiva in Hano. Stooping down in front of it, Ahul drew a vertical mark with meal on the inside of the front of the hatchway, on the side of the entrance opposite the ladder. He turned to the sun and made six silent inclinations, after which, standing erect, he bent his head backward and began a low rumbling growl, and as he bent his head forward raised his voice to a high falsetto. The sound he emitted was one long expiration, and continued as long as he had breath. This act he repeated four times, and, turning toward the hatchway, made four silent inclinations, emitting the same four characteristic expiratory

calls. The first two of these calls began with a low growl, the other two were in the same falsetto from beginning to end.

The kiva chief and two or three other principal members, each carrying a handful of meal, then advanced, bearing short nakwakwoci hotumni ["stringed feathers tied to a twig"], which they placed in his left hand while they uttered low, reverent prayers. They received in return a few stems of the corn and bean plants which Ahul carried.

Ahul and Intiwa next proceeded to the house of Tetapobi, who is the only representative of the Bear clan in Hano. Here at the right side of the door Ahul pressed his hand full of meal against the wall at about the height of his chest and moved his hand upward. He then, as at the kiva, turned around and faced the sun, holding his staff vertically at arm's length with one end on the ground, and made six silent inclinations and four calls. Turning then to the doorway, he made four inclinations and four calls. He then went to the house of Nampio's mother, where the same ceremony was performed, and so on to the houses of each man or woman of the pueblo who owns a tiponi or other principal wimi (fetich). He repeated the same ceremony in houses in Sichumovi and Walpi.

–Fewkes (1897, 277; 1903, 33-34) and Stephen (1936, 171-172)

The "Cloud chief's marking" is the term applied to Ahola's mark on the kiva and houses. It is an appeal to all the cloud gods of the six regions to bless these kivas and houses. Stephen (1936, 173) repeated the Hopi tenet, "Prayers given to him will be efficacious only if there is a perfect union among the Hopi people." He continued with his informant's words, "If men lie and talk crooked… and speak foolish and bad speech, nothing will result from any prayers no matter how strong." This Hopi philosophy remains a deep-seated principle practiced by the Hopis as they prepare for and conduct their religious ceremonies.

On the concluding night of the Powamu, the young initiates experience a ponderous change in their life-long beliefs. They are brought to the kiva to see their first Night Dance. Titiev, who had not been initiated in the Katsina society, was allowed to attend the final kiva ceremonial (Titiev, 1944, 119 n. 55). He observed the initiates seated together on an elevated portion of the floor, with knees drawn up to their chest, while waiting for the late night appearance of the Powamu Katsinam.[9] Eventually, the familiar sounds of bells, turtle shell rattles, and voices announced the approach of the Katsinam. Throwing several ears of baked sweet corn down through the hatchway, they called to the new initiates saying the corn is for them. The children remained motionless. They had been instructed not to leave their assigned seats. "The Katsinas are coming"—with this call, and the audience silently waiting, the personifications of the spirit ancestors climbed down the kiva ladder. Their appearance as they entered the fire-lit chamber at an hour approaching midnight was a traumatic experience for the youngsters. Then, the shattering instant when the Katsinam appeared unmasked, the children saw they were human beings, their fathers, uncles, and other men from the village, not the Katsinam they had reverently watched all their lives.

Don Talayesva, (Simmons, 1942, 84) when recalling his initiation, felt very unhappy. He shared the common feelings of shock and anger of other children who so abruptly found that their fathers and male relatives played the role of Katsinam. Over a century later, in 2005 when queried about the event that had just ended, a Third Mesa Hopi said his son was surprised to see the performers unmasked and find, as they entered the kiva, they were his uncles and then his father. He added, "I still remember, it was a greater shock when I became initiated into the society. Kids now are more sophisticated with TV and computers."

The final dance celebration is an event with village-wide participation. Each kiva group will dance in every kiva presenting their choice of Katsina and a distinctive selection of songs. These dances are carefully rehearsed, and as part of the preparation and practice for the final dance, preview shows are put on in neighboring kivas. A competitive spirit assures the final presentation will be well executed. A group's performance lasts for about twenty to thirty minutes and then they move on to another kiva and repeat their performance.

On First Mesa, for all groups to perform in the nine kivas, the celebration continues most of the night.

Evolution of the Katsinam

Eototo and the Soyal Katsina were with the Bear Clan during their four directional migrations. Voth (1905, 25) wrote, at that time they had not so many Katsinam, "There were only the Hopi Katcinas which the Hopi brought with them from the underworld." While other clans were still completing their migrations and lived in settlements scattered along the Little Colorado River and in Canyon Diablo, the Bear Clan had completed their journey and settled at the foot of the middle mesa in the group that would be the permanent home of the Hopis. Here they built the first Hopi village, Shungopavi, ("place by the spring where the tall weeds grow"). In time, the Bear Clan split[10] and a faction led by Matcito moved westward close to the land of Maasaw ("Earth God"). They asked Maasaw for land and wanted him to be their chief. He gave them land, but chose not to be their leader. The people settled in Oraibi with Matcito their chief and Eototo the spiritual equivalent of the chief. As other clans came and wanted to settle here they offered to exchange beneficial ceremonial performances for a share of the land. As clans arrived and were accepted in the settlement, the Bear Clan leader became the village chief, and he or his delegate would act as Eototo during important ceremonies (Voth, 1905, 128-37). The migration and settlement of the various clans into the Hopi region has invigorated the Hopi culture, and has unified the people by adding new rituals and Katsinam who brought successful ceremonies that reinforce Hopi beliefs.

Voth (1901, 102) wrote, "Towanjashabe is an imaginary place about three miles south of Oraibi. Here the Honani ("Badger") Clan is said to have lived awhile after coming from Kishiwuu, being at first refused admittance to the village of Oraibi." On Badger clan's fourth request, in the midst of the winter's frozen presence, Matcito visited their encampment. After he saw the Badger camp surrounded by flowers he granted the people permission to live, and land to farm. Courlander (1970, 41) recorded narrations of the first Powamu celebration from people who lived on Third Mesa. Included in their recitation was the description, "... the Badger people went to Ojaivi in a procession, everyone carrying bean sprouts that they had grown with the aid of fire."

The Patcava Ceremony

In years when novices are admitted into the various tribal societies, a special pageant called the Patcava[11] may be performed. It is a reenactment of the legend in which the Badger Clan is admitted into Oraibi. Their Powamu chief and a group of Katsinam are seeking a home and land in exchange for sharing and teaching their Powamu. He´e´e ("Warrior Maiden"), a mother Katsina, gathers and directs "her children" during the multi-day ritual. In the concluding performance, He´e´e is accompanied by many energetic Katsinam and four Patcava maidens, one from each of the participating kivas. The procession travels across the mesa towards the village with each maiden carrying an oversize basket heavily loaded with corn and young bean plants. The delegation enters the village and offers Eototo these gifts representing bountiful crops, and they promise their celebration of Powamu will bring such ample crops each year. After the Powamu chief's fourth request to enter the village, Eototo allows the procession to enter.

For an outsider, the significance of the solemn procession of Katsinam carrying gifts to the village is not apparent. Without a script or program—and there is none except the teachings passed on to each generation of the Hopis—the importance of this traditional ritual is easily missed. To the uninformed, the group of Katsinam appears gathered for a casual walk across the mesa.

Katsinam in Powamu

On account of the large number of masked men who appear in Powamû, it is one of the most important festivals in which to study katcinas.

–Fewkes (1903, 32)

Powamu marks the return en masse of the Katsinam. Throughout the celebration, outdoor activities are laced with many personators. It is the first time in the new season when they bring gifts, including the popular hand-carved *tithu*. Fewkes (1903, 36) wrote, "The theory of Powamu is that all the katcinas return, and one comes on them unexpected in all the pueblos."

Ronald Honyouti's one-piece carving captures elements of the dramatization of the Patcava ceremony. Attired in her finest manta, white moccasins with attached leggings, and hair styled in large butterfly whorls, Patcava Maiden carries an oversize basket loaded with corn. Traditionally, a Katsina partner assists the maiden and carries the heavy burden into the final walk into the village.

The high relief carvings on the base of Honyouti's carving include three Katsinam who have prominent roles in the Patcava. The figures carved are a mere 2 1/2 inches tall, each with their traditional paraphernalia. Patcava Hu accompanies two Katsina mothers, *He´e´e* with her raised bow and quiver of arrows, and Hahai Wuhti carrying her sacred water jar. They appear against a pueblo background surrounded by lush corn plants and blooming flowers, gifts to be offered for admission to Oraibi.

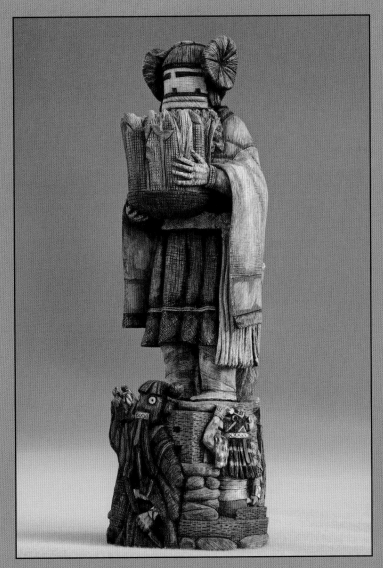

Fig. 4-6: **Patcava Maiden**, *Pachavuin Mana*, by Ronald Honyouti, 9 3/4" h.

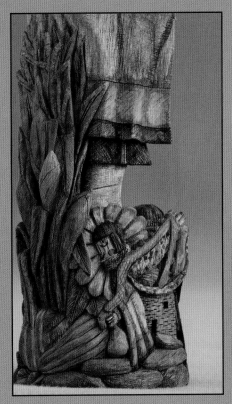

Fig. 4-7: **Patcava Maiden**, base carvings include the gift of a bountiful crop, Hahai Wuhti, and pueblo house

Talavai: One of several types of Katsinam may appear in this role. Since they appear at dawn, they are called *Talavai* ("Dawn"). Fewkes (1903, plate XX) pictures the *Talavai* Katsina ("Dawn" or "Morning Singer") with distinctive rain-cloud symbols on each cheek. Although *Talavai* is usually identified with this role, Fewkes (1903, 81) noted Malo, Owa, Tacab, or others may assume this responsibility. Stephen (1936, 456) writes of the midsummer dances when *Tala'vaiyi* appeared on the house rooftops singing a typical stamping Katsina song.

Eototo and Aholi: Eototo, a *wuya,* or clan ancient of the Bear clan, assumes leadership roles in both the Powamu and Niman ceremonies on First Mesa. Fewkes (1903, 77) determined: "The god Eototo was introduced from the old pueblo, Sikyatki, and his old mask or helmet is in the keeping of the descendents of the Kokop family, which once inhabited that pueblo." Fewkes reported Eototo as one of the most prominent masked personages at Walpi in the departure ceremony of the Katsinam.

Eototo and Aholi are cataloged in Colton's comprehensive publication *Hopi Kachina Dolls*. His notes indicate they appear on Third Mesa.[12] Both were observed as principal performers on Third Mesa by Voth in his *The Oraibi Powamu Ceremony*.

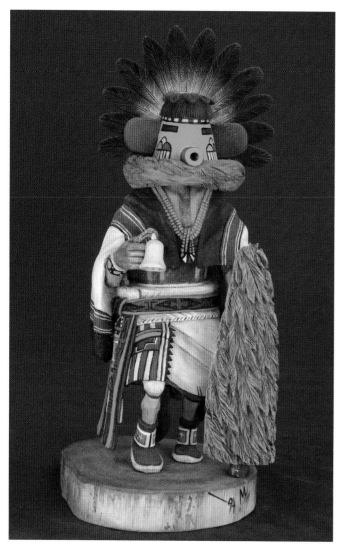

Fig. 4-8: **Early Morning Singer**, *Talavai*, by Morgan Murphy, 11" h. Talavai appears on housetops as the Morning Singer. He carries a bell to alert the people to his message. He is identified by the rain cloud designs on his cheeks and his elegant embroidered ceremonial robe, kilt, and sash.

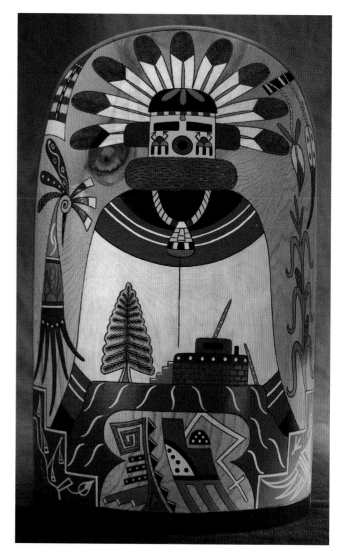

Fig. 4-9 **Early Morning Singer**, *Talavai*, by Ernest Selona, 12" h. Selona outlines Katsina images on curved surfaces of wooden forms and bowls, and then paints the Katsina and intricate background designs.

Voth's meticulous nineteenth-century study of the Hopi at Oraibi on the West Mesa included the first full description of Eototo. Little has changed in his appearance since that time. He wears a sash, kilt, and a simple native cloth shirt embroidered on the sleeves and body with designs of clouds and plants. Over this he wears a ceremonial blanket and a bandolier of dark blue yarn. He wears knitted cotton leggings and moccasins. His mask is very simple and made of native cloth. A fox fur tied around his neck bridges the gap between his mask and jacket. He carries a *mongkoho* (chief's badge of office) and *mongwikuru* (Voth, 1901, 112).

Stephen observed the Powamu on First Mesa in 1892 and 1893, and his Hopi informants described Eototo's activities (Stephen, 1936, 156, 206-07). Although Eototo and Aholi appear together in major sacred rituals on Third Mesa, Aholi did not appear with Eototo during equally important ceremonies on First Mesa. Ethnologists may or may not delineate the cultural activities common in Hopi settlements as well as the differences. Variations in ceremonies and a variety of Katsinam performing are not necessarily contradictory, but generally present a detail based on local tradition that has not been generally accepted across the reservation or understood by scholars.

Aholi, Eototo's lieutenant, is also a *Mongkatsinam* prominent on Third Mesa, and a clan ancient brought to Hopi by the Pikyas clan. Aholi wears the Hopi sash and kilt. Draped over his shoulders is a cotton-cloth, multicolored cape with designs of clouds and other symbols. In his right hand he carries a staff called a *rupsi* with six *makwanpis* (an aspergill of feathers tied to a staff used to sprinkle holy water). His cone-shaped mask is framed of yucca leaves covered with native cotton cloth tipped with a collection of feathers. A fox skin wraps around the neck, and he carries the chief's badge and water jar (Voth, 1901, 112).

A Hopi legend tells of Aholi's close relations with Eototo. While traveling together they encountered their enemy. Against an overwhelming force, Aholi stayed behind to fight, allowing Eototo to escape. Later in the period of migrations they were reunited. Well aware of Aholi's loyalty and courage in the face of death, Eototo holds Aholi as his closest friend and ally.

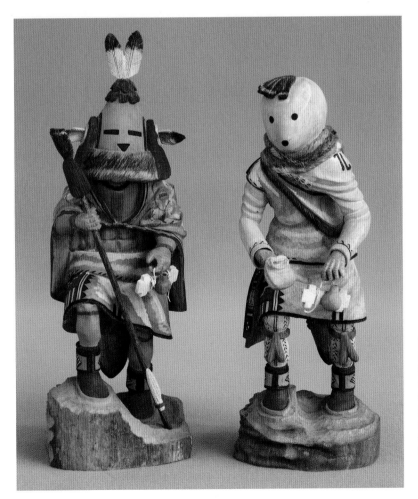

Fig. 4-10: **Eototo and Aholi**, by Silas Roy, 11" h. Roy, from Third Mesa, carved this matched pair of dolls as the Katsinam appeared in the last decade of the twentieth century, similar to Voth's description recorded a century earlier.

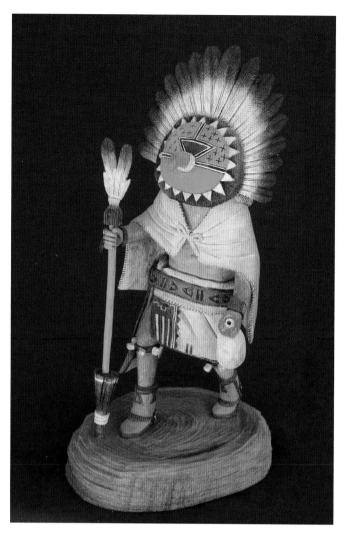

Fig. 4-11: **Ahola**, *Ahu'l*, by Avonne Naha, 11" h. Naha's all-wood carving of Ahola follows the traditional appearance of the Katsina as he appears on First Mesa. He wears a fine robe, embroidered kilt, and ceremonial sash and carries a staff crested with eagle feathers tied with red horsehair and a chief's sacred water gourd.

Ahola and Kokosorhoya: During preparation for the Powamu at First Mesa in 1893, Stephen (1936, 162) watched the men in the kiva scraping off all the old paint from the Ahola mask used in last year's ceremony. He described the Ahu'l (Ahola) mask as made of wicker in a convex, saucer like form covered with cloth. The bird like beak was made from the neck of a gourd. The face is green on one side and brown on the other, with the lower part green. The paint is speckled with fine fragments of selenite, and black stars and circles decorate the face. Eagle feathers fan out as a crown on the head. During the Bean Ceremony, Ahola is accompanied by Kokosorhoya.[13]

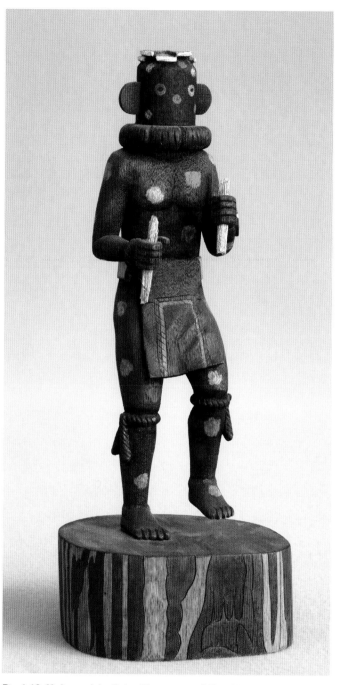

Fig. 4-12: **Kokosori**, by Brian Honyouti and Floyd Nutumya, 9 1/4" h. As with many of Honyouti's carvings, the base design presents a decorative balance to the kachina carving. Kokosori is a smaller Katsina usually impersonated by a young boy. His body and mask are darkened with corn smut and painted with spots of a variety of colors.

Warrior Maid, *He'e'e:*

A long time ago, some Hopi were living at Batangwoshtoikave (Squash-seed-point) about a quarter mile east of Oraibi. One day a mother was putting up her daughter's hair. When she had completed one of the whorls, the daughter observed a party of enemies sneaking towards the village. She at once snatched from the wall a bow, quiver and arrows, rushed to the village, warned the inhabitants, led the defending party and defeated the enemies. That Hopi maiden now occupies a prominent position in the Katsina pantheon of the Hopi as the Haaa [He'e'e] Katcina and is called the "Katcina mother."

–H.R. Voth (1901, 117, note 1)

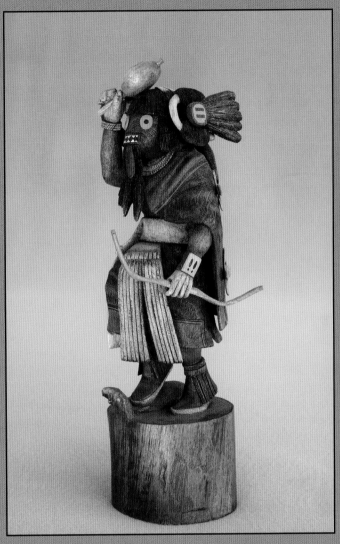

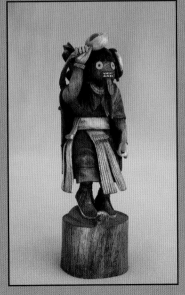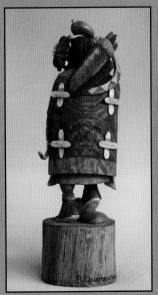

Figs. 4-13, 4-14, & 4-15: **Warrior Maiden kachina**, *He'e'e*, by Bryce Quamahongnewa, 9 1/2" h. He'e'e has the leading role in Patcava ceremony. She wears a blanket-robe of the same material as her dress. Corn husk crosses are attached to the back of her robe, and she wears a large white belt around her waist.

Crow Mother: Voth wrote of Hahai-I (*Angwucnasomtaka* or "Crow Mother") and her role in the initiation ritual into the Katsina society on Third Mesa. In the same role, the Hopis on First Mesa know her as Tumas (Fewkes, 1903, 68-69).[14]

Crow Mother translates as "Raven-wings-bound-up," descriptive of the fan like appendages made of crow feathers attached to each side of the mask. Her face is painted turquoise blue with a black triangular image outlined in white in place of the nose and mouth (Fewkes, 1903, pl. VII). She wears a white wedding belt or sash tied on her left side, a white robe or bride's blanket with embroidered symbols, and buckskin moccasins. She is often pictured or carved carrying bundles of yucca leaves that will be used during the initiation into the Katsina society.

A variant of this Katsina is Crow Bride. Wright (1973, 23, 66) wrote *Angwushahai-I* is Crow Mother on Third Mesa. She plays an active role directing the Hu Katsinam in the whipping ritual, while Crow Bride, Angwusnasomtaka, appears at dawn on the last day of Powamu, symbolizing the return home of a new bride after the wedding.[15] However, he points out other Hopis from Third Mesa say *Angwushahai-I* is Crow Bride. Some informants consider the two to be separate Katsinam. Others think they are the same Katsina in different roles. Crow Mother is a married woman and mother of the Hu Katsinam while the other is the bride. Earle and Kennard (1971, Pl. VI) depict *Angwusnasomtaqa*, "The one with Crow tied on," as she appears in the initiation ritual, and note when she comes at dawn when neither eyes nor mouth are seen upon the triangular face designs, she is known as *Angwushahai*.

Ogres: The infamous Ogres also appear during the Powamu. Stephen's account of the Powamu celebration puts the time of their first visit four days after the beans have been planted. The legends and traditional multi-visit rituals of the Soyoko and the Nata'aska are an entity that will be described along with descriptions of the drama of the Ogres in a later chapter. The colorful ogre kachina dolls are favorites for both Hopi carvers and doll collectors. The expressive real-life actions of the Nata'aska present a gratifying challenge to carvers and are in great demand by collectors. Contrary to the general benevolent force of the Katsinam, the Nata'aska sing about eating children, while the Soyok Wuhti demand food or threaten kidnapping.

Closing of the Powamu Moon

When the *Powamuy'iyawu* goes it takes the winter cold with it, and the optimism of spring prevails. One of the most complex and elaborate Hopi ceremonies has ended. The events of the period of purification are over. The growing of the beans, the preparation of *pahos* and gifts, the preparations of the masks, the initiation of the children, the final day of blessings and distribution of gifts, and the Night Dance remain to be relived as memories. This by no means is the end of the Katsina season; it approaches the midpoint. The rewards of dedication to their religion, care and attention to performing rituals according to tradition, and living with pure thoughts and a good heart bring the Hopi positive expectations for a bountiful season of growth. With the coming of the *Ösömuya* (March moon), a time called *Anktioni,* with its Night Dances, kiva performances, and the sacred puppet ceremonials, takes the central role.

Chapter 5: Visit of the Ogres

Unwelcome Visitors

A terrifying event that focuses on the children of the village is the visit from the Ogres. When writing of the visit, the question arises: What will the reader think as the ritual is described? Is this a display of cruelty towards children that is inconsistent with the statement by many authors and anthropologists claiming the Hopi are "people of peace"? It does not appear to follow the prevalent pattern of supportive behavior and warmth of Hopi parents towards their children.

Recalling some myths and traditional rituals from our own past puts this stressful performance in perspective. Most cultures have stories of child-threatening monsters. For the descendents of European immigrants the bogeyman took many forms; he came down the chimney and somehow entered the house through the central wood-burning stove. Our house was modernized; the old kitchen wood burner was replaced by a gas stove. The only remnant of the old stove was an embossed tin plate that covered the stovepipe exit high on the kitchen wall. When we were children, we were told this is the way the bogeyman entered the house if we were bad. Over 60 years later, in discussing the legends of the Ogres with a Hopi mother from Shungopavi, she pointed to the capped chimney access in her home and said this was the way the Hopis' bogeyman entered her home when her children were bad.

The threat to a young child, "be good or Santa Claus will not bring you a present" had its origin in the many variations of the pagan festivals celebrating the harvest, or return of the sun following the winter solstice. Warnings for the child to behave are part of the tradition in many cultures. On the eve of December 6, in Czechoslovakia, St. Nicholas visits each home. He comes down to earth along with an angel, and a chain-carrying devil. They leave gifts for the sleeping children. Bad children are given lumps of coal, and wood or onions, while nuts and fruit are left for good children. Children who are mostly good are given a small lump of coal along with their gifts—nobody is perfect!

In Finland, the pagan people held ceremonies to ward off evil spirits. Bogeymen dressed in goatskins and horns frightened the children and demanded gifts. Greek legends speak of the *Killantzaroi* creatures or ogres who come from the earth entering the homes through the chimneys. Fires must be kept burning for the twelve days of Christmas to keep the *Killantzaroi* out and prevent them from destructive actions in the home. In Japan, on New Year's Eve, the houses are cleaned thoroughly from top to bottom. When thoroughly cleaned, the house members dress up in their best clothes, and then the head of the household leads the family through the house. He scatters dried beans into every room and corner driving evil spirits away and welcoming good luck.

And so the Hopi are not alone in merging their traditions with thanks for bountiful harvests. Their celebrations following the winter solstice include an exchange of gifts and rewards to the children, and visits by the Ogres to support the quest for proper behavior.

The Visit

The visit of the Ogres is an annual dramatization that takes place during the Powamu ceremony. The drama takes place in the village with one set of Katsina performers walking from house to house. These monsters seek the young children not yet initiated in the Katsina society. Entire families play active roles, but only the children are unaware it is a staged performance.

In this ritual, the Soyoko and the Nata´aska (together known as the *Soo´so´yoktu*) are the villainous Ogres; the children are their prey. The Ogres are the bad guys acting the part of the ubiquitous bogeyman in their visit to each home. Their role is to threaten the children. The purpose of the ceremony is to teach the children proper behavior using the threat of being abducted and "eaten" by the monsters if they misbehave and do not perform tasks expected of young Hopi. A second purpose of the stressful visit is to strengthen the youngster's bond to the family, just as in many Anglo cultures parents use the bogeyman. However, the Hopis go a step further. The appearance of the monsters, generally called "Those Things," proves the existence of monsters and enforces parental warnings for bad behavior.

The monster role is physically demanding. *Soo´so´yoktu* must appear threatening, and yet cautious in dealing with small children. They spend time with each child, questioning them on their behavior and bargaining for gifts of food or else abduction. In earlier times, a single ogre family visited all households on First Mesa. Now with an increased population and the time-consuming, one-on-one negotiations with the children, each First Mesa village has its own family of monsters. The villages of Tewa and Sichomovi each have two kivas. In each village, on alternate years, a kiva group sponsors and performs the annual ritual. Walpi has five kivas, and each kiva group takes its turn enacting the annual visitation.

The ogre families and their function have evolved and differ slightly in the settlements scattered across the rugged Hopi mesas. The behavior and performance of the monster Katsinam follows the socio-religious traditions of the local village. Ogre family members have duties to perform, and each display distinct personalities. Hahai Wuhti, their mother (Fig. 4-1), is their spokesperson in the First Mesa Tewa villages. She leads the procession that includes Nata´aska *Na´amû* (their father) and *Nata´aska Mana* (the younger sister, also called *Soyok Mana*) (Stephen, 1936, 187). In the Hopi villages, Soyok Wuhti leads her family.

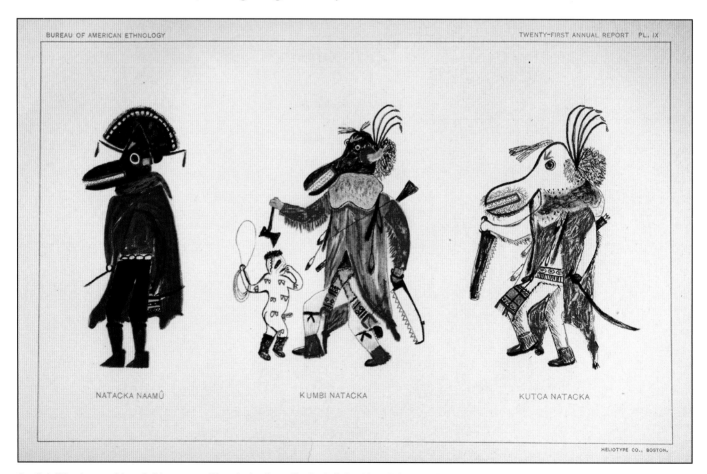

BUREAU OF AMERICAN ETHNOLOGY
TWENTY-FIRST ANNUAL REPORT PL. IX

NATACKA NAAMÛ

KUMBI NATACKA

KUTCA NATACKA

HELIOTYPE CO., BOSTON.

Fig. 5-1: **The Large-Mouth Monsters**, *Nata'aska*, from Fewkes' *Codex Hopi* (*left to right*): Nata'aska Na'amû, the father; Kumbi Nata'aska, Black Ogre; and Kutca Nata'aska, White Ogre (Fewkes, 1903, pl. IX).

A few days before the coming of the monsters, parents remind their young children of the approaching event. Meanwhile the *Soo´so´yoktu* are planning their role in great detail to bring reality to the public ceremony and visit with the children. Their dress is carefully prepared and exacting, and the paraphernalia they carry is traditional and consistent with their role as monsters attempting to abduct the children. One of the first outsiders to witness and record the visitation was Alexander Stephen. He described the Nata'aska preparation in the Horn kiva at Walpi in 1893. While they were putting on their masks, Ha´hawi the Powamu Chief climbed the kiva ladder until he appeared just above the hatchway:

Hahai´yiwuqti stood at the foot of the ladder and assuming the hollow falsetto in which she always speaks, announced that she was ready to visit the children. Old Ha´hawi shouted his replies to her that the children were asleep and she had better wait till tomorrow.

–Stephen (1936, 183)

The debate continued for several minutes. Voices from the kiva hatchway reverberate as if from a giant drum and echo throughout the tight-packed village. Hahai Wuhti's stage-whisper announcement of the arrival of the Ogres serves its purpose to give warning to the children who are still awake.

The next day when the monsters approach the homes, each family in the village takes its turn changing its role from audience to target; and most important, the parents are protectors of their children. On the first of two visits, Hahai Wuhti comes to each home presenting her demands and ultimatum to each family. She does not enter, but merely peers through the door. For dwellings on the second level, she climbs several rungs on the entry ladder, just high enough to be seen through the doorway and calls in her unique shrill hoot. Women in the home bring the children forward and the Ogre Mother speaks to them in a shrill falsetto (Stephen, 1936, 188).

Hahai Wuhti carries corn and commands the girls to grind corn meal. She carries yucca leaves and sticks used to construct simple snare traps that the boys must use to catch field mice, bats, and other small game (Fewkes, 1903, 35). In her high-pitched voice, Hahai Wuhti demands meat and other sacred food from each household and reminds the children they have four days to perform these essential tasks and show proper behavior before the monsters return. If the children do not meet their obligations, they will be taken away and eaten. The parents are warned the fiends will seek additional bounty and ransom in order to spare the children. As the Ogres travel from door to door they scold both adults and children pointing out individual faults and failures. In any case, the monsters expect to come away with fresh meat and food gained as ransom for the children.

While waiting for the return of the monsters, the children's behavior improves. Seeking parental protection from "Those Things," the children are more responsive to family needs and volunteer to help in household chores and farming tasks. The girls grind the corn and prepare special food treats, and the boys assemble the traps and try to snare rodents and game that are a continuous threat to the family's field crops. Family bonds are strengthened as the entire family prepares for the return of the *Soo´so´yoktu*.

Adding suspense and anticipation before their next visit, the Ogres delay it until the fifth day. In the Tewa villages, Hahai Wuhti, Nata´aska *Na´amû*, Soyok Wuhti, and two crooked-mouthed Heheya Katsinas return to collect the fruits of the children's labor, or the children themselves (Fewkes, 1897, 288). The Heheya Katsinam are not Ogres but relatives informally called "Silly Boys." On Second Mesa the *Toson Koyemsi* ("Mud-head Katsinam") accompany the dreaded troop and do the arguing and negotiating between the families and the *Soo´so´yoktu*s. Some *Koyemsi* swing lariats reinforcing the threat to carry off the children if the preliminary ransom and gifts offered are insufficient.

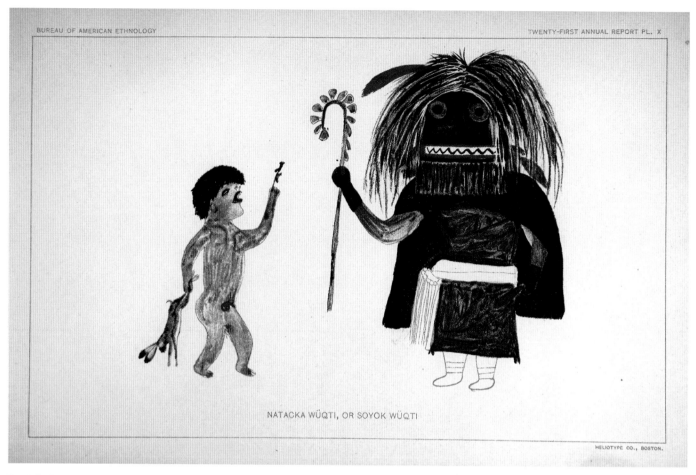

NATACKA WÜQTI, OR SOYOK WÜQTI

HELIOTYPE CO., BOSTON.

Fig. 5-2: **Soyok Wuhti**, from Fewkes' *Codex Hopi* (Fewkes, 1903, pl. X). The Ogre Woman carries a long crook and a bloodied knife. The young boy offers her his catch of small game collected from the traps he was given on the Ogre's first visit.

In the Walpi performance in 1893, Stephen observed Soyok Wuhti dressed as a dilapidated old woman carrying a 7-foot long crook. "In her right hand a knife, hands and arms and knife all smeared with rabbit blood. She speaks in a wailing falsetto, emitting occasional long wailing hoots," that gives her name "soyoko´-u-u-u" (Stephen, 1936, 220-224).

In the First and Second Mesa villages, the ogre party includes several fierce-looking uncles, the *Kumbi* (Black) Nata´aska and *Wiharu* or *Kutca* (White Ogre), sometimes called the Big Mouth Katsinam. On First Mesa, the Nata´aska are taller than their counterparts on Second Mesa. The performer's face is hidden inside the mouth of the mask. The snout and headdress extend above the head of the performer, and the personator views through the ogre's mouth not through the eye apertures as on the typical Katsina mask. The full weight of the Big Mouth's mask presents a balancing problem and is a great burden for the many hours the drama continues. The unbalance is greatest when the Nata´aska tries to toss his head back and forth. The performer will use his bow to prop open the jaws and give movement and lifelike motion to the Ogre's huge mouth. The burdensome mask and its unwieldy form limit the monsters to threatening, slow back and forth movement, and they rely chiefly on their frightful appearance rather than aggressive action to frighten the children.

On their second visit, the Soyoko push aside the children's gifts while the children stand behind their parents who protect and defend them. Often when a young boy presents his meager catch, the Ogres will reject the tiny carcass, and then offer the boy a chance to run a race or compete with a Katsina. If the boy wins, he saves his life. The children may be asked to demonstrate their skills in performing household chores like sweeping or chopping wood. Surprisingly, the frightening visitors seem aware of each child's weakness and behavior when they point out the details of each child's recent misdeeds,

like fighting with their brothers and sisters, and neglecting family chores. The monsters have done their homework. In secret meetings held in the kiva before the Soyoko's first visit, the parents who want a visitation tell the performers of the children's bad deeds. The monsters must remember these details as they travel from house to house linking each child with the appropriate tales. They must appear real, aggressive, and yet cautious in dealing with the smaller children.

In an animated performance, Hahai Wuhti controls the discussions, speaking incessantly in a high pitched singing voice directed at each child. The Nata´aska noisily supports her demands by continuously hooting like an owl, stomping, and scraping old carpenter saws or knives against the adobe buildings. Meanwhile, in the background *Soyok Mana* whistles and the Heheya dash about threatening to lasso the children. On this second visit, the parents act as protective intermediaries and are supportive of their children. Their display of family unity against the monsters gives a strong lesson to the youngsters. When describing the "Collection of Food by the Monsters" J.W. Fewkes wrote:

> *It is customary for the boys to first offer Hahai wüqti a mole or rat on a stick. This is refused, and then a small piece of meat, generally mutton, is held out. The Natacka examines it and if not large enough hands it back as he did the rat, shaking his hideous head…. The girl or woman is then asked for meal, and she offers meal that she has ground from the corn presented by the monsters on their previous visit. This is refused and more meal is demanded until enough is given to satisfy the monsters, who transfer it to the basket of Natacka mana, after which they retire.*

–Fewkes (1903, 39)

The negotiations continue as the Soyoko demand additional ransom of food from each family on their travel through the village. The women must provide food staples and groceries, the men meat. Initially dissatisfied because not enough is offered, or the food is not to their liking, the Nata´aska and *Soyok Mana* continue their dreaded motions and sounds. The Nata´aska chant they will eat the children—bones and all. The greedy villains refuse to leave until proper food has been given.

The stressful meeting at each household is physically demanding. Their garb and oversized masks are heavy and have changed very little from the time Stephen observed them over a century ago. During warm weather, their cumbersome and poorly ventilated clothing presents a problem of overheating, and the helmet mask stifles breathing. In cold, wet weather the water soaked attire brings the performers a bone chilling cold.

The Katsinam's dress is fastidiously maintained. With the tradition to continue day-long performances even during weather extremes of wind, rain, and snow, the dress and paraphernalia are subject to damage and staining. The sacred clothing, masks, and paraphernalia are carefully attended, refreshed, and repaired for each ceremony (Voth, 1901, 107).

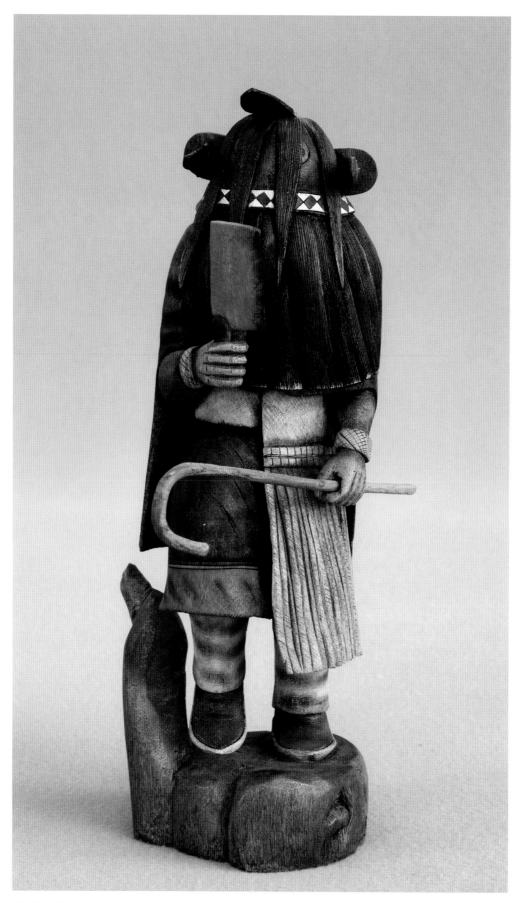

Fig. 5-3: **Ogre Woman**, *Soyok Wuhti*, by Bryce Quamahongnewa, 9 1/4" h. Ogre Woman carries a blood stained cleaver and the traditional long crook used to grab the children.

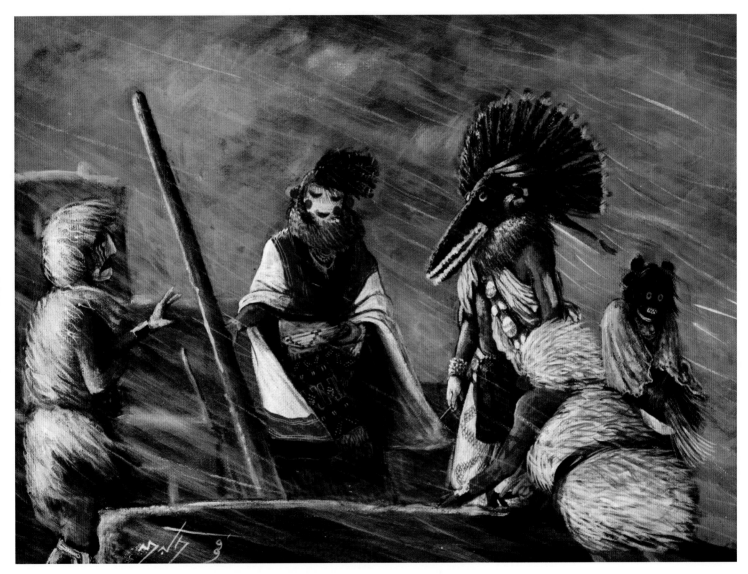

Fig. 5-4: **Blizzard on the Mesa**, by Neil David, acrylic, 15 1/2" x 11 1/2". After a long day of house-to-house visits, the public Ceremony of the Ogres is about to end. Tired, cold, and soaked from the driving snow, Hahai Wuhti, Nata'aska Na'amû, and So'yok Maiden return to the kiva. Two Heheya assist the shivering ogre family across the slippery stone cap of the kiva.

Neil David's painting *Blizzard On The Mesa* pictures the Ogres returning to the kiva after their day-long performance exposed them to harsh weather. David said he would never forget the sight of the performers enduring the bitter winds and blizzard conditions. At the end of the day, Hahai Wuhti, Nata´aska *Na´amû*, and *Soyok Mana* await their turn to descend the kiva ladder.

David recalled, "Their moccasins were soaked and covered with the wet red sand of the village pathways. Their clothing was saturated with moisture from the driving snow, and the father's [Nata´aska] headdress of turkey feathers was wet, some feathers were broken." He added, "It is important not to complain about the stormy weather which brings the moisture for the crops." The Heheyas' day-long activities range from clowning to harassing the children. Wearing sheepskin garments that are tolerant of the elements, the "Silly Boys" stepped out of character to assist the three exhausted Ogres over the kiva hatchway to the ladder. The bitter cold and wind-driven snow were difficult for the performers. With their suffering and the day's gloom, the fearsome monsters appeared even more menacing.

Describing one of the encounters in the early part of the twentieth century, Frank Waters (1961, 186) wrote: "The spectacle at Sichomovi is a disagreeable sight: the screaming children being dragged out of doorways, the avid greed for groceries...." In more recent times, the forceful threatening of children by the Ogres has been moderated and is under parental control. (Likewise, in the surrounding American culture, use of the bogeyman threats for misbehaving children is no longer in social favor.) There is controversy between the Hopis on the allowable limits of aggressive and threatening behavior by the monsters. Even though the performance at Oraibi appeared forceful and the Ogres would feign seizure of children, they were not allowed to touch the children. It was believed the evil power from direct contact with the Soyoko would permanently harm the child. The last performance of the Soyoko Katsinam at Oraibi was held in 1911 (Titiev, 1944, 219).

On First and Second Mesa, greater parental restrictions guide and control the performer's actions during their arduous performance. Touching or "pulling" the children is forbidden on Second Mesa. Here in the new millennium, we found at least one family with strong ties to traditional ceremonies and yet did not allow their children to participate in the tense drama. They participate as spectators when they are older and are aware of the role-playing by the Katsinam.

The fear of the *Soo´so´yoktu* is foremost in the minds of the uninitiated youngsters. Just days after the Ogres' visit in 2003, we were visiting Hopi friends in Sichomovi when the spring Fest Parade was taking place. The men of our host family were noticeably absent, while the women of the household were preparing food for the day's feast. Young family members, two teen age girls and two boys about six years old, guided us to a choice place in the plaza where the Katsinam would pass in their walk through the village. It was a cloudless day; visiting spectators were beginning to gather. We enjoyed the tranquility of the ancient surroundings and exuberance of the two boys as they prepared us for the coming of the Katsinam. It was a long wait; there is no rigid schedule for a Katsina performance, but in time our young Hopi guides alerted us to the distant sounds, "The Katsinas are coming!" Now we heard the sounds—first drums, then bells and ceremonial rattles, and occasional calls and hoots from the approaching paraders. Suddenly, our two uninitiated guides bolted away. We would not see them again. We were told they ran home and hid in the bathroom, still remembering their recent encounter with the Ogres. Meanwhile, dozens of Katsinam came through the narrow streets of the pueblo performing traditional movements and pantomime skits related to their legendary past.

At the beginning of the twentieth century, Don Talayesva (Simmons, 1942, 45) witnessed an encounter between a young boy and the Nata´aska. He saw some giant-like Katsinam with long, black bills and saw-like teeth stalking through the village. They stopped at a certain home and searched out a particular boy. The monsters identified the boy as one who fought with children, paid no attention to old people, and killed chickens. They were ready to grab the boy when his parents interceded and offered them fresh meat. With exaggerated movement, a Nata´aska reached out as if to grab the boy but took the meat instead.

There have been a number of reports of young boys who when faced by the fierce monsters rise to a level beyond their capacity and choose to protect their family and defend their home by attacking the intruders. Talayesva (Simmons, 1942, 85) writes of a boy known for his misdeeds who when confronted by the Ogres used his bow and arrow and shot one of the giants in the face. A second ogre lassoed him and threatened to take him away and eat him. The boy's parents worked hard and finally gained

his release with extra gifts. At the Mishongnovi performance in 1934, when the *Koyemsi* were bargaining with the parents, some noteworthy activities developed (Titiev, 1972, 239). A young girl showed little fear of the Nata´aska, and boldly challenged one to a game of hopscotch. At times, the *Koyemsi* would confront a young boy, strip him naked, douse him with cold water and challenge him to run a race to save his life.

As the village performances conclude, the Ogres retreat with their spoils. The children have been saved by promises of good behavior and successful negotiations by their parents. The *Soo´so´yoktu* will carry away substantial booty of groceries and meat. Stephen (1936, 242) made an interesting observation on collecting and selecting food at Mo'nete kiva in Tewa village. Hahai Wuhti demanded an offering of fresh meat. Kiva members laughed and presented her with the horns of a freshly killed ox. The Ogres angrily refused, and the

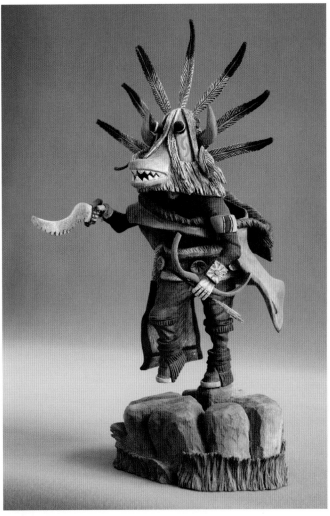

Figs. 5-5 & 5-6: **White Ogre kachina,** *Wiharu*, by Cedric Honyumptewa, 16" h. The Large Mouth Ogre uncle is carved in a stomping pose brandishing a carpenter's saw in one hand and bow in the other—a quiver with arrows is hung over his carrying sack.

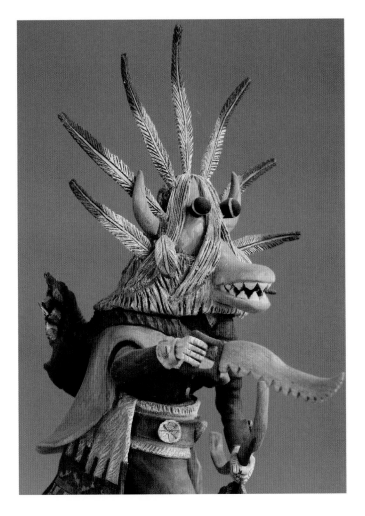

kiva members offered a meager piece of mutton wrapped in an animal hide. The Nata'aska jumped and hooted and rejected the insulting gift. Once again the kiva men responded, this time with a generous gift of meat. It was accepted and the monster family moved on.

In 1888 Stephen (1936, 254) wrote of the closing ogre rituals, "They came to my door demanding flesh, saying…I had been given a trap to go hunting. Where was my game?…I offered them mutton, but they would not take it, it must be game. So I got them a jack rabbit." They went on to every house accepting nothing but game.

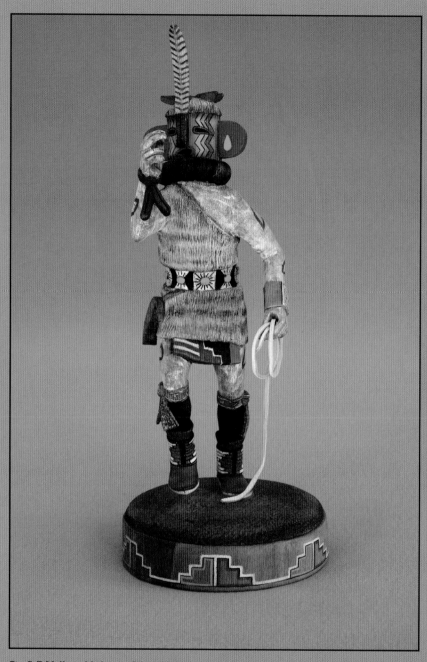

Fig. 5-7: **Yellow Heheya**, *Sikya Heheya*, by Lauren Honyouti, 12" h.

Heheya carries his lariat for catching children. Stories give reasons for his dress and mask. In one legend enemies attacked Heheya's village, he escaped and hid in a nearby cave. The enemy started a fire in the cave and Heheya suffered from the heat. His face and mouth were distorted, and feathers on his head were burned. That is why the Katsina's face paint is a series of twisted lines. On Third Mesa he appears with a chili-pepper *ristra* as a headdress (David, 1993, 126).

Stephen (1936, 254) then described the final act of the performance in Tewa village. The monsters came from Corner (Pen'dete) kiva and went to Court (Mo'nete) kiva. Hahai Wuhti, in her typical continuous chatter form, held lengthy conversations with the kiva chiefs who presented the Ogres with prayer feathers. They then returned to their home kiva. Here the Nata'aska rejected gifts of food and entered the kiva. After noisy disturbances, they emerged dragging several men by the hair. Two Heheya came out pulling several boys with them. The Heheya had their lariats around the boys and grouped them with the men already captured. Brandishing daggers and saws, the Nata´aska acted out an attempt to saw off their captive's heads. The women and children, who had gathered around the kiva hatchway and on the rooftops, were screaming and crying as they watched the men and older boys of their families being tormented. The kiva chief now bartered for the lives of his men. His men returned to the kiva and emerged with all the booty the monsters had collected throughout the day. With this food and a bribe of additional gifts the Ogres relented and ceased their aggressive moves. Finally, they proposed that the Heheya race two boys. The winners would gain all the food gathered throughout the day. The Katsinam raced the boys and allowed them to win, and the provisions gathered were awarded to the families of the men of the kiva. Traditionally, in closing the performance, the Ogres are driven from the village, routed to the mesa edge, and forced to scurry down the trails.

The Hopis are determined and committed to keep their traditions and religious celebration as they were for many generations. A mother from the Second Mesa village of Shungopavi offered the following description of the Soyoko ceremony as it is in the new millennium. "In March, the Ogre woman comes with small amount of corn kernels for the girls to grind and yucca leaves for the boys to make traps to catch small game. She says she will come back in four days to see if the children have completed their tasks. Four days later she returns with her boys—the Mud-heads, their sister So'yok maid, and the large mouth Katsinas. The monsters remain outside our home, stomping and hooting. My children stand in the doorway next to me for protection and help." The Ogres, who have been briefed earlier, surround the doorway. They remind the children of their misdeeds and fighting with their brothers and sisters. She continued, "Ogre woman may tell a boy to go fight with her boys; or

'Those Things' may attempt to capture the children, holding them until they promise to be good and help in household chores like sweeping and doing the dishes." Although the ceremony is focused on the children, family members from infants up to older ladies participate. "The older people also give gifts to the Soo´so´yoktu. This gift payment also serves to take away sickness. The Hopis say the ceremony is not limited to the children. Other family members are reminded of their misdoings and may be ridiculed to encourage a more Hopi-like behavior."

Fascinating, a Hopi mother's description of the meeting with the Ogres as it is performed in the twenty-first century compares to Stephen's writings from his journal where *Soyok Mana* appeared dressed in black, wearing a buckskin mantle, and hair whitened with clay. She whistled while the Nata´aska *Na´amû* hooted and stomped his feet. The younger children showed fear of the monsters, while the older ones held them in considerable awe and tried to assume a bold stance (Stephen, 1936, 186-187).

Voth's account of the ritual based on his observations between 1894 through 1898 is included in his publication *The Oraibi Powamu Ceremony*. His words, the earliest documentation of the Third Mesa ritual describe the ritual in its simplest form:

When a child is naughty or disobedient, the parents or relatives threaten that they will call these monsters, who will come and get it. On these occasions, when the latter are in the village, these threats are often carried out, and the conversation that occurs when they come to a house where a child is to be frightened into good behavior is usually about as follows: The Cooyoktu[1] Pawaamu approaches the child and says: "You are naughty and bad; we have come to get you. You fight the other children, kill chickens (or other similar misdeeds are mentioned), and we shall now take you away and roast you and eat you." The Cooyok Wuhti chimes in and repeats the charges and the threats. The child begins to cry and to promise good behavior, but the Katcinas refuse to relent. "of course, you will be bad again, we

do not believe you," and the woman begins to reach after the child with her crook. The latter screams and begins to offer presents, usually meat if it is a boy, sweet corn meal if it is a girl. The Powaamu pretends to take the present but grabs the child's arm instead. The pleadings and promises to be better are renewed and finally the two Katcinas say that if the two Tahaamu are willing to accept the presents, they will relent this time. The latter declare themselves satisfied, the meat is put into the hoapu (basket) carried by the woman, the meal into sacks carried by the two Hehea, and with many admonitions and threats to certainly take the little sinner if they hear of further complaints, the party moves on to another place, where the same scene is repeated. The Hopi say that formerly the Katsinam would occasionally actually take a child with them, but that once a child died of fright, and since then they content themselves with frightening the children as described.

–Voth, 1901, 118

Not all the Hopis follow the tradition of the coming of the Ogres. Geertz and Lomatuway'maa (1987, 126 note 38) were told, "We believe that the ogres have cold breath. That is why we have cold winds and snow right now.... It is worse when they do it in the middle of March, when we wish to plant our early crop, and we need the warmth."

Ogre Family History

As with most legends and stories, variants and differences in details are found in the narratives as they are repeated from elders' recollections and interpretation by the younger generation. The legends are common to a society, but over the years the stories will evolve differently in the isolated settlements. The appearance of the Ogres is fundamentally a ritual related to the purification rites of the Powamu ceremony and is used as an obedience-teaching tool for the Hopi children.

In January 1893, while kiva preparations were being made for the visit on First Mesa, Stephen asked of the origin of the Nata'aska. His advisor, Ta'hyum, would only say they were monsters who lived in caves in the San Francisco Mountains and they came to capture the children. Stephen (1936, 183) also was told the four Nata'aska were offspring of Cha'veyo and his wife Hahai Wuhti.

The Third Mesa story of the creation of the Soyoko follows the common historical outline of creation of mythical beings[2]. Titiev's (1944, 216) account and the story Talayesva (Simmons, 1942, 45-47) told follow this outline. The Two-Hearts (witches) from Oraibi believed the population of village children had increased to a level where they were out of control. They lacked respect for the old people, disobeyed their parents, and fought continuously with their playmates. The chief of the witch's kiva told the kiva members, who were also suspected of being witches, of a plan to correct the problem. Young men were sent out to gather large amounts of piñon gum. Then secret rituals were held in the kiva. Elders gathered around the fire and formed two large masses of piñon gum, and covered them with a wedding robe (ova). Magic songs were recited and in time the covered masses began to move. When the robe was removed, two giants, a male and female appeared. They would be known as the Soyoko. The kiva chief said, "We need some help. We have too many children and you could catch some of them and eat them."

The giants were offered a site for their home on the east side of the Oraibi wash. This was close enough to Oraibi to make raids for children. The Soyoko lived here and raised a family. Each day the father would travel to Oraibi and kidnap two children, put them in a basket and bring them home for his family's meal. Soon the villager's began to worry about the disappearance of the children. The village chief of Oraibi called on the War Twins, guardians of the Hopis.

He brought the War Twins, Pyüükonhoya and Palüñahoya, gifts of weapons and balls made of buckskin and shinny sticks for the twin's favorite game. He presented them with pahos and asked for help and protection from the Soyoko. The twins lived with their grandmother, Spider Woman3, who said it was up to the brothers to decide what to do. They agreed to help the people of Oraibi. Spider Woman gave them a magic potion to assist them in their confrontation with the monsters. The next morning the twins traveled to Oraibi, playing ball as they walked. The Soyoko giant took them by surprise, captured them, and carried them home in his basket. His wife stuffed them in an oven and started a fire to cook the young twins. Using the magic potion

from their grandmother, the brothers survived the night and escaped. They took the monster's children and put them in the oven in their place. Later the monster's wife opened the oven and the Soyoko began to eat the cooked meat. The Twins told them what they did with the children, and then they fought the Soyoko. The elder twin threw a rabbit stick and knocked down the Soyoko man, and then his brother decapitated him when he threw his rabbit stick. Then they seized Soyoko's mate and threw her over the edge of the mesa. They brought the heads of the monsters to the village where the Katsinam took them. Later they would be used to scare the children when they misbehaved. The villagers were thankful and the Oraibi chief rewarded the brothers with gifts of new buckskin balls and sticks.[4]

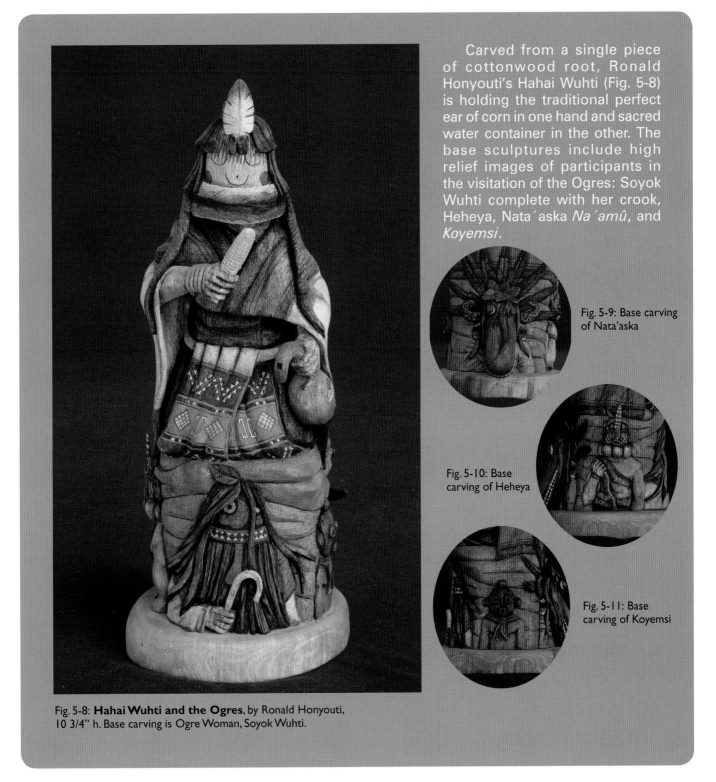

Carved from a single piece of cottonwood root, Ronald Honyouti's Hahai Wuhti (Fig. 5-8) is holding the traditional perfect ear of corn in one hand and sacred water container in the other. The base sculptures include high relief images of participants in the visitation of the Ogres: Soyok Wuhti complete with her crook, Heheya, Nata'aska *Na'amû*, and *Koyemsi*.

Fig. 5-9: Base carving of Nata'aska

Fig. 5-10: Base carving of Heheya

Fig. 5-11: Base carving of Koyemsi

Fig. 5-8: **Hahai Wuhti and the Ogres**, by Ronald Honyouti, 10 3/4" h. Base carving is Ogre Woman, Soyok Wuhti.

The Drama of the Ogres, Cast of Characters

The cast in the public performance of the Hopis' Coming of the Ogres is not fixed from village to village or performance to performance. Based on Hopi oral tradition and the information written by the first outsiders to see the drama, the main performing Katsinam are familiar to all the Hopi even though the cast varies in each of the mesa settlements. The roles are carefully practiced and played, but performers' interpretations and limits or restrictions as to the degree of reality allowed in the performance preclude rigid descriptions of each role. A brief biography of the central cast is indispensable for a complete playbill.

Hahai Wuhti: Hahai Wuhti, a Katsina mother, appears in many ceremonies sometimes playing a lead role. She has eyes of crescentic form, and hair done up in two elongated bodies which hang by the sides of her head, and she has a bang of red horsehair on the forehead (Fewkes, 1903, 68). Her facial expression is in agreement with her good-humored personality. She wears a red fox skin around her neck, and to her waist are tied two sashes; and she usually carries a perfect ear of corn and a gourd water container from which she pours a small amount of water into her hand and pats it on people's heads—a symbolic gesture of the hair washing ritual.

Hahai Wuhti's most notable role is during the Powamu when she leads her children, the Nata'aska, on the visits throughout the pueblo. She is a dynamic Katsina, running around, and constantly talking in a shrill singing voice. Hahai Wuhti also has prominent roles in major Katsina rituals including the kiva puppet performances with the Shalakmana and the Water Serpent Effigy, and she may appear with the female Katsinam in the Niman dance. Infant girls are given *putsqatihi* (flat kachina cradle dolls) during the major ceremonies. The first *putsqatihi* they receive represents Hahai Wuhti because she possesses all the qualities of a good mother.

Nata´aska *Na´amû* (the father): Stephen (1936, 184) described *Na´amû* in the 1893 performance on First Mesa. He was wearing a cloth shirt, fox skin around the base of his mask, and radiating turkey feathers at his back. Two buckskins hung as loose mantles over his shoulders. He wore trousers and buckskin leggings, and a tortoise rattle tied on his right leg completed his dress. Hopi artists and carvers depict Nata'aska *Na´amû* wearing garments described by Stephen, or modern dress since the Nata'aska no longer wears old-style Hopi clothes. His modern dress may include a ready-made shirt and trousers (Dockstader, 1954, 114).

Joann Kealiinohomoku (1980, 49) wrote of the ogre group on Second Mesa, "[It] is not as complete as the three families on First Mesa. Second Mesa village presentations vary in both the cast of characters and their costumes. In 1966, for example, the Shungopavi father was wearing the Nata'aska mask, but was otherwise accoutered as a Mudhead."

Nata´aska *Na´amû* is not associated with any other major Hopi ceremonies, but sometimes appears as an incidental performer in Katsina performances. He functions as bogey to scare children away from trees of ripening fruit, or to round up men to participate in the harvest, or organize communal work parties for such civic duties as clearing springs (Parsons, 1939, 795). Stephen (1936, 345) reported in March 1892 Nata'aska appeared making loud growling cries during the water serpent celebration.

Nata´aska Uncles: The Nata´aska uncles usually come in groups of two or three each of the Nata´aska *Kwü´mbi* (Black Ogre) and *Wiharu* (White Ogre). Nata´aska *Kwü´mbi* wears a buckskin garment over a calico shirt and carries a saw in one hand, a hatchet in the other. A set of eagle feathers rises from a bunch of black feathers on the back of his head (Fewkes, 1903, 72). *Wiharu* has a white, oblong ovoid gourd snout with white, husk teeth; he resembles the black uncle except the mask is white instead of black (Stephen, 1936, 189). Before the introduction of metal weapons, the Ogre Uncles carried a flint or obsidian stone knife. Now *Kwü´mbi* may brandish a butcher's knife or a rusty carpenter's handsaw. *Wiharu* may carry a saw in one hand and bow and arrows in the other.

The uncles stand in the background growling, clacking their beaks, and stamping their feet. With deliberation, they drag their saws on the ground or noisily whip them against the sandstone blocks of the houses while the Soyoko leaders negotiate with each family. Steven (1936, 188) noted the masks of the Nata´aska group hang on the walls of Horn kiva and are the only ceremonial objects to be seen in any kiva.

Soyok Wuhti: Soyok woman is feared by the children because of her threatening physical appearance and aggressive actions and the ultimate threat that she will take them away to be eaten. In one hand she carries a long crook and in the other a huge knife or cleaver. She wears dark, well-worn clothes,

and her knife and hands are smeared with blood. The children are suspicious of the crook being used as a weapon to capture them. She is a terrifying sight with her disheveled hair and yellow bulging eyes while she snarls and grunts.

Occasionally Soyok Wuhti uses her crook to thump the Heheya on the head when their clown antics are badly chosen or when they are collecting food during their house-to-house visits. She calls out in a wailing falsetto combined with an occasional hoot, a sound like her name, soyokoʹ-u-u-u (Stephen, 1936, 222).

Soyok Mana: A younger sister of Soyok Wuhti follows their father through the village and occasionally whistles or howls during the critical negotiations for ransoming the children. The mana's hair-do is the traditional Hopi maiden whorls or "squash blossom" over each ear. The Nataʹaska examine the food given by families and accept or reject it. If it is accepted, they give it to Soyok Mana who then carries the food in her burden basket to the Ogre's home kiva. This relatively passive ogre is not as aggressive and intimidating as Soyok Wuhti. "Soyokmana was personated by a lad of twelve years, wearing a woman's blanket and a buckskin mantle." (Fewkes, 1894, 281; Stephen, 1936, 224).

Heheya: The Heheya varies in appearance and function in different regions of Hopiland (David, 1993, 126). The yellow face Heheya (Sikya Heheʹya) is seen on Third Mesa, and white-faced Heheya on First Mesa. Heheya carries a lariat when traveling with the ogres. His role may include threatening the children or roping bystanders who refuse to give the Soyoko food. He is not an ogre, but sometimes referred to as an Ogre Cousin. On First Mesa, two Heheya travel with the Soyoko, and they assist in collecting the gifts. Heheya is also seen in other Katsina dances and ceremonies. He also plays a prominent role in Anktioni night dances, and the sacred Corn Maiden puppet and Water Serpent Effigy kiva performances.

Supporting performers: The Koyemsi (Mudheads) are optional supporting performers in the First Mesa ogre drama, while at Second Mesa the Koyemsi do all the bargaining and accept or reject gifts in a semi-comic mood. They then assist in delivering the gathered loot to the sponsoring kiva.

In 1934, Titiev observed the Soyoko performance at Mishongnovi. In addition to the Soyoko he saw two Maasaw Katsinam accompanied by a group of Koyemsi, two of them carried lariats. While the Koyemsi negotiated for food at each house, the Maasaw carried the abundant contributions of booty to the ogre's home kiva (Titiev, 1944, 220).

Titiev wrote of the ogre ritual on Third Mesa where Kwikwilyaka (Mocking Katsina) traveled with Hahai Wuhti to each kiva announcing the Soyoko rites, and he assisted in distributing corn for the young girls to grind and material for the boys to make snare traps (Titiev, 1944, 218). In his role, Kwikwilyaka also acts as a clown reducing the tension of the drama by imitating those around him. In his typical clowning performance, he mimics the voice and actions of Hahai Wuhti. The Mocking Katsina appears in a variety of dress in many outdoor ceremonies and mimics ongoing actions including the behavior of the spectators. He is pictured in Neil David's painting Fest Parade (Fig. 8-1).

The Wah-uh-uh Piki Sona or Piki Craver Kachina, who originated in the village of Shungopavi, may travel with the ogres (David, 1993, 92). He grabs piki bread while the Soyoko are negotiating ransom for the children. This disrupts the bargaining and the monsters take food instead of the children.

The Helpful Soyoko

At variance with the tales of terror and threatening behavior of the Soyoko, Harold Courlander (1971, 69-70), writing of the destruction of Palatquapi, includes the tale of the helpful Soyoko. A crippled man and a blind man were left in the abandoned village of Palatquapi. They miraculously found each other and teamed up—the crippled man using his eyes and the blind man carrying him. They found a bow and arrows and hunted deer successfully. In the dark of night while roasting the deer, the crippled man saw movement beyond the reaches of campfire. After tense moments, he determined it was a Soyoko. While attempting to shoot an arrow into the monster, the Soyoko stood up and released his own arrow. It flew towards the campfire and hit the roasting deer in the head. It exploded; hot ashes and bits of deer meat covered the two men. Suddenly the blind man discovered he could see and the crippled man could walk. They determined the Soyoko had been sent to help them. The men traveled on until they reached the camp of their clans who left Palatquapi. Here they told of the good work of the Soyoko and made a shrine and offered pahos to the spirit who sent the Soyoko.

Chapter 6: Two of Four Hundred

Buyers should take the time to study and appreciate the religious traditions on which these carvings are based. Only then can the Katsinam truly speak to you.

–McManis, 2000, 49

Two Katsina Profiles

In the cultural and religious events we all celebrate, a variety of mythical and legendary personages are associated with a particular season or ceremony. To us they have a logical order in the timing of their appearance; while to the uninformed they may appear as a random group performing on impulse. Likewise, the Hopis have learned of Katsinam since infancy, and have joined with them in celebrations and religious rituals throughout their lives. The function of the Katsinam is predetermined and is part of daily life, and the Hopis see perfect harmony in their appearance. To an outsider, the variety of Katsina performers appearing in the festivities seems chaotic, and the need to catalog and classify the members of the Katsina sect approaches an obsession. We may strive to understand the Katsina cult and sort them by their function, ceremony in which they participate, or as the more important (chief Katsinam) and less important. Several publications, some of which are listed in the bibliography, have identified and cataloged many of them. In the last century, a number of new Katsinam have appeared, while others have apparently been forgotten. In addition, the Hopis have a number of deities and very sacred Katsinam they have managed to keep mostly secret from outsiders. These rarely appear in public performances and are seldom carved as dolls to be sold. Our awareness of these Hopi spiritual beings is limited to a few historical references that were achieved many years ago by outsiders, sometimes against the Hopis' wishes.

A census of the Katsina population is as difficult as a census of the general population. Let's just say there are several hundred in this dynamic group. Some Katsinam appear every year, others are seen only a few times in a generation while others are now mere history. As the Hopi migrations brought new clans to Tusayan, the people also brought their Katsinam. Katsinam were also added through exchange visits between the people of Tusayan and the pueblo dwellers from the Rio Grande region and Zuni, if they had powers that would benefit the Hopi society. Katsinam may become extinct if their powers are determined to be ineffective, or when their sponsors, the keepers of the masks, no longer perform.

Over the past century, kachina carvings have changed from the simple static posed dolls carrying traditional ceremonial items to elegant sculptures with accouterments and background carvings related to the role of the Katsina. *Tithu* carved at the time when museum collectors and travelers first became aware of the Hopi and their Katsinam have become highly valued collectibles. We have selected two Katsinam, Cha'veyo and Cold-Bringing Woman, to profile and follow their history as gathered from oral teachings, ethnological journals, and a pictorial evolution made by Hopi artists and carvers. Both Katsinam are carved as dolls reflecting the role they play in Hopi life.

Today, Cha'veyo appears in many ceremonies and dances, while Cold-Bringing Woman appears infrequently. In our inquiries, most individuals interviewed knew of her, but had not seen her in Katsina performances.

Cha'veyo

There are numerous stories and legends of the misdeeds and eventual destruction of Cha'veyo.[1] Stories of the Hopi migrations include tales that establish his reputation as a monster called the

Giant Ogre. A number of stories developed as these tales were passed down from generation to generation. In some situations fear of the legendary past has restrained some informers telling of the means of destroying the ogre monster.

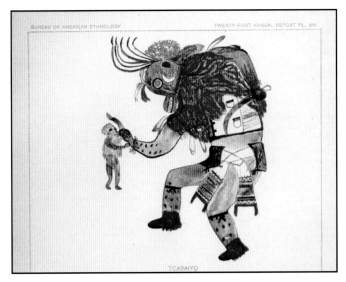

Fig. 6-1: **Cha'veyo (Tcabaiyo)**, from Fewkes' *Codex Hopi* (Fewkes, 1903, pl. XIII). This Hopi artist's rendition of the Katsina is dressed and armed as he would appear during performances on First Mesa.

Tcabaiyo is still another of the bogy gods.... The picture represents him in the act of seizing a small boy who, from the zigzag marks on his face and the sheepskin blanket, may be a Hehea child.

Tcabaiyo is threatening to kill the boy with the great knife which he carries in his left hand. In the picture the black mask has a long swollen proboscis. The eyes are protuberant, and there is a broad-headed arrow in the middle of the forehead. A white crescent is painted on the cheek. Feathers of the eagle wing form a fan-shaped crest, and a bunch of feathers is tied to the back of the helmet. Tcabaiyo wears a fox skin about the neck. Feathers of the eagle tail are attached to his upper arm. The red-colored garment represents a buckskin; that part of the dress in the form of a white man's waistcoat is an innovation. Arms and legs are spotted with black dots and the breech clout is held in place by an embroidered sash.

Tcabaiyo occasionally appears in Powamu and his symbolism has a close likeness to that of other Natackas or Soyokos.

–Fewkes (1903, 75)

Cha'veyo's appearance in one of the tales of the Hopis' ancestors serves as a prologue to the legend of the destruction of the village of Palatquapi (Courlander, 1971, 59). In the era of the migrations, the Patki people were joined by others and became the Water Clan. They established a settlement called Palatquapi (also called *Palatkwabi or Palotquopi*) on their migration northward toward Homol'ovi.[2] Palatquapi was an interim stop, and not to be their final settlement in the plan of the great migration. Water was plentiful; crops and game were abundant, and after some years the people, secure in their position, had forgotten

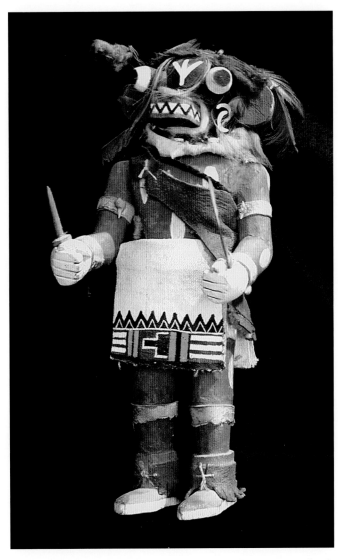

Fig. 6-2: **Cha'veyo**, mid-twentieth-century, free-standing carving made of cottonwood root decorated with cloth and feathers. *Courtesy Brian Hill.*

their purpose in life, and the reasons they had left the Third World. They quarreled with one another, they displayed inappropriate behavior with their women, and the children were disrespectful towards the old people. The Village Chief and clan elders selected a young clan member to dress as the monster Cha'veyo and confront the villagers with their shortcomings. Brandishing a stone ax, he warned the people their village would be destroyed if they continued their decadent ways and did not return to a righteous life. They accepted Cha'veyo's warning, but unfortunately in time they returned to their immoral behavior. Now the chief was forced to have the village destroyed. The destruction of Palatquapi has become one of the more important stories of the Hopi migrations.

Alexander Stephen (1929, 14) noted Cha'veyo wore a skin mask with bits of cedar wood strung together laid over the top. His heart was made of stone, just like his war axe, and he had a saber which he carried like a staff. Stephen wrote, "... he trotted along, listening for the footsteps of a possible victim. He was constantly looking for victims, men, women, and children.... Children wept when they heard him trot by."

Stephen collected stories from First Mesa informants during the last decade of the nineteenth century. Those he collected were relatively free of outside influence and are now considered a primary source of Hopi history and folklore. He wrote, "Cha'veyo was married to Hahai Wuhti, who bore him four children, the Nata´aska. Cha'veyo lived with his four sons at the San Francisco Mountains. The five ogres traveled the region slaying people, especially children. One story describes the slaying of Cha'veyo and the Nata´aska by the War Twins— *Pyüükoñhoya* and *Palüñahoya*"[3] (Stephen, 1929, 20-21).

At this time, Spider Woman lived to the east near the Little Colorado River with her two grandsons, the War Twins. Pyüükoñ wanted to go to the house of Cha'veyo. Using her magic, Spider Woman prepared him for this venture. She made him a piñon gum garment that looked like Cha'veyo's flint shirt. Then, applying more magic, Spider Woman became invisible, perched on her grandson's ear, and traveled with him. Pyüükoñ crossed the river and traveled west towards the mountains where he met the Giant Ogre who invited him to his home. Cha'veyo dug a pit and tricked the young War God to sit in it. He covered the boy with wood and set it on fire. Through her magic, Spider Woman protected her grandson from the

fire. When the wood burned out, Cha'veyo returned to find Pyüükoñ sitting in the pit unharmed. He saw the youth had powerful magic so he brought him into his home. Cha'veyo took off his flint shirt and placed it on a wall peg. While they ate, Spider Women replaced the flint shirt with the piñon gum replica. Afterwards the giant took what he thought was his shirt from the peg and put it on. Pyüükoñ put on the flint shirt while the Giant Ogre stoked the fire with the intent to burn the boy. Instead as the flames grew higher the gum shirt burned and Cha'veyo perished. The War Twin then slew the four Nata´aska with Cha'veyo's flint saber and brought their heads to the Hopi people. Now, replicas of the ogres' heads are worn by the Nata´aska Katsinam.

In another tale, one day when the War Twins were at a pool drinking water, Cha'veyo also came to drink. He knelt on the ground and drank from the pool until it was dry. He then approached the twins and hurled his flint saber at them. Pyüükoñ leaped into the air over the approaching weapon and caught it. Cha'veyo responded by firing a bolt of lightning that was also caught. Pyüükoñ then threw the weapon and the lightning at the monster. It merely stunned him, and so Pyüükoñ hurled his own bolt of lightning. It knocked Cha'veyo down. Finally, he was killed when Palüñahoya flung his lightning (Stephen, 1929, 19).

A teaching story told by a First Mesa storyteller to Mando Sevillano (1992, 85) introduces the evil Cha'veyo as the reason for the destruction of Awatovi. The story then follows the traditional form of Hopi oral literature where when the people of the village behave improperly their chief seeks help to end their evil ways.

It was said, Cha'veyo would kill the people of Awatovi when they traveled to gather firewood in the area on the edge of Antelope Mesa. A son of the village chief of Walpi went to the area to look into the story. While gathering wood, he was stalked by Cha'veyo who stabbed the young man and killed him. When the chief of Walpi went to search for his son, he found his body and buried it.

This was the first time there was trouble between the villages of Walpi and Awatovi. The chief believed the one dressed as Cha'veyo would also be punished. All the people of Walpi were angry and wanted to do something to the people of Awatovi. The village elders said this was not the time, other problems would curse Awatovi. As time went on, the Awatovi chief was angered with his people, because they behaved in a non-Hopi manner. He wanted his village destroyed, and he

sought help from other Hopi settlements to war against his village. Finally, the chiefs of Oraibi sent a war party to destroy Awatovi. They were joined by a small group of warriors from Walpi and Awatovi was destroyed.[4]

In days past, when a villager was behaving ka-Hopi, the War chiefs would call on someone to impersonate Cha'veyo. In his full warrior-hunter regalia he would confront the offender and then order him to follow Hopi societal law. If he did not change his ways, Cha'veyo threatened to return and fight him using his intimidating array of weaponry. In more recent times, Cha'veyo assumes the role of policeman during the summer dances and uses methods of control that include whipping the offenders, whether spectators or performing clowns, who have violated the rules of proper behavior (Titiev, 1944, 66).

On First Mesa in 1893, Alexander Stephen witnessed the events of the Powamu ceremony. After Ahola's house-to-house ritual and final appearance for the year, nine Katsinam came from a Walpi kiva and danced in the court. In their traditional performance, a group of *Koyemsi* clowns came up from Horn kiva and danced madly around the court. Easily identified by their clay-covered bodies and knob masks, the Mud-heads carried a gourd rattle in one hand and an eagle feather in the other. When the Katsinam left the Walpi court to go to neighboring Sichomovi, the clowns remained, continuing a burlesque performance until Cha'veyo appeared carrying a handsaw (Fewkes, 1897, 278). The clowns feigned fear of the giant. Stephen (1936, 175) wrote, "He knocks hell out of the clowns with his hand saw, chasing them all round." Cha'veyo demands food from the clowns, rejecting their

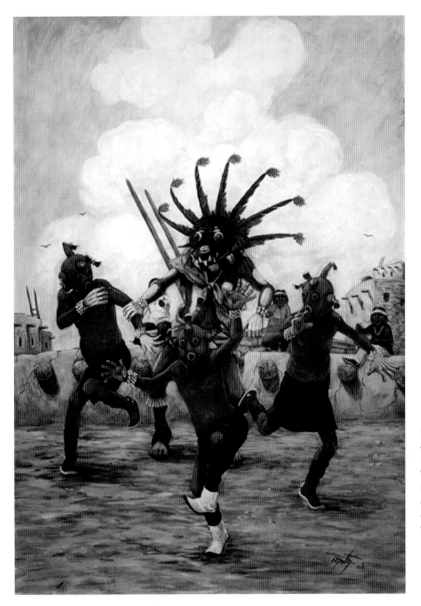

Fig. 6-3: *Cha'veyo Routs the Koyemsi*, 2006, by Neil David, acrylic, 20" x 14". With yucca whip in hand, Cha'veyo tussles with and quickly disperses the dancing clowns while spectators watch from the kiva roof.

inedible gifts, then retaliates with blows from his saw. He accepts only jerked-venison. After a short break Cha'veyo returns, hooting and carrying a whip. The tussle repeated with the Mud-heads badgering the old giant who responds using his whip. Neil David's *Cha'veyo Routs the Koyemsi* (Fig. 6-3) captures the actions of the often played script first observed by Stephen.

Cha'veyo's array of weapons has changed over time. In early tales he carried a stone war axe or flint saber. Today he is armed with metal weapons such as a large knife, a metal saber, or a handsaw. By the middle of the twentieth century Hopi carvings of Cha'veyo looked like the kachina doll in Fig. 6-2. Carvers used materials on hand to create dolls dressed as their real counterpart. They used cloth, fur, and feathers to decorate the wood figurines as the Katsinam. The dolls were colored using native mineral paints of low sheen, which have an almost chalky appearance.

When one enters a Hopi house where there are children, one's attention may be attracted by bright-colored images of carved wood hanging from the rafters of the dwelling...they were made for [as] dolls and presented to the little girls at the great spring festival called Powamu.

–Fewkes (1922, 379)

Tithu had a stilted look and were not freestanding, and Hopi carvers made dolls to be sold as curios in the same way. When buyers from the East displayed their travel souvenirs, they preferred to put them on shelves or tables. Unfortunately, these early style carvings were unstable and suffered many accidents, usually broken arms and legs. Carvers adjusted by improving the dolls balance and making larger feet to make them more stable. They soon found by attaching a small cottonwood disk as a base, the kachina could be safely displayed in a more natural standing position.

Hopi oral history conveyed the story of the sword bearing Cha'veyo and several other warrior Katsinam who spearheaded the Pueblo Rebellion at Oraibi. They killed the priest and soldier guarding the priest's quarters and so terminated the Spanish presence on Third Mesa (Pearlstone, 2001, 27). Cha'veyo now serves in a less aggressive, tempered role as a disciplinarian and monitor during festivities and civic duties when the people gather to perform tasks such as cleaning the springs.

Ronald Honyouti's one-piece carving of Cha'veyo (Fig. 6-4) portrays the Katsina as he appears in public performances, wearing a buckskin robe and carrying an intimidating oversized saber and a bundle of yucca fronds he uses to whip misbehaving spectators. He wears a black mask, has bulging eyes, and radiating feathers on his helmet. The terrifying figure has a large protruding nose and mouth with sharp teeth. Honyouti's carving, a mere eight inches tall, includes detailed base carvings of a young boy and maiden in tears, and a *Koyemsi* and a naked clown downed by Cha'veyo. These base carved images tell the story of the monster Katsina's personality and menacing actions.

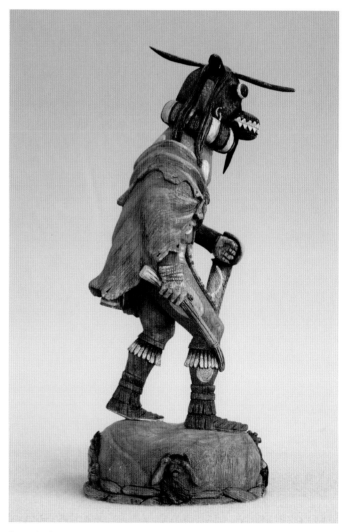

Fig. 6-5: **Giant Ogre**, base figure is a frightened young maiden brought to tears by the intimidating ogre.

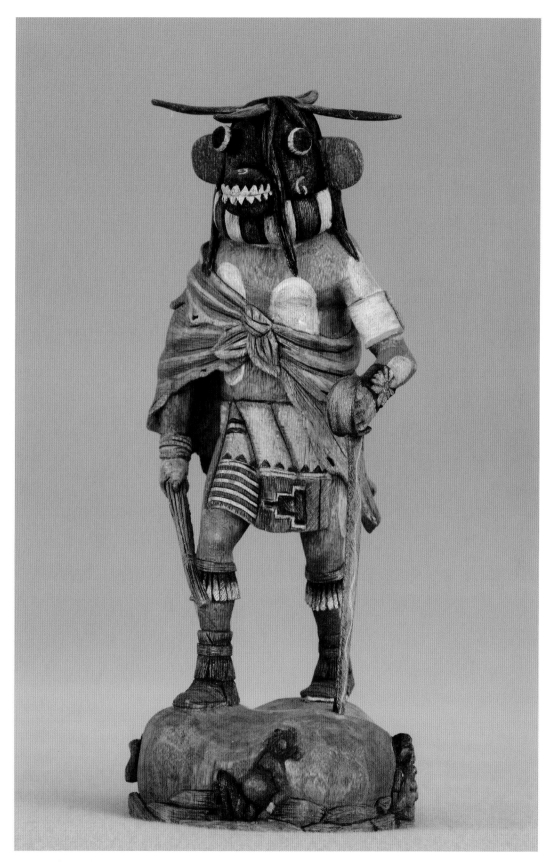

Fig. 6-4: **Giant Ogre**, *Cha'veyo*, 2006, by Ronald Honyouti, 8" h.
Base carvings on Honyouti's one-piece carving portray Cha'veyo's victims. Each is less than one inch high. Base figure is a Mud-head downed by the giant.

Cold-Bringing Woman

Winters on the Hopi mesas are long and bitter. The only moderating factor is the warming of the sun as it penetrates the thin atmospheric layer in this high elevation desert during the midday hours. The Hopi people are eager, as are most of us, for the winter cold to end and look for the coming of spring. Stephen was told:

Pyu'ukanhoya, his breath is ice cold, he understands the cold, hence appeals to him in the cold moons of kya and pa ["December" and "January"]. During these two moons it is especially desirable to have plenty of rain or snow to permeate the land, then cold to make plenty of ice.

–Stephen (1936, 239)

Cold-Bringing Woman may appear at the time of the Powamu, in mixed dances, or in the Fest Parade. Her disheveled hair and windswept white robe is the image of blustery weather. She carries a stiff hairbrush made of split yucca leaves and approaches the spectators. She combs their hair in the opposite direction to what they have, or "combs hair up" as if gale winds were blowing. In his benchmark publication, Harold Colton (1959, #101) uses the name "Comb Hair Upwards" Maiden and the Hopi name *Horo Mana* in identifying this Tewa Katsina, who is also commonly called *Yohozro Wuhti*.

She plays the role of the wintry blizzards and serves to bring moisture in the form of snow. While heavy rains are often lost through wasteful runoff and flash flooding in the land of mesas and barren desert, the cold winter temperatures are ideal for preserving moisture and releasing it slowly as the growing season opens. Agronomists would commend the Hopis for having Cold-Bringing Woman support their efforts to achieve bountiful harvests.

It is not known when Cold-Bringing Woman first appeared. Pottery fragments, with a figure of a Katsina resembling her, date back to the early fourteenth century (Schaafsma, 1974, 57, 69). This black-on-white pottery shard has a Katsina mask with round eyes with pupils, rectangular toothed mouth, and an extended tongue overlapping a beard. The mask design is consistent with the first published drawing of *Yohozro Wuhti* made for Fewkes' *Codex Hopi* as she appeared on first Mesa in the last decade of the nineteenth century. Fig. 6-6, taken from the codex, was drawn by White Bear (Kutcahonauû), Neil David's grandfather. He painted more than forty kachina drawings for Fewkes. White Bear's distinct style included outlining the figure, and hands were simple round stubs. He painted the legs and feet head on, pointing downward (Munson, 2006, 76).

The Cold-bringing woman, who is connected with the Nüvak or Snow katcina, is claimed by the people of Hano as one of their supernaturals. She is depicted as wearing a white mask with a red spot on each cheek, a small beard, and a red tongue hanging from a mouth which has prominent teeth.

She has ear pendants and a red feather is attached to the crown of her head. There is a fox skin about her neck, and she is clothed in a white blanket, tied with a knotted girdle.

–Fewkes (1903, 84)

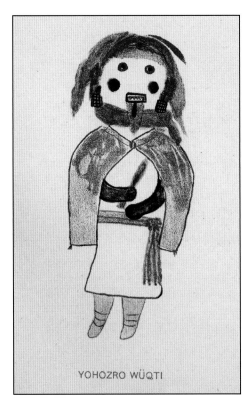

YOHOZRO WÜQTI

Fig. 6-6: **Cold-Bringing Woman,** *Yohozro Wuqti*, from Fewkes' *Hopi Katcinas Drawn by Native Artists*, plate XXII.

66

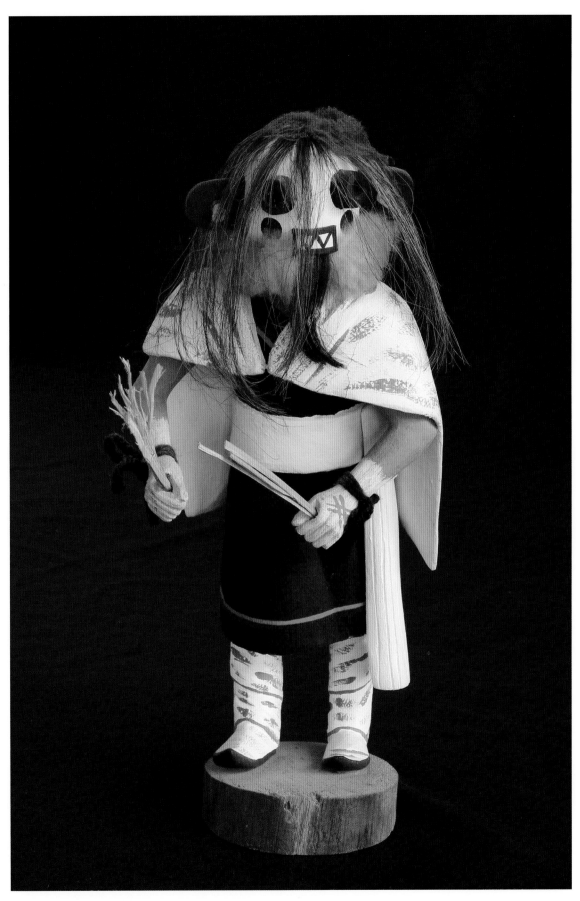

Fig. 6-7: **Cold-Bringing Woman**, *Yohozro Wuhti*, by Tino Youvella, 12 1/2" h.
Late-twentieth-century carving decorated with cloth, hair, and fur.

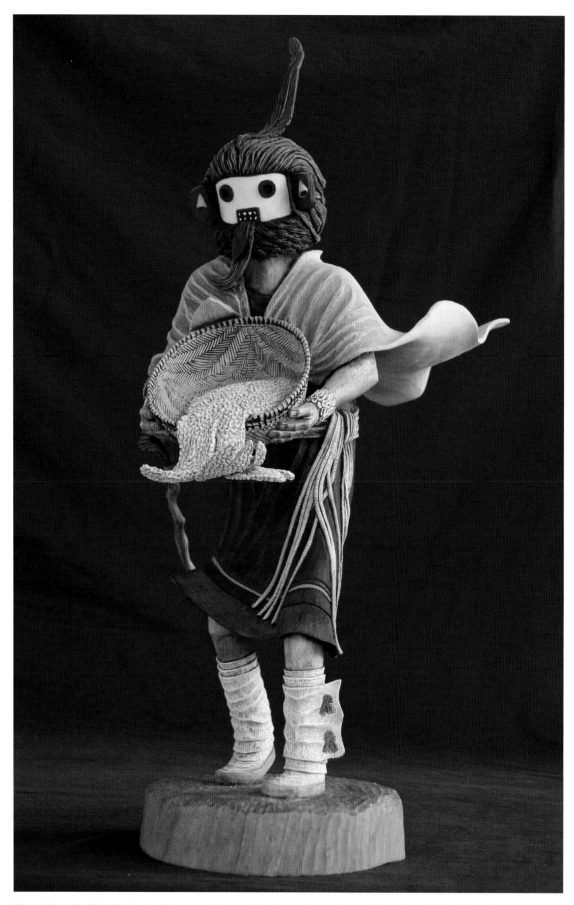

Figs. 6-8 & 6-9: **Cold-Bringing Woman,** *Yohozro Wuhti,* by Dennis Tewa of Moenkopi, 2004, 21" h. *Yohozro Wuhti* is enacting a rare ritual by scooping up a basket of snow and scattering it to the wind as a prayer for additional winter moisture in the form of snow. (abone and opposite page)

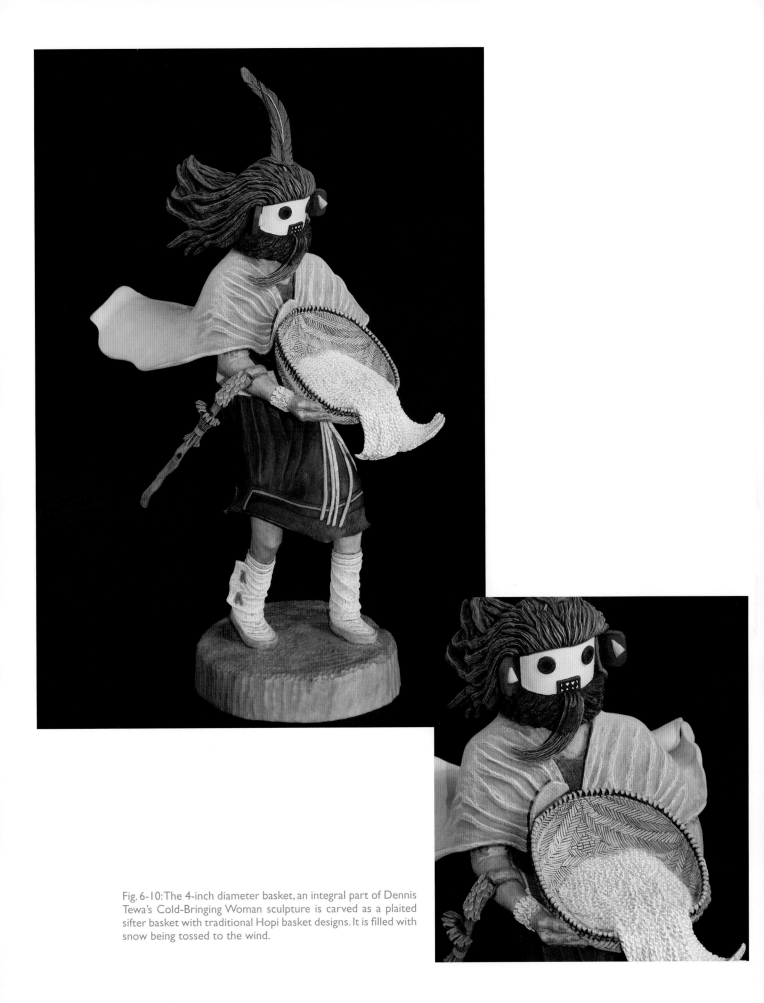

Fig. 6-10: The 4-inch diameter basket, an integral part of Dennis Tewa's Cold-Bringing Woman sculpture is carved as a plaited sifter basket with traditional Hopi basket designs. It is filled with snow being tossed to the wind.

Tino Youvella's carving of the Cold-Bringing Woman (Fig. 6-7) was made in the 1980s. This kachina doll wears a white cape and knotted white wedding sash, fur collar, white decorated leggings and moccasins, and holds a hairbrush made of abrasive yucca leaves in her hand. Youvella, who lives in Polacca, described the Katsina's performance: "Cold-Bringing Woman comes in the final days of winter after the Powamu, and appears in the night dances with the Snow Katsina. She carries the stiff hairbrush and approaches spectators and combs their hair opposite to what they want—disarranges it. She takes small steps or tiptoes when stalking her next victim."

Dennis Tewa, of Moenkopi, carved Cold-Bringing Woman as the Katsina performs a sacrament rarely pictured or carved. When there is snow prior to her performance, she uses a Hopi sifter basket and scoops up snow and throws it into the wind as she recites a prayer of thanks for the moisture and a prayer to encourage the spirits to bring additional moisture in the form of snow in preparation for the approaching growing season.

Tewa's sculpture, one piece from the base through the feather topping, shows Cold-Bringing Woman carrying traditional paraphernalia as she appears for the late winter ritual. Complete to the smallest detail, her skirt has the hand-sewn seam properly placed on the right side, and the wedding sash carved as customarily tied on the left side. Swirling tassels extend to the hem of the dress. Intricately carved moccasins, with spiral leggings wrapped to the middle of the calf fastened with leather strap decorations, appear as real as the deerskin footwear the Katsina wears for the dance celebrations. Tewa produced his tupelo wood creation in an action stance symbolic of the ceremonial ritual. He captures the sensation of winter conditions on the mesa summit with the kachina's cape and hair swept almost horizontally from the high-force wind. Just as the Zuni Old Salt Woman carries a crook to bring down the rain clouds, Tewa's Cold-Bringing Woman carries a long crook purported to grab the snow-burdened clouds and bring down the moisture. Her Hopi hairbrush of split yucca fronds is attached to the crook, ready for use as she moves past the spectators.

Completed in 2004, this sculpture is an outstanding example of the evolution in carving kachina dolls from the traditional *tihu* to collectable pieces of art. Over the last century, Hopi carvings have changed from stilted figures with minimal carved outline, where fingers and details of dress are mostly painted on, to a true-to-life figure with flowing robes and finely carved details such as fingernails and pieces of jewelry. On Tewa's carving the texture of the plaited basket, its geometric design, and vivid selvage demand a second look to affirm it is carved of wood and not woven. The design is exacting to the extent when holding a flashlight under the basket, not only do the diamond patterns exist on the bottom side, traces of light shine through as one would find on a traditional basket.

The new century carvings of Cold-Bringing Woman are a long stride from the kachina dolls of the nineteenth century when they were carved with details limited to the mask, just adequate enough to identify the particular Katsina. Today the aesthetic demands of collectors and art galleries plus the efforts of the talented Hopi carvers have created a niche art form.

In spite of the colorful and entertaining performance of Cold-Bringing Woman, there is some discord with her performance to bring the winter weather. With the low annual snowfall across the Hopi region, apparently the Cold-Bringing Woman has found it difficult to meet her objective of bringing moisture since winter cold brings little snow; this may be why she appears infrequently. When we asked one Hopi to carve this kachina he politely declined and suggested other Katsina manas. Geertz and Lomatuwayma (1987, 126 note 38) presented a point of view of a Third Mesa resident when interviewed during a cold period following the Powamu ceremony. He said, "We believe that the Ogres have cold breath. That is why we have cold winds and snow right now—because of the Ogres on Second Mesa." As the planting season approaches, the Katsina dances reinforce the farmers' prayers for good weather to allow timely spring planting. To assure the dance is successful and prayers are answered, individuals with good hearts must conduct the Katsina ceremonies. If some participants are unhappy, in this case the farmers, the success of the dance is at risk. If Cold-Bringing Woman's performance extends the winter and thus shortens the growing season, a good harvest is put in jeopardy.

Chapter 7: Hopi Legends of Destruction

It would be difficult indeed to find a more "Christian" people than the Hopi—this, when they had not yet heard of Christ.

–James (1956, 38)

Legends of the Hopi are intertwined in their daily life, in their religious beliefs and festivities. From the last quarter of the nineteenth century through the first half of the twentieth century, ethnologists and writers collected stories of the emergence myth and migrations from the generation of Hopis who had been taught these stories by their elders. Stories that make up Hopi history and evolution of the Katsina cult were transferred to succeeding generations through family teachings, via presentations made by the priests during initiation rites, and through recitations made by the new initiates when they were inducted into the Hopi societies. Relaying of history and Hopi tales in their aboriginal form ended after the white man recorded and published the Hopi stories and legends. Limited skills with the Hopi language certainly influenced the ethnologists' interpretation of the details in the published version of these Hopi stories, while the cultural background of the Anglo reporters also hindered their ability to report unbiased versions of the Hopi tales. No doubt, when today's Hopis read these reports and publications, these Anglicized versions influence their oral recitation of Hopi history and legends.[1]

When the Hopi Hearings were held in 1955, they supplemented and in part verified Hopi history as gathered by the nineteenth century researchers.[2] Before Washington could correct the problems, it needed to know something of the Hopi way of life. At the hearings spokesmen from the villages across the reservation presented detailed accounts of Hopi history from the time the people left the Third World. These speakers, respected leaders of their communities, had a dedicated fervor in describing the Hopi way of life and Hopi life plan.[3]

Regardless of clan affiliation or home village of Hopi informants and spokesmen, there is a commonality in the main theme of the stories they tell of their ancestor's emergence from the Underworld and travels in the Fourth World. Details, however, follow the perspective of the clan affiliate and the traditions of the narrator's village. Andrew Hermequaftewa of Shungopavi pointed out:

This village is referred to as a Hopi village, and other villages are referred to as Hopi villages but each group or clan who came to these villages carried their own version of their traditional instructions or religious beliefs and when they were admitted to these villages they formed one united group of Hopi people and in this way our traditional instructions and teachings are different a little in some respects but the basis is the same.

–Hopi Hearings (1955, 75)

During the centuries of migrations, the experiences gained from the hardships of daily life gave added strength to the growing religion and Katsina cult of the gathering clans. Ideal weather conditions and the resulting abundant crops were attributed to proper behavior and strong religious convictions. Disease and natural disasters were caused by bad behavior, lack of dedication, and impure hearts when preparing for religious celebrations. Stories preserved as part of Hopi history describe the weakness of the people— forgetting their spiritual values and living an evil and immoral life. This behavior was not tolerated and was brought to an end when the village chiefs and

elders sought help to punish the sinful people—even to the level of death and destruction of their village. Fortunately, some of the people of good hearts survived these disasters and continued their odyssey, the search for their final home, a place of harmony—their promised land.

Evidence supporting the migrations and wandering of the Hopis' ancestors lies in the existence of the spectacular pueblo ruins preserved as national parks and monuments from Chaco Canyon and Mesa Verde to Wupatki, Homol'ovi, and the hundreds of small ancient ruins in the Southwest.

Today on the three Hopi mesas each clan in each village has its own version of the tales of the destruction of the villages of Pivanhonkapi, Palatquapi, Awatovi, and Sikyatki. Legends of destruction or failure of villages have been repeated in Hopi history from the time of the Emergence, through the destruction of the villages during the migrations, and to the twentieth-century split of Oraibi. Yukioma compared the conflict between the people in the Underworld with the trouble in Oraibi in the last decade of the nineteenth century.[4] He was not alone in believing Oraibi would suffer the same predestination as Awatovi and the other Hopi villages destroyed or abandoned in prehistoric times. Oraibi's kismet was to survive the split of 1906, although it never regained its former prominence.

In Voth's collection of stories, *The Traditions of the Hopi*, the migrations follow the theme of the Emergence from the Third World.[5] The people were living down below and things were peaceful and living was good. The land was fertile, it rained, and crops were abundant; and yet the people began to quarrel and treat each other poorly. Conflicts were more frequent and the people talked bad and did bad. Voth (1905, 16) quoted the storyteller, Yukioma: "The people began to live the way we are living now, in constant contentions." Rains diminished and crops failed. The number of evil persons and sorcerers increased. The leaders decided it was time to seek a new world for the remaining good people. When they heard sounds from above as if someone was walking, they decided to send a messenger to explore this new world to see if it was a good place to live. The *Kikmongwi* (Village Chief) created a bird that would fly up to the new world. It failed its mission. Additional messengers, each a different species of bird, were created and sent. Finally, the forth messenger found the opening into the new world and discovered the place where Oraibi is now, and the people began their journey into the Fourth World.

When speaking at the hearings in Shungopavi, Andrew Hermequaftewa told of the arrival of the people in the Fourth World where they found Maasaw (Massua), "...and asked for permission to come and live in this land. Massua said he would be very glad but he said it was up to them if they would be willing to live according to his way of life and if they didn't doubt his way they would be welcome." The people wanted him to be their leader in this new land:

...but Massua said no. He said, "You have many intentions or plans that you want to do in this life. I will not be your leader now until you have completed all the things that you want in this life.... I will set a date at which time we will gather here again to prepare you to move on to other parts of the land where you will settle and live this life that I will give you.... Your name shall be Hopi and you must lead your people in this life along the good life which I have given to you. Take care of your children. Take care of this land and life so that all people will be well and shall live long lives, that there shall be plenty of food for all people.... You must never harm anyone.... You must never make wars against any people."

–Hopi Hearings (1955, 79-80)

He continued:

Our life plan and the things that they were told were put in on the stone tablet...it will be upon these stone tablets that the Hopi life will be based.... Massua said they must never forsake; never doubt his teachings and instructions, for if they ever doubted it and forsaked the stone tablet and all its teachings, they will cause a destruction of all life in this land....

–Hopi Hearings (1955, 81)

The people wandered throughout the Southwest, and the clans evolved as the population grew larger. Cyclic changes in environmental conditions and enemy raids on fields and homes forced the clans to move from one region to another until one by one they converged and found their home on the mesas of Tusayan. As the people journeyed, searching for a secure home, the stories of their life's successes and disappointments were preserved in legends through oral teachings and dramatized in their traditional ceremonies.

Destruction of Pivanhonkapi

Voth (1905, 241-244) recorded a tale of disaster as told by his informant from Third Mesa. The villages of Pivanhonkapi and Huckovi (the ruins of these ancient settlements are still visible) were just a few miles west of Oraibi. The people of Pivanhonkapi were behaving poorly. Even the village chief's wife neglected her children, choosing to participate in games of chance held in the kivas. The chief saw his people forgetting the Hopi way, and angered by their wicked behavior wanted them punished. He went to the *Yayaponchatu*, a group who lived in an isolated village north of where the villagers of Oraibi dry their peaches.[6] The *Yayaponchatu* were believed to be in league with supernatural forces. They were known to have influence over storms and fire, and the chief sought their help to punish his people. They said he should choose the element by which his people would be judged. He wanted their sinful ways to end and chose judgment by fire, hopefully to instill religious and moral motivation to his people to return to the traditional way of life. Later he met with the chief of Huckovi and told him of his plan.

A dance was to be held in Pivanhonkapi in four days and the people of Huckovi would also attend. On the dance day, different Katsinam performed each dance. The last group to perform was the *Yayaponchatu*. While dancing, they sang this ominous song (Voth, 1905, 242):

> *Why, at last here*
> *You your houses*
> *Red cloud with*
> *When enveloped*
> *Somewhere over there*
> *The mist through*
> *Carrying one another*
> *Villages along*

Some of the spectators were concerned with the message in the song, but few understood the meaning and the presence of the *Yayaponchatu*. The dancers carried prayer offerings and each had a small packet attached that contained a spark of fire. After the ceremony, prayer offerings were given to the two chiefs. A third was taken to the San Francisco Mountains far to the south, and the chief of the *Yayaponchatu* kept the last packet.

The next night some of the people resumed their gambling and carousing. An unusual light was seen coming from the San Francisco Mountains. The people continued their games while the light grew larger each night. By the third day the supernatural aura of fire and smoke was visible in the daylight. On the forth night it approached and overwhelmed the two villages. Many of the decadent people died in the kivas, others died as they tried to flee from the fire that destroyed Pivanhonkapi and Huckovi.[7] When the chief of Oraibi saw the fire approaching his village, he sought Spider Woman for help. With her intervention the force of the fire was broken before it reached the village.

Destruction of Palatquapi

The legend of Palatquapi and the Great Horned Water Serpent is one of the traditional stories of the Hopi migrations, and part of the Water Clan history. In his account of the Water Serpent, Armin Geertz (1987, 177) was puzzled that relatively less was written about this powerful Hopi deity in the published literature from Third Mesa. The account we present follows the tale as told in the First Mesa villages.[8]

Cha'veyo had forewarned the people of Palatquapi to resume a virtuous way of life or their village would be destroyed; unfortunately, they ignored the warning. They had forgotten their life plan to seek the land that would be their permanent home. Many had abandoned their religious ceremonies, neglected their fields and civic responsibilities, and fallen to an immoral life and spiritual decay. Their *Kikmongwi* was determined to destroy his village. He enlisted his nephew to carry out his plan. He was to put on four Katsina masks, one over the other. Further, to create a terrifying image the chief taught his nephew magic. By using burning coals under the top mask of Maasaw, it would appear as flame surging from his breath and eyes. On four consecutive nights he appeared as walking fire, first circling the village, and then running through the plaza. Each night the people grew more terrified as they saw what they believed was a sorcerer that

glowed with unnatural brightness. On the fourth night, when the blazing vision crossed into the village, the people blocked his pathways. He was captured, and the people took him to the kiva. They removed his mask only to find another. When the last mask was removed they were surprised to see it was the chief's young nephew. Knowing it was a serious matter and unsure of what to do, they took him to the plaza and buried him with his hand protruding from the ground. The thumb was folded down and the four fingers were extended. At dawn the next day the people came to the burial site and saw one finger folded over, the other three pointing upward. Each day one less finger pointed to the sky. On the fourth morning they saw the last finger turned down. The earth quaked and water began to flood the village. The water covered the plaza and it flowed into the houses. The chief's nephew, transformed into *Palulukonti* ("Great Horned Water Serpent"), rose from the water and floated on the water that filled the plaza. Some villagers ran into their houses to save their things. The old and frail people who could not run were helped up to the rafters of their homes and perched there. As the water continued to rise, the buildings began to crumble and the remaining people fled from the village. The village of Palatquapi was in ruin. The survivors fled and would not return, and the clan leaders called for a new beginning and once again continued their migratory search to find their final home. Left behind were two children. Palulukon protected them and showed his identity as the chief's nephew. He taught the children many things and told them why the village of Palatquapi was destroyed. Then he assisted the children in their search for their family, and instructed them to carry his teachings to their people.

Fig. 7-1: *Legend of Palatquapi*, by Neil David, acrylic, 26 1/2" x 12".

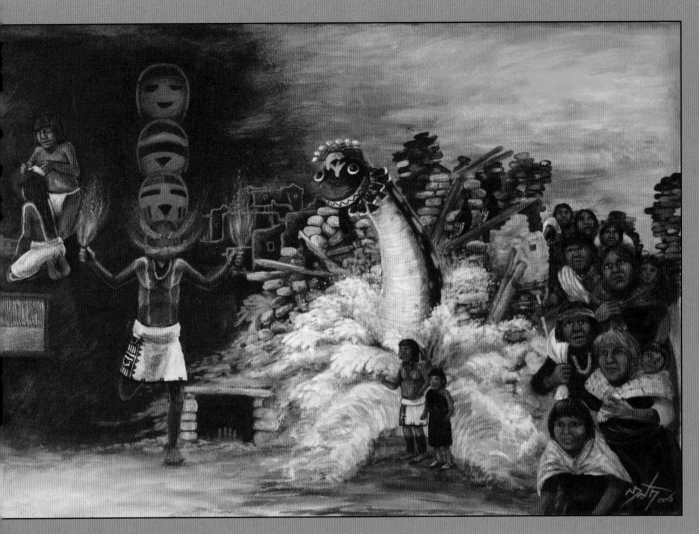

Neil David's multi-scene interpretation, *The Legend of Palatquapi,* pictures the series of events leading to the collapse of the Hopi culture at Palatquapi, the village chief's means of resolution, and the destruction of the village. Each element of the tale is pictured as the artist has been taught and now as he tells the story. On the left side of the painting, men and women are "living it up, acting crazy—dancing and partying in the kiva until the light of the approaching dawn." In the left foreground is a cluster of incidents of ka-Hopi behavior: "On the left, two men, who participated in a village-wide hunt, are fighting over their kill and tearing a rabbit apart. It's a very bad omen to argue over captured game." The second incident shows "the disrespect the young had for the old people—the boy harassing the crippled old man." Finally, "The husband who should be weaving his ceremonial vestments on his loom is instead caring for a hungry baby while his wife is partying in the kiva." Centered in the painting, the *Kikmongwi* is washing his nephew's hair using *movi* (yucca root) suds in preparation of his eventual capture.[9] To the right, disguised with four masks, the young man appears as a fiery spectacle running through the village. "Upon capture he was killed and buried in a small shrine in the plaza with his four fingers pointed skyward."

David's vivid portrayal concludes with Palulukon surging from the water and the people fleeing the collapsing village.

The boy and girl are left behind. Three turkeys are perched on the broken rafters and building rubble. David added, "According to Hopi legends, the spirits saved the old people huddled on the rafters and turned them into turkeys. As the water rose, the foaming waves touched the turkeys' tails, and that is why turkeys now have white-tipped tail feathers."

As the clans completed their migrations and settled on the three extensions of Black Mesa, the stories and tales of their wanderings continued to guide the people and even today remind them of the importance of proper behavior. The Hopi people are more unified by their religion and cultural traditions than by economic or political factors. Straying from the Hopis' life plan with foolish and wicked conduct causes poor health, famine, or the ultimate self-destruction as cited in the legends of Pivanhonkapi and Palatquapi, and recorded in historic times with the obliteration of Awatovi. The normally protective Hopi deities support such severe punishment.

Yukioma was imprisoned for his protest against government control that conflicted with the traditionalists' view of the life plan. He told Leo Crane, head of Moqui Agency and school superintendent at Keams Canyon, "I am doing this as much for you as for my own people. Suppose I should not protest your orders—suppose I should willingly accept the ways of the *Bohannas* ["white men"]. Immediately the Great Snake would turn over, and the Sea would rush in, and we would all be drowned. You too. I am therefore protecting you." (Crane, 1925, 188).

Chapter 8: Night Dances

The period following the Powamu is a festive time, a time of positive thinking and ongoing effort in preparation for the new year of crop growth as well as the continuing growth of mankind. Kiva members are already meditating and making preparations for the demanding round of the *Anktioni* or Repeat Kiva Dances that continue the annual rituals for seed germination, proper rain, and bountiful crops. Passionate villagers look forward to the series of winter night kiva dances, when on each dance night the Katsinam perform in a round of dances moving from one kiva to another.

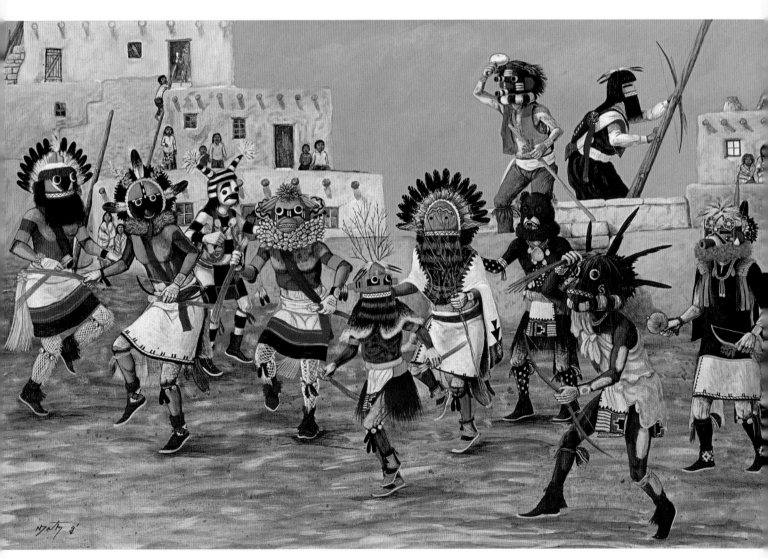

Fig. 8-1: **Fest Parade**, 1998, by Neil David, acrylic 28" x 17 1/2". After four days of fasting and purification rites for germination and rain for the coming planting season, great numbers of Katsinam parade through the village announcing the beginning of the late winter night kiva ceremonies.

Fest Parade

With the conclusion of the Bean Dance and after four days of kiva preparation and the participant's abstaining from fats, salt, and sexual relations, the day of the Fest Parade and the Puppet Doll drama has arrived. At late-morning a large contingent of Katsinam emerge from the kiva, their presence announces the beginning of the series of night dances, and at the same time allows final preparations of the kiva for the evening performances. Turtle shell rattles and bells attached behind their knees provide background sounds to the hoots of the Katsinam announcing their presence moments before they parade into view on the winding, village lanes. They move in small groups through the summit settlements on a circuitous route past the kivas. Spectators gathered in the plaza are alerted to their approach when an observer calls out, "the Katsinas are coming." Fearful of meeting the overwhelming force of mysterious and feared paraders, a contingent of boys not yet initiated into the Katsina society runs from the plaza. To the first time spectators, the large number and variety of Katsinam passing on the serene paths of the pueblo seems unbelievable. With such an array passing, it is likely that at least a few may be recognized from kachina doll carvings and books featuring museum-collected photographs taken almost a century earlier. Several whipper Katsinam move through the crowd and give the viewers a ceremonial lash with their yucca whips. As spectators in Sichomovi, the middle village on First Mesa, we were told, "the whipping is an exorcism for pain, the Katsina whips you where the pain is."

Mindful that photographing is prohibited, spectators must concentrate on memorizing the individuals in the parade of Katsinam as they pass. The sight of a Katsina leading another tied with a rope around his neck, and the vigorous dance of some of the others are remembered, so we may search our books on Hopi Katsinam to identify and reinforce the day's fleeting images. As the performers complete their walk through the village, they return to their respective kivas. Festivities continue with open house feasts in every home. Meanwhile, the kivas are being prepared for the first set of Night Dances, among them the favored and revered Puppet-doll dance.

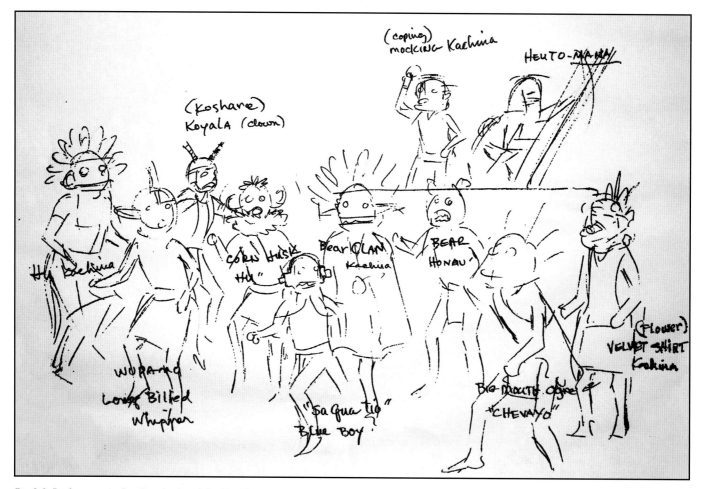

Fig. 8-2: Performers in *Fest Parade*, sketch by Neil David

Night Dances

Members of each kiva seek the opportunity to sponsor a dance where they select a favorite Powamu performance to be repeated. On First Mesa each of the nine kivas will present their well rehearsed performance in each of the nine kivas in a single night. With each presentation lasting about twenty minutes, and the complete round consuming most of the night, the movement from kiva to kiva is carefully scheduled. The dancers work up a sweat in each vigorous performance, and endure a range of temperature extremes from the warm kiva crowded with spectators and performers, to the frigid late-winter conditions as the Katsinam travel between kivas scattered across the mesa.

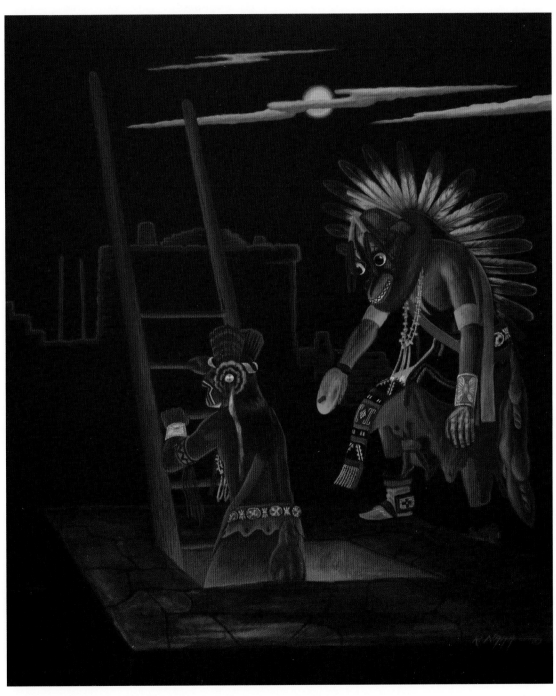

Fig. 8-3: **Katsinam Entering the Kiva**, c. 1965, by Raymond Naha, 15 1/2" x 18 1/2".
Comanche and A'hote Katsinam descending into the kiva for a nighttime ceremony.

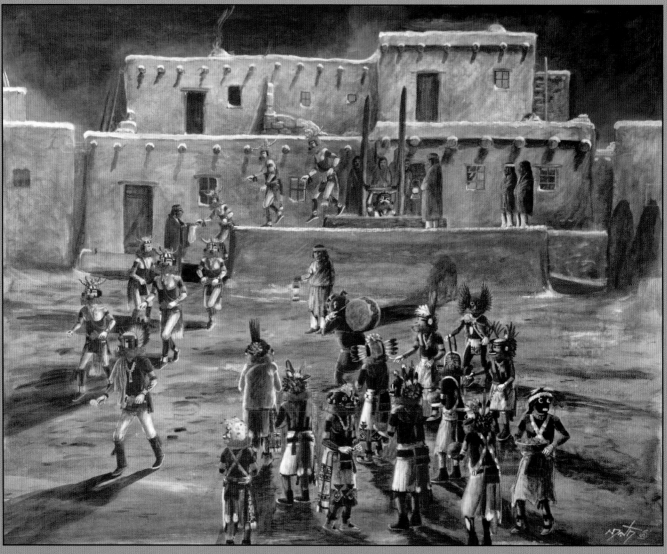

Fig. 8-4: **Changing Kivas for the Night Dance**, 2005, by Neil David, acrylic, 20" x 16". A group of mixed Katsinam is waiting in the plaza while a group of Corn Dancers and a single Sotungtaka are walking from the kiva where they have just performed.

Neil David's painting *Changing Kivas for the Night Dance* portrays the festivities on a crisp winter night as one group of Corn Dancers climbs from a kiva after completing their performance. A second group of Katsinam, led by the Mud-head drummer, waits its turn to enter the kiva. Snow crusted vigas extending from the multi-storied pueblo roof hint at the bracing nighttime temperature. The priest carrying the lantern controls the movement of the two groups of performers. The man standing at the base of the kiva collects gifts of delicacies made by the Hopi maidens and given to each performer as they concluded their dance. These gifts will be redistributed after the night-long round of dances.

Consistent to his commitment and self imposed demands to produce accurate and informative ceremonial paintings, Neil David produced a line sketch, or key, identifying the Katsinam in the painting's foreground. To further enlighten the viewer, he felt obligated to paint a set of six ink and water color portraits of the Katsinam, who were pictured in the foreground facing away from the front of the painting.

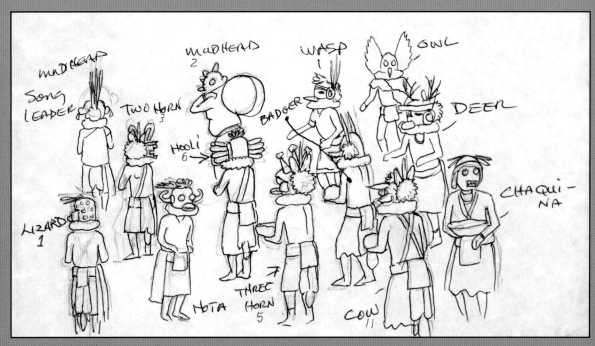

Fig. 8-5: Key for *Changing Kivas for the Night Dance*, by Neil David. Katsinam waiting to enter the kiva are identified in this sketch.

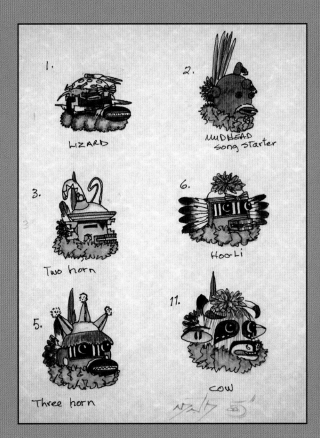

Fig. 8-6: **Katsinam portraits**, 2005, by Neil David, watercolor, 8" x 10 1/2". The Katsinam pictured are six who are facing away from the viewer in David's painting, *Changing Kivas for the Night Dance*.

Puppet Dance

Titiev presented a succinct account of the events in Hotevilla in 1934 at the beginning of the *Ösömuya* ("March moon"). Early in the day, the Hahai Wuhti and He'e'e impersonators along with a large group of mixed Katsinam, made a circuit or parade of the village and concluded with a return to their respective kivas. Titiev watched the night's dances from the *Hawiovi* kiva. The main attraction that evening was the Puppet-doll Dance. It was preceded by several groups of dancers as part of the first of the *Anktioni* series. After the third dance group left the kiva, the fires were muted and the fourth group of Katsinam entered the kiva. In the darkened kiva a drop curtain, painted with sacred images, was set up; and the marionettes, hidden in blankets, were brought in and all the wiring necessary to control their motion was connected. The stage was set and kiva fires were brightened. Titiev pictures the drop screen with the two-foot tall Corn Maiden dolls (*Shalakamana* and *Palhikmana*), and the sandpiper effigy sits on the screen top. Cloud symbols are painted on the screen and a small spruce tree stands at each corner of the stage-set. The two puppets sit centered before the screen, and a Heheya sits at each corner. When the first song began, the two puppets moved in rhythm with the dance music. On the second song, the maidens were bent over *metates* and moved as if grinding corn. At the end of their performance, the Katsina Father gave corn meal, seemingly ground by the maidens, to the audience (Titiev, 1972, fig 19; 324-325).

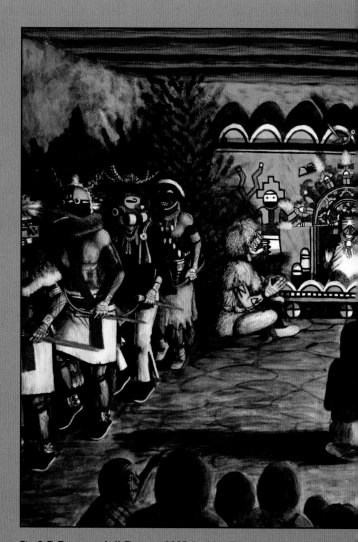

Fig. 8-7: **Puppet-doll Dance**, 2002, by Neil David, acrylic, 24" x 14 1/2

Neil David's painting *Puppet-doll Dance* shows the kiva performance with the two marionettes centered before the screen, and snipe effigies wired to dart across the top. David captures the added drama with the flickering light from the central fire creating the long shadows cast from the performer's images. A Heheya Katsina sits at each end of the stage area. In the center, Hahai Wuhti directs those who control the puppets' motion. Even though the kiva is dimly lit, the Katsinam are not to be seen unmasked. Since some may have to raise their masks to enable them to sing, those grouped on each side of the stage normally face the stage. However,

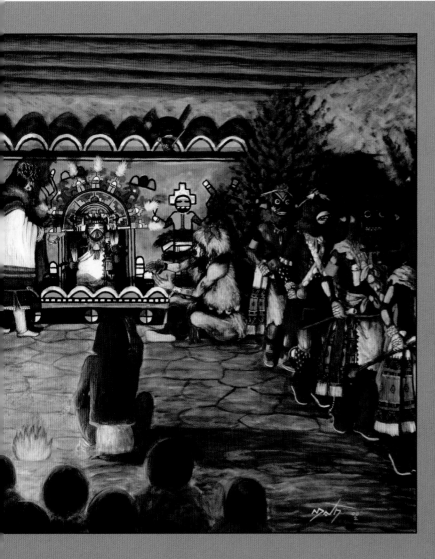

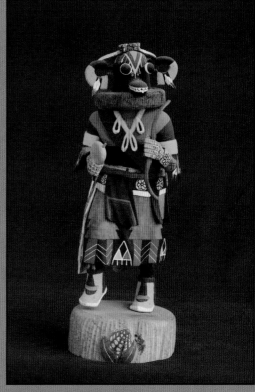

David, intent on presenting an informative account in his paintings, has them facing the spectators. Their singing overrides the Katsina Mother's high pitched voice as she directs the performance.

The kiva priests are seated at the fire, and the spectators are seated in the foreground. The kiva ladder is not pictured in the painting; it would be in the center of the scene. The Katsinam identified by David (rear to front), left side: *Chaquina*, *Chospos*, *Wupano*, and *Hilili* (partial figure); right side: *Hoota* (*Ho´óte* Fig. 8-8), Wolf, Big Mouth Ogre, and Warrior Mud-head (partial figure).

Fig. 8-8: *Ho´óte*, by Cailol Silas, 14 1/2" h. Fewkes' *Codex Hopi* pl. xxxvii pictures A'hote with a similar mask. Ho´óte appears in the mixed dances and is in Neil David's *Puppet-doll Dance* (Fig. 8-7) on the right.

In his *Codex Hopi*, Fewkes depicts and describes the Puppet-doll Dance with the two Corn Maiden figurines against the backdrop screen painted with designs of rain and clouds, and topped with two bird effigies which are manipulated to go back and forth across the top of the screen (Fewkes, 1903, pg 88; pl. XXVII). The puppets' arms, controlled by strings from behind the screen, are moved as if grinding corn to the rhythm of the music. If a puppet string breaks, the feeling of guilt for incomplete preparation for the ceremony is shared by kiva members and puppet operators.

Theatrical dramas may vary from year to year and from village to village. As an alternate to the Puppet-doll Dance, the Palulokong, or "Water Serpent Dance" is performed. Fewkes (1903, 40) called this period the "*Palülükoñti*" or "*Añkwañti*," a time when many masked personages appear in sacred kiva dramatizations with the central figures effigies of the mythical water serpent. Throughout the performance two kiva priests direct the program and keep the fire, the sole method of lighting the kiva, going by adding greasewood sticks. With the kiva filled to its limit with an audience primarily of women and children, and the groups of energetic performers dancing for many hours, the open-fired and poorly ventilated kiva becomes very warm and the air stifling.

With the conclusion of the *Anktioni*, the Katina season has passed its midpoint. The Hopis now look forward to the warmer weather of spring and the outdoor dances. These will continue until the Niman Dance following the summer solstice.

Chapter 9: Niman or Going Home Ceremony

The Hopi artists' ability to translate the richness of the Going Home Ceremony, the Niman, to a permanent record gives us another dimension that brings us closer to this celebration. We follow the adage, "A picture is worth a thousand words," to enhance our account of the Niman ceremonial through the creative works of several Hopis. To fulfill our understanding of the Niman, the farewell celebration, and obtain a tangible record that would reinforce the memories of seeing the Katsina performances "live," we asked three Hopi artists, each living on a different mesa, to produce a signature piece of art that would leave us with their image of the last Katsina celebration of the year. No other suggestions were made on what was expected in each artist's interpretation of the farewell.

Our selected artists have pictured the Niman as they have experienced it. Their remarkable pieces of art—a painting of the plaza Farewell Dance and kachina carvings—bring us closer to understanding the ritual when their supernatural ancestors close their annual visit to Hopi and return to the mystic peaks beyond Flagstaff. Story writers are advised: write about what you know, Kevin Pochoema and Ronald Honyouti carve what they know and love—the Katsinam. Their carvings are expressions of the totality of their lifelong memories as devoted participants in Hopi celebrations. Neil David's work is inseparable from his Hopi/Tewa culture and religion.

Not surprising, the independent styles and different art forms in the painting by David and kachina sculptures by Honyouti and Pochoema share a remarkable similarity in depicting the spirit of the farewell, and presentation of the elements of ritual importance in their interpretation of the Niman. With the addition of Raymond Naha's (d. 1974) painting of the closing farewell, as he saw it a half-century earlier, we are pleased to present our visual essay and description of the Niman.

In'tiwa has taken no prominent part till now. He sprinkles the visiting dancers. He alone sprinkles. These are the Niman Kachinunuh, just what that means, the gods only know. They go to visit all the kivas [in Walpi] in succession.[1]

–Stephen (1936, 49)

This was Alexander Stephen's reaction when the Katsinam who would dance in the Niman made their introductory appearance during the Soyal ceremony of December 1892.[2] The Hemis were chosen to perform the Niman Katsina celebration scheduled for the following July. After a few rehearsals the Katsina impersonators would visit all the kivas in the village and present a preview performance.

Preparation

Stephen describes the preparations for the Niman ceremony in 1892 as extensive, complex, and continuous for nine days. He shows his frustration in trying to gain a complete picture of the multi-ritual ceremony when a number of rites take place at the same time, in separate locations, and at all hours–day or night. He said, "My God! I wish it was so," when In'tiwa told him "Na'kwibi (Fewkes) knows all this, knows all about Niman because I (In'tiwa) told him and saw him write it down." (Stephen, 1936, 523).

The annual Katsina cycle begins in late November. It begins, one day after the *Wuwutcim*[3] ritual ends, and just before the winter solstice when the Soyal ceremony opens. A lone Katsina appears. He enters the village tottering as an old man and moves feebly towards the kiva responsible for the Soyal. Some say his staggering is due to the long absence or dormant period of the Katsinam who are returning from their home in the San Francisco Mountains. The Soyal Katsina sprinkles sacred meal around the kiva hatchway then hobbles to the plaza, sprinkles meal on the shrine, and slowly walks out of the village. At the closing of the Soyal, the Katsina and Powamu societies begin planning for the summer Niman ceremony.

Niman officers are appointed and assigned responsibilities by the society chiefs. From this time on, the Katsinam appear in increasing numbers in kiva ceremonies and public dances, until a half year later when the Niman ceremony closes the Katsina season. As the last Katsina celebration of the year, it is also known as the Going Home ceremony or Home Dance since the Katsinam will leave Hopi to return to their home on the San Francisco Peaks (*Nuvatikyao* or "Snow Peaks"). The chief of the kiva sponsoring the Niman becomes the Father of the Katsinam for the farewell celebration, and as the Niman chief he sets up the Niman altar. Rehearsals for the Niman are held in the kivas from early spring and continue until the July celebration. An event of traditional importance begins in mid-April. Kept secret from the children, sweet corn is planted in secluded fields before the regular planting season begins. This will be the first corn harvested and will be brought to the Niman Dance by the Katsinam.

The schedule of the Niman is set by the position of the sun at dawn on a predetermined summer day. The village Sun Watcher observes the sun's position from the roof of the Sun House and reports its progression to the village Powamu and Katsina society leaders. After the sun reaches its furthest point in its annual journey to the north (the summer solstice), it begins its return passage towards the winter solstice. The Niman begins several weeks after the summer solstice as the sun rises at a specific landmark coincident with its position in the spring that signaled the time for the first planting. Hopi villages scattered over the three mesas hold separate and independent Niman celebrations. Each settlement determines the starting date of its celebration, and as a result the starting date of each Niman may vary and the Katsina farewell celebrations occur over a several-week span.

On Third Mesa the responsibility for conducting the celebration rotates between the village kivas. Katsina and Powamu chiefs meet with the selected Niman officers to determine the type of Katsina that will perform. At this time the leaders select the performers who will become the Niman Katsinam, the song leaders, and the Fathers of the Katsinam. Titiev (1944, 227) writes of the Niman as it was performed on Third Mesa during the early years of the twentieth century. He noted the choice of types of Katsinam that could be selected to perform was unlimited. On the other hand, in Walpi, the five kivas rotate the honor of conducting the annual ceremony.[4] This fixed rotation and fixed selection of type of Katsina that will perform is unique to the village of Walpi.

Following the announcement by the pueblo's Sun Watcher that the sun has reached the landmark which determines the start of the Niman, the Powamu and Katsina society leaders open the ceremony. The priests and participants begin a period of fasting and abstinence. People are optimistic as they look forward to the harvest season. They are expected to continue living with a good heart and participate in the Niman with pure thoughts to insure the prayers for good crops, health, and good lives are fulfilled.

During the final eight days, traditional rituals, preparation of gifts, and final rehearsals take place in the kivas. The Niman chief is assisted by priests from his kiva in coordinating and conducting daily song practice and prayers, and many families assist in preparing *pahos*. Meanwhile, the men carve dolls and other gifts the Katsinam will distribute in the plaza during the finale. Katsina masks and headdresses are completely rejuvenated, and prayer sticks will be placed at the sacred shrines around the village.

It is the custom for each Katsina personator to renovate and decorate his own mask (Stephen, 1936, 519-521). Paint is scraped off and the scrapings are carefully collected and deposited in a sacred place. The masks and headpieces are then repainted. During this period, clowns and Katsinam, other than those who will dance the Niman, appear in the kivas and outdoor court. The rituals, prayers for rain and singing of songs, continue as part of the Katsina dances preceding the Niman (Stephen, 1936, 500-509).

Several days before the farewell dance a group of young men are sent to gather spruce. Shortly after sunrise on the day of departure, they travel to either the Black Mountains north of the Hopi Mesas to Kishyuba ("Shaded Water") Springs, or to the San Francisco Mountains for evergreens. When the men reach the sacred gathering place, they place prayer sticks at the site and conduct sacred rites. Young spruce trees are cut and will be placed at central shrines in the village plaza for the last ceremony. Choice spruce boughs are collected and will be worn tied to the dance kilts of the Niman Katsinam. Smaller pieces of evergreen are gathered and will be used as collars for the dancers. It is said, if the evergreens are glossy and healthy it is an indication rain will come; if dull, evil is forecast. The men also collect water from the sacred springs in the mountain region. Water-carrying gourds are filled and will be used by the Katsina fathers in sprinkling blessings during the farewell performance.

Throughout the Katsina season, the clowns call attention to behavior not considered proper and beneficial for the Hopi people. Their role is to search out habitual ka-Hopi behaving individuals for public ridicule. Traditionally, no clowns appear at the sacred and reverent Home Dance (Fewkes, 1892, 38). This is not a time for the typical clown reprimand of the spectators for incidents of improper behavior. Respectful behavior is expected at this final and most solemn ceremony.

We all have experienced the multiple rituals and activities associated with holidays. For example at Christmas we celebrate the birth of Christ, and at Thanksgiving we give thanks for bountiful harvests and fruitful life. Aside from the fundamentals of prayers, meditation, and thanks, the giving of gifts and renewing friendships are integral and essential elements of these religious and cultural celebrations. The Niman, with its multiple rituals, is a major celebration by all who respect and accept the concept of the Niman.

With the growing season well underway, the Niman serves to recognize and thank the Katsinam for their support in bringing the field crops from germination to a mature state. The Hopis celebrate the event with intense prayers for late summer rains to produce a plentiful crop. This ceremony must be performed with dedication and careful execution of religious rituals. Natural disasters, disease, poor harvests, and inadequate moisture for growing crops are attributed to deficient performance and lack of pure hearts in both performers and spectators.

The Day of the Dance

Kevin Pochoema's bold one-piece carving of the Yellow Corn Maiden portrays the Katsina at first morning light as she strides towards the village plaza clothed in the finest dress, embroidered robe, and handmade buckskin moccasins. Adorned with silver and turquoise rings and bracelets, she carries gifts of bunched stalks of sweet corn and a Hilili kachina doll tied to a single cattail bloom.[5] Pochoema completes the base of his sculpture with the memorable and emotional end-of-day farewell manifestation of four Katsinam leaving the village descending the timeworn sandstone stairs carved from the mesa wall. Snow Maiden leads the procession and is followed by *Hoho Mana*; both carry their gourd music instruments. Yellow Corn Maiden is next on the trail, and the last is the Hemis—complete with the traditional painted tableta, and decorated with a spruce collar and spruce boughs hanging from his waist. Although each of the kachinas carved in the base are less than three inches tall, Pochoema continues his self-imposed demands carving full figures with accurate and elaborate adornments such as the earrings, turquoise bracelets, finger rings, and the gourd music makers.

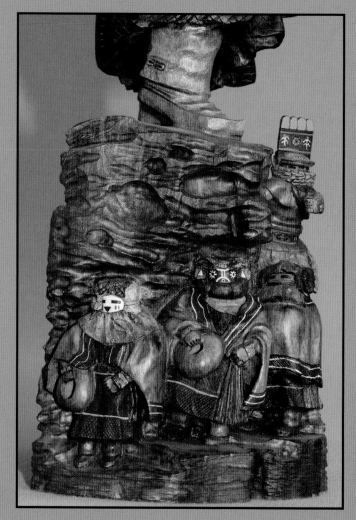

Fig. 9-2: Base carving of *Yellow Corn Maiden*, by Kevin Pochoema

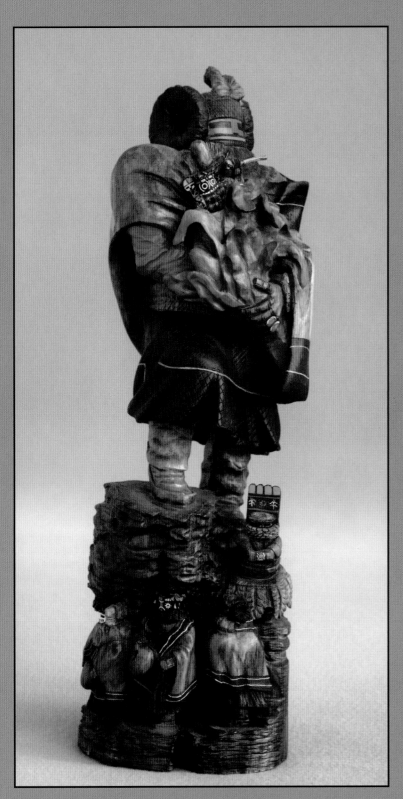

Fig. 9-1: **Yellow Corn Maiden**, *Takursh Mana*, 2002, by Kevin Pochoema, 14" h.

Led by the Powamu chief and the Katsina Father, the Niman performers file into the plaza just after daybreak on the final day of festivities. The Father sprinkles corn meal on the ground making a pathway for the Katsinam to follow. The performers form two columns, one is a line of the Niman Katsina *takas* ("males"), and the other is the Katsina *manas* ("maidens"). Each carry a bundle of the clandestinely grown first-harvest corn plants bearing ears of sweet corn, or fruit from the first harvest of melons and peaches. These new harvests along with handmade gifts that were made secretly in the kivas are distributed during the dance sessions throughout the day. Simply painted, two-dimensional *tihu* (dolls cut from a thin piece of wood) are given to the infants, more detailed carvings to the young girls and brides of the past year. The children may be given moccasins. The boys are given lightning sticks and bows and arrows painted in bright colors. In more recent times gifts of canned goods and store bought items have been distributed to families. In return, the Katsinam are given sacred gifts and blessings.

Stephen's (1936, 569) description of the final day of the ceremony at Walpi in 1891 compares to the Farewell Dance as it is celebrated today. "At sunrise thirty-one kachina came up from the break in the mesa to Walpi and distributed green corn in bunches to the children. To each child they gave a small bundle of corn to which is fastened a "doll" (*tihu*), the flat doll the most common." On this day, the Heheya-aumutaqa ("Heheya-uncle") Katsinas danced along with "six kachina 'maidens', masked, with notched stick fiddles."

Neil David portrays the public performance of the Niman's Katsinam as it has been presented for generations. The stately Hemis, each with a tableta decorated with unique symbols and traditional designs in paint and feathers, form one line. The Katsina manas carrying their music-making instruments decorated with rain cloud designs form the second. David paints the performers during the opening dance with their finest dress in exact detail with fresh vivid colors, from tableta to moccasins. Interspersed in the line of *Hemis Manas* are *Hoho Mana*, *Kutca Mana*,[6] and Hahai Wuhti. A young boy recently initiated into the Katsina society portrays the Blue Corn Boy Katsina leading the group.[7] He carries a sack of parched corn of which he gives a handful to nearby spectators. The white spots on his body represent grains of corn.

At the front of the performers, the Katsina Chief and the Katsina Father direct the dance.[8] In the foreground traditional gifts of pulled corn plants with corn, peaches, first harvest vegetables, *tihu*, and bows and arrows, await distribution by the Katsinam. Villagers dressed in their finest clothes and wearing turquoise and silver jewelry, sit on benches around the periphery of the plaza. Seated together on front-row seats, Hopi maidens wear their hair in the butterfly whorls style. Spectators appear on the upper levels of the pueblo, and tethered eagles observe from their rooftop perches. David's painting provides details rarely found in writing and preserves a celebration few outsiders will see.

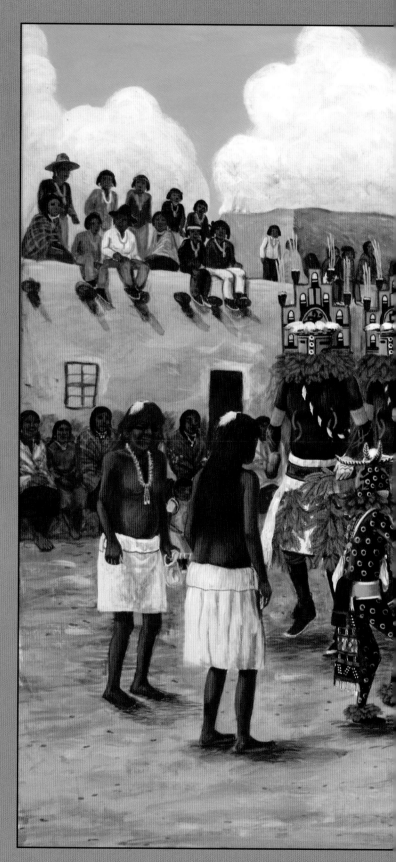

Fig. 9-3: **Home Dance**, 2003, by Neil David, acrylic, 19" x 16"

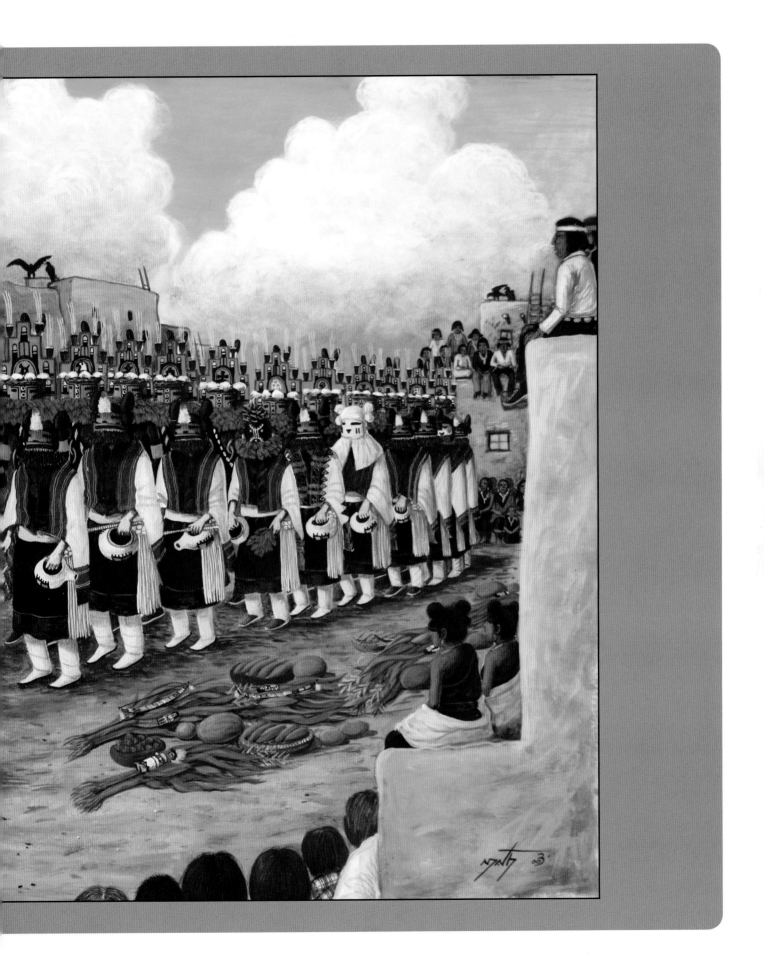

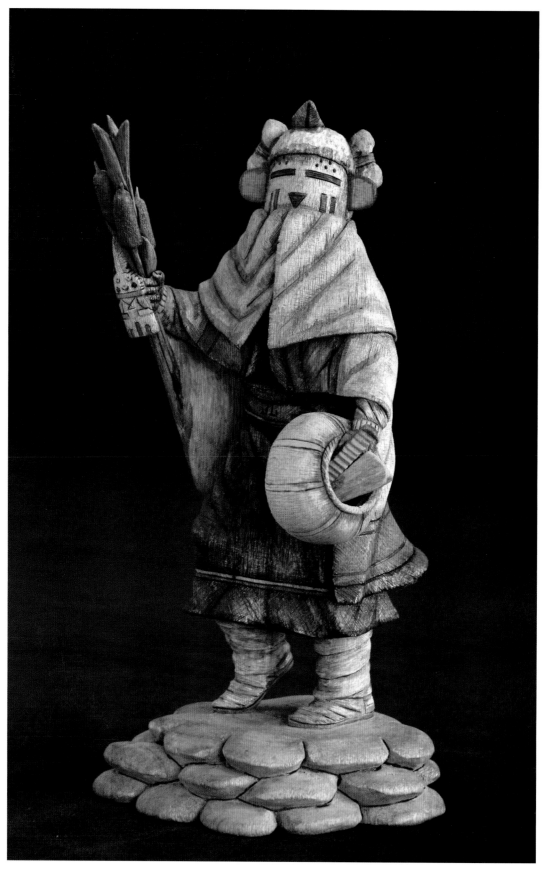

Fig. 9-4: **Snow Maiden**, *Nuvak-chin Mana*, by Ronald Honyouti, 9" h. Snow or White Maiden is carved from a single piece of cottonwood root. Ready for the Niman Dance, she wears a white shawl and white buckskin boots, and carries a gift for a young girl and her resonating music-maker.

Typically six to eight Katsina *manas* will perform dancing in one line next to the Katsina *takas*. Their hair is styled in the Hopi fashion for maidens with squash-blossom type whorls above each ear. At their first appearance of the day they are dressed in their finest clothes, they wear white ceremonial sashes, and they are wrapped in white blankets with brightly colored embroidered borders. During the celebrations of the latter part of the nineteenth century, a time of meager means for the Hopi, Stephen (1936, 534) observed that the female impersonators wore the embroidered cotton blankets only at the sunrise exhibition. For the rest of the day they wore the much less valuable bordered woolen blanket.[9]

Ronald Honyouti's Snow Maiden (Fig. 9-4) is carved as she appears entering the plaza for the final Niman Dance. Dressed in her finest, she brings a gift *tihu*, Hahai Wuhti, attached to a bundle of cattails. This first gift *tihu* is intended for a specific infant girl. Snow Maiden carries the rasp gourd musical instrument in her left hand.

Each maiden carries the traditional Hopi musical instrument—a gourd resonator, a notched stick, and a sheep scapula. As the dance begins, the maidens kneel on animal fur rugs or old blankets and place the gourd on the ground, open side down, pressing on its base with the notched stick. The scapula is brushed against the notched stick in quick strokes setting the rhythm for the dance. As the rasp vibrates the gourd, it produces a resonating sound. The Katsina *takas* dance in vigorous steps in beat with the instrumental background. Turtle shell rattles tied to the knee and handheld gourd rattles contribute to the tempo, while the dancers sing in deep-pitched voices. The maidens sing in falsetto while making the rasping, rainmaking music. In some cases several different Katsina *manas* will appear in the line of performers. These may include *Hemis Mana*, *Nuvak'chin Mana* (Snow Maiden), *Takursh* (Yellow Corn Maiden), *Hoho Mana*, and *Hahai Wuhti*.

The Katsina Father directs the dance and makes sure the performers don't miss a stanza of the song. He guides the movement of the long double line of Katsinam as they move across the plaza, and when the two columns change direction between each song. They sing five verses, and then the two columns move to a new position in the plaza, face a different direction and sing again. The father sprinkles them with corn after they sing the first verse, not after the second; then sprinkles them after the third; skips the fourth and reminds them of their place in the dance sequence as he sprinkles corn during the singing of the fifth verse. He responds to each verse of their song. After moving to a third position and singing, the dancers march out of the plaza to their secluded resting place, a break in the mesa. They will rest in seclusion for about one half hour and then return to dance the next cycle which lasts about 15 to 20 minutes.

The dance will be repeated a number of times throughout the day. The dance pattern remains the same with the Katsina *takas* in one line and the *manas* in the second line. At midday the performers will have a longer rest period for their noon meal, and time to smoke, meditate, and sing in low voices. While they are in retreat and preparing for the afternoon rituals, the spectators are invited to the host village homes to join in feast and festivities.

An important ritual in the Niman is the presentation of the brides. Late in the afternoon on this final day of celebration, the brides of the past year are presented to the Katsinam. The brides wear their wedding apparel and white cotton robes that were woven by the groom's male relatives. This is the last time the wedding clothes are worn until the woman's burial (Eggan, 1950, 56). Standing together, the new brides watch the last dance. The Katsinam will give them gifts of kachina dolls and special blessings for a fruitful life. At the end of the farewell dance, the Katsinam depart, and will not return until the next Soyal ceremony.

Hemis Katsina

Recognized by their striking tableta, the Hemis is the Katsina most often selected and favored to perform in the Niman. Its popularity and frequency in performing has led to the Niman and Hemis Katsina being synonymous. The Hemis, with its prominent headdress, and wearing the Niman's signature mark of spruce boughs around his waist, is one of the more elaborate carvings made by Hopi carvers and eagerly sought by collectors.[10]

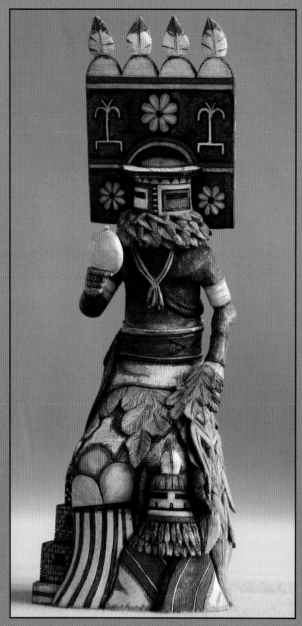

Ronald Honyouti carved this Hemis Katsina with a decorated tableta headdress, a dance rattle in his right hand, and a spruce branch in his left. The base of this one-piece carving presents more of the rich images of the Niman ceremony. Rainbow and rain cloud designs form a background for the high relief base carving of the *Hemis Mana*, and on her left, bundles of the first-picked sweet corn rise through spruce boughs tucked in the Hemis' waistband. The base carvings include three of the flat cradle dolls. The dolls (left to right) *Hahai Wuhti*, *Hano Mana*, and *Palhik Mana* are given as gifts to infant children at six-month intervals. Against the background of the kachina's kilt and sash is a detailed multi-level pueblo dwelling typical of those enclosing the plaza.

Fig. 9-5: **Hemis Kachina,** by Ronald Honyouti, 11 1/2" h.

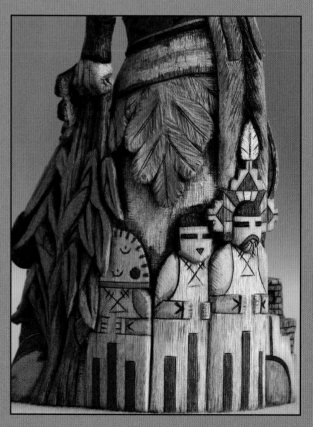

Fig. 9-6: The base carving of Honyouti's Hemis Katsina includes three flat cradle dolls.

The Hemis wears a collar of spruce below his mask. Ten to twelve spruce boughs, fastened around his waist, reach down to nearly touch the ground. In his right hand he carries a painted gourd rattle, and in his left a spruce branch. He wears a feather-topped tableta decorated with a set of symbolic designs that outline a central image of rain clouds,[11] rainbow, lightning, eagle, butterfly, or other figures.

Stephen witnessed the Niman celebrations at Walpi in 1893 when the Hemis Katsina danced. While preparing for the Niman ceremony some First Mesa Hopis of the Horn kiva proposed to present the Zuni Hemis in place of the Hopi Hemis.[12] However the Niman Katsina chief and the Horn kiva chief rejected this proposal since they feared using a borrowed Katsina in a critically dry period would cancel the ceremonial objective to bring moisture and good growing conditions (Stephen, 1936, 520).

Prayers for Rain

People devoutly attend the final public dance. They wear their best clothes and finest jewelry. Young girls wear their hair in the traditional hairdo of the maidens. As with all Hopi Dances, there is no applauding or unnecessary noise. Expectations are fulfilled when the Hopis' prayers for rain are answered. Stephen (1936, 540, 574) wrote of the heavy rain on July 27, 1891, at the closing of the Home Dance. Clouds were drifting over First Mesa all day, and then about 5 P.M. it began to rain. Heavy rain covered all the mesas for some time. At sunset the Katsinam delivered the remainder of the presents. Certainly the farewell celebration was a success. The people had approached the Niman farewell with pure hearts and their prayers were answered. The rain came at an opportune time to assure a good harvest. What more could we ask for?

Rain is a universal need. Some regions are blessed with natural rainfalls and climate conditions like those of the Garden of Eden. Unfortunately, the Hopi people live in an arid land where each year, even with extreme effort, the prospects of growing an adequate crop are marginal at best. For many centuries the Hopis have relied on self-taught ways of dry land farming. Fields are located to catch the runoff water from the rare downpour on the Hopi mesas. Even so, as with most farmers, the Hopi rely on their religious beliefs and prayers for assistance with rain and good weather to bring their crops to harvest. Just one year after the "two hours of real rain" came during the Niman Dance of

1891, Stephen (1936, 543) wrote of July 11, 1892: "Cloudy today and a few drops of rain fell at noon. We have had no rain yet on the mesa, since early in May." Imagine the condition of a cornfield in the Midwest with no rain from early in May until mid July. Chances of even a poor crop and harvest are low. Such thoughts may help in understanding the Hopis' request to the Katsinam to bring rain. Hopi people are pragmatic. If blessed by rain during the Dance, to show respect and sincere thanks to their benefactors for the precious gift, they accept the rain without cover, and they frown on spectators using umbrellas.

Although Hopi villages conduct independent ceremonial dances, they do not exclude visitors or performers from other villages.[13] After the First Mesa celebration during this very dry period in 1892, Stephen (1936, 543) saw a Hemis and Snow Maiden carrying their paraphernalia and masks. Without ceremony, they were walking to Mishongnovi some ten miles away, to participate in the Niman Dance the following day. Other Second and Third Mesa villages also sent couples to perform and give thanks with the Mishongnovi people.

Eagles

The season of the eagles parallels the season of the Katsinam. It opens in early spring when Hopi hunters watch for the right time to remove the young eagles from their nest. The new hatch are collected from carefully marked nesting areas and brought to the Hopi villages. Eagle nesting sites are on clan lands, and are deeded to certain families based on hereditary rights. Hunting regions extend to Canyon Diablo to the south, the San Francisco Mountains and the cliffs of Grand Canyon to the west, and the mountain regions of Black Mesa to the north.[14]

Eagles build their nests into the protective cliff recesses that are accessible by climbers who descend by rope to reach the nests. It is no simple task hanging over the cliff's edge and at the same time catching and carefully tying the young eagles to protect them from injury or, worse, from struggling out of Hopi hands and fluttering down the cliff side. As they are removed from their nest, they are carefully hooded and bagged to prevent injury. If taken too soon, the eagles may not be able to feed themselves, while in a matter of days they are capable of flying from their roost when intruders approach. When collected, the young eagles are over a foot tall, still with patches of yellow hair or

fuzz that still shows between growing feathers. For the long journey to Hopi, they are carefully tied to a wood-frame rack or eagle cradle. Upon reaching the hunter's home, the young birds are treated as newborn children. They are kept indoors until they are named and anointed by using a wash of corn ground from a perfect ear called the Mother Corn. Considered members of the family, the young birds are given a new home, tethered on a house rooftop, and are fed small field game as they grow to full size by midsummer.[15] From their perch, they watch over the Hopi throughout the summer. They will be given gifts—female eagles receive eagle *tihu*, or *Kwa'hü ti'hü*, simply painted flat dolls, and male eagles are given bows and arrows. Stephen (1936, 540) observed bows and arrows and *tihu* were hung at the eagles perch until the final sacred ritual when the eagles are sacrificed and their spirit will travel with the Katsinam to their home. The traditional ritual of the eagles is completed at the closing of the Niman.

In nearly all the principal ceremonies the eagles are remembered by prayer offerings, prepared for them by the priests. These consist usually of small eagle or hawk feathers, tied to a twisted cotton string, about four inches long, and are called nakwakwosis. These nakwakwosis are handed to those priests who are part owners in an eagle allotment, and who deposit them with some sacred meal in shrines, devoted to the eagles.

On the day after the great Niman (Farewell) Katcina in July all the eagles in the village, except here and there one that is not fully-grown, are killed. The killing is done about 8 or 9 o'clock in the morning. While one person holds the rope, another throws a blanket over the eagle and carries him down from the roof, choking him while he descends. No eagle is killed by any other method. When life is extinct the feathers are plucked and sorted.... Nakwakwosis are then tied to the wings and legs of the carcass "that the eagles should not be angry but hatch young eagles again next year." During this time...a small flat doll

and a few rolls of blue piki are prepared. The eagle bodies are then taken to a special burial site where the eagles are buried with their gifts.

–Voth (1905, 107-108)

Plucked eagle feathers and down are sacred and are carefully preserved for use in religious celebrations, in the making of prayer sticks, on sacred paraphernalia, and on Katsina masks and headdresses.

The Farewell

At the end of the last dance and in response to the Katsina songs, each year the Katsina Father recites a formal farewell speech containing the same basic thoughts.[16] "We have had a good dance today. The sky darkens and sunset is near, now you must return to your home." He asks the Katsinam to tell their families to help bring rain to the Hopi fields to make the crops grow as the rain is needed to produce good crops and adequate food for the winter. If the season has been exceptionally dry, the request is more urgent and the need for rain is crucial for crop survival. In any case, the priests remind the Katsinam not to forget to bring rain and return soon, and then they are given gifts of prayer feathers.

In the final ritual, the spectators pluck the spruce boughs from the waistbands of the dancers. These will be planted in the fields as a continuation of the prayers for a good harvest (Simmons, 1942, 140). After a final blessing, the audience remains silently in place while the Katsinam leave the plaza to return to their spiritual home in the San Francisco Mountains. It is a sad feeling to see them go. It will be a long time before they come again.

Titiev notes Fewkes' observation of the relation of the Katsinam to the living and the dead. When a Hopi dies, he is changed into a Katsina, or Cloud spirit (*Omauüh*) another form of the Katsina (Titiev, 1944, 108; Stephen, 1936, 826). The "breath-body" or essence of the dead is represented by the Katsinam when they come from their home on the San Francisco Mountains to visit the Hopi. "...the eagle is sacrificed that its breath may mount to Cloud with the Hopi prayers for rain; that its breath-body may return to its real home." (Stephen, 1936, 568).

Visiting the Hopi mesas and seeing the ever-present dynamic cloud formations hovering

Raymond Naha's painting depicts the late afternoon closing ceremony of the Niman. At the end of the final dance, Katsinam distribute the remaining gifts. A Hemis presents a bundle of corn and an arrow to a young Hopi lad, a second Hemis gives a collection of cattails and a bow to a youngster sitting on the rooftop, and the *Hemis Mana* bears the last gift including a *tihu*. As dusk approaches, solemn spectators linger on rooftops memorizing the Katsinam farewell knowing they will not return until the next year.

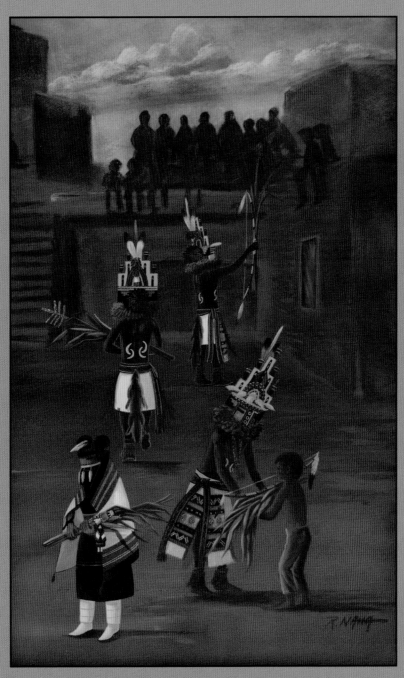

Fig. 9-7: **Closing of the Niman**, casein on board, Raymond Naha, 19" x 31"

over the San Francisco Mountains, we can begin to understand the powerful relationship between the Hopis and their spirit ancestors. It is an exhilarating experience standing on the mesa summit and seeing the snow tipped peaks, over fifty miles distant, and visualizing them as the legendary home of the Katsinam. The silence, interrupted only by gusts of wind reverberating between the pueblos' walls sound like inspirational voices of the Hopis' spirit beings.

A century after Don Talaye'sva summed up the farewell celebration, his words remain fitting for the Niman: "In July I was happy to bring a few sweet corn stalks into the village for the Niman dance. I made dolls and tied them to cattail stems.... We feasted and danced all day and presented sweet corn, dolls and other gifts to the children." (Simmons, 1942, 232). At days end, with final prayers for rain, the Katsinam were sent home.

All too soon, the final somber moment arrives, and the Katsinam wend their way from the village. Memories of these old friends must last until next year. The end of a perfect day brings added hope that prayers for rain will be answered. Each spectator in his own way now strains his senses, listens for sudden wind gusts or rumblings of thunder as forerunners of rain, or looks to the sky hopefully for a hint of rain clouds to darken the sky, or watches for the first drops of moisture bouncing off the dust-covered courtyard floor to find fulfillment of the communal prayers.

With their departure, the Hopi calendar opens to a new phase. The Katsina time has come to an end but other sacred rituals will abound until the new season of the Katsinam. As the Niman concludes, the ceremonial calendar continues with meetings between the Powamu chief and Snake chief and the planning of the Snake ceremony takes center stage. Fewkes (1894, 273) determined the astonishing Snake Dance takes place on alternate years in several of the villages of Tusayan. This world-recognized ritual typically starts about four days after the Niman ends. Important considerations to keep in mind when setting the final schedule include, the position of the sun weighed against the immediate need for rain in a period of drought. However, if the start of the rituals is advanced, and the Snake-Antelope ceremony starts too soon, an early freeze could jeopardize the crops.

As memories of the Niman celebration fade, the fortunate will see the Katsinam return with the turning of the sun following the winter solstice. A few outsiders will be privileged spectators at the new year's ceremonies. For the rest, we shall rely on the images of the Niman preserved by Hopi artists to rekindle our memories of the Katsina celebration.

Chapter 10: Deity, Katsina, and *Tihu*

Early ethnologists were overwhelmed with the many different Katsinam they observed during the almost continuous cerebrations and dances of the Hopi people. Even today the Hopi population remains relatively small and yet the Katsina dances and their Katsina spirit beings are widely known and studied. The seed of interest in the Katsina cult was planted in the mid-eighteenth century with the first rumored word of the mesa dwellers that had a revolting religious ceremony, the Snake Dance. After hearing of the rattlesnake dance performed by a remote tribe in the Arizona Territory, Lt. John C. Bourke, an Army officer on special assignment to study the Pueblo ceremonials, was determined to become the first white man to record an accurate and truthful account of this heathen rite first hand. He hoped to present a truthful and instructive "narrative of incidents which may serve to entertain and amuse, if they do not instruct, those into whose hands this book may fall." He was completely unaware of the impact his vivid report would have. Since it was published in 1884, well over a thousand articles, journals, and books have been written about this pueblo tribe, not only of their Snake Dance, but also their complex religious ceremonies, and their enigmatic and colorful Katsina dancers and sacred deities.

To the outsider fortunate to visit Hopi and see a Katsina dance, the relationship between the various performers may appear chaotic. Fortunately, the Hopis remain willing to teach interested outsiders about the Katsina, their performances, and the part the Katsinam play in Hopi history. However, they also continue to keep secret many aspects of the Katsina dramas and rituals. Since the opportunity to observe the Katsinam and their performance is limited, and photographing it is prohibited, museum collections, publications as well as kachina carvings and paintings remain the fundamental resource for study of the Katsina cult. Comparing available information on a specific Katsina's role may show a contradiction, but differences in function and appearance are generally resolved as regional variations.

Adding to the complexity in identifying the Katsinam, scholars soon found the Hopi religion includes two sets of sacred spirit beings, the Katsinam and the Hopi deities. Fewkes (1897, 253) was concerned with the use of the words "gods," "deities," and "worship" when writing of the Hopi religion, and said, "We undoubtedly endow the subject with conceptions which do not exist in the Indian mind, but spring from philosophic ideas resulting from our higher culture." With an admitted lack of understanding and tolerance of foreign religions, Fewkes applied these words to explain the Katsina ceremonies and the Katsina cult: for "gods" and "deities" he suggests the more cumbersome term "supernatural beings" is more expressive, and the word "spirit" more convenient, "except from the fact that it likewise has come to have a definite meaning unknown to the primitive mind."

Colton's definitive *Hopi Kachina Dolls* catalogs 266 kachina dolls. It is a much easier task to describe and document the details of dress and produce the line drawings of the face of a doll representing the Katsina, than to try to memorize the fleeting images of a multitude of Katsina performers as they appear in a spirited plaza dance or the dim light of a kiva. Recording images of the Katsinam had been prohibited since the early part of the twentieth century, long before Colton published his book. Aware that conservative Hopis have been opposed to any form of recording their Katsinam, writers found it appropriate to explain the decorative dress and details as seen in the carved dolls rather than risk the chance they might disclose secrets of the Katsinam and sacred rituals of their society. Long-standing edicts of the conservative Hopis to preserve the secrecy of the Katsina society by prohibiting the recording and photographing of Katsina dances were respected and followed. To

this day, internal struggles continue between the conservative Hopis, who want the Hopi culture and religion to remain private, and the liberal faction, which seeks openness of the Hopi world. At this time, attendance at public ceremonies in the eleven Hopi villages is in a state of flux; the ceremonies, for the most part, are closed to non-Native Americans. Supporting this conservative stance, we find most Hopi carvers will not carve certain dolls that are of sacred importance, and Hopi deities are rarely carved.

Colton (1959, 77-86) compared the Hopi religion in part to that of the ancient Greeks because of its many gods. The Hopis recognize more than thirty deities, and Colton lists thirty six that "certain" Hopis consider deities, not Katsinam. Our text has introduced several deities including the *Palulukonti* ("Plumed Water Serpent") and *Pyüükonhoya* and *Palüñahoya* ("Twin War Gods"). Two other gods Maasaw, and *Tawa*, ("Sun God") are noted and the Katsinam that bear the same names are pictured and their role is described.

Maasaw, Deity and Katsina

Of the Hopi deities, Maasaw is the most important (Malotki, 1987, 3). He is known as the god of death, ruler of the underworld, and creator of all things. Some call him Skeleton Man. Although feared by the people, who generally describe him as an ugly monster, he is a friendly and benevolent deity to the people who agree to accept his simple way of life. His appearance and role are best understood by reviewing some of the stories of his encounters with the people.

Voth (1905, 11-13) wrote of the Hopis' first meeting with Maasaw as told by Lomavantiwa of Shipaulovi. When the people left the Third World, the leaders' plan was to leave the evil and wicked ways behind. Unfortunately, witches, or two hearts, also entered the upper world at the time of emergence. The people emerged from the underworld through the *sipapu*, into the Fourth World. There was no sunshine, and without fire it was cold and dark. For a while they lived close to their entry into the new world. The people looked for firewood, but in the darkness they found none. Then a flickering light was seen. The chief sent a young man to seek the source of light, but he failed to locate it. A second explorer was sent. He was successful and found a field of corn, squash, and beans surrounded by a series of wood fires, which provided light and kept the plants warm for growth.

A handsome young man sat by the fire. "By his side was standing his friend (a mask) which looked very ugly, with large open eye holes and a large mouth. So it was Skeleton (Másauwuu)...." Maasaw asked the messenger who he was and where he came from. He told Maasaw they came from below, and here the people were cold and without fire. Maasaw directed the young man to bring his people to him. The people came and Skeleton gave them food. The field was small but they always had food, it was never gone. The people remained there and in time planted their own crops.

Tales of the first meeting with Maasaw as recorded by Malotki (1987, 49-50) and Nequatewa (1967, 24-26) describe him not as a handsome man, but as a terrifying giant with a large hairless head covered with blood. On first sight of the monstrous being, as he turned from the fire to respond to their call, the visitors suffered brief paralysis. On recovery they presented Maasaw with gifts of *pahos*. He was pleased with the prayer offerings, and said he was waiting for the arrival of the people and, as owner of this land, welcomed the people to his world. Upon meeting with the leaders of the people, he told them he was their god, god of the Upper World, and god of death and life. Their god said, "I roam and look after the land into its farthest reaches.... I'm no evil being, however, I'm simply keeper of death. This means that anyone who dies with a pure heart will come to me" Malotki (1967, 12).

In kiva conversations with various Hopis, Stephen learned Maasaw, the guardian deity, occupies the thoughts of the people. The land of the *Hopitu* ("the peaceful people") was his land originally. In *Hopi Tales*, Stephen wrote, "He made trees grow gnarly and crooked and twists men's faces into ridiculous shapes so he could laugh at them." He plays many roles including a trickster and a liar, and he is very jealous and a persistent practical joker. "Today, however, Maasaw comes to us in the daytime and shows us by his pantomime how he used to treat his enemies and teaches us that he would treat us in the same way if we grew lazy and refused to plant his corn." (Stephen, 1929, 55-57).

Maasaw appears in ceremonies where he, as the god of germination, is central. Malotki (1987, 129-130) reminds the reader, impersonators of Maasaw, who wears tattered woman's dress, must not be confused with the related Maasaw Katsina.

Maasaw Katsina is known as a funny Katsina, almost a clown. In the outdoor performances they may appear as a group of dancers in a spontaneous

Fig. 10-1: **Maasaw kachina**, *Masauû*, 1997, by Horace Kayquoptewa, 10" h. The carving depicts Maasaw kachina dressed in rabbit skins, an embroidered shawl, and Hopi sash. His helmet is painted with red, turquoise, and white spots, and he has cylindrical ringed eyes and mouth with protruding teeth. He carries a bundle of piki bread.

dance. They give gifts to the spectators, and in some cases the performers may receive gifts of food from the people. In return, the Maasaw will cut wood for the women who give them gifts. Maasaw is the only type of Katsina that remains in Hopiland beyond the Katsina season.

Maasaw characteristically does things the opposite of what is expected; for example, they enter the plaza from the direction opposite the traditional entrance. In November, 1933, after the Katsina season ended, Mischa Titiev (1944, 236-388) observed the Maasaw performance in Hotevilla. Their performance followed the pattern of the Hemis Katsina where the male performers formed one line, and a smaller number of the *Maasaw*

Mana formed the second dance line. After a break in their dance rounds, they returned to the plaza but instead of bringing the traditional gifts they brought cooked foods and Hopi delicacies for the spectators. They concluded their performance with a comic pantomime routine. After the afternoon rest period they continued their burlesque routines, mimicking other Katsina dances, and at a break period imitated the stereotyped clown act of eating in excess.

Each Maasaw wore a dance kilt draped around his neck, a rabbit skin robe, and a fox pelt hung at his back from the waist. Several twigs tipped with feathers were fastened to the top of their masks. Red, blue-green, and white circles were painted on the face helmet. Their eyes were circled in cornhusks and painted black with narrow slits for vision, and three oversized teeth protruded from a mouth which was formed with cornhusks shaped in a ring.

Tawa, Deity and Katsina

Tawa, the Sun God, travels across the sky each day. His followers ask for his aid in keeping the Hopi course straight or "Keep the Ways." When he is impersonated his headdress is of white eagle feathers (Colton, 1959, D6).

Colton (1959, #146) describes *Tawa* Katsina with a disc mask made of woven yucca leaves completely surrounded by eagle feathers. *Tawa* represents the spirit of the Sun God. He does not have a major role in public dances, and his ritual role is kept in confidence. *Tawa*, the Sun, is one of the chief Katsinam. His image appears on pottery dating to as early as the fourteenth century.

Fewkes (1903, 100) describes him with a ring of red horsehair between the eagle-feathers circled around his basket mask. This Katsina is frequently carved and its striking appearance makes it a favorite among collectors.

Fig. 10-3: *Tawa*, 1974, by Clifford Bahnimptewa, 14 1/4" x 19 1/2". Bahnimptewa's collection of 237 paintings has become a primary reference for Hopi kachina doll carvers and collectors of Hopi kachinas (Wright, 1973).

Fig. 10-4: **Hahai Wuhti**, a flat cradle doll, a simple image of the Katsina Mother, is given to infant girls as a first Katsina gift.

Fig. 10-2: **Sun kachina**, *Tawa*, by Lester Quanimptewa, 13 3/4" h. Tawa's mask represents the sun's disk and is surrounded by rays of feathers. He carries the Hopi flute in his left hand.

Tithu

The first *tithu* presented to Hopi infants are simple, two-dimensional carvings. They are given by the Katsinam during the Katsina celebrations to infants less than one year old. Base carvings on Ronald Honyouti's Sio Hemis Katsina, as he appears in the Niman ceremony, (Fig. 9-6) include three *tithu* favored as the first sequence given to the infant. Each year thereafter the young girls are presented with different *tithu* carved in greater detail. These gifts are not intended as toys, but are respected and carefully displayed in the home.

The Spanish intruders saw *tithu* hung from the walls and rafters of pueblo homes, and disbelieving, doubting Christian missionaries had a strong bias against the possession of these figurines. They believed they were used in a form of devil worship. As time went on and outsiders began to understand the relationship between the people and their Katsinam, they sought examples of these figurines.[1] These dolls are highly collectible, and with the interest and increased demand in the last half-century, Hopi carvers have refined their carvings and raised kachina carving to an art. At the same time, some have created some of their finest work as *tithu* for their daughters, and not as saleable pieces of art.

Borrowed Katsinam

A number of the spirit beings seen in Hopi ceremonies have been referred to as borrowed since they first appeared at Zuni or the Eastern Pueblo villages. For example, plates 19-33 in *Kachinas in the Pueblo World* (Schaafsma, 1974) show the variations in the Long-haired Katsina (Angak´china) in a set of drawings of similar spirit beings from pueblos of Santa Ana, San Felipe, Zia, Cochiti, and Zuni. Borrowing and adapting a Katsina from a neighboring pueblo may have occurred so long ago the origin is lost or forgotten.

Other Hopi Katsinam and clowns are identified with neighboring tribes who have close ties with the Hopis through trade and marriage. Among them are the Supai relatives, Navajo relatives, and Navajo clowns.

In some cases a borrowed Katsina retains a distinct name. At Hopi the Hemis and the Sio Hemis (borrowed from Zuni) are distinct performers in Katsina ceremonies (Wright, 1973, 214, 218).

Sio Salako is a Hopi Katsina also borrowed from Zuni who appears at Hopi infrequently,

averaging an appearance once in a generation. The Zuni Shalako (Fig. 10-5) differs from the Hopis' Sio Salako in Neil David's painting (Fig. 11-2). The most obvious difference is that Sio Salako wears an array of feathers appearing as a skirt. Several examples of Zuni *Koko* (*Koko* is the Zuni spirit being or performer the Hopis call Katsina) are included here for comparison.

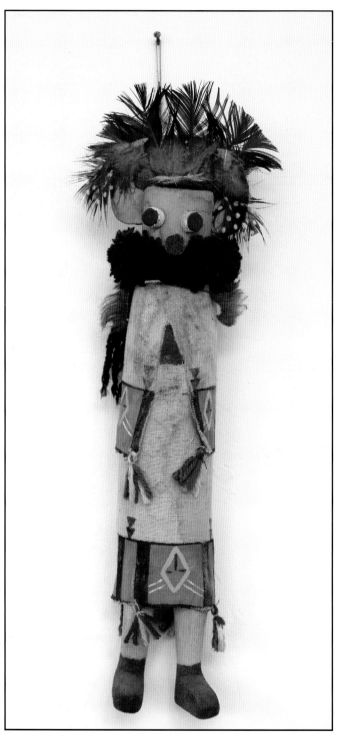

Fig. 10-5: **Zuni Shalako (*Ca'lako*)**, c. 1950, 15" h. This is a Zuni carving of the Zuni Katsina. It is decorated with cloth, fur, and feathers.

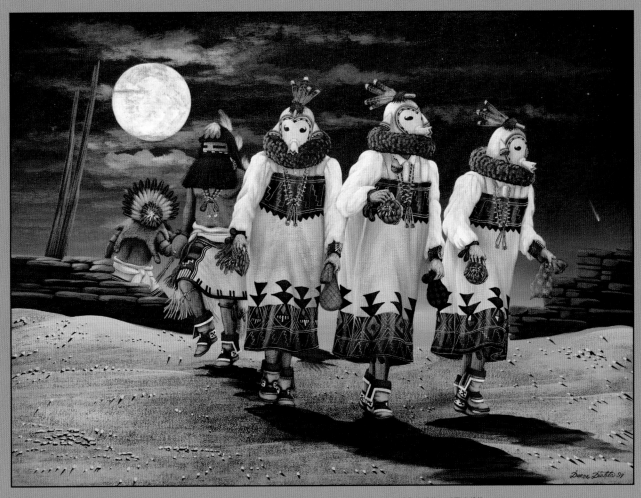

Fig. 10-6: *Appearance of the Käna'kwe*, Zuni Katsinam, by Duane Dishta, acrylic, 23 1/2" x 17 1/2"

Zuni artist Duane Dishta's painting of Zuni Katsinam includes the Zuni Kokkoshi (Long-haired) who resembles the Hopis' Long-haired Katsina. He walks with three Käna'kwe Moson (chief). Käna'kwe are distinctly Zuni and not part of the Hopis' Katsina cult. They are striking in appearance, richly dressed with eyes like tadpoles and rainbow design fringing the face. They wear embroidered blankets over native cloth shirts. Turtle shell rattles are carried in the right hand, and a bag of sacred seeds in the left. Käna'kwe come only once every four years and stay for just one day. The elegantly dressed Käna'kwe has not been noted in Hopi ceremonies.

Because of close relations with neighboring tribes through trade as well as warfare, the Hopis have created a number of Katsinam that bear tribal names and have some characteristic or link related to historical or legendary events. Among the tribes so linked to the Hopis are the Apache, Comanche, and Havasupai.

Comanche Indians came from Wyoming and moved into the Southern Plains during the seventeenth century. Well-known as fierce warriors, they lived in Oklahoma and Texas and attended the trade markets in Santa Fe and Taos where they traded horses, weapons, and goods gained from their raids on neighboring villages. Comanche battles were terminated in counting coup (touching an opponent in battle without physically harming him). The Hopis' Comanche Katsina was derived from the legends of the Comanche warriors, and the Hopis' Comanche Dance was adapted from Comanche ceremonies and related dances the Hopis witnessed in the eastern pueblos.

In late May 2011, the Hopis of First Mesa held a Comanche Dance. Neil David's painting *Comanche Dance* captures the vigorous dance performed by the Hopis' Comanche Katsinam. Tewa clowns form a ring around the dancers, singing in response and blessing them with sacred corn meal. Directing the dancers, the Katsina Father is pictured behind the second and third Comanche dancers. Three Koshari circle the Katsinam, sprinkling them with sacred corn meal. The warriors are led by the Comanche Katsina dressed with his ceremonial war bonnet. Two of the dancers are pictured carrying woven replicas of war shields in their left hand; the first Katsina in line has his shield strapped to his left hip.

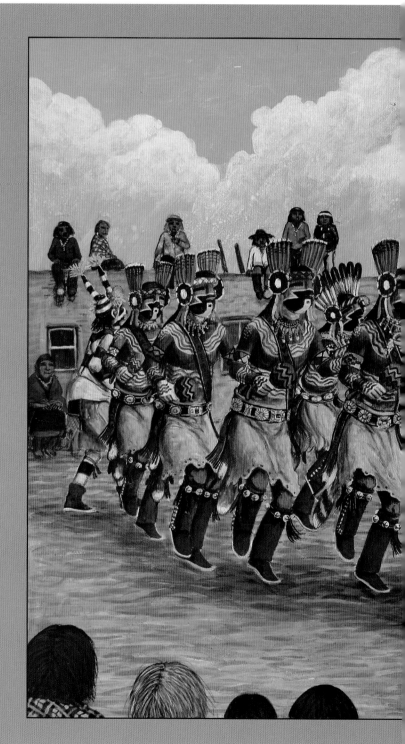

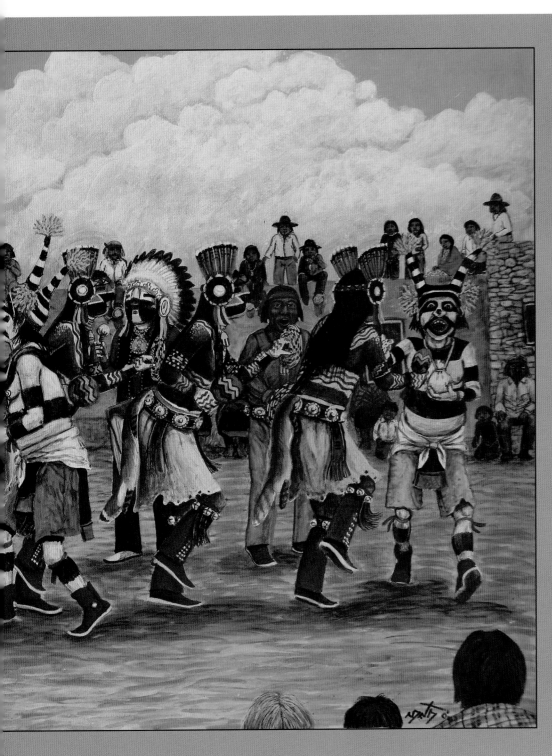

Fig. 10-7: *Comanche Dance*, 2011, by Neil David, acrylic, 21" x 15"

How Many Katsinam Are There?

The total count of Katsinam[2] is estimated at more than four hundred. Because of their function and role, a large number appear in multiple ceremonies. Others are rarely seen while some are believed extinct. As the Katsina year progresses, the number and variety of Katsinam seen in public festivities increases with the greatest number and variety appearing during the March moon when the kiva Night Dances and plaza dances take place. Neil David's painting, *Changing Kivas for the Night Dance* (Fig. 8-4), shows the range in numbers with thirteen different Katsinam in the group waiting to enter the kiva. In contrast, except for their leader, the dancers leaving the kiva are all Corn Katsinam.

A sampling of photographs of kachina carvings and the popular Warrior Mouse are presented in closing this chapter.[3] Browsing through this set of photographs we might imagine a visit to a Hopi village at the time of a village walk-around when a mixed array of Katsinam is the central attraction. The variety of Katsinam may include a number of human counterparts: chiefs or leaders, warriors, guards, and clowns; and non-human forms representing insects, animals, birds, and plants.

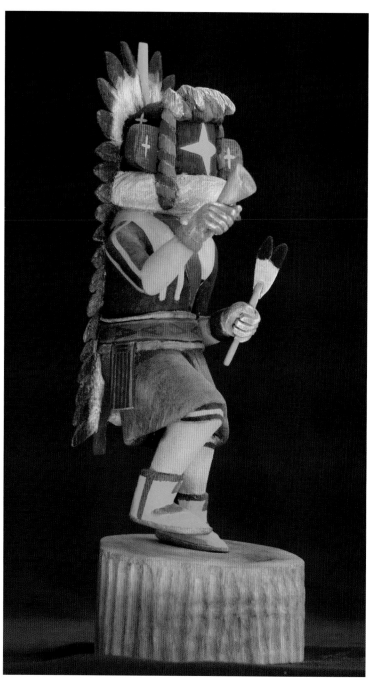

Fig. 10-8: **Chasing Star kachina**, *Na-ngasohu*, by Rod Phillips. 11"h.

The Cactus Katsina is an older Katsina who appears in mixed dances. The carved headdress on this doll is the cactus plant with pear-shaped edible fruit. Yunya is included in Fewkes' codex of all known Katsinam, published in 1903. He wears elaborate armlets of yarn and feathers and has a feather-tipped rod in his left hand and a yucca whip in his right. A crescent moon and stars are painted on the white mask.

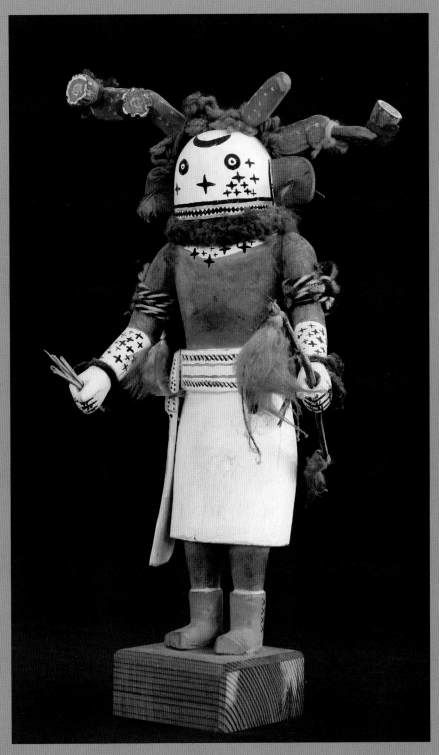

Fig. 10-9: **Prickly Pear Cactus kachina**, *Yunya*, c.1950 ,15 1/2 " h.

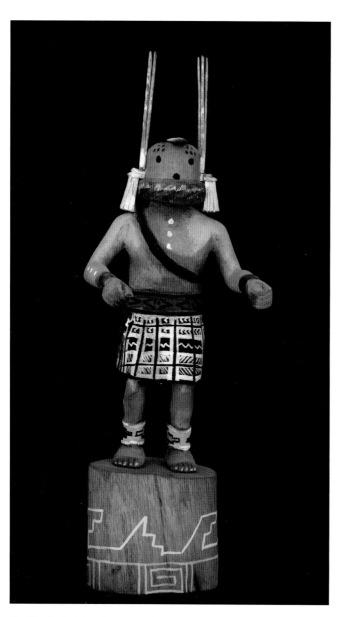

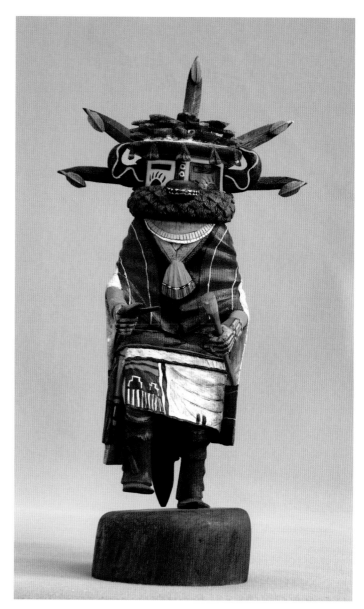

Fig. 10-10: **Cricket kachina,** *Susopa,* by Rod Phillips from Oraibi, 10" h. Cricket appears with yucca fronds rising from his head as insect antennae. His kilt is carved and painted as the traditional cloth of a wearing blanket.

Fig. 10-11: **Badger kachina,** *Honan,* by Leander Tenakhongva (from First Mesa), 13" h. Badger claw prints are painted on his cheeks.

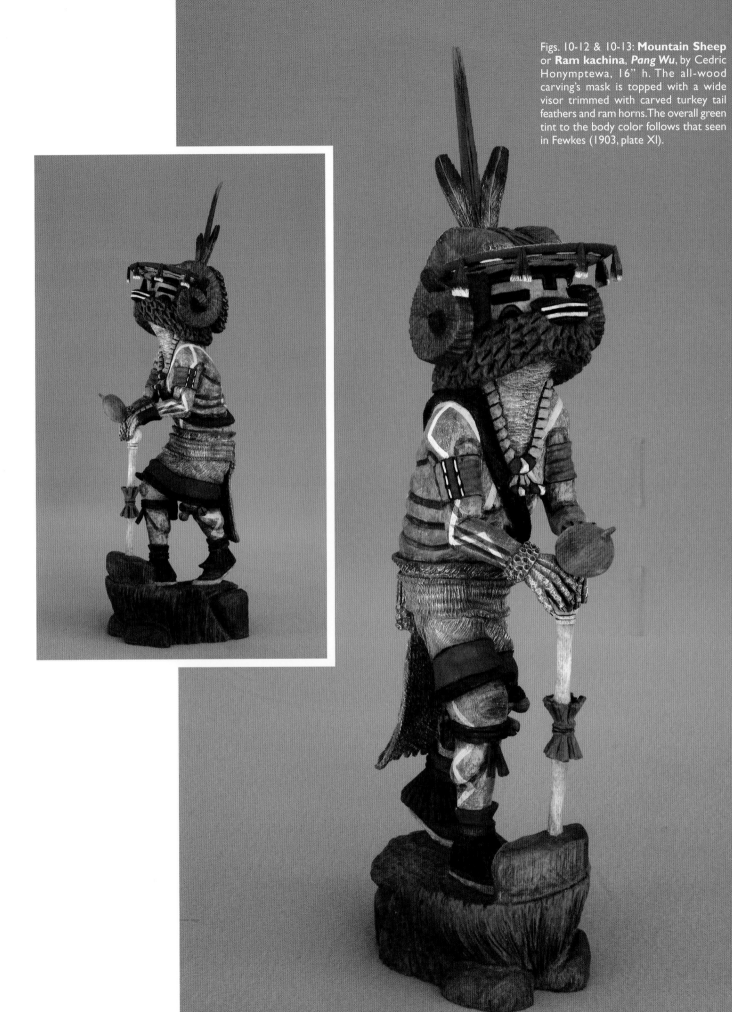

Figs. 10-12 & 10-13: **Mountain Sheep** or **Ram kachina**, *Pang Wu*, by Cedric Honymptewa, 16" h. The all-wood carving's mask is topped with a wide visor trimmed with carved turkey tail feathers and ram horns. The overall green tint to the body color follows that seen in Fewkes (1903, plate XI).

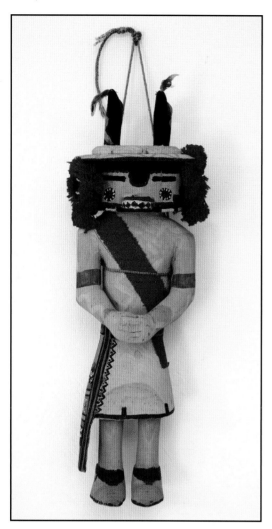

Fig. 10-14: **Antelope kachina**, *Chof or Tcüb*, c. 1940, 13 1/2" h. This carving is meant to be hung from a wall.

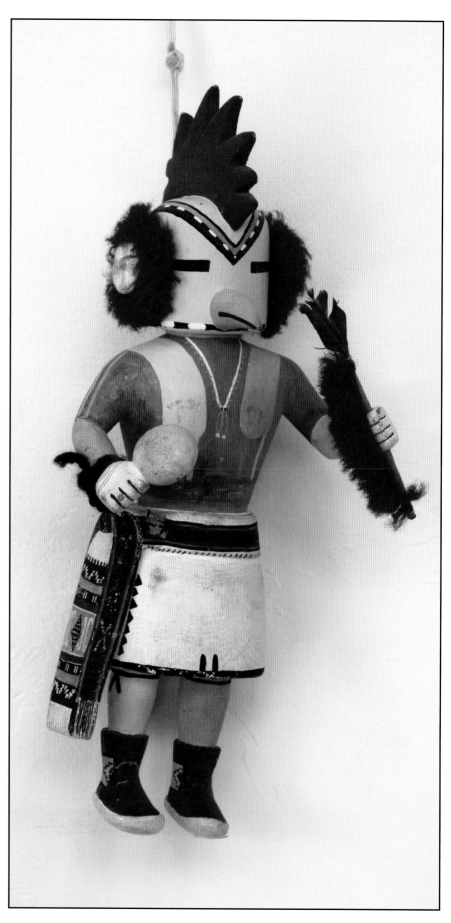

Fig. 10-15: **Rooster kachina**, *Kowaku*, c. 1950, 12 1/2" h. This is a newer Katsina whose appearance followed the introduction of chickens to the Americas by the Spanish.

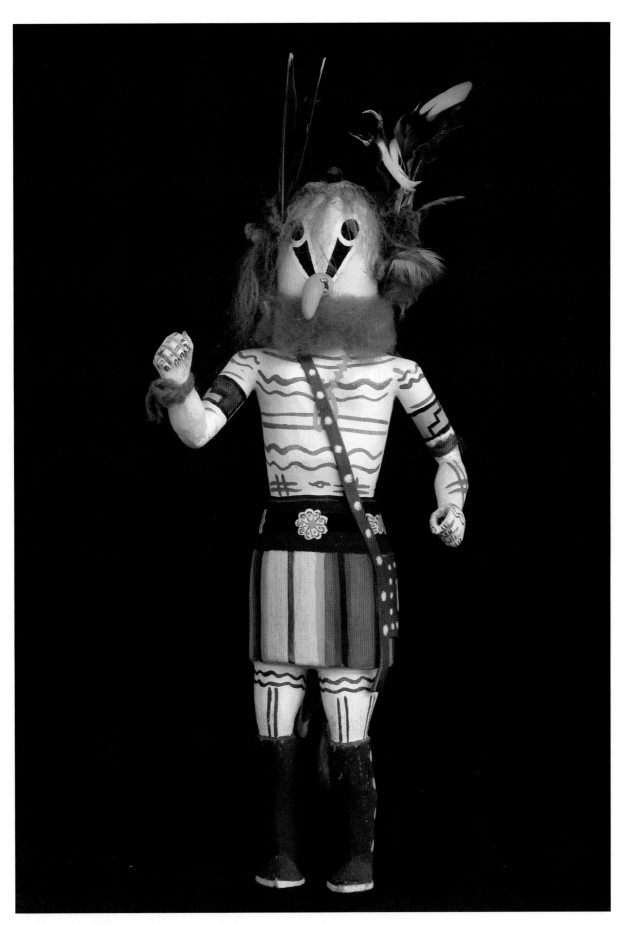

Fig. 10-16: **Small River kachina,** *Tunei-nili*, 12" h. The colorful Tunei-nili is of Navajo origin and first appeared in Hopi performances in the late twentieth century.

Hilili is a popular performer as a whipper, or guard. He appears during the Powamu ceremony and the Night Dances and carries yucca whips in both hands. His elaborate mask is decorated with an arrow pointed with a sun and trimmed with feathers. His name is based on the call and sounds he makes during his lively dance. Fewkes noted this dynamic Katsina dancer wears a horsehair beard. He speculated, the rattling sound from the band of small tin cones tied below each knee probably led to his name: *Helilülü*.

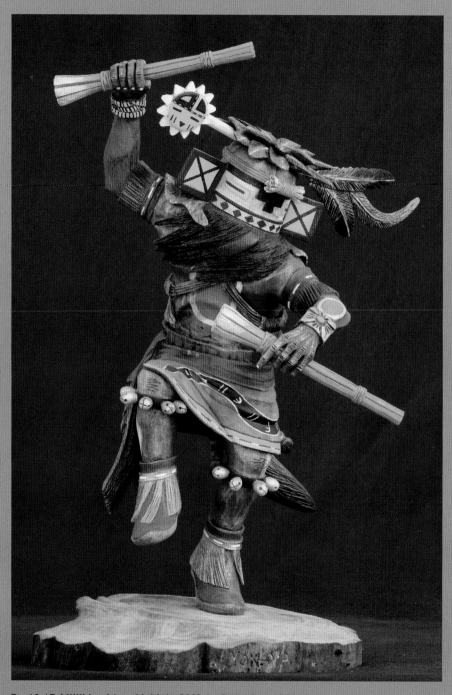

Fig. 10-17: **Hilili kachina**, *Helilülü*, 2002, by David Roy, 15" h.

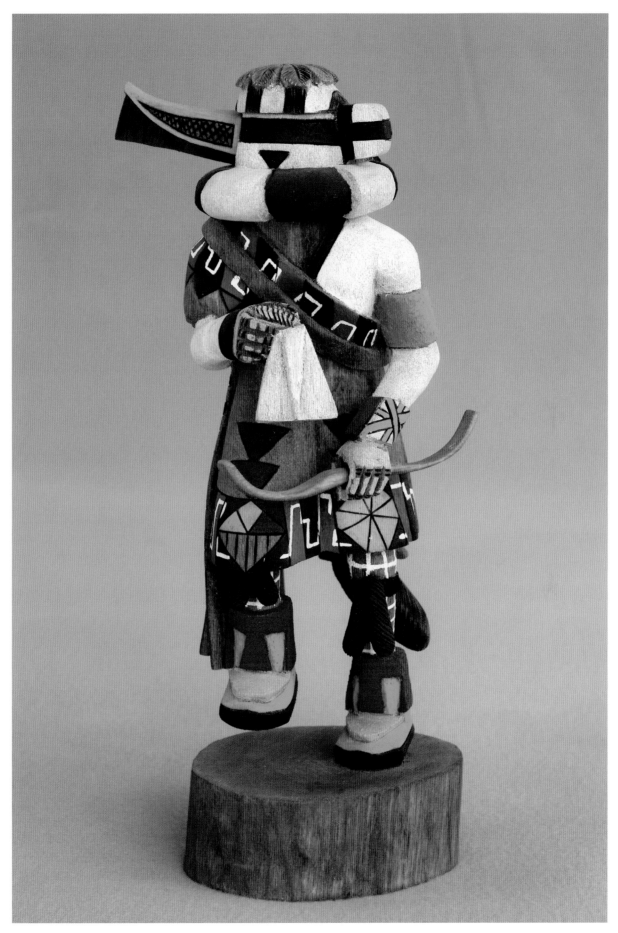

Fig. 10-18: **Rain Priest kachina**, *Sai-astasana* or *Hututu*, by Carlton Timms, 9" h. Sai-astasana appears in late winter in the mixed dances where his calls sound like Hututu. Fewkes makes a distinction between Sai-astasana and Hututu: Sai-astasana wears a woman's white blanket and Hututu wears an antelope skin (1903 plates II and III).

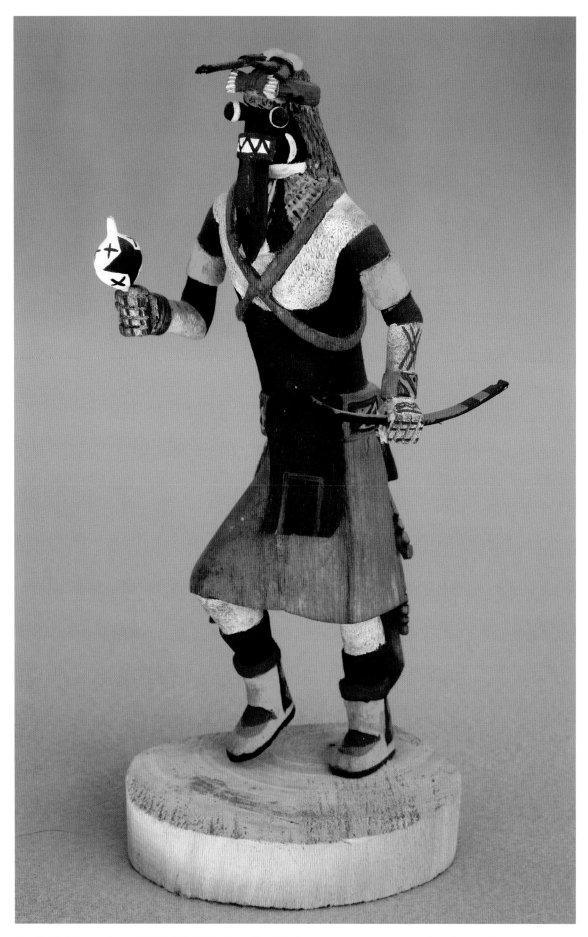

Fig. 10-19: **Chakwaina**, c1990, 7 3/4" h. This First Mesa Katsina warrior appears in the night dances. He is among the Katsinam waiting to enter the kiva in Neil David's *Changing Kivas for the Night Dance* (Fig. 8-4).

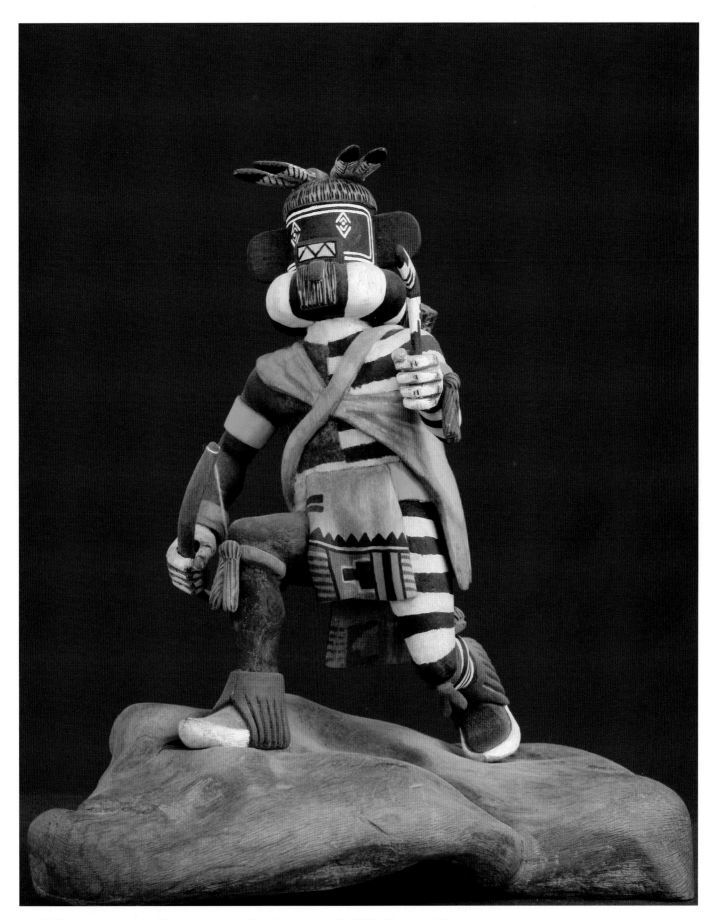

Fig. 10-20: **Left–handed kachina, *Suy-ang-e-vif*,** by Gary Shupla, 11 1/2" h. *Suy-ang-e-vif* is a hunter and warrior, he is carved with a bow and quiver of arrows and carries the Hopi rabbit stick. He works and performs as a left-handed person.

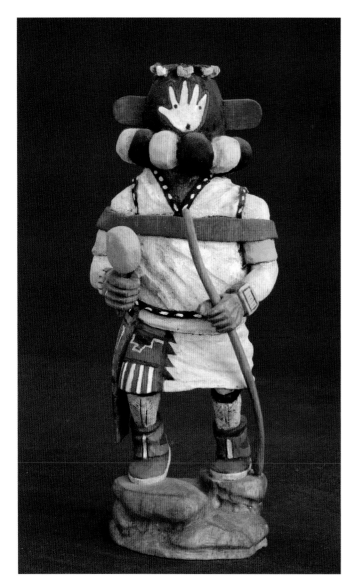

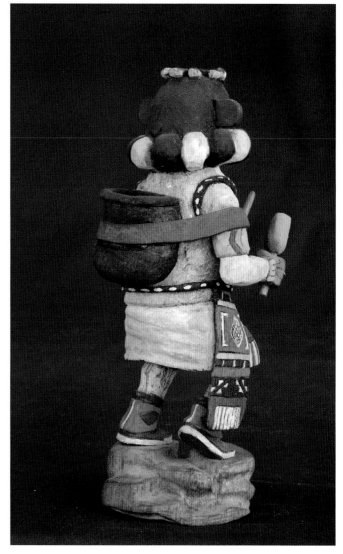

Figs. 10-21 & 10-22: **Pot Carrier Man**, *Sivu-i-quil Taka*, 1997, by Alph Secakuku, 8 1/2" h. One legend notes the Pot Carrier Man carries fertile soil in the pot strapped to his back. He travels ahead of the migrating Hopi to prepare the soil and give spiritual guidance to the people.

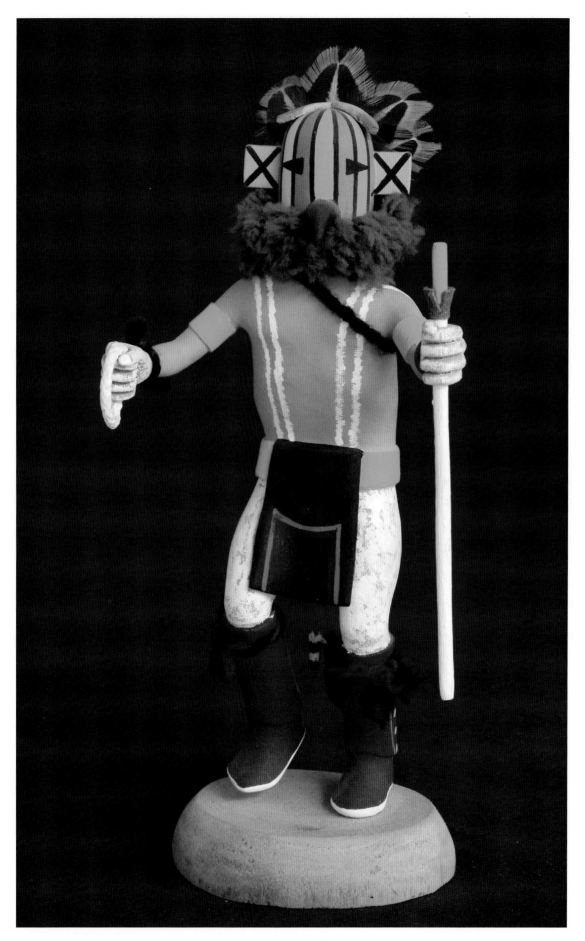

Fig. 10-23: **Gambler kachina**, *Sotungtaka*, 10" h. *Sotungtaka* is a Corn Katsina who first appeared in the mid-twentieth century. In Fig. 8-4 (*Changing Kivas for the Night Dance*), a single Sotungtaka leads the group of Corn Dancers from the kiva.

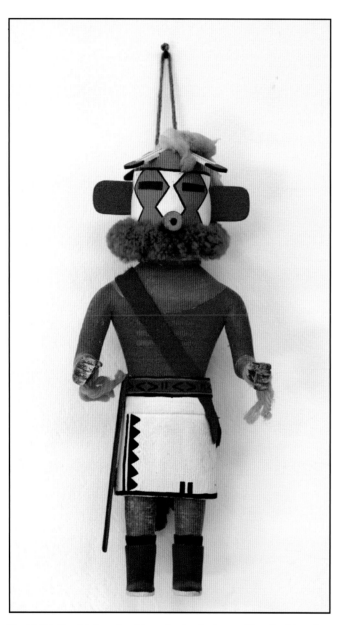

Fig. 10-24: **Cocklebur kachina**, *Pachotktsina or Navuk-china*, 9 1/2" h. The center portion of his face is white, and the geometric orange pattern encompasses his eyes and cheeks.

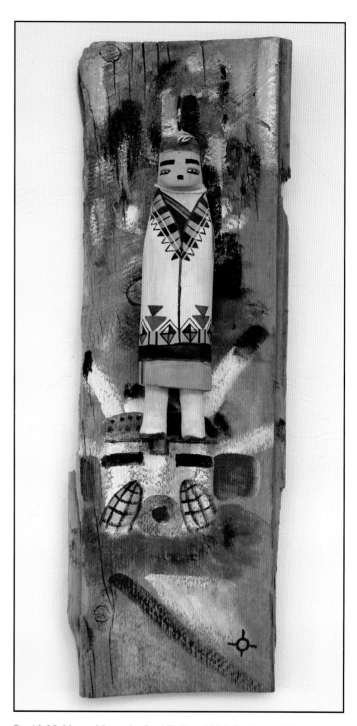

Fig. 10-25: **Hano Mana**, by Rod Phillips, 10" h. Traditional *tihu* given to Tewa children. Phillips recovered a board from Old Oraibi and painted the Corn Dancer, *Ka'e*, and other designs for the background of this *tihu*.

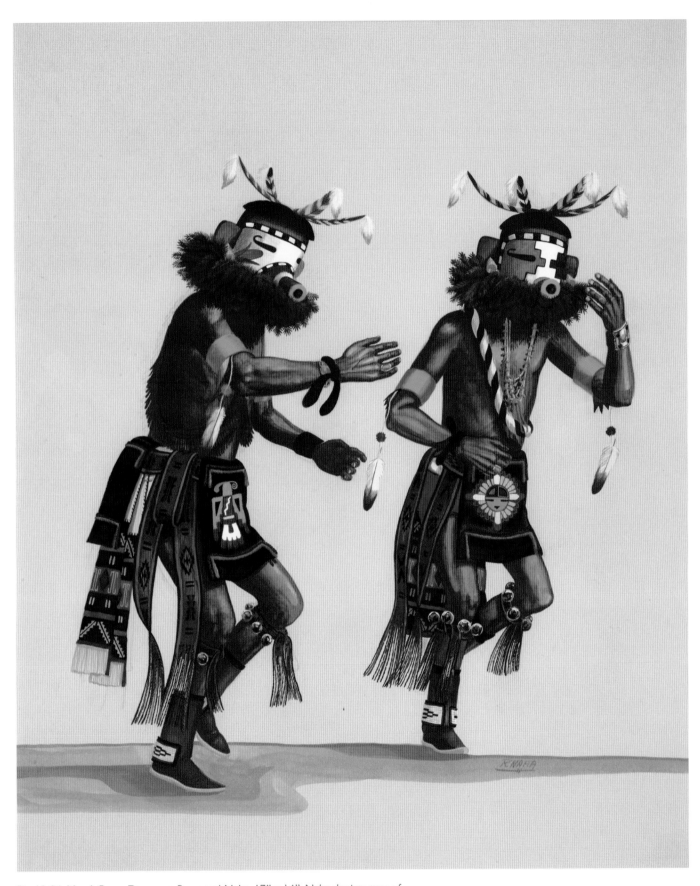

Fig. 10-26: **Hopi Corn Dancers**, Raymond Naha, 17" x 14". Naha depicts two of the many variations of the Corn Dancers. On the right is the Cocklebur.

Although he is not a Katsina, the Warrior Mouse is a highly desirable carving for collectors of Hopi art. The Second Mesa legend of an ordinary field mouse that comes to the aid of the villagers harassed by repeated raids on their flocks of chickens has resulted in an alternate carving challenge and an opportunity for Hopi carvers to broaden their repertoire.

The villagers were concerned with the daily raids on their chicken flocks by Red-Tailed Hawk who was depleting their precious flocks. The people tried repeatedly to kill the hawk but were unsuccessful. *Tusan Homichi,* the lowly field mouse, approached the Village Chief and asked if he could try to kill the hawk. Since all else failed, the chief granted his request. The next day the mouse began to dig a hole some distance from his kiva, and he asked the chief for assistance in getting some greasewood branches. The people brought him several pieces from which the mouse selected a straight and sturdy one. He carved one end to a sharp point and planted the greasewood stick with its sharpened tip pointing up near the hole he had dug.

The next morning, dressed as a warrior, he paraded around his kiva, taunting the hawk who was circling high above. As the hawk began his dive towards the earth, the mouse scurried into his kiva. Each day for three days he danced and jeered the hawk, and then raced to the kiva before the hawk could catch him. The fourth morning, the little warrior danced further from his kiva while the village people watched and the hawk circled overhead. As the mouse sang, deriding the hawk, he danced near the hole and carefully moved around the greasewood stick so it was not seen by the hawk. The hawk, angered by the mouse's insulting song, dove towards the mouse; at the last instance the mouse dodged away from the greasewood spear and leaped into the hole he had dug. Too late, the hawk flew so fast it plunged into the pointed spear and was killed. The Warrior Mouse saved the villagers from further loss of chickens and was rewarded by the people.

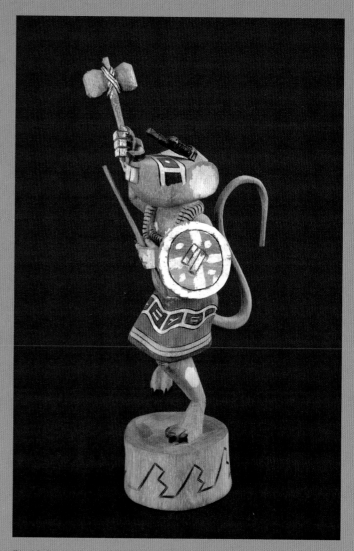

Fig. 10-27: **Warrior Mouse**, *Tusan Homichi*, by Loren David, 7" h.

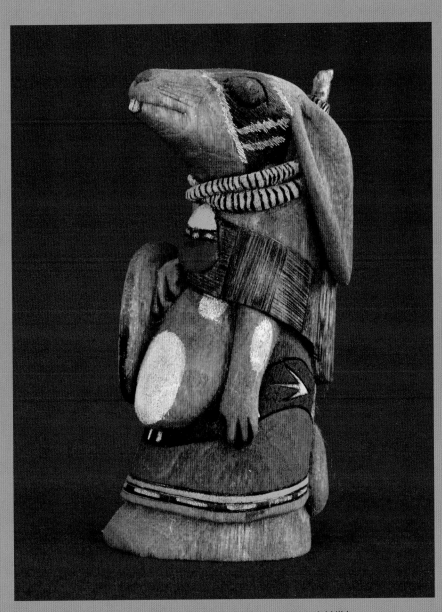

Fig. 10-28: **Warrior Mouse**, *Tusan Homichi*, by A. Hongnowa, 4 1/4" h.

Chapter 11: Hopi Clowns

It is well to dream of the clowns dancing, rain will follow.

–Alexander Stephen (1936, 341)

On every continent and in many societies, clowns are a part of the theatrical scene. Whether in a circus performance, or a formal celebration where a variety of performers entertain a select audience, clowns appear and frolic during intervals between major acts or intermission. Hopi clowns are best known for their antics and comic role during plaza ceremonies. On the more serious side, they serve as disciplinarians and police during the public ceremonies. Through their buffoonery and horseplay they assure the audience is attentive, and the performance moves smoothly from one setting to the next. Attention-getting interactions with the crowd include calling out misbehaving spectators and correcting their inappropriate actions through parody and public ridicule. The clowns excel in reminding people of their weaknesses and faults of self-indulgence, gluttony, selfishness, and self-importance.

Hopi clowns perform many unheralded functions and assume additional responsibilities as well. Alexander Stephen (1936, 412) was informed, "We (*Koya'la*) [Koshari] are the fathers of all kachina." In his journal of 1894, he recounted the preparation for the observance of *Pa'lulukonti* ("Horned Water Serpent Dance") in a kiva performance. Two *Ava'shhoya* ("Speckled Corn Katsina") seized and bound six or seven *Chukuwimkya* (clowns), later to whip them with yucca sheaves. This ritual was performed to ward off cold weather (Stephen, 1936, 341 n.1; 461). Titiev (1972, 268) suggests there may be a tie between some clown functions such as whipping and certain Katsina activities. Cha'veyo, Maasaw, and other Katsinam may also carry out disciplinary enforcement or play a police role that includes whipping of offenders.

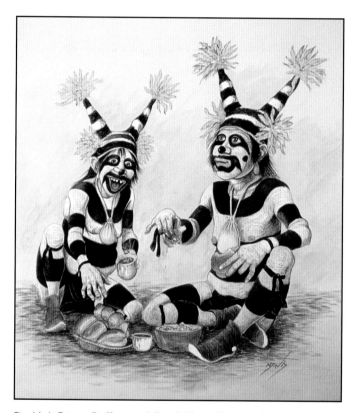

Fig. 11-1: **Stew, Coffee, and Fresh Yeast Bread**, 1999, by Neil David, watercolor, 12" x 13 1/4". Two gluttonous Koshari take a break following their crowd-pleasing performance.

Many of the clowns' roles remain secret because of their ritual importance; as a result, their public performance with its comic and often ribald humor is mostly known. Titiev (1972, 255) observed clowning is performed at the ordinary dances and festivities and excluded from the serious and secret kiva rituals. Artists and kachina carvers choose to portray the Hopi clowns' behavior as tricksters and

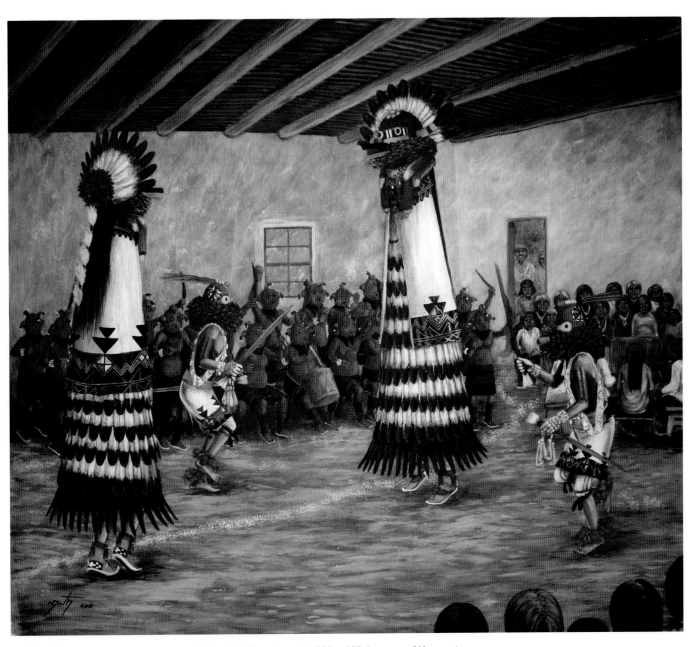

Fig. 11-2: **Hopi Sio Salako Dance**, 2006, by Neil David, acrylic, 20" x 18". A group of Koyemsi provide the singing and drum beat for the Sio Salako Katsinam.

show their frolicking actions as they work to provide a light-hearted change of pace during rest intervals of Katsina dances. Most commonly portrayed are the *Koyemsi* ("Mud-head") and the ubiquitous Koshari ("Hano" or "Tewa clown").

Hopi carvers and artists display the lighter side of Hopi life and express their views of Hopi and American cultures through their creations. Frequently, they speak their mind through their clown caricatures, and from a safe distance they state their position on human frailties through their art.

In defining and cataloging the various religious fraternities of priests, Fewkes (1892, 10) wrote, "...at least three kinds of priests [clowns] may be referred in this assemblage." They are: *Ta'chukti, Pai'yakyamu,* and *Chuku'wimkya, or Tcu-ku-wymp-ki-ya.*[1]

Ta'chukti

The *Ta'chukti* (*Koyemsi*) originated from the Zuni *Koyemsi*. *Koyemsi*, commonly called Mud-heads, are unique in appearance and easily identified. Earth-colored clay pigment covers their body, and they wear an old kilt or mantle. Their head is covered with buckskin masks stained with the same earth-colored clay. Several knobs, or sometimes sausage like projections, of earth-colored cloth stuffed with seeds and filled out with cotton and tipped with tufts of turkey feathers, decorate the mask. Stephen (1936, 181-82) was told the Mud-head was finely dressed in the underworld, punished for misbehavior, and henceforth was to wear women's castoff cloths. They have no novices or initiation ceremony, and anyone who wishes to play their role may dress as a *Koyemsi* and join the performers.

Koyemsi have prominent roles as drummers, singers, and interlocutors in Katsina dances. During the Powamu, they carry out a ritual of gathering firewood for distribution to homes, and they stoke kiva fires for added heat for growing bean plants. In related kiva performances they sing, but do not dance so as not to shake the containers of bean seedlings. Stephen (1936, 175) describes the continuing tussle between the *Koyemsi* and the Giant Ogre Cha'veyo in the public performance of the Bean Dance. Neil David captured the dynamic Katsina scene where the clowns pretend to dread the ogre, while he hoots and knocks them around (Fig. 6-3).

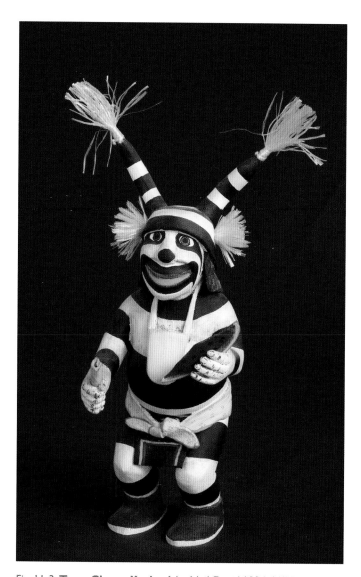

Fig. 11-3: **Tewa Clown, Koshari,** by Neil David,1994, 11" h.

In the Hopis' Sio Sha'lako (Sio Salako) performance (Fig. 11-2) when two Sio Salako, a brother and sister, danced, Stephen (1936, 352-353, 416-426) wrote they were supported by Sipikne or *Shi'phikini* Katsinam and fifteen or more *Koyemsi* singers accompanied by a *Koyemsi* drummer. This ceremony is rarely performed and, with makeshift substitutions, compared to the more formal Hopi celebrations. Sometimes intervals between appearances of the Sio Salako range from a few years to as much as half a century or more. Neil David has never seen this dance, and he consulted with his uncle who provided detailed descriptions of the ceremony as he had seen many years earlier. David relied on oral recollections from his uncle to explain the celebration and allow him to create the painting. Only a few houses on First Mesa have ceilings high enough to accommodate the Sio Salako who are between eight and ten feet tall.

At Hopi, the Sio Salako dance is improvised and occurs sporadically. At Zuni, the Sha'lako is a major celebration with six Sha'lako and a limited number of *Koyemsi*. The performance at Zuni is the high point of the year-long Katsina cycle and takes place in late autumn. The Hopis' Sio Salako celebration is performed in mid-summer. Fifteen to thirty or more Mud-heads with their knobbed masks, clay-painted bodies, and kilts made of women's old dresses, provide the singing and drum music. Stephen (1936, 415-441, P441, fn. 1) wrote of the preparation and performance in 1893, and determined the previous Sio Salako at First Mesa was performed between thirty and forty years earlier. The next two performances were performed in 1912 and 1914.[2]

Pai'yakyamu

Stephen (1936, 448-49; and Fewkes, 1892, 11) determined the *Pai'yakyamu* ("Koshari" or "*Koyala*") clowns were of Tewa origin. Koshari are common to the Rio Grande Pueblos and were introduced to the Hopi at the time of the migration of the Tewa people to First Mesa where they established the village of Hano (Tewa). At Tewa the clowns are called *Koyala* or *Kossa*, and they are considered leaders and fathers of the Katsina.

While the *tithu* made for Hopi children were hung from the wall, tourists seeking kachina dolls preferred free standing figures they could display on fireplace mantels or bookshelves. These trade dolls were initially carved without a base, a difficult task to carve an action doll with the weight distributed so it would not tip over. Larger feet made the balance

easier. Neil David's free standing carving (Fig. 11-3) of the Tewa clown pictures him in the traditional role as the glutton with a slice of watermelon in one hand and piki bread in the other. His dress remains as described by Alexander Stephen in the nineteenth century. He wears a coarse breech cloth covered with a simple commercial bandana around his hips, and carries his ceremonial cornmeal pouch from a strap round his neck. David's clown has no base, but has feet larger than life. Another characteristic of David's carvings is the powerful hands common to most of his work.

The Koshari's appearance and actions remain as first pictured in Fewkes (1903, pl. LVIII). Their faces are outlined with black corn smut, when it is available, or charcoal around the eyes, lips, and on the cheeks. Broad bands of black encircle their bodies, legs, and arms painted white with a *kaolin* clay wash. They wear close fitting caps with two long animal-hide horns stuffed with grass. The cap and horns are whitened with clay and painted with black bands, and corn husks are tied to the horn tips. Generally, their dress is simple, just a coarse breech cloth. Some wear cutoff pants or an additional covering of a colorful bandana or a well-worn blanket around their hips. Their signature corn meal pouch is hung from the neck. Stephen (1936, 412) was told, "Long ago, before we had sheep, when we lived at the Northeast at Tewa yonder, we used no skins of any kind as a headdress. We set a stick on each side of the head upright, and round them we lashed our long hair with cotton string wound round and round it."

Among their functions, the Koshari still follow the traditional role described by Stephen (1936, 547-53). At the predawn opening of the Niman held in 1892, the Ang-ak-china ("Long-haired") from Walpi were the primary performers at Tewa village. As Stephen watched, four Tewa clowns joined them and in their characteristic burlesque style, they danced and sang alongside the Ang-ak-china. After dancing, the Katsinam went into Pen'dete kiva and the Koshari slept on the roof. This ended the predawn activities. About 1 P.M. that afternoon, the black and white striped Koshari, in their sheepskin horn-shaped headdress tipped with corn husk tufts, climbed from Pen'dete. Shouting, they climbed the ladders to the housetops and scrambled from rooftop to rooftop in a role suggestive of walking over clouds. Later, in the plaza exhibitions between Katsina dance intervals, they confirmed their role as gluttons. They ate bowl after bowl of stew and immense amounts of piki bread and rolls.

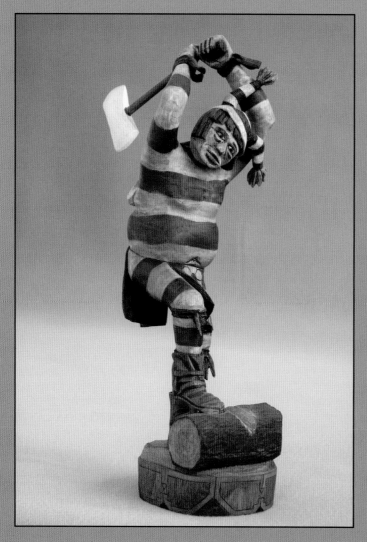

Fig. 11-4: **Koshari Clown, The Wood Chopper**, by Brian Honyouti, 11 1/2" h. Brian Honyouti's *Wood-chopper* is a self-portrait carving. Even when busy with the precarious job of chopping wood, Honyouti who is always thinking of his next carving, encountered some near misses and came up with the idea for his next carving.

Brian Honyouti excels in creating Koshari carvings that tell a story of everyday life. Honyouti's works range from the pictured examples of the near disaster to the *Wood-chopper*, a self-portrait carving where he carelessly uses his foot to steady the log, to the sullen, clown basketball player forced to a time-out.

Fig. 11-5: View of Brian Honyouti's *Wood-chopper* with his foot and already mangled moccasin tip still within striking distance of his axe.

Although Honyouti was not a basketball player, he modeled the dynamic carving of a dejected Koshari basketball player during a time-out for a foul from images he recalled from watching his brothers' play. He calls it *Fouled-Out Pout*. The Koshari wears the tasseled hat, carries the sacred cornmeal pouch around his neck, and wears his hair in the traditional Hopi style; and of course, he has the necessary sports drink to replenish lost nutrients during an all-out ball game. Honyouti's carving (Figs. 11-6 and 11-7) tells a story from all angles. Here he shows the true-to-life form of the ballplayer sitting on his basketball.

Figs. 11-6 & 11-7: **Koshari Clown,** *Fouled-Out Pout,* by Brian Honyouti, 9 3/4" h.

Kerry David carved this Koshari doll with his sacred pouch decorated with a sun design hung from his neck, a carefully knotted wrap around his midsection, and cutoff jeans. David captures his lighthearted personality in the overall-muted colors and drooping tassels on his hat. In contrast, he stands with his right hand behind his back and the large knife in his left hand. The carver leaves us wondering what he is hiding. The clown's impish expression is countered by the frightened mouse held in the clown's left hand. The whimsical Koshari carrying the large knife and innocently posing with a mouse behind his back brings to mind the children's rhyme, "Three blind mice... cutoff-his tail with a carving knife."

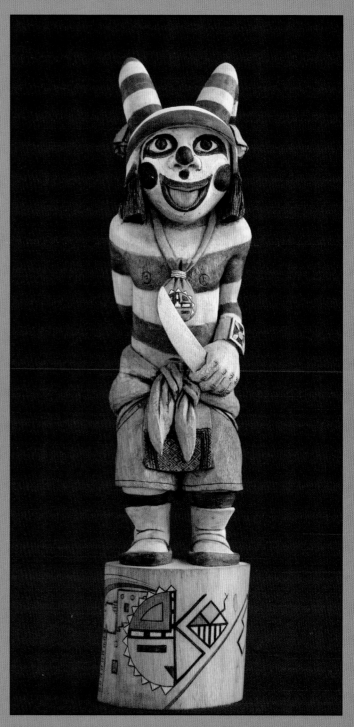

Figs. 11-8, 11-9, & 11-10: **Tewa Clown**, **Koshari**, by Kerry David, 10 3/4" h. (above and opposite page)

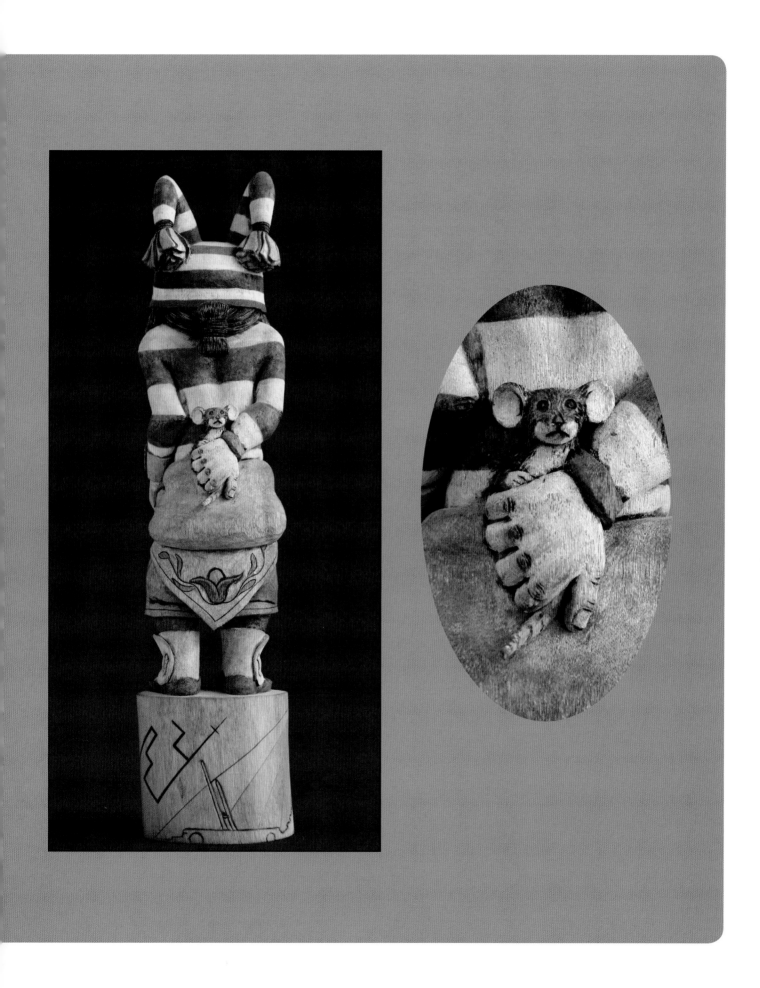

In June 1893[3], Stephen (1936, 406-13) observed the Laguna Dance held in Walpi. About 9 A.M. he went to Pen'dete kiva in Hano where five Koshari were preparing for the day's performance. After noon they emerged from the kiva shouting wildly and traveled slowly towards Walpi. They stopped along the way to look into a house, jest, and perform some antics. At Walpi they climbed to the rooftops and made a clamorous entrance as they descended into Pillar court. Here the women gave them gifts of food. Throughout their performance of frolic and dance, they stopped and from time to time ate as gluttons. About 4 P.M., during a break in the Laguna Katsina dance, the Koshari were in Pillar court when five "grotesques"[4] came from over the housetops carrying an assortment of containers filled with clean water. They doused the spectators and drenched the Koshari. Two of the grotesques carried long rods with lightning bolt decorations and thrust them at the clowns. When one is touched, he falls over and feigns death. When all the clowns were down, the remaining water was poured out, thus closing the dramatic performance symbolizing rain and thunderstorms, essential elements of survival in the Hopi world.

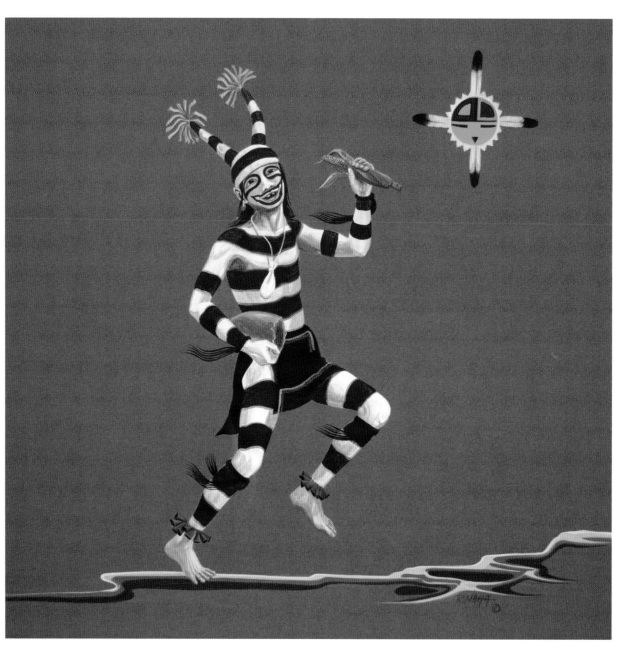

Fig. 11-11: *Koshari*, by Raymond Naha, 14" x 14". Naha's painting is descriptive of the robust Koshari's performance as he appears in the pueblo plaza.

During the next rest period for the Laguna Dancers, the grotesques sprinkled the clowns with ashes and acted out a crude initiation of purification of the resting Koshari. Then they took the gifts of food from the clowns and redistributed them to the spectators.

It is a tribute if you are asked to be a clown. In his biography, Albert Yava (1988, 42), a Hopi-Tewa from Tewa village, commented, the Tewa clowns purify themselves before the ceremonial performance just as the Katsina dancers abstain from salt, meat, and various things. He had no further comment of their society since he was not a member. When new clowns are needed, selected men from the community are recruited and confirmed through a traditional kiva smoke.

Neil David, always looking for a way to express his thoughts, drew this cartoon with a Tewa Clown golfer (Fig. 11-12).

Chuku'wimkya

Fewkes (1892, 11) saw the *Chuku'wimkya, or Tcu-ku-wymp-ki-ya,* the true Hopi clown in the Second Mesa village of Shipaulovi. He wrote, "These priests do not wear masks, neither have they the corn husk horns which characterize the *Pai'yakyamu* [Koshari]. Their faces and bodies are painted yellow, and they wear a wig of sheepskin. Across the face, on a level with the eyes, is drawn a red mark, and a second parallel band is painted on the cheeks and lips."

Fig. 11-12: **I've Got My Birdie Now Get Yours**, 1996, by Neil David, 9 1/2" x 8". Neil David, internationally recognized for his drawings and carvings of the "Chicken-Thief" Koshari, drew this cartoon for the author, an avid golfer.

Fig. 11-13: **Snack Time**, 1969, by Neil David, 8" x 10 1/2"

Neil David drew this portrait of his uncle, a *Sikya Tcu-ku-wymp-ki-y a* clown from the Second Mesa village of Shungopavi, who was participating in a First Mesa celebration. He wears a breech cloth, thick yellow clay covers his body, and red paint marks extend from his eyes and mouth. His head is covered with a huge sheepskin wig, rabbit tails are ear pendants, and purple strips of yarn are tied around his wrists and below his knees. As the traditional glutton, he snacks on *piki* with his bundle of food at his side.

Pipyuyakyamu

Stephen notes a forth type, *Pipyuyakyamu* or grotesques.[5] He usually refers to them as grotesques, not clowns, to separate them from the three clown subgroups. The *Pipyuyakyamu*, an ad-hoc group, gather a night or two before their performance. Their spontaneous and impromptu performance includes the usual horseplay and buffoonery, but nothing very immodest. They tend to follow a behavior pattern or character that developed over the years based on the audience's positive response. For example, the Navajo clown *Tasavau* is considered a *Pipyuyakyamu* and he performs during break periods of the dance. Central to his comic routine, he mocks the Navajo, many of whom attend the Hopis' plaza celebrations and learn to tolerate his mocking performance.

Another *Pipyuyakyamu,* the Mocking Katsina (*Kwikwilyak*), is identified by his mask featuring a black-and-white striped, tube-shaped snout and eyes. He has no mouth and his hair is a bunch of cedar bark, often the fuel for fun as other clowns divert him by setting it aflame. Frequently he wears the white man's ragged coat and pants, as pictured in Figure 8-1, standing on the kiva, and in his staged pose is searching for his first target. *Kwikwilyak* focuses on an unfortunate bystander who he mimics continuously until distracted by another potential victim. No one is immune to his copying antics where he mimics every movement of his unfortunate victim. *Kwikwilyak* is identified as *Lapukti* in Fewkes' publication of 1903, pl. XXV.

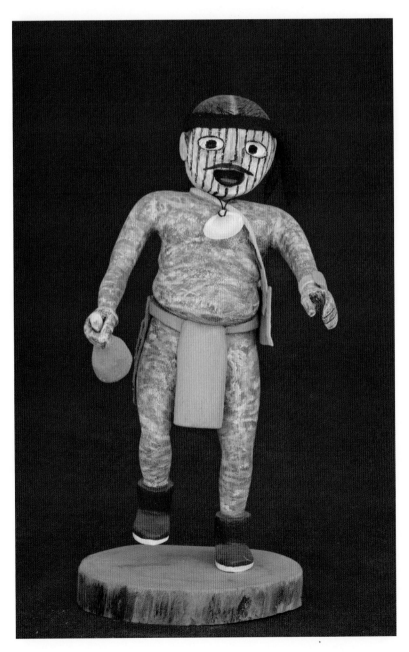

Fig. 11-14: **Navajo clown,** *Tasavau*, by Benjamin Wytewa, 7 1/2" h. This late-twentieth-century carving is an unmasked caricature of the Navajo, and typically wears a red cap or bandana.

135

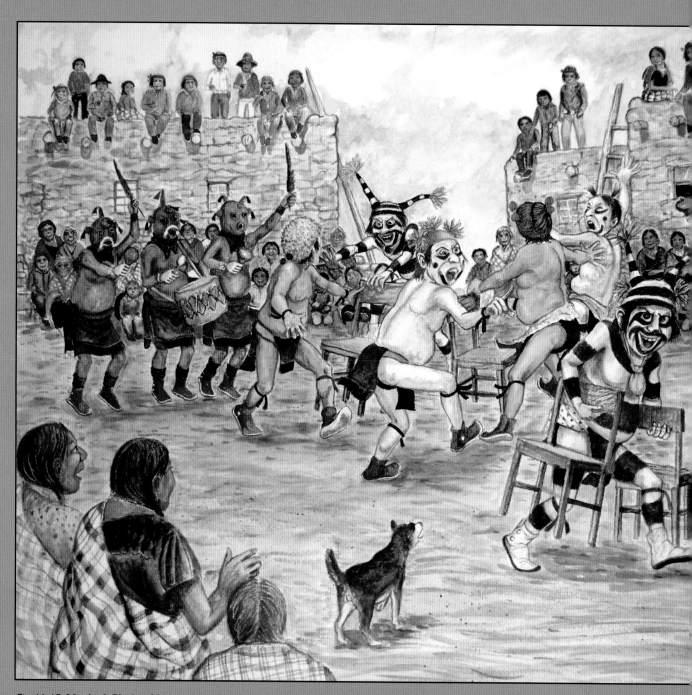

Fig. 11-15: **Musical Chairs**, 2011, by Neil David, acrylic, 16" x 12". A gathering of Hopi and Tewa Clowns play Musical Chairs.

Fig. 11-16: **Winner, Loser??**, 2011, by Neil David, watercolor. Neil David could not resist drawing the outcome of the Hopis' game of Musical Chairs.

Neil David's painting of a plaza celebration centers on five Hopi clowns; the entertainers play an unpredictable and turbulent game of musical chairs. Once again a Tewa clown goes beyond the expected behavior and decides to remove two chairs. Music for the game is provided by the white-mustached Mud-head singer, drummer, and the younger Ball-on-Head *Koyemsi* with ring-shaped eyes and snout. The singers carry Hopi dance rattles, and the ubiquitous Hopi dogs join the music makers with voice and dance. The five clowns remaining in the game are left to right: a yellow *Sikya Tsuku* from Mishongnovi who wears his signature sheep-hide hat; a black-and-white striped Tewa Koshari from Polacca; a white Hopi clown, *Kocha Tsuku,* from First Mesa who wears a skull cap with corn husk tufts; a yellow *Sikya Tsuku* from Shungopavi with his hair tied in the form of the maiden's hair; and a white clown *Kocha Tsuku* from Hotevilla with black dots on his face and two tufts of hair accenting the top of his head. Adding to the chaotic clown performance of each music cycle, a trouble-making Tewa clown carries away the chairs, while the frustrated *Kocha Tsuku* continues dancing and complains by holding up one finger in protest for removing two chairs. On the right is a Mud-head who orchestrates the activity. The dancing clowns' dress are simply a breechcloth, moccasins, and black yarn tied around wrists and knees.

Continuing our 25 years of friendship and long distance communications, David could not resist drawing the final result of *Musical Chairs* (Fig. 11-16) with the Koshari from Polacca and *Sikya Tsuku* from Mishongnovi and only one chair left.

Summary

In all cultures, when an entertainer with an exaggerated appearance, or in ridiculous costume, appears during public festivities we expect a clown's diversionary performance. Although the Hopis' clowns serve multiple roles, during the intervals between Katsina dances their function is to amuse the audience and distract them. They also act out human shortcomings, showing their audiences how one should not behave. At times, some actions exceed the limits of humor and their role as enforcer appears. They threaten unruly spectators through intimidation or embarrassment if they go beyond the boundaries of acceptable behavior. Their intent is to correct their victim's conduct.

Carvings of the Hopi clowns have created a remarkable public relations image and warm our hearts through their actions. They express the humor in everyday life and feature the accident prone clown or present a reenactment of one of our own vices or silly episodes. Kachina doll collections are not complete without a representative figure from one of the clown societies.

Chapter 12: Documentarians

I know of no painless process for giving birth to a picture idea. When I must produce, I retire to a quiet room with a supply of cheap paper and sharp pencils. My brain knows it's going to take a beating.

–Norman Rockwell

Kachina doll carvers share Rockwell's feeling. Leading carvers go far beyond the mechanics of carving a traditional kachina doll. Whether carving a clown in a unique comic situation or a sculpture of a Katsina in a memorable performance, the artist relives the activity as he documents his feelings and experiences from the Hopi celebration.

Hopi carvers have been the best possible ambassadors and public relations agents for their people. While living in Arizona on the remote reaches of the reservation, they have stimulated international awareness and interest in the Hopi culture and life far beyond expectations of a society with a population of a mere ten thousand. Hopi carvers have opened the door to understanding their Katsina beliefs through the wood figurines they traditionally create for their children. As a result, marketing has been straightforward and kachina carvings made for sale are merely an extension of Hopi custom where the dolls are made and given as gifts. With little promotion this unique art form has become a desirable collectible worldwide.

Per capita, the number of indigenous artists, including carvers, painters, and pottery and basket makers in the Hopi population ranks high when compared to any community noted for its concentration of artists. In Eric Bromberg's book about carving Kachinas, he lists a total of more than 600 Hopi carvers (approximately six percent of the Hopi population), including some who live off the reservation, and he includes sixty-one carvers whose work he pictures; of these he estimates fifty carve full time. (Bromberg, 1986, 88-93).

The following essays introduce a few of the legendary Hopi artists and carvers among the prominent documentarians of the Hopi Katsina cult. Our sample portrays individuals as they live and work in the regional settlements on the Hopi Reservation. The meetings are written as if our odyssey across the reservation were limited to one stop on each of the three mesas and a final visit at the far west Hopi settlement of Moenkopi. Each individual introduced is internationally known for his kachina carvings. By no means is this group of Hopi carvers and artists complete—it's merely a representative group.

Hopi carvers have documented significant portions of Hopi life and have drawn our interest to their people and extended our awareness of the Hopis' beliefs. The artists' thoughts and feelings of their culture are captured in their art and so aid in teaching and understanding the Hopi ceremonies and legends central to the Katsina cult. Hopis who carve kachina dolls and create works of art, either as traditional gifts to be presented by the Katsinam, or collectibles to be sold are true documentarians, and Hopi history is indeed a book with at least one chapter written in wood.

Neil David, Sr.

Norman Rockwell painted a slice of life in mid-twentieth-century America and preserved a series of visual documents of American culture. In the same manner, but in a very remote section of our land, Hopi/Tewa artist Neil David, Sr. has captured the spirit and culture of the Hopi people in his paintings and carvings. David has gained worldwide recognition in two fields of art: his carvings of kachina dolls and clowns, and his paintings and drawings of the Katsinam, Hopi/Tewa clowns, and Hopi festivities and ceremonial performances.

David is descended from the group of Tewa people who migrated from the Rio Grande pueblos to First Mesa at the end of the seventeenth century.

He lives and works in the First Mesa village of Polacca. Here the mystical Hopi Buttes, rising from the desert to the south and the snow-capped San Francisco Peaks to the west provide the background ambiance and inspiration for his artistic creations, distinctly Hopi, and truly American.

Born in 1944, David was carving kachina dolls before he was a teenager. By the time he was in high school, he was selling his carvings and sketches. Byron Hunter, who at that time managed the trading post in Polacca, purchased David's paintings and sketches, encouraging and advising the teenager in what was to become his life's work.

David entered the army in 1965 and served in Germany for more than three years. Upon his return home, he began his career in painting. He first received international recognition when his paintings and carvings were given more space than any other artist in the *Arizona Highways* magazine reference issue (June 1971) devoted entirely to kachinas. Some of his most significant works dating from 1969 are displayed at the Heard Museum in Phoenix and the Heard North in Scottsdale, Arizona. This collection is of particular importance since it documents Hopi ceremonies that are now closed to non-Native Americans. David's work may also be seen at the Hopi Cultural Center museum on Second Mesa. His art, ranging from paintings of the sacred and colorful Katsina ceremonies to his famous ink and watercolor caricatures of the Koshare clowns, is the result of an original vision that began in his childhood.

David, along with Michael Kabotie and Terrance Talaswaima, founded the Artist Hopid in 1973, a group that Delbridge Honanie, Milland Lomakema, and Tyler Polelonema later joined. Their objectives were to establish communications through art to non-Hopi people, to document Hopi history and culture through their art, and to experiment with new ideas in art using traditional Hopi designs. Although the group disbanded in 1977, David continues to work towards these objectives.

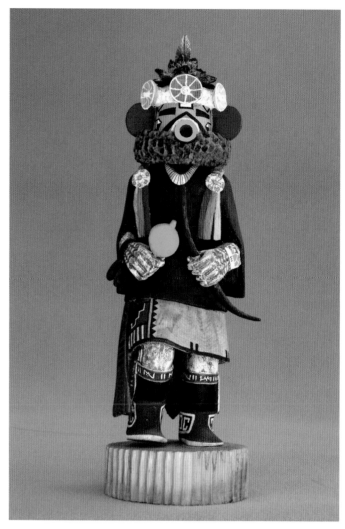

Fig. 12-1: **Velvet Shirt Kachina,** *Navan,* by Neil David, 13" h. Fancifully dressed in a velvet shirt draped with colorful ribbons, *Navan's* headdress is trimmed with flower blossoms. The Katsina's garments and facial coloring vary in appearance at each of the Hopis' mesa regions. The carving represents the Katsina as it appears on First Mesa.

With his intimate association with the Koshari society, David's carvings of Hopi clowns have become his most recognized work. To the perceptive observer, Neil David Sr. is synonymous with the Tewa clown—their image is his icon. He has been awarded "Best Clown Kachina Carver" in Indian Market several times. His carvings and illustrations of the first American clowns have brought him international recognition. Spontaneous clown antics and the mischievous, gluttonous, and accident-prone behavior they display in Hopi festivals are captured in his lifelike creations.

David, a sagacious and respected historian of the Hopi/Tewa traditions, has learned of traditional ceremonies and Hopi history as they are handed down through oral teachings in the home and through his kiva society. He has studied the ethnological work done at Hopi by Fewkes, Stephen, and Voth. Detailed accounts of the events he has experienced throughout his lifelong participation in Hopi/Tewa societies and their religious ceremonies are documented in his art. His paintings and kachina carvings have been included in more than a dozen books, he has illustrated several books on Katsina art and Hopi life, and he has been interviewed for his observations on Hopi art and the Hopi world.

Fig. 12-3: Neil David finishing a Tewa clown carving.

Fig. 12-2: Neil David at his drawing table.

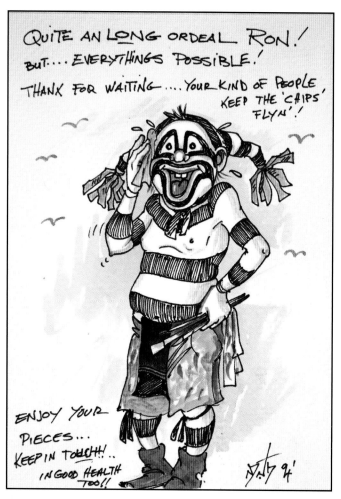

Fig. 12-4: **Keep the Chips Flying**, 1994, by Neil David, watercolor, 4" x 5". This drawing was mailed along with one of David's Tewa clown carvings. The ordeal noted refers to a kachina carving that was lost during shipping.

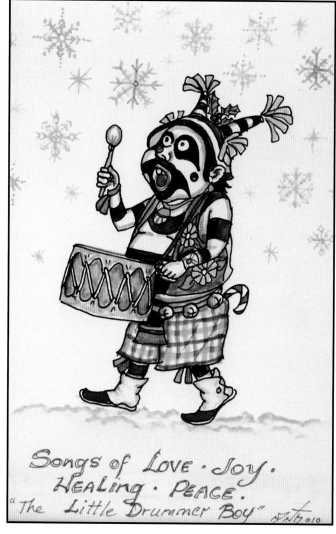

Fig. 12-5: **The Little Drummer Boy**, 2010, a holiday greeting by Neil David, watercolor, 3 1/2" x 5 1/2"

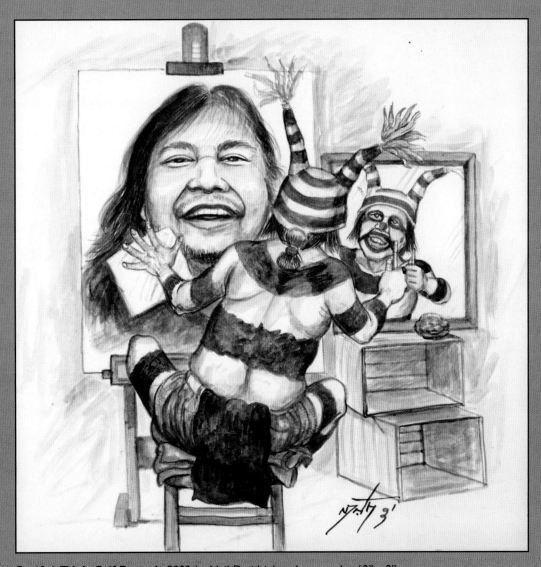

Fig. 12-6: **Triple Self-Portrait**, 2003, by Neil David, ink and watercolor, 12" x 9"

After being called "The Hopis' Norman Rockwell," Neil David created the triple self-portrait using the Koshari clown as the artist painting his portrait. No real surprise, the image on canvas is Neil David. When the self-portrait was exhibited in Santa Fe at the Wheelwright Museum's *About Face, Self-Portraits by Native Americans, First Nations, and Inuit Artists* exhibit, it was thought of "as the signature image for the project." David, carver and artist, is seen as closely tied to the Koshari, even "infatuated" with this clown who he frequently uses as his spokesman (Zena Pearlstone, 2005, p42; #48).

David's paintings of Katsina performers and his drawings of the Tewa clowns portray everyday life and reveal the heart and soul of the Hopi culture and beliefs. For those fortunate to have, in the past, seen a Katsina dance, viewing one of David's paintings ignites long silent memory cells and brings to life the vivid ceremony. His commingling of art and dedication to the Hopi/Tewa culture and religious traditions captures Hopi life and values, allowing us to observe and learn about his people without intruding on their society. For all of us, his works are a matchless record of traditional festivities as they have been enacted for generations. Like Norman Rockwell, David's work includes paintings and ink drawings, illustrations and cover art for books, posters, lithographs, and a series of commemorative plates. No kachina collection is complete without a clown carved by David. A gifted humorist, he captures every day comedic events in his drawings and clown carvings. Above all, his dedication to his religion and sincere participation in his cultural ceremonies remain paramount.

One of David's most notable achievements was his contribution, in the form of painting, to research conducted to recover the details needed to create a portfolio of seventy-nine paintings of Katsinam, many of which had not been seen for many generations, and, aside from oral tradition, some had never been described before. Published in book form (*Kachinas: Spirit Beings of the Hopi*), his portraits show incredible attention and accuracy in the detail and color of the masks and dress, and they bring out the essence of the Katsinam.[1] Original artwork of this collection now resides in the Kashiwagi Museum in Tateshina, Nagano, Japan. Most satisfying to David, this work parallels the contribution of his grandfather, David "White Bear" Kutcahonauu, to J. W. Fewkes' *Codex Hopi* monograph of all the known Katsinam. Setting the record straight, David said, "Since my grandfather was not well known, some people mistakenly credit Oswald 'White Bear' Fredericks for the drawings."[2] Neil David's family adopted his grandfather's name "David" as their family name.

Displaying great versatility in his art work, David created forty pen and ink drawings for the book, *Neil David's Hopi World,* thus preserving a pictorial review of important milestones in Hopi history, and events in his life as it was when he grew up on First Mesa. He includes traditional civic responsibilities rarely pictured, such as the cleaning of springs and the daily announcements of the town crier, ways of life which have lost their importance and are seldom performed since the Hopi economy and culture have adjusted to technological advances since the mid-twentieth century.

Our visit to the artist's studio presented an opportunity for a close study of his active projects. In one corner of his workshop, aged cottonwood root logs were stored, waiting to be carved.[3] David pointed out his most important carving tool resting on his carving table, a pocketknife he purchased in a flea market. The scalpel-sharp blade, well suited for the finest carving, was worn thin from heavy use and frequent sharpening. Kachina dolls awaiting completion sit on the shelf above his carving table.

On David's art table was a partly completed painting of a Katsina. Beside it, an art pad was covered with ink and pencil sketches, each the possible inspiration for his next painting. On the studio walls, copies of David's paintings and posters serve as the background for his grandchildren's arts and crafts projects.

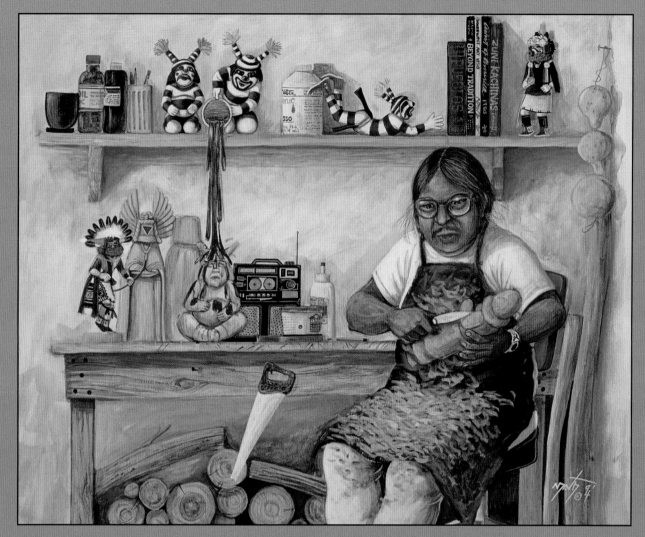

Fig. 12-7: **Self-Portrait, Kachina Carver**, 1994, by Neil David, acrylic, 20" x 16"

Neil David's painting *Self-Portrait, Kachina Carver* refreshes past memorable visits with David at work. His workshop is like Geppetto's magical home. A variety of kachina dolls and his trademark, the comic Tewa clown lie about in various stages of completion waiting for the woodcarver to complete and perhaps perform the Pinocchio-like miracle of life. On the top shelf, David's "Chicken Thief" clown awaits the carving of his prey, and on the left, two Koshari engage in a bit of horseplay, which helps the carver paint a sitting clown who has been patiently waiting for his final coat.

As our interview concluded, a neighbor came to pick up carved dance wands needed for the weekend Bean Dance. David had outlined them with traditional symbols of lightning bolts, clouds, and rain, and the neighbor would paint the wands. David suddenly remembered his plan to make gifts for the weekend celebration. A formidable task, making gifts for distribution to his seventeen grandchildren! And so, completing a painting and a carving for his clients would be delayed because of family values. To David, such an interruption (as was our disruption for this interview) was no cause for alarm; it was simply part of everyday life, all handled in the "Hopi Way."

Living on First Mesa, surrounded by dozens of talented neighbors, nationally known artisans skilled in the arts of pottery, jewelry, and kachina carving, David sees their creativity as the norm for a Hopi. When David received the prestigious Arizona Indian Living Treasure award in 2005, he did not realize the importance of the honor until it was recognized with congratulations by his neighbors.[4]

Ferron McGee, who knows David and has great respect for him as a person and artist said, "[Neil David]...enjoys life, and loves to laugh. He is such a good worker, kind-hearted, and generous. Neil supports his family through his carvings, and he really enjoys what he does. His joy and personality always seems to come across with each of his pieces."[5]

Kevin Pochoema

Kevin Pochoema, our next master craftsman, lives with his wife Twila and their four children in Shungopavi, the mother village of Second Mesa. When giving directions to their home, Twila proudly landmarks it: "Ours is the house with two trees in front." It is no simple task to grow trees on the arid Colorado plateau—on Second Mesa—where trees are a rarity. Pochoema's workshop is a small building next to their home. A wood-burning stove heats it, and he notes, "In the winter, after a very cold night, I may have to schedule my painting later in the day. My wood burning stove must be fired up long enough to keep my paints liquid."

Pochoema lived in Flagstaff until he was fifteen years old. He then returned to his home village of Bacavi, where he lived with his grandmother. His introduction to Hopi ceremonies was limited to weekends until he returned to live on the Hopi Reservation where, now with the security of a permanent home, he gained full exposure to the Hopi religion and culture. In time, he was initiated into the Katsina society.

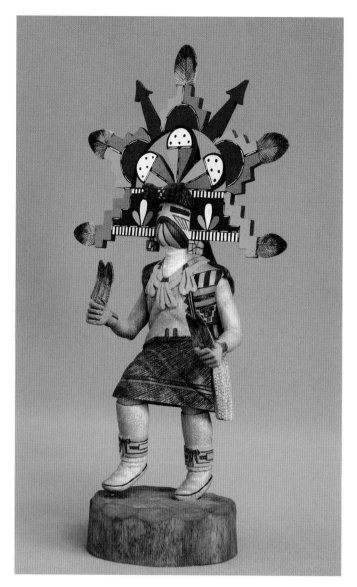

Fig. 12-8: **Butterfly Maiden**, *Shalko Maiden* or *Poli Mana*, by Alvin James Makya, 14" h.

Living in an isolated village provided little chance for a boy to make money. The only opportunity to augment his family's meager income was to carve kachina dolls. These could be sold as mementos to visitors of Hopiland. Pochoema recalled, "My grandmother suggested I carve. She pointed out the trend setting carvings of Alvin James Makya who also lived near us on Third Mesa. My grandmother showed me pictures of Alvin James' carvings in the *Arizona Highways* magazine and said they were sold for as much as a $1,000."[6] Needless to say, Kevin began carving and joined the ranks of the young Hopis who wanted to live the traditional Hopi way on the reservation and unfortunately had limited opportunities for cash income.

Self-taught in the art, Pochoema learned the fundamentals of carving from watching village

men carving dolls, studying kachina dolls made by other carvers, and observing the movement and costumes of the Katsinam as they appeared during their dances. He credits his older brother Greg for getting him started in carving. Pochoema recalls selling his simple kachina dolls for ten to fifteen dollars. Firm in his memory is the time he walked ten miles from his village of Bacavi to sell his kachina doll to visitors at the cultural center on Second Mesa. Without a sale, he continued on to the shops in other villages and art galleries on Second Mesa, and then to the trading post at Keams Canyon. He walked and hitchhiked across the reservation, a distance of more than thirty miles one way, without selling his doll. Discouraged, he said, "I felt like throwing the doll along the roadside, but it took too much work." Smiling, he continued, "I tried again the next day, and sold my doll."

This character-building experience was a far cry from today's demands for his challenging creations. Thirty-four years old at the closing of the twentieth century, Pochoema had already captured major awards at Intertribal Indian ceremonials, and his kachina carvings were featured in several books and periodicals. Collectors eagerly seek his remarkable creations. Most often they are sold before the opportunity to exhibit them. Some buyers have waited up to three years for one of his powerful carvings. His large, multi-figure kachina sculptures sell in the five-figure price range. Pochoema states, "I want to make every carving better than the one before." Adding in the typical easygoing Hopi manner, "I tell my buyers, by waiting longer, you get a better carving."

As the new millennium was about to begin, *Native Peoples Arts and Lifeways* magazine asked more than three dozen experts in the Native American art field for five names, looking back, and five names looking forward, of Native American artists who have made a deep impact on their genre in the last half of the twentieth century, as well as artists whom we expect will do so in the first half of the twenty-first century. Hopi kachina doll carvers Kevin Pochoema and Brian Honyouti were recognized as the top qualifiers in both categories (Hice, *Native Peoples Arts and Lifeways*, Feb/Mar 2000, 54-59).

Pochoema rarely works only on one doll until it is complete. He finds by putting the work aside and coming back to it later he changes his designs. "Setting a doll aside for as little as three or four days brings out things I missed earlier." Life for Pochoema is a blend of family, Hopi beliefs, and carving. His advice to other carvers: "Carve what you know and respect." He has certainly followed this fundamental directive, and he turns to the Katsina ceremonies to find inspiration for his work. On occasion, when selecting logs, a distorted piece of root wood will remind him of a Katsina performance. Such a log may result in a multi-kachina sculpture taking months to complete. In modest terms Pochoema states his carvings merely tell the story of what is taking place during the Katsina celebration. Knowledge of his subject is collected through participation and astute, candid observation of the Katsina ceremonies. His artistic abilities allow him to open new vistas in carving and to sculpt incredibly strong forms that capture the emotions of the Katsina celebrations.

Pochoema starts a new carving by blocking it out of the cottonwood root log with a handsaw. A hammer and chisels are then used to bring the wood to a recognizable outline. A Dremel tool, with diamond edge cutters was used to carve the miniature kachinas in the base of the Yellow Kachina Mana (Figs. 9-1 and 9-2) and hollow the cavities in the gourd music instruments they carry. An "Old Timer" knife is his favorite tool, and sharpening tools and a burning iron are heavily used. Although sanding does not show much progress in the creation of a doll, Pochoema believes frequent sanding during progressive stages of carving is necessary to create a realistic kachina figure with exacting details.

When asked what materials he uses to finish a carving, Pochoema pondered, "It depends on the Katsina action and the spiritual meaning of the ceremony represented." He uses a wood burning iron to polish and add color to the carving, then wood sealer and his own mixture of stains and lacquers are applied. Finally, two coats of acrylic paint complete the colorful and inimitable carving.

Pochoema's most satisfying carving challenges are the complex, multi-personage pieces that portray a ceremonial ritual or Hopi legend. His creations, including the base, the body of the kachina, and through the uppermost headdress elements, are carved from a single piece of cottonwood root. Pochoema uses the base to carve details that complement the kachina figure. Frequently, background terrain or other Katsinam that also appear in the ceremony are carved around the entire base. He brings lifelike feeling into his dolls by carving the Katsina's stance, dance paraphernalia, and flowing garments as they would appear during the dance on the windy mesa. He explained, "I try to capture the movement and flow of their clothes and hair in the wind." He repeated

his goals, "I like to make the robes flow, I always want to do better, and I'm never satisfied. The toughest part of carving is the sanding." He works with cottonwood root, the traditional wood used for *tithu*. It is a soft wood and requires a lot of sanding to produce superior work.

Pochoema, as well as most Hopi carvers, puts his profession aside when major Hopi celebrations arrive. Handmade gifts which the Katsinam will present to the children must be made. Then the artist may also have obligations in preparing for the ceremony and participating in the performance. Many buyers are disappointed when they come to the reservation to pick up a carving and learn the artist has not completed his commission, but has deferred his work to higher priorities. Often it is spoken as the "Hopi Way" when, to an outsider, time seems to have secondary value to a Hopi. But this is not the case. Hopi sense of priority is different from their Anglo neighbor intent on buying and who believes business comes first. For the Hopis, ceremonial obligations are first. Many times when our commissioned work was put on a back burner, although impatient and frustrated, we envied our friends for setting priorities in the Hopi Way, a praiseworthy trait. Little has changed from more than a hundred years ago—the dance comes first. When John Bourke came to see the Snake Dance he said, "Our mules were brought up from the plain [to the mesa] very soon after daybreak; nobody in the pueblos could be hired for love or money to take care of them during the dance." (Bourke, 1984, 114).

Fig. 12-10: Kevin Pochoema with his finished carving of the Yellow Corn Maiden.

On a planned visit to Pochoema's home to pick up a commissioned carving, we were disappointed to find our carver's efforts to complete it were interrupted by the need for emergency house repairs. What at first appeared as a wasted trip turned into a pleasant experience. While staying at the Hopi Cultural Center motel, each day we would visit the family and see our carving take form. Pochoema worked deep into each night to meet our travel schedule. Twila and her children were perfect hosts during our daily visits, and they thoughtfully invited us to an enjoyable evening of dinner and entertainment at their school, the Hopi Mission on Third Mesa. The most painful moment for Pochoema came when he announced the completion of his carving, and I asked to take his photograph with the kachina. Twila supported our urging. Although camera shy, he kindly relented and proudly posed with the Yellow Corn Maiden kachina. This commanding sculpture rose above the incredible base carving of four kachinas, each just over two inches tall and complete to the small details of rings and bracelets, music makers, spruce trim, and perfectly carved moccasins. And indeed, the entire piece was carved from a single log of cottonwood root—our conservative Hopi carver noted, however, that a piece was added for the yucca-leaf whip held in the hand of Hilili, the *tihu* carried by the Corn Maiden.

Fig. 12-9: An unfinished carving of the Yellow Corn Maiden Katsina rests on Kevin Pochoema's work bench.

Ronald Honyouti

Since the 1980s, Ronald Honyouti, from the Third Mesa village of Hotevilla, has consistently achieved a high degree of originality and warm realism in his trendsetting carvings. On our first quest to meet Honyouti, we stopped at the end of the paved road in Hotevilla and asked directions from a man who was sitting on his porch carving a large kachina.[7]

He promptly stopped carving and showed us his work, offering it for sale. When we asked if he could direct us to Ron Honyouti's house he thoughtfully started to direct us, then seeing bewildered travelers confused by the ancient trails that the unpaved village roads now followed, he smiled and said, "Follow me." He drove his pickup truck to the far end of the village on terrain city-folk believe requires 4-wheel drive. We took sandy, rut-swollen roads we would not attempt on our own. He brought us to within four hundred feet of Honyouti's home and carefully attended farm plot. Here the westerly winds had built drifts of fertile sandy soil, ideal farmland for the Hopis. Honyouti's solar powered home bordered a field bearing a promising crop. Noticeably, the plants lacked the size and abundance of water-wasting leaves Easterners are accustomed to seeing. Honyouti greeted us at the door and welcomed us into his home.

Fig. 12-11: Ronald Honyouti in his studio.

Our first impression of his studio/workshop was that it did not match the magnitude of his reputation and his outstanding carvings. It was small and well organized. The shelves and walls were decorated with photos of his children, notes relating to his work, and Chicago Cubs baseball team memorabilia. Several carvings in various stages of completion were clustered on a shelf above his workbench. His collection of prize-winning ribbons, mostly blue, with Best of Division and Best of Class awards from the most prestigious and competitive Native American art shows, including the Indian Market in Santa Fe, and the Heard Museum Fair and Market in Phoenix, were hung together creating a bunch over a foot in diameter and more than a foot long. Honyouti's kachina carvings have been featured in numerous books on Hopi art published in the last quarter century, and he has also been honored with a fellowship award from the South Western American Indian Association.

Ron Honyouti learned to carve by watching his father Clyde and also his older brother Brian. Clyde carved primarily to make gifts which are given at ceremonial celebrations. Carving during idle hours while attending his sheep, he found it practical to carry a single piece of wood and carve the entire doll rather than attach separately carved arms and legs. Brian and Ron adopted their father's techniques.

The Honyouti brothers are among the most influential Hopi carvers of our time. Brian is recognized as the first Hopi carver to use wood preservers, stains, and varnishes to finish his dolls. Once art galleries and collectors accepted this innovation, other carvers followed his lead. Brian was recognized as one of the artists of change at the pivotal step into the new millennium. Kent McManis wrote, "Brian Honyouti does not accept accolades easily. Yet, the kachina art form would be radically different today if not for Honyouti's ingenuity and vision." (Hice, *Native Peoples Arts and Lifeways*, Feb/Mar 2000, 54-59). Brian is Ron's mentor and role model for creative expression through his carving. Ron credits Brian as a pioneer in active poses and carving entirely from a single piece of wood, and with pride states "Brian is the greatest of anyone."

With the base as an integral part of the carving, the Honyouti brothers added carvings of pueblo dwellings as a background for their kachina. Ron is recognized as one of the early innovators who added high-relief carvings, relating to the legends of the Katsina, to the base of his carvings. He won first prize at the Annual Indian Fair in Sedona in 1987

with one of his innovative sculptures. Ron's work is most distinctive and recognized for its elegant form, exquisite detail, and muted coloring. Helga Teiwes fittingly wrote, "Ron Honyouti's carvings are in a class by themselves.... Possessing a Honyouti kachina doll is the dream of many collectors." (Teiwes, 1991, 89)

Ron Honyouti carves *tithu* to be given as gifts during the Bean Dance and Niman ceremonial. These dolls are made with the same care and detail as the kachina dolls made for sale. However, they are carved without a base, and are to be hung from the walls or rafters of the recipient's home. Kachina dolls he carves for collectors and dealers are also accurate representations of the Katsinam as they appear in their traditional dress carrying ritual related items. Deriving a strong background of artistic craftsmanship from his father and brother Brian, Ron Honyouti developed a style to include elements of aesthetic and cultural importance in each carving, even though their relative size made them unnoticeable to the casual view. His base designs blend with the kachina, and may include inscribed and painted Hopi symbols of traditional images such as rain and clouds. More detailed pieces include intricate carvings of the mesa terrain, houses in a Hopi pueblo, and miniature carvings of kachinas. These incredible pictorial base sculptures often require as much work as the main figure.

Honyouti begins each carving by sketching the figure on the log of cottonwood root. The entire figure, the ceremonial objects it carries, and the base are carved from this single piece. For the first rough cutting he uses a band saw. He uses a wide array of tools from power rotary tools like the Dremel, to carefully honed chisels, and a meticulously sharpened pocketknife. He explained, "The finest details are made using a burning tool and an X-Acto knife and a crazy mount of blades." He carves each kachina with a natural body form and stance. Each doll is finished in warm colors, easily identified as Ron Honyouti's work. He enjoys carving the *mana* Katsina, with flowing garments that balance the action pose of the figure, and the Long-haired characters as they appear bearing gifts in public ceremonies.

While carving, Honyouti plays music from his large collection of CDs. He enjoys Jamaican reggae, country western, and rock, especially the Rolling Stones. An avid Chicago Cubs baseball fan, he listens to their radio broadcasts even during their most dismal seasons. Recently he has added "serious talk radio" to his listening while carving or driving the long distances across the reservation. In

this way he keeps abreast of the life and problems we all share.

Beyond his work as a carver, Honyouti divides his time between raising his youngest son Kevin, participating in kiva activities, working with the Hotevilla/Bacavi school as athletic director, and basketball and track coach; and he has served as president of the PTO for several years. He enjoys the schoolchildren's greeting, "Hi coach" as much as attaining a winning entry in an art show. Honyouti continues farming and manages his work commitments to fit the school's sports calendar. Recently he and several other carvers have conducted a series of informal classes to teach the young Hopis the basics of carving. He participates in art gallery exhibits, as well as the annual juried Native American art shows, as time permits. At the same time, he is looking forward to his kiva's responsibility in sponsoring the Niman celebration.

Fig. 12-12: Ronald Honyouti at his carving bench.

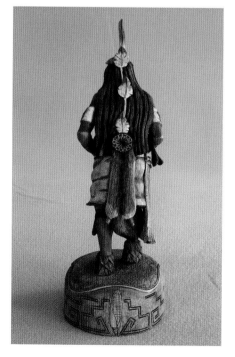

Fig. 12-14: Honyouti's Long-haired kachina with feathered hairpiece terminated with a finely carved Hopi wicker plaque.

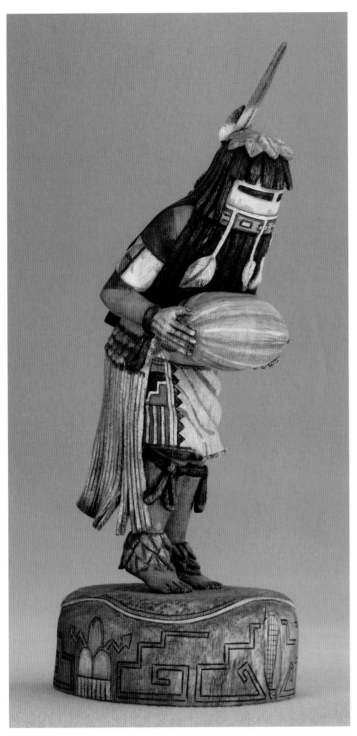

Fig. 12-13: **Long-haired kachina**, *Katoch Angak'china*, by Ronald Honyouti, 10" h. In this one-piece, cottonwood root carving the barefoot Long-haired Katsina carries a melon to be given as a gift during the dance celebration.

Dennis Tewa

Continuing west from Third Mesa, and after driving across forty-four miles of untouched desert landscape, the tranquil setting of organized farm fields appears abruptly, several hundred feet below the edge of the descending highway. Here the Moenkopi wash, the only continuously flowing rivulet on the reservation, meanders through this valley oasis presenting a matchless scene in this dry land. Our travel to interview top carvers from each region of the Hopi Reservation brings us to the western most Hopi village of Moenkopi. Today, our goal is to locate Dennis Tewa and hopefully interview him.

In the picturesque, tightly packed pueblo of Lower Moenkopi with its narrow, randomly oriented streets, you travel by landmarks and directions volunteered by villagers. Finally a turn to the northeast on a narrow lane proved we were on the right trail. The sky-blocking silhouette of the close assembly of Hopi homes bordering the narrow passageway opened to a bright blue sky. Our route now follows the brink of the Moenkopi bench. The view of the serene farmland below against the background of the mesa's edge and distant buttes from the road gripping the bench's outer edge is tensely spectacular. Steering the car as far as possible from the edge, driving partially on parking spaces in front of the houses, we approach Tewa's home overlooking the fertile fields.

The Hopi Reservation in the forgotten reaches of the Colorado Plateau is not the place of manicured lawns. The sight of organized fields below the village gives well deserved recognition to the hard fought victory the Hopis have over nature's omnipresent domination, least friendly to farming. The fields support a variety of crops; the only one easily identified from here was corn. After soaking up this peaceful view fenced in by the wide arc of the raw desert ledges, we knocked on Tewa's door. We heard the typical Hopi response without question, "come in." The door was not locked and as we entered, Dennis Tewa greeted us in the large modern family room still being finished with elegant woodwork and cabinets hand carved by neighboring Hopi artisan Rick Honyouti.

Tewa accepted our intrusion without hesitation, and agreed to our request for an interview. One of the foremost Hopi carvers, Tewa consistently seeks the challenge of producing one-piece realistic carvings in original, rarely depicted poses that epitomize the Katsinam's role in a specific

ritual. He promptly showed us the kachina doll he was carving. It was about eighteen inches tall, and appeared complete, ready for painting. Tewa corrected us and described the additional work necessary before the carving of the Nambeyo Katsina would be painted. We questioned why the doll's raised leg remained attached to the base. Tewa told us this link relieves the stress on the other foot, which links the massive body to the base while the doll is still being carved and sanded. It will be cut away when the carving is complete and the doll is ready for painting.

Tewa pointed out several pieces of tupelo wood he uses for carving. It comes from North Carolina, and is a hardwood, more difficult to carve than cottonwood root. Tupelo is more tolerant when carved into thinner elements, and its fine grain allows greater detail when carving designs on leggings, wrist cuffs, tasseled ceremonial sashes, and paraphernalia like the sifter basket carried by Cold-Bringing Woman (Fig. 6-8). The blocks of tupelo seemed surprisingly massive for carving the elegant kachina dolls he creates. They appeared about 10 x 10 x 20 inches in size, fine grained, and free of flaws. But, realizing the full flow of Tewa's carvings, this size block of wood is essential when the kachina is to be made from a single piece of wood. It is no simple feat to create a three-dimensional figure in perfect form when viewed from any angle and at the same time carve the flamboyant sweep of the extended capes and flowing garments and include the smallest details of the kachina's embellishments. The strength and fine grain of a good piece of carving wood (and the carver's stamina!) are proven when after several hundred hours of handling, rotating, and carving, the sculpture takes form without a catastrophic fracture.

Tewa's kachina carvings are rarely available on the open market. Each represents several months of effort. To the frustration of a client who has commissioned him to produce a specific kachina, the total time to completion may stretch out over a longer calendar time. Tewa reminds his clients his time is scheduled with the highest priority given to family, cultural responsibilities, and his ranching and farming. Carving is deferred during critical periods when fields must be attended, and when kiva ceremonies are celebrated. Currently he farms forty acres, and the planting season extends from March until June. Once the demanding

schedule is relaxed, he settles into a summertime routine: rises at dawn; works in the fields during the cooler morning hours; carves midday; and in late afternoon he returns to the fields, working till dusk. Tewa has never been a prolific carver, with his busy schedule he produces from two to five kachinas a year.

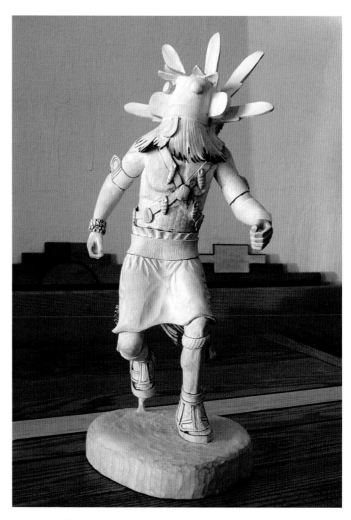

Fig. 12-15: **Nambeyo Katsina,** *Tu-wa-tcu-ah,* nearly complete carving by Dennis Tewa

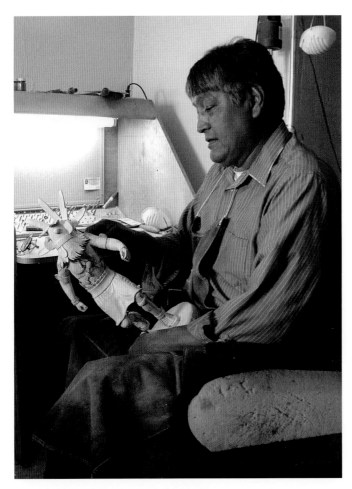

Fig. 12-16: Dennis Tewa at his work bench.

When asked if he would let us take his picture along with his Nambeyo carving, Tewa agreed. With a smile he said, "Wait a minute." He left the room and returned, "Let me put on my new wood-carver's apron." He then tied on his recent gift, and was ready for the photo. Tewa sat at his well-organized workstation. It was without clutter, and needed no tidying.

Before we left, we added our name to Tewa's list of clients for a kachina doll. Knowing the number of buyers and their specific requests, we put no restrictions on time to complete our order or stance of figure. He reminded us of his backlog; his comments for scheduling and completing the commission were not encouraging. We gave Tewa a list of several kachina *manas* we had in mind, it included Cold-Bringing Woman, a doll seldom carved. We gave him the opportunity to carve a doll he had not carved, in a stance of his creation. Our impression was Tewa's creativity took hold, and he already visualized the carving as the Katsina performs in a public ritual, rarely if ever pictured or

carved—the tossing of snow (an act of seeding the clouds) to encourage the winter snow. And yes, we were delighted when, in the buyer's eye—"finally" the doll was complete. This was not the first time, as buyers, we had survived the delays of the artist's queue of buyers and higher priority responsibilities for a fine piece of Hopi art.

During our interview, Tewa briefed us on Hopi history and his concerns about the future of traditional Hopi life. His great-great grandfather Lololoma was village chief of Oraibi in the last quarter of the nineteenth century. At the closing of the century, Tewa's ancestors were among the people sent to establish a permanent settlement at Moenkopi. While discussing his family background and the future of the Hopi culture, Tewa felt the reduced use of the Hopi language will in time result in a loss of Hopi religion and traditions. At the present rate he senses within a generation or maybe thirty years, the Hopi language may no longer be used. The lack of use of the Hopi language by the younger generation could in time result in a loss of the traditional Hopi beliefs, and Katsina ceremonies would be held primarily for entertainment. Along with many Hopis, he is concerned the religious meaning of the ceremonies is being diluted and the traditions are blending with the cultures and celebrations of the world surrounding Hopiland. His goal is to carve images of all Katsinam, as they appear in public performances, to preserve their image for the future. Tewa told us how he learned the Hopi traditions and history. In the evening his grandfather would gather his grandchildren and pass on the legends, orally, that were handed down to him. Periodically he would stop talking, and wait to see if the children were listening before he continued. Tewa now wishes he had been more attentive at these teaching sessions.

Tewa wears many hats and accepts his civic responsibilities. In typical unassuming Hopi manner, he requested we not write of his cultural activities. We would like however to credit him for the time we waited "patiently" for our carving. We did learn, beyond his heavy schedule including important time-consuming work on behalf of his kiva, when the local dam was threatened by heavy rainfall, government officials planned an emergency release of water to protect the dam. Along with a group of citizens, Tewa convinced the officials the dam could be saved and the water conserved. The group of farmers spent many grueling hours diverting the water to the fields rather than release it wastefully downstream. As a farmer, he sees the need for

conserving water and condemns the wasteful effects of depleting the ground water table by using the water from Black Mesa to slurry coal to power plants in Nevada.[8]

Tewa's work ethic and engineering talents are put to use in a variety of continuing unscheduled tasks from kiva responsibilities to community work like irrigation control, and even packing his kachina carvings for shipment. Always a perfectionist, he called on his wife to consult in the design details of the sifter basket carried by the Cold-Bringing Woman kachina. Tewa proudly puts a buyer at ease when describing the effort he puts in when packaging his exquisite carvings for shipping. In shipping Cold-Bringing Woman, to our amazement, when the package was opened it took a significant time to read the sequence of unpacking instructions Tewa wrote on the inner box. We are happy to report, the kachina doll was received in perfect condition. The fragile extensions of the kachina's accoutrements and billowing cape were spared the damaging forces expected during shipment by using his well engineered packaging.

Summary

The *tithu* are carvings of the Katsinam the Hopi artisans have seen throughout their lives in Katsina dances, or learned of during oral recitations of the Hopi legends. These figurines are treated with reverence and respect by Hopi carvers. Whether the dolls are given as *tithu*, sold to collectors or preserved in museum collections, they document and supplement the Hopis oral history in a visual form.

A common link between the Hopi carvers we have met is their love of their work. Over the last century, carving wood figurines has grown beyond a cottage industry and is recognized as an art form. Carving kachina figures is emotionally satisfying and reinforces the artist's religion. Their art is important because it *is* their culture and tradition.

The carving of *tithu* is a religious ritual and a time of reverence.

Traditionally, the men secretly carve the *tithu* in the kiva. The Katsinam then give these simple carvings to the young girls during the Bean Dance and Niman. Whether the carver's products are gifts for the Hopi children, or their profession and major source of income, priceless satisfaction is gained from seeing the excitement and happiness when a Katsina performer singles out the special youngster and presents a *tithu*, or when a collector smiles when the artist hands him a kachina doll specially made for him. Carvers, as most artists, get further satisfaction from people admiring their work, and patrons asking questions about the Katsinam and the dances. However, there are stressful times when, after spending many hours on a carving, the potential of a single slip of a carving tool may result in an irreparable loss to a finely carved cape or kachina mask. Unfortunately, peace of mind is also interrupted with economical concerns—will my carving sell? Is the carving what my client had in mind when he commissioned the work? A final moment of apprehension arises when the carver presents the kachina doll to his patron. Its appearance may not agree with the client's visualization of the Katsina seen in a dance or another pictured form. As noted in many publications, a Katsina's appearance may differ from village to village.[9]

Many carvers say they relive the dances and songs of the Katsina while carving. It is a time for reminiscing and recalling their experiences and participation in the Katsina ceremonies. They may sing and chant while playing tape recordings of music recalling the lively actions of the Katsinam and clowns as they move through the village. When a carver expends a great amount of time and effort in visualizing and creating a kachina doll and then must sell it, he has the same emotions we have when we must part with a cherished item—hopefully it will have a good home.

Chapter 13: Afterthoughts, Signing, and Sign-off

Masked Katsina dancers are a cultural entity identified with the Pueblo Indians of Arizona and New Mexico. Archeologists have used Katsina images found on ceramic pottery along with rock art to determine the origin in time and place of the Katsina cult. While the Katsina cult has existed for nearly a millennium, the history of the Hopis' spirit beings is relatively scant. Although the Hopis' *tithu* are found in every Hopi home, and traditionally given as gifts to all Hopi children, they have not played a significant role in archeological research in determining the origin and development of the cult. Unfortunately, little prehistoric Katsina iconographic records exist from either wood carvings or woven baskets, since these organic artifacts are perishable.

Ancestors of today's Hopi Indians were living under the influence of the Katsina spirit beings and asked for their support in every aspect of life long before the Spaniards came to the New World. Earlier we credited the Hopi carvers as documentarians of the Katsina history for the past century, since the story of the Hopi people's relations with their Katsinam is told mainly through Hopi paintings and carvings of kachina dolls. The prehistory of the Hopi people and their relations with the Katsinam is stored in ancient kiva murals, ceramics, and rock art. Following the trend of their ancestors, Hopi potters also include Katsina images on some of their work. Potters as well as Hopi basket weavers take the opportunity to visit with their spirit ancestors while they are creating their kachina designs on their crafts. Whether created as social gifts and wedding payback[1], or are made for sale to outsiders, these crafts have a reverent place in Hopi homes and are treasured.

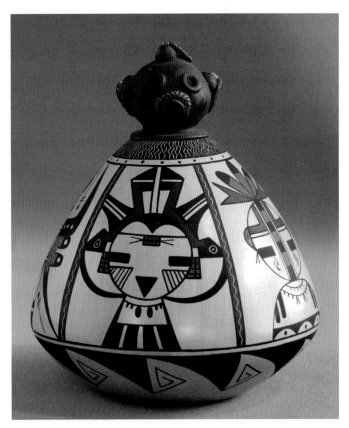

Fig. 13-1: Hopi pottery jar with cover, by Agnes L Nahsonhoya, 7 1/2" dia. x 8 1/2" h. Nahsonhoya's pottery includes images of Salako Taka and Salako Mana, and has a carefully sculptured cap in the image of a Koyemsi (Colton #117 and #118).

Pottery

A fraction of the pottery made by the ancient Pueblo potters was painted with Katsina images. Today, a few Hopi potters may decorate some of their pieces with Katsina masks or figures.

Agnes L. Nahsonhoya from Antelope Mesa added a cap designed as a *Koyemsi* to her jar with the two Salako figures.

Joy Navasie, most notable of the Hopi family to be known as Frogwoman, smiled when she was shown photographs of her creation and stated the large jar (Figs. 13-2 and 13-3) is one of two she made with images of the *Salako Taka* and *Salako Mana* Katsinam (See Wright, 1973, 248-9; and Colton, 1959, #117 and #118 for images).

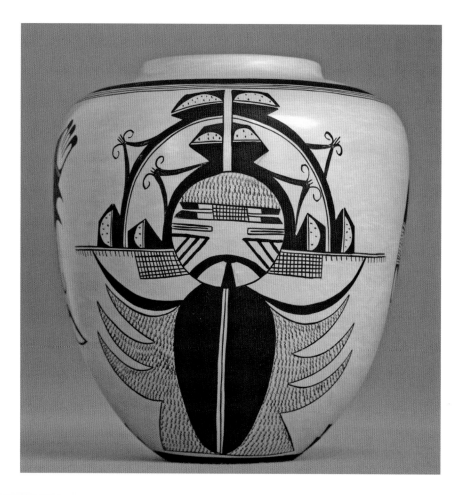

Figs. 13-2 & 13-3: ***Salako Taka* and *Salako Mana***, Hopi polychrome pottery jar, c. 1980, by Joy Navasie, 7 1/2" dia. x 8 1/2" h.

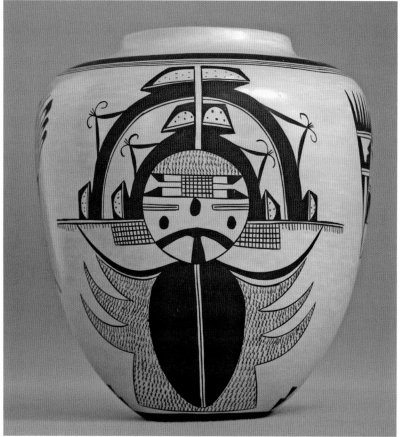

Joy Navasie's daughter Marianne, and her husband Harrison Jim, collaborated on the whiteware jar (Fig. 13-4), combining the polychrome designs of Frogwoman with the incised design of the Katsina War God *Pookang Kwivi* (Colton, 1959, #180, Wright, 1, 138). Pö-ökang Kwivi wears a netted war bonnet. The four double-line tracks on his chest are referred to as warrior foot prints.

Nampeyo's grandson Thomas Polacca is noted for his sgraffito-style pottery where figures are carved on the pottery, which is then painted and fired. Polacca's daughter Elvira and her husband Marty followed his teachings and excel in producing pottery with Katsina figures that are carved and painted before the pottery is fired.

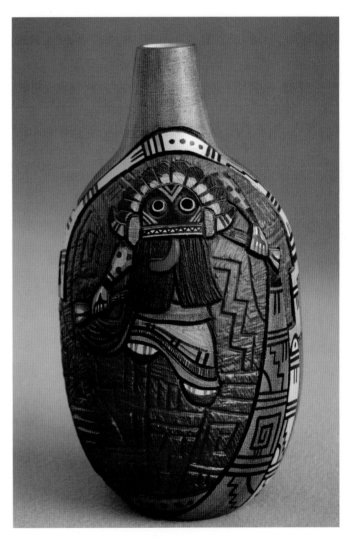

Fig. 13-4: **Proud War God**, *Pö-ökang Kwivi*, Hopi pottery jar, by Marianne Navasie and Harrison Jim, 7 1/2" dia. x 8 1/2" h.

Fig. 13-5: **Broad-faced Kachina**, *Wuyak-ku-it*, by Marty and Elvira Naha Nampeyo, 5" dia. x 8 1/2" h.

Baskets

Over the last half-century the use of handmade baskets as utilitarian objects, as containers for seeds and food, has diminished. Hopi weavers make baskets and plaques first and foremost to be given as gifts to newborn infants, to children as gifts from the Katsina dancers, and wedding payback. While in the past century baskets and plaques made for tourists and collectors have been a source of income for Hopi artisans, they have not attained the level of sales that Hopi kachina dolls have. However, basketry has been received as an art form and has generated a substantial income for the weavers.

Basketry is primarily a social group activity with the added benefits of producing traditional gifts and providing a means of income. The number of Hopi basket weavers is small and their labor-intensive art is in high demand and brings a premium price. Master weavers often sell their creations direct to collectors, dealers, and tourists who travel to the reservation seeking to commission weavers or compete with others purchasing baskets while they are still being woven.

Designs on large jar-shaped coiled baskets are usually repeated around the entire surface. Popular designs include deer, corn plants and ears of corn, and Katsina masks or figures. Geometric designs or clouds and lightning patterns may be used as borders and background. Central designs on plaques appear most striking when a single geometric or star-shaped design, Katsina image, or animal such as the turtle or eagle is used. For many weavers the time spent weaving is a peaceful time, a time of meditation and thoughts reliving Hopi beliefs and traditions.

Hopi basket weavers prefer natural colors in their designs. These are achieved by harvesting the yucca leaves at different stages of growth. Mineral and vegetal dyes are used to extend the spectrum of colors. Image resolution, or fineness of detail, is limited by the size of the stripped yucca fiber (splint) used as weft material. About an eighth of an inch minimum width and one quarter of an inch in length is possible for coiled baskets. Stitched designs are in reality a digital form, where the splint width is the smallest bit of information. As a result, woven basket color changes lack the smooth flow of designs painted on paper or on ceramic vessels, where curves and color changes can be made on an infinitely smaller implement depending on the size of the artist's brush tip and steadiness of his hand.

Representations of Katsinam are difficult to weave since design or color changes are only made at the stitch position and limited to the size of the yucca splint. However, Hopi basket makers have successfully overcome this limitation by producing delightful baskets with Katsina images in a stylistic form. Some of the favored images found on both coiled baskets and plaques are: the Mud-head, Crow Mother, Heheya, and *Pahlik Mana*.

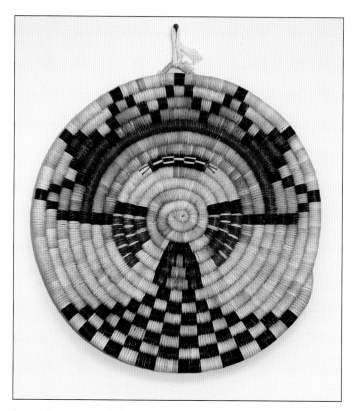

Fig. 13-8: Hopi coiled plaque with Katsina mask of Pahlik Mana, 11" dia.

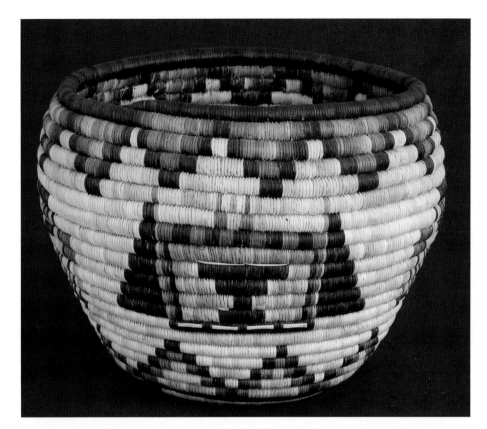

Figs. 13-6 & 13-7: Hopi coiled basket, by Roberta Namingha from the village of Shungopavi on Second Mesa, 12" dia. x 9 1/4" h. Namingha's award-winning basket has alternating designs of Crow Mother and Heheya.

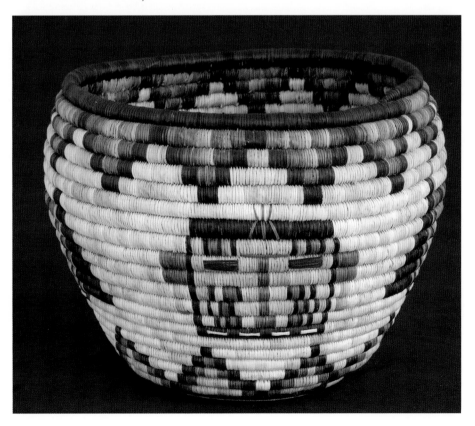

Mistakes, Apologies, and Recovery

We all make mistakes. Even though Hopi artists are meticulous and precise in their work, they are not free from human error. Unfortunately, a slip in a carver's tool can result in a fault in a delicate kachina carving made of a single piece of wood; however, a potter's error in painting is permanent once the pottery vessel is fired. As we look back over our years of dealing in Hopi art, time has healed some of the incidents of error, while some artistic mistakes may add to the value of the artwork.

Fig. 13-10: Eagle Kachina painting, back-side inscription.

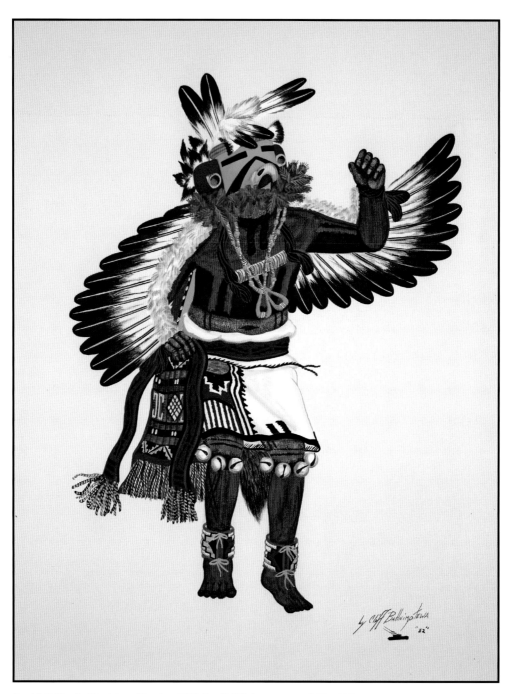

Fig. 13-9: **Eagle Kachina**, *Kwahu*, 1982, by Cliff Bahnimptewa, 14" x 19"

Cliff Bahnimptewa painted a comprehensive series of 237 Katsina paintings which were published in book form (Wright, 1973). A series of his Katsina portraits were exhibited at the Arizona State Bank and a number of his paintings were purchased by bank employees. When the *Kwahu* Kachina (Fig. 13-9) was purchased, Bahnimptewa signed the back of the painting (Fig. 13-10) and identified the Katsina as "Owl Kachina (*Kwahu* Kachina)." Truly, it is the *Kwahu*, an Eagle dancer, but his translation to English fell short.

Dextra Quotskuyva Nampeyo, great-granddaughter of Nampeyo of Hano, once again demonstrated her virtuosity in producing the Sikyatki revival pottery (Fig. 13-11). Dextra, recipient of the Arizona Indian Living Treasure award in 1994 and the number one Hopi potter of her era, made this fine piece in the traditional style of Nampeyo. We hesitate to call it flawless even though it is perfectly symmetrical in shape and design execution with an error-free repeating pattern, equally balanced in all four quadrants of the curved outer surface. In the final moments of extreme concentration, as she was completing painting the designs, Dextra reminded herself to sign the base of the pottery before it was fired. She did. Now relaxed and with the satisfaction of seeing an unblemished piece completed, she signed the piece. It was dried, and then carefully placed on the burning platform and fired in the traditional way. The signature, made with a yucca fiber brush has overlapping characters "e" and "x" but they look like "ax."

During the 1980s, on our first visit to the Hopi Reservation, we were told of a weekend Katsina dance on First Mesa, and when a number of Hopis at the Hopi Cultural Center encouraged us to attend, we took the opportunity. It was an unforgettable event, seeing our first Katsina, the Velvet Shirt, and watching a Katsina celebration. On our return to Hopiland the following year we met Neil David and commissioned him to carve a Velvet Shirt kachina doll in the image of the dancers we had seen (Fig. 12-1). David always has a long waiting list for his work; often it may take several months before delivery. When the carving was finally completed and mailed, it met our expectation—the artwork was great, the doll was received in perfect condition and as expected carved to the finest detail, but David forgot to sign it. Of course, our prized kachina doll then accompanied us on our next trip from Illinois via California to the Hopi Reservation for the artist's signature.

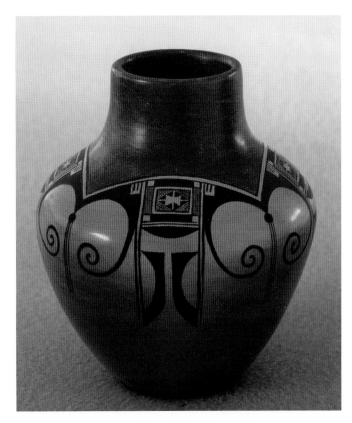

Fig. 13-11: Hopi pottery by Dextra Quotskuyva Nampeyo, 3 3/4" dia. x 4 1/2" h.

Fig. 13-12: Base; signature by Dextra Quotskuyva Nampeyo

161

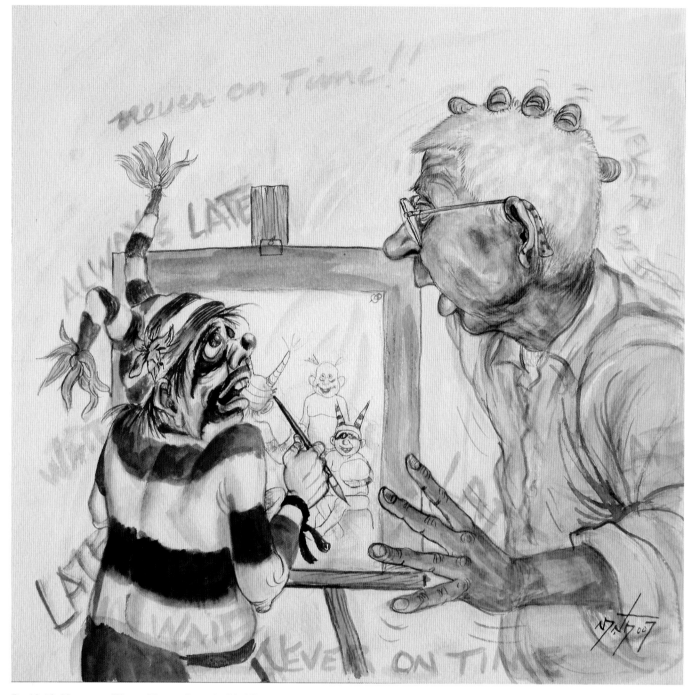

Fig. 13-13: **Never on Time, Always Late**, by Neil David, watercolor, 13" x 13"

When accepting a commission to produce a work of art, the artist may have a number of concerns: will I meet the schedule promised, will my creation meet expectations, and will I get paid? A few years ago, Neil David missed a promised date for completing a painting intended as a birthday present for the author's wife. When he mailed it, he included a surprise gift. It was watercolor caricature of the artist as a Tewa clown and the author. David acknowledged the belated completion of our painting through the actions of his trademark Tewa clown in the painting: *Never on Time, Always*

Late. This caricature of the relations between artist and client reminds us Hopi artists share the same concerns as do most artists. An art piece is a creative challenge, and meeting a timetable is not always possible. Also, we must remember, identification and naming of the Katsinam is not consistent. A Katsina may have several names with multiple spellings, and even differences in dress or mask as they appear in various villages on the Hopi mesas. Common concerns among artists who are dedicated to their art include: "Is this what my client expected?" and "will my client be pleased?"

Signing Works of Art

In prehistoric times potters and basket weavers made items essential for everyday use, and they were rarely recognized for the quality or artistic value of their work. In times of plenty, when more time was available for cultural development and trade with other tribes, creative artisans found ways to make their wares more attractive and of greater personal worth or barter value. By the late nineteenth century, the Pueblo Indians began to sell their baskets, pottery, and kachina dolls to outside buyers. Artists who excelled in their work soon found added value in putting their clan symbol, mark, or signature on their creations. It is not the Hopi way to draw attention or recognition to the individual, and until the mid-twentieth century few Hopi arts and crafts were signed. Hopi artists accepted their cultural modesty and did not boast of their creative skills. Following the urging of traders and collectors, and finding the monetary benefit outweighed their modesty, potters and kachina doll carvers finally began signing their work.

For Native American collectibles and art pieces, just as with any art object, the provenance adds significance and the signing is most important to authenticate the artwork. Many Hopi kachina doll carvers and potters have been equally creative in using a unique sign or symbol to identify their pieces. These range from a simple two-character signature to a pictorial with the artist's name part of the background scene on kachina dolls to the iconic signs on pottery by Paqua Naha and her family. In later years, Paqua Naha who was called Frog Woman (*Paqua* means "frog" in Spanish) signed her work with the symbol of a frog. Upon her death, the name Frog Woman was passed on to her daughter Joy Navasie, and she signed her pottery with a similar frog design. Joy Navasie and Helen Naha (Feather Woman) have used hallmarks that have proven to be among the most recognized pictorial signatures among Native American potters.

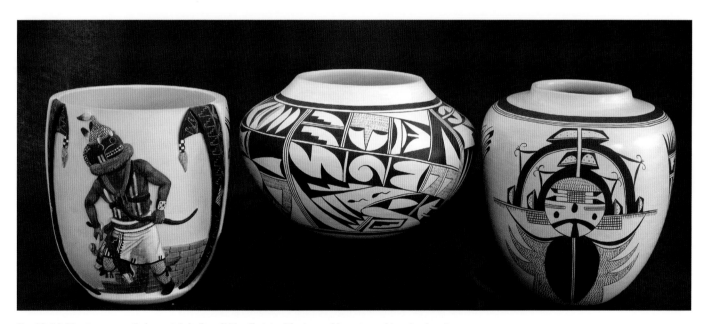

Fig. 13-14: Hopi pottery (left to right): *Proud War God*, by Marianne Navasie and her husband Harrison Jim; Joy Navasie's large bowl; and Navasie's jar with Katsina images

Fig. 13-15: Signing of the *Proud War God* pottery jar by Marianne
Navasie and her husband Harrison Jim

Fig. 13-16: Base signature used by Joy Navasie, Frog Woman, shown as
it appears on the large jar with Salako images.

Helen Naha originated the feather design as a signature symbol. When she married Paqua's son Archie and began her career as a potter, she took the name Feather Woman and signed her pottery with the feather symbol. Feather Woman studied pottery from relics and shards from the abandoned Hopi ruins at Awatovi on Antelope Mesa, and used these recovered designs to create a distinctive style of pottery art. Naha's large seed pot is typical of her creativity. Her fine work in pottery has been continued by her descendents who also use the white slip background and her geometric designs and the star pattern along with their own innovations. Her children sign their work with the feather design plus an additional distinguishing symbol.

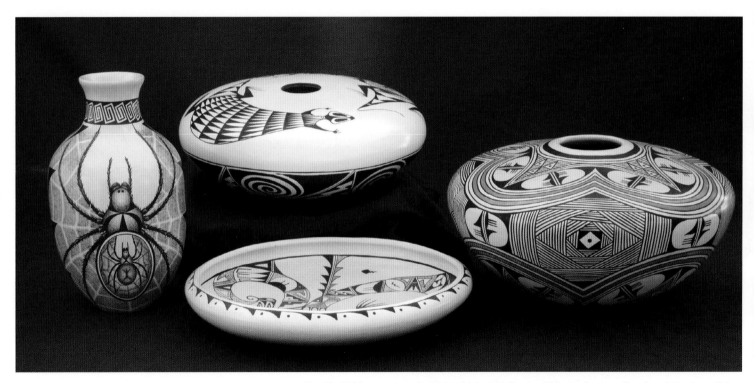

Fig. 13-17: Hopi pottery by Helen Naha (d.), Feather Woman; her son Burel; and daughter Sylvia (d.) (*clockwise from left*): Burel Naha's Spider design; Sylvia's 9 1/2" dia. seed pot features lizard designs and the Awatovi Star pattern on its base; Feather Woman's 10" dia. seed jar; and Sylvia's piki bowl includes tadpoles linking her to her grandmother, Paqua.

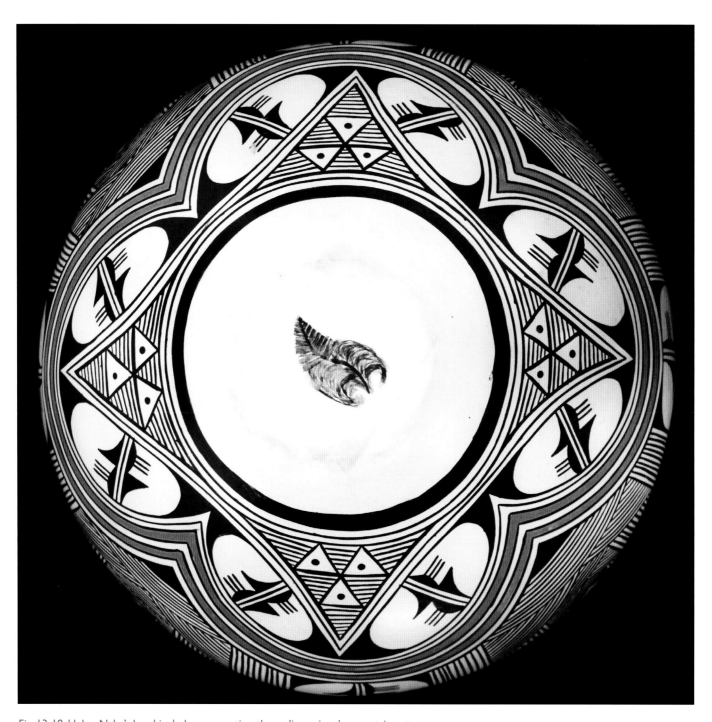

Fig. 13-18: Helen Naha's bowl includes an exacting, three-dimensional geometric pattern. Centered on the base is her Feather Woman's signature, a fine-line feather.

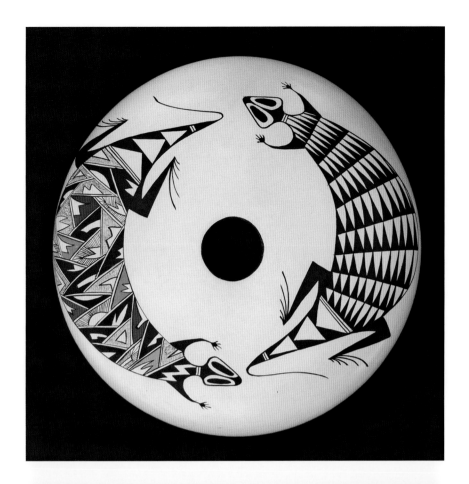

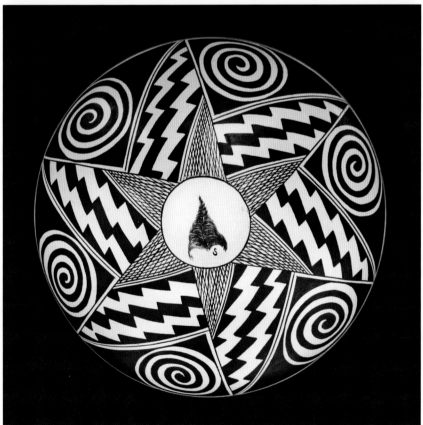

Figs. 13-19 & 13-20: Helen Naha's daughter Sylvia (d.) created this seed pot with lizard designs on top. The bottom design includes the Awatovi Star pattern made famous by her mother. Sylvia signed her works

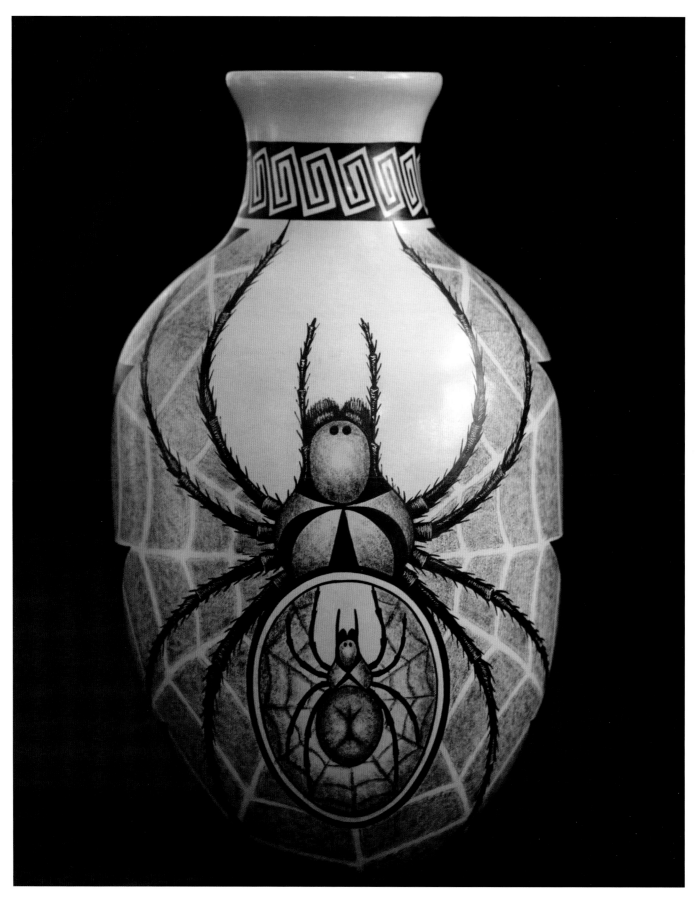

Figs. 13-21 & 13-22: Burel Naha's pottery features spider designs. He signs his pottery with the profile of the Longhair Katsina and a feather. (above and opposite page)

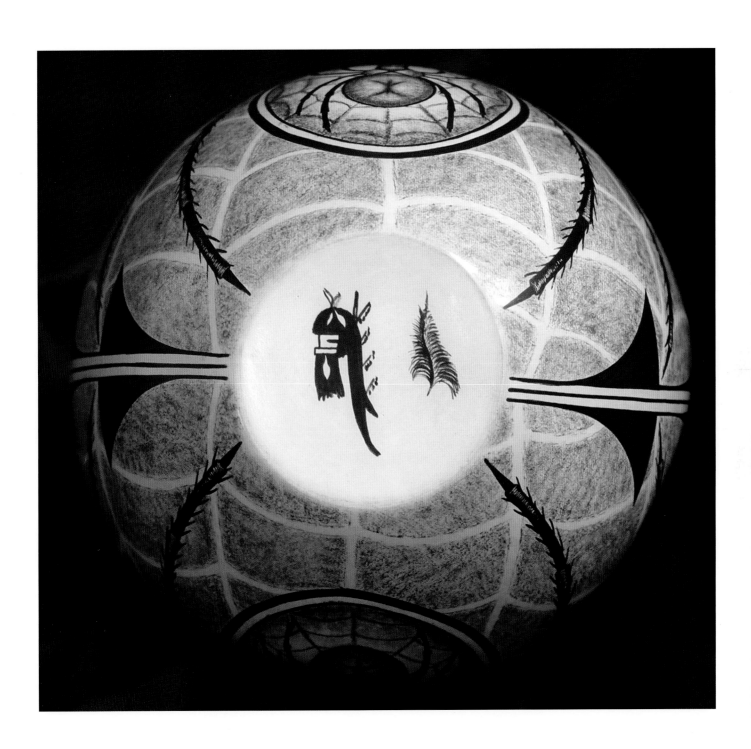

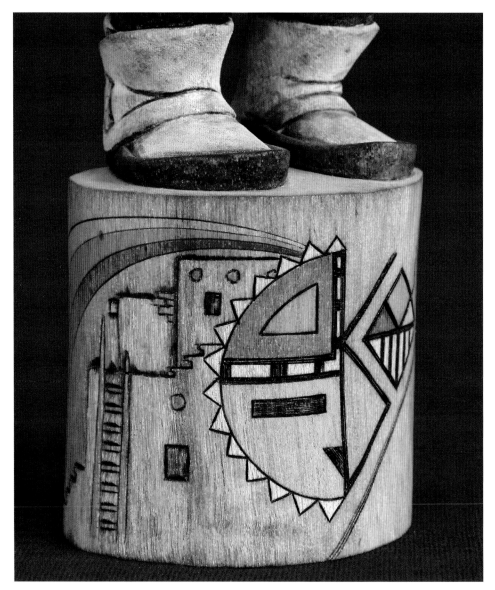

Figs. 13-23 & 13-24: Kerry David, signs his work on the base with the pictorial "Kerry."

Traditionally artists reserve the signing of their work as one of the final tasks declaring their artwork is complete. Signatures presented on these last pages are a sampling from the many contributions of Hopi art that formed the indispensable images in this book. These creative pieces contain details of Hopi Katsinam and the Katsina rituals far beyond what has been put to words. The artists and artisans whose work is pictured in our manuscript have indeed verified the adage a picture is worth a thousand words. The informative and instructional value of the Hopi artists' creative work related to the story of the Katsinam is the essence of our publication, and we gratefully use these signatures to close our work.

Fig. 13-26: Neil David, Sr.

Fig. 13-28: Kevin Pochoema

Fig. 13-27: Ronald Honyouti

Fig. 13-29: Brian Honyouti

Fig. 13-25: Dennis Tewa

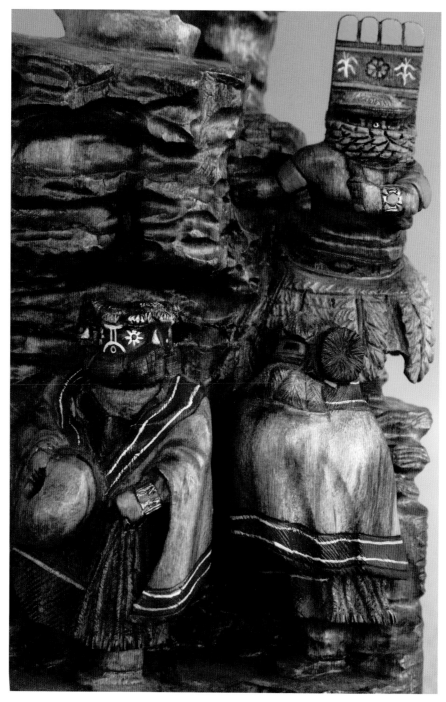

Going Home

Endnotes

CHAPTER 2

1. *kiva*—the underground ceremonial chamber of the Pueblos, where religious celebrations are planned and performed. It is entered through an opening in the roof by ladder. Espejo identified the *kivas* as *estufas* "which are houses built underground, very well sheltered and closed, with seats of stone against the walls to sit on... at the door of each estufa they have a ladder to descend and great quantities of firewood of the community, so that strangers may gather there." (Bolton, 1916, 177-79).

2. The Spaniards originally called the home of the Hopi Indians Tuzan (Tusayan).

3. Stories of Las Siete Ciudades de Cibola, the legendary seven cities of gold and riches sought in the sixteenth century by Spanish conquistadores in North America were first reported by Alvar Núñez Cabeza de Vaca who, after being shipwrecked off Florida in 1528 had traveled along the Gulf of Mexico, Texas, and Northern Mexico before his rescue in 1536. When Coronado reached the province of Cibola, the legend of a total of seven cities rich in gold and silver persisted. Terrell (1973, 52) describes Cibola as the six Zuni pueblos as confirmed by archaeological research. The pueblo of Hawikuh, now a ruin about twelve miles from today's town of Zuni, is the settlement Coronado approached and where he attempted to assure the defenders he came in peace. The Native Americans, aware of the white intruder's history of aggression, drew a line of sacred cornmeal on the earth and warned the soldiers not to cross it. However Coronado then proceeded with his attack on the village.

4. Pedro de Castañeda and other members of the band of explorers who accompanied Coronado on his explorations in the Southwest wrote accounts of their experiences as members of Coronado's expedition. These are collected in the publication *The Journal of Francisco Vazquez De Coronado 1540–1542*. The Dover unabridged edition was published in 1990 under the title *The Journey of Coronado*, a second interpretation is found in *Narratives of the Coronado Expedition 1540–1542* by George P. Hammond and Agapito Rey; University of New Mexico Press. Albuquerque 1940.

5. The province of Tusayan is the home of the Hopi Indians in northern Arizona. In 1870, Major John Wesley Powell, who led the first expedition down the Colorado River, visited Tusayan. The province included today's Hopi Reservation. Powell (1972, 16) wrote: "the 'Province of Tusayan' is composed of seven towns—Oraibi (Third Mesa); Shi-pau-i-luv-i, Mi-shong-i-ni-vi, and Shong-a-pa-vi (Second Mesa); Te-wa, Wol-pi, and Si-choam-a-vi, (First Mesa)."

6. A number of Katsina rituals include the drawing of lines in the sand or spreading corn pollen as a symbolic representation with special meaning to the Hopis. See the performance and legends of Aholi and Eototo.

7. Centuries before the coming of the European explorers, the Rio Grande Indian Trail was the main route linking the Rio Grande pueblos of New Mexico with El Paso del Norte, the gateway to Mexico. The Chamuscado expedition followed this route in their travel to the Eastern Pueblos. It became the northern link of the

Camino Real, (Royal Highway of the Interior Land) used by traders and settlers, between Mexico City and Santa Fe. The Pan-American Highway in Mexico and Interstate highway I-25 North to Santa Fe now track the route of the Camino.

8. The painted sticks with feathers are sacred offerings called *pahos*. Making *pahos* for sacred ceremonies and placing them at sacred shrines is described in detail by Stephen in his *Hopi Journal*. These rituals remain an important activity in today's religious celebrations.

9. Notes from interview with Ken Seowtewa, and the publication: *Native Peoples*; Winter 1992, pages 10-16.

10. *Kachinas, A Hopi Artist Documentary* by Barton Wright pictures several Hopi Katsinam that were adapted from the Zuni, and lists others cataloged by Dr. H. S. Colton as related to the Zuni using the prefix *Sio* in their name.

11. Edmund Nequatewa (1967, 43-44) relates a number of similar stories passed down through oral teachings of the behavior of the priest at Shungopovi during this period. In one case, he reports the priest wanted all the young girls brought to him. He told the people they would be better women if they lived with him for three years. The people found the same problems existed at Awatovi. No wonder the priests who were on the Hopi Reservation during the Pueblo Rebellion were killed.

12. Terrell (1973, 294) concluded the religious oppression was only one reason for the eventual conflict. Paying tribute to both church and state consumed the pueblo's productivity. The governing Spaniards "lived off the land" even during the several years of drought and famine when hundreds of Native Americans died of starvation—450 from one pueblo.

13. Stephen Plog (1998, 183) cites an additional cause of the decline in population among Pueblo people. Living in close packed settlements "must have promoted the spread of diseases including gastroenteritis, tuberculosis, and treponematosis as well as increased infection resulting from bacteria such as staphylococcus and streptococcus." These diseases, along with those introduced by the Europeans, were significant factors in the collapse of native populations between the time of the Spanish intrusion to the New World and the end of the eighteenth century.

14. To this day people of Tewa ancestry maintain their heritage and continue to identify themselves as Hopi-Tewa. They maintain contact with their relatives in the Tewa pueblos of New Mexico. At the beginning of the twentieth century many pieces of pottery sold through the First Mesa trading post carried stick-on tags or were painted before firing with the inscription "Tewa Village – First Mesa."

15. Irving Pabanale's life story was transcribed from audiotapes into *Standing Flower, The Life of Irving Pabanale, an Arizona Tewa,* edited by Robert A. Black.

16. Approximately one mile north of Interstate 40 on highway 87 is Homol'ovi Ruins State Park. Hopi legends tell of this thirteenth-century home of the Hopi ancestors (*Hisat'sinom*) who lived here during one stop in their migrations. Homol'ovi, "The Place of the Little Hills," had four major pueblos located at the head of the usually dry basin of the Little Colorado River. Near Homol'ovi II and IV ruins a number of forms are carved into rocks. Here, among the earliest documented iconographs of Katsinam, Hopi informants have identified Sun (*Tawa*), Giant Ogre (*Tseeveyo*), Mud-head (*Kooyemsi*), and other spirit forms. (Adams, 1991, 62)

CHAPTER 3

1. In 1873, a ferry service, Lee's Ferry, crossed the untamed Colorado River at a location sixty miles north of Moenkopi. The same year Mormon colonizers used the service as they traveled southward to settle along the Little Colorado River. Initial attempt to establish the Little Colorado Mission along the barren land and nearly dry riverbed failed, but the route from Utah to central Arizona was opened. In 1878, Tuba City was founded on land conditionally granted by the Oraibi leader Tuva (Toovi or Tuba) at a place called "white sands" with the

agreement the Mormons were to protect the Hopis from the Navajo and Paiute raiders. The Tuba City settlement was a halfway point for traveling between Utah and the new colonies along the Little Colorado drainage basin. In 1928, Navajo Bridge crossed the Colorado at Marble Canyon; the need for Lee's Ferry had ended.

2. State Route 77 follows the wagon trail, and travel time today is less than 1 1/2 hours.

3. Since the split of 1906, the population of Oraibi has decreased significantly with the establishment of the Third Mesa villages of Bacavi, Hotevilla, and Kykotsmovi.

4. The nearest general store was at Keams Canyon some forty miles to the east over the rough terrain of three mesas and their dividing washes. The closest railroad stop was at Winslow, a day's ride to the south.

5. Mischa Titiev summarized Voth's work in research: "Although he was untrained in anthropology, he was amazingly diligent in the pursuit of ethnographic details, even to the point of defying native prohibitions. His publications are accordingly, filled with details that are priceless, but meaningful only to specialists." (1972, 355 n. 2)

6. The dispute continues over a century after the white man first gathered cultural items from the Pueblo Indians. *American Indian Art Magazine's* (Spring 2002, pg. 82) article on repatriation of cultural items reported two Hopi altars which were part of an exhibit "constructed by Hopi priests and artists specifically for the Field Museum exhibit...from components that had been prefabricated in Arizona" were repatriated to the Hopi tribe.

7. Titiev (1972, 361, n. 6), fearing the loss of Ned's help and also the loss of the anthropological field party's acceptance and standing among the Hopi, promptly sent a letter to the museum's director who explained the exhibit was prepared based on Voth's notes. Ned had no part in the exposure of the intricate details of this sacred ritual. Titiev (1972, vii) noted his diary was written in secret, no doubt to keep communications open between the Hopis and

his research team. As a protective measure, Titiev (1972, 355 n. 5) used pseudonyms for his Hopi informants. Ned is the Sun Chief, Don Talayesva in the autobiography *Sun Chief* edited by Leo w. Simmons, Yale University Press.

8. Major J. W. Powell, a veteran of the Civil War, led the first expedition down the Colorado River in 1869. He visited the villages of Tusayan in 1870. His publication, *The Exploration of the Colorado River of the West* (1875), and his reports of the Native Americans of the plateau region stimulated interest in the indigenous populations of the Southwest in the adventurous mind of the American public.

9. Frank H. Cushing, a brilliant and competent field ethnologist recognized for his pioneer work on the Zuni culture, was spokesman for the Oraibi Expedition.

10. *Neil David's Hopi World* (Pecina and Pecina, 2011, p 36-37) includes the artist's pen and ink interpretation of the confrontation.

11. John Bourke, lieutenant in the army, was granted a year's leave to observe and record the customs of the Pueblo Indians. His book *Snake Dance of the Moquis* includes accounts of his travel from Santa Fe, visits to several of the Rio Grande River pueblos, and his adventures when he visited the Hopi villages to observe and write the first complete report of the celebration where it was rumored the Native Americans danced with poisonous snakes in their mouths!

12. In 1882, the tracks would be completed to "Railtown," today's Gallup, New Mexico. By 1893, the tracks went further and Voth traveled by train to Holbrook, the railroad station closest to the Hopi Reservation.

13. The route they followed is today's Arizona State Route 264. It runs from north of Gallup to Keams Canyon and then westward following the contours of the three Hopi mesas. The trip from Fort Wingate to Keam's ranch, a distance of about 115 miles, took three days. The trail followed an ancient route (the same one used by Tovar when he traveled from Zuni to Tusayan in 1540) to an assured water source in a narrow box canyon—a Southwest oasis. In time, this rest stop became a small trading

center where the Hopi and Navajo Indians met to barter with the white trader. Thomas V. Keam bought the post in 1875. In 1880, he made his permanent home in the canyon. At the time of Bourke's venture, he was returning home and also planned to see the Snake Dance. Keam, always hospitable to visitors, offered Bourke and Moran his ranch as lodging and for use as their headquarters during the Hopi ceremonies.

14. In 1881, when Bourke traveled the route to observe the Snake Dance it was called Moqui Canyon (Bourke, 1984, 79). The Hopis call it *Poongo-sikia* named for the edible, water-seeking plant that grows in the spring-fed rain-collecting canyon. (Neqquatewa 1967, 130, n. 34; Graves, 1998, 119)

15. On Leo Crane's first view of Keams Canyon as the new Superintendent of the Moqui and school superintendent, the agent he was replacing said, "And there is your Agency. You can see as far as you like from that place, if you look straight up." (Crane 1925, 106). At the time of his appointment in 1911 he was agent for 2,200 Hopi and a slightly larger number of Navajo. The agency had offices, living quarters, shops, a boarding school for 150 children, and five day-schools located close to the pueblos. The first school was opened in 1887 and was closed in 1915 for fear the buildings would collapse. The edict of forced schooling away from home caused the greatest conflict between the Hopi and the Government.

Crane (1925, 159-178) wrote of the clash between the Government and the Indians of Hotevilla shortly after he took office. Assisted by Army Colonel Scott whose intimidating cavalry troop surrounded Hotevilla, Crane and two of his employees went house-by-house searching for hidden children. Children ten years and older were taken from home to attend the school at Keams Canyon. Crane wrote, "those children spent four years at the Cañon school, and without vacations." It was a forty-five mile journey from Hotevilla to the boarding school. Even by wagon, which few Hopi had, it took two days to complete the journey. Rare would be the opportunity for the typical Hopi family to visit their children living in the school dormitory, another reason for resistance to thoughtless government policy.

16. Frank Cushing (Green, 1990, 168, 389 n. 8) visited Tusayan in 1881. After his visit to the East Mesa villages, he went to the Agency headquarters in Moqui Canyon. Here at Keam's store, he met "Prof. Stevenson," who managed the store in Kean's absence. "Prof. Stevenson" was Alexander Stephen, tagged as professor because of his degree from Edinburgh.

17. Stephen helped with the surveys, contributed to the writing of clan legends, and wrote the chapter on the history of Tusayan. This study, published in 1892, remains the most comprehensive text on the subject (Nabokov & Easton, 1989, 419). Many examples of Stephen's ability in surveying and careful attention to details may be seen in the set of officially recorded maps of the trading post and other buildings; a topographical map showing locations of springs and improvements; plan view of the residences of Keams Canyon (Graves, 1998, 122-124); and the set of maps showing landmarks, pueblos, and kivas in the First Mesa Villages (Stephen, 1936, insert at end of Vol. 2).

18. Mischa Titiev's anthropological work in the 1930s is recognized as the most reliable and in-depth view of the Hopis available. Dr. E. C. Parsons gave him a complete set of galley proofs of Stephen's *Hopi Journal* she was preparing for publication. He wrote, "These I used throughout my extended stay at Oraibi, and they proved to be of immeasurable help in my work." (Titiev, 1944, xiii). This was a half-century after Stephen had recorded his observations.

19. In *The Group of Ceremonials called Katcinas*, Fewkes (1897, 251 n 1) wrote, "...the memoir, which was prepared in 1894, includes the results of the observations of the late A. M. Stephen as well as those of the author." In this monograph, many page-long passages from Stephen's journal were used with minimal editing.

20. Frank Cushing lived with the Zuni between 1879 and 1884. He dressed as a Zuni, learned their language, slept in their homes, and ate their food. His approach to scientific investigation by

living with his subjects as opposed to working as an outside observer was a successful model for studying the Pueblo Indians. He wrote to his director, the Secretary of the Smithsonian, "[I] will look with unfeigned reverence on their beautiful and ancient ceremonies, never laughing at an absurd observance." (Green, 1990, 60).

After living as a Zuni for two years he was accepted into the prestigious Bow (War) society whose membership requirement included possession of an enemy scalp. As Priest of the Bow he was allowed entrance to all the secret, medicine, and sacred orders of the Zuni (Cushing, 1990, 180, 196). He was so integrated to the life of the Zuni, he suffered the same discrimination and humiliation of his companion Zunis when they visited Fort Wingate and were housed in an old shed, formerly a hen house. Cushing, expecting loss of face with his Zuni companions, was surprised when they said, "Well, you see we are Zunis." They added, "That is your baptism in Zuni." (Green, 1990, 84).

21. Although the objective of compiling pictures and descriptions of all the known Katsinas was not met, Fewkes' work includes descriptions and drawings of more than 190 Katsinam. Among them are several drawings of Katsinam he believed either extinct or abandoned. They were pictured wearing ancient masks as they were found hanging from the rafters of clan dwellings (Fewkes, 1900, 109).

Kachinas: A Hopi Artist's Documentary by Barton Wright describes 237 Katsinam with paintings by Cliff Bahnimptewa. Eric Bromberg's *The Hopi Approach to the Art of Kachina Doll Carving* lists and cross-references some 356 of the Hopis' Katsinam. Neil David's *Kachinas: Spirit Beings of the Hopi* includes 79 paintings, many unusual Katsinam—some that had not been seen for over a generation—and a number that were not included in the above publications. Harold Colton cataloged 266 Katsinam and 35 Hopi deities in his 1959 *Hopi Kachina Dolls with a Key to their Identification*.

The Katsina family is dynamic. New members continue to be added, at the same time others are abandoned or are rarely seen. Dockstader places the number in the Hopi pantheon "estimated at numbers ranging from 250 to 500—depending entirely upon which 'authority' one reads." (Bromberg, 1986, 6).

22. *American Indian Art Magazine's* (Autumn 2006, pgs. 70-83, 120) article "Creating the Codex Hopiensis" delves into the history of the paintings in Fewkes' codex.

23. Titiev and other scholars following this legendary first group of ethnologists approached the task of refining earlier studies and interpretation of the Hopi life with great sensitivity for the native culture. Investigators had to be watchful to separate the aboriginal mores from cultural changes brought about by the influx of scientists, scholars, and travelers. Visitors who came from a cash economy and bought services of the indigenous group caused notable changes. Hiring language interpreters, informants who would describe the elements of Hopi life and rituals, guides, and laborers to work on archeological digs created an economical unbalance in a subsistence society and as a result influenced the validity of the research activity. The Hopi society was divided by the acceptance of the more liberal Hopis to allow archeological digs on sacred land and reveal secret rituals of Hopi religious societies.

CHAPTER 4

1. Stephen (1936, Vol I, fig. 16; Vol. II, maps 4, 12) has mapped the Hopis' viewing points and landmarks on the horizon, marking the position of the rising and setting sun at the summer and winter solstice, and the point the sun reaches on its journey northward—the time when general planting begins.

2. February, the hardest month of the winter is called the "Getting-ready moon" (Hough, 1915, 31). Powamu is derived from *pawatani,* to put in order or condition as in: by this ceremony the fields and gardens are put in proper condition symbolically, and protected against destructive

forces (wind, sandstorms, ants, etc.) and in every way consecrated for the approaching planting season (Voth, 1901, 72). Stephen (1929, 156) called it a ceremony of exorcism or cleansing, to banish snow, cold, and winter winds.

3. To preserve the Hopis wishes in their esoteric celebrations, and at the same time provide background material relevant to our topics, our descriptions of the Hopis' celebrations and kiva rituals are limited to previously published accounts.

4. Many Katsinam have multiple names; the original is closely tied to clan groups (phratry) and regional ceremonial events. When the clan divides and a fraction moves to another region, it brings along its *wuya* ("clan ancients") and shares them with the clan's new neighbors. Katsina functions, physical appearance, and name may change as they adapt to the migrations and consensus of the people. With the meticulous work by the early ethnologists, the multiple names of the spirit beings were carefully documented through interviews with Hopi elders. Voth wrote the "Ho" Katsinam perform the flogging rituals at Oraibi. They are the *Tungwup* in Fewkes' writings of the initiation whipping at First Mesa. In English they are called "Hu" following the *hu* sounds they hoot.

5. No initiates were whipped at Bacavi in 1934 because no men wanted to play the role of the whippers. Seeking a reason, Titiev believed whipping was contrary to Hopi way. When his notes were published in 1972, he offered a second explanation; the men were not as deeply interested in Hopi ceremonies to the degree whipping was essential (Titiev, 1972, 217).

6. Voth (1901, Pl. L) wrote, "As this Katcina never appears in public, it was very difficult to get a *tihu* of the Katcina made and the maker has been severely censured for it by the priests."

7. Fewkes (1897, 288) and Stephen (1936, 220) noted the distribution of presents which were made at Walpi in 1893. In the *Tcivatoki* ("Goat") kiva, the *Pawik* ("Duck") Katsinam brought them to selected homes following the instructions of the men who made them. *Nuvak* ("Snow") Katsina made multiple trips to deliver gifts from *Nacabki* and *Mon* ("Chief") kivas. Two unusual Katsina, *Tcoshuhuwuh* ("Cross-legged") hurried around delivering the *tihu* from *Al* kiva. The Cross-legged Katsina has a unique gait, crossing his legs and wobbling on the sides of his feet.

8. Simmons was the editor for Don Talayesva's autobiography. Talayesva, from Oraibi, Third Mesa, wrote of his experiences and ceremonies as he observed on Third Mesa. See Titiev (1944, 117) and Voth (1901, 113-115) for interpretations of the Third Mesa performances. Titiev was told that the mark drawn by Eototo symbolizes the village, and Aholi's act of circling his staff over the cornmeal symbols claims ownership of the village by the two Katsinam. Titiev (1944, 117 n. 48) presents a caveat on the certainty of the meaning of the ritual act. Voth, Fewkes, and Stephens all had concerns of the accuracy of interpretations presented by informants. This in no way implies a conspiracy to misinform. Consider asking the typical member of any religion to explain the meaning of rituals being performed as part of their religious celebrations. A wide range of interpretations would be the norm. Interviews with informants frequently show variation in descriptions of ceremonial activities as performed in different settlements on the three Hopi mesas. These differences reflect the traditional interpretation used by the people in a particular village.

Research by nineteenth-century ethnologists provided the first detailed studies of the culture and religion of the Hopi Indians. Their notes and publications are our best historical resource documenting the life of the Hopi people before the surrounding American culture made major infringements on their land and changes in their culture.

9. The opportunities for outsiders to witness the major events of the Powamu rituals held in the kiva have been rare. Two descriptions, prepared in the same era, show great similarity in the performance and appearance of the Katsinam in the Powamu ceremony in two villages located

at the remote ends of the Hopi region. Fewkes (1897, 287) described the Powamu Katsinam as they entered the Walpi kiva on the East Mesa when the male personages wore a yucca fillet with imitation squash blossoms on their head, a kilt, sash, and a fox skin hung from the belt. They had tortoise rattles on the legs and carried a gourd rattle in the right hand. Their hair was loose and they were without masks. Their moccasins were green or blue. Voth (1901, 120) saw the Powamu Katsinam appear unmasked. Each wore an embroidered kilt and sash, a bandolier across the right shoulder, a turtle shell rattle tied to right knee, ear pendants of green beads and strands of beads around the neck, moccasins usually green, and they carried a gourd rattle in the right hand and pine sprig in the left. Three artificial squash blossoms made of painted corn husks were worn attached to a yucca frame headband.

10. The splitting of Hopi settlements is a dynamic process. Hopi legends describe internal struggles and ka-Hopi (un-Hopi) behavior of the people as the cause of the many divisions of settlements throughout Hopi history. Following the splitting of ancient Shungopavi, Oraibi was established in about 1125 A.D. It has survived to become the oldest continuously inhabited village in the United States. The most recent breakup of a settlement occurred in 1906, when the conservative faction of the people of Oraibi left to form the village of Hotevilla. Following the Oraibi-Hotevilla split, the villages of Bacavi and Kykotsmovi (New Oraibi) were established. Their growth can be attributed to an increase in Hopi population as well as internal social conflict. Titiev (1944, 69-95) describes the disintegration of Oraibi and establishing the satellite villages. All have continued to grow while their mother village is in a period of static existence with its current population a mere 1/10 of its peak of 3,000. Moenkopi, some forty miles west of Oraibi, was a farming outpost of Oraibi and eventually settled primarily for the higher potential productivity of the land. Driving westward on State Route 264 as it exits the Hopi Reservation, the road curves along the walls of the Moenkopi plateau overlooking the flourishing farmland bisected by the only stream on the Hopi land that flows year round. In the arid land dominated by scrub brush, this picturesque scene is the Hopis' lone oasis.

11. Titiev (1944, 120,222-225) collected information from informants and descriptions from Voth (1901, 122-125).

12. Early studies of Katsinam are based on reports by ethnologists who lived with the Hopi on either First or Third mesa. It should not be assumed the Katsina life and function is less notable on Second Mesa. More likely, the differences in appearance and duties fall between those on the outer mesas. In general, the Katsinam most effective in achieving the ceremonial objectives are called upon each year.

13. Kokosorhoya (Kokosori) appears on Second Mesa with Eototo and Aholi. Cholawitze (Shulawitsi) or Zuni Fire God, appears on First Mesa (Wright, 1973, 20,128) (Colton, 1959, ref. numbers 9 and 151). The two Katsinam are similar in appearance. Kokosorhoya, a very young Katsina, accompanies Ahola (Secakuku,1995,13). Fewkes (1903, Pl. III) pictures Tcolawitze, and he notes (but is not sure), the Zuni Indians claim Sichomovi as one of their towns (Fewkes, 1903, 26). The Hopis sometimes refer to it as a Zuni pueblo.

14. Photographs in Voth (1901, Pl. LIX, LXIIb, and LXIVa), drawing in Stephen (1936, fig. 156), and the painting by a Hopi artist in Fewkes (1903, Pl. VII) and narrative descriptions show this commonality.

15. See Arizona Highways, landmark issue Living Spirits of Kachinas, June 1971 page 3, depiction of Angwusnasomtaka as she appears at dawn during the Powamu. Carver: Neil David, Sr.

CHAPTER 5

1. The Cooyoktu are the Soyoko, and the Tahaamu are the Ogre Uncles.

2. Courlander's (1970, 21) story of the coming from the Underworld summarizes the oral history

tale of the creation of the four birds that were sent to find a new world for the Hopi. Each was formed of clay and placed on a robe made for brides, *kwatskiavu cloth*, and then the clay form was then covered with an *ova*. After completing a sacred rite, the covering was removed. The bird, now alive, was then sent on its mission to find a way to the upper world. Not until the fourth bird, a hawk, was created in this manner was it successful in entering and exploring the fourth world.

3. When the Hopi are in trouble, they turn to Spider Woman and her grandsons, the little War Twins, for assistance and advice. They lived near the shrine of Achamali, about 1/8 of a mile north of Oraibi (Voth, 1905, 86).

4. In *The Fourth World of the Hopi*, Harold Courlander (1971, 73) presents a legend of the *Cooyokos*. During the Hopi migrations, when the people stopped at Homolovi, they were threatened by wandering earth-giants called *Cooyokos*. The people called upon the twin warrior gods to help them. The brothers put aside their stick games and took up their weapons and killed the *Cooyoko* using their bows with lightning arrows.

Voth (1905, 86-88, legend No. 21, *How the Pöokongs Destroyed Cooyoko and His Wife*) follows the same theme with the exception the story takes place at Oraibi and the Cooyoko live in Munavi, several miles to the east. Once again, the village chief made buckskin balls and ball sticks as a reward for each of the twins.

CHAPTER 6

1. Alternate spellings: Cha'vaiyo (Stephen, 1936, 175); Tcaveyo (Titiev, 1944, 66); Tcabaiyo (Fewkes, 1903, 75).

2. Homolovi Ruins are now an Arizona State Park located off Interstate 40 near the Winslow exit, about 50 miles south of the Hopi Reservation.

3. *Hoya* means "child." One who has completed the initiation into adulthood—just reaching maturity.

4. Here, just as in the tale of Palatquapi, the actions of Cha'veyo present an early warning of impending disaster. The improper behavior of the people leads to the destruction of the village. The historical evidence leading to the destruction of Awatovi was a result of cultural decadence, religious intrusion of Catholic missionaries, and the acceptance of Christianity by the villagers in place of the traditional Hopi religion. See *Neil David's Hopi World* (2011, 18-19) for David's visual interpretation of the destruction of Awatovi.

CHAPTER 7

1. The opportunity to collect the stories and myths in their prehistoric vernacular, meaning, and content ended when the white man first published them. Armin Geertz (Geertz and Lomatuwayama, 1987, 10) acknowledges Don Talayesva's autobiography (Simmons, 1942, 1) as an important source of information about a Hopi's thoughts, doubts, fears, desires, needs, and reflections. However, he notes, "This book is weakened...by the fact that Talayesva was paid by the page. Consequently we find him plagiarizing Voth and Dorsey."

2. The hearings were a result and follow-up of meetings held in Washington, D.C., with a delegation of Hopi leaders. It gave the Hopis the opportunity to put in plain words problems and complaints to Washington. The Department of the Interior, Bureau of Indian Affairs (BIA), conducted the hearings. They were held in villages on all three mesas. Government agents repeatedly stressed the meetings were not limited in time; the people had ample time to speak. Topics covered included: land squeeze, stock reduction, stock permits, schooling, Tribal Council, and alcohol. The Hopis made a number of presentations on Hopi history beginning with the time of Hopi Emergence into the Fourth World.

3. In the BIA hearings held on the reservation, a number of problems and concerns were opened for discussion. The Hopi knew the importance of the hearings. Government regulations had taken much of the traditional way of life away

from them—so much it could lead to its eventual demise. Feeling their backs were against the wall, they wanted Washington to know the Hopis, their culture, and their beliefs. The BIA delegation admitted it had a limited awareness of the Hopis' problems until the first meeting in Washington. As a result, the Commissioner wanted his office to have full awareness of the Hopis' problems first hand. During this intensive hearing, prominent citizens representing villages on the three mesas presented accounts of their Hopi teachings and beliefs. Unexpectedly, the hearings offered an exceptional opportunity for historians and scholars to gain information from a knowledgeable and diverse group of people with strong convictions and dedication to their culture. Much of the information, up to the time of the hearings, had not been included in material published by the early anthropologists and ethnologists. They had relied on a small, select group of (most often paid) informers who for the most part were friendly towards the white man; fortunately the speakers at the hearings were community leaders (some elders needed the assistance of translators) from both conservative and liberal factions of the Hopi population. Andrew Hermequaftewa's testimony about the Hopis' migrations brought out several statements relevant to our current topic.

4. Yukioma was the leader of the traditional or Hostile faction at the time of the civil dispute at the end of the nineteenth century and through the time of the Oraibi Split in 1906. The conflicts between the progressive or Friendlies and the Hostiles continued to grow primarily because of their alliance or opposition to the white man and his government. By 1891, each group was conducting separate kiva ceremonies and soon after separate Katsina dances. The outbreak of smallpox in 1887, the second in less than fifty years, took a heavy toll on the Hopi people. Tensions increased among all the people searching for a cause of the epidemic— each group blaming the other. The stress and cumulative effect of more than a quarter century of contention resulted in the breakup in 1906

when the Push War ended with the Hostiles driven from Oraibi. The town the Spaniards looked on as the capital of Tusayan never recovered and by the 1930s its population was less than ten percent of its peak.

5. Voth collected more than one hundred stories from the Hopis of Oraibi and Second Mesa villages. These were told in the native language; Voth interpreted them and published them in 1905 in *The Traditions of the Hopi.* Included were stories telling of the destruction of: Sikyatki, Awatovi, Palatquapi, and Pivanhonkapi.

6. *Yaponcha*, the Wind God and Dust Devil, a fearsome deity, is never impersonated and has sorcerer's power over the forces of nature (Colton, 1959, 84).

7. The Hopis' migratory history had been conveyed orally until the late 1800s when ethnologists carefully recorded the stories. Some events relating to nature's rage described in the legends have been correlated through scientific research, while others are accepted in faith. Archaeologists and anthropologists use natural elements such as floods, earthquakes, and volcanoes to establish the time of events in prehistoric eras.

A volcanic cone (Sunset Crater National Monument) erupted less than fifty miles southwest of the tip of Third Mesa, eight hundred years before this story of the destruction of Pivanhonkapi was told to H. R. Voth. In 1064–1065 it spewed volcanic ash over eight hundred square miles. Fire and clouds of smoke in the foreground of the San Francisco Peaks were visible from the Hopi mesas. People who lived in the immediate region of the eruption lost their homes. The thick layer of volcanic ash added fertility to the poor soil and preserved moisture. About this time there was a minor increase in annual rainfall in the region. With the increased moisture, crops thrived in this nutrient-rich blanket, and a new settlement, Wupatki, grew to become the tallest pueblo in the region and home to nearly one hundred well-organized Sinagua Indians. By 1300 weather conditions changed again. With cooler temperatures,

shorter growing season, and less rain, crops failed and forced abandonment of the region. Many of the people moved northward towards the Hopi settlements.

8. A number of books include accounts, with embellishments unique to specific villages that follow the traditions and influence of the storyteller's teachings. Variations in the story as told on First Mesa are included in: *Truth of a Hopi*, *The Fourth World of the Hopi,* and *Hopi Painting: The World of the Hopi*. Third Mesa versions are in: *The Traditions of the Hopi* and *Children of Cottonwood*.

9. Washing hair with yucca root (soap weed) suds is an ancient indispensable ritual of purification for rebirth or beginning a new journey. This ancient rite is performed at the time of naming of the newborn child, initiation into one of the prominent societies, marriage (for both bride and groom), and death before burial. When captured young eagles are brought to their new home, they also are ritually washed, and then again prior to their final journey following the Niman.

CHAPTER 9

1. In'tiwa was the Katsina clan chief and chief of Powamu society. He also served as one of the Fathers of the Katsinam, and "sprinkles" the dancers (blesses them with sacred corn meal).

2. It is easy to understand the frustrations Stephen had when he was commissioned by J. W. Fewkes in 1890 to observe and record the daily life and ceremonies of the people of First Mesa. Although he had been accepted as a friend of the Hopis, he still found it difficult to gain the spectrum of knowledge he felt necessary to accomplish his study. Thus the "gods only know" feeling when he tried to understand the Hopi ceremonies in just one observation of the annual rituals that include esoteric rites only the priesthood is privileged to perform.

3. *Wuwutcim* is the tribal initiation ceremonial when boys are formally accepted into one of several societies of manhood and will achieve tribal membership. This event is concluded prior to the new season of the Katsina.

4. Stephen (1936, 194) wrote, the type of Katsinam appearing on First Mesa village of Walpi follow a five-year cycle of rotation. Each of the five kivas presents the same Katsina each time its turn comes to sponsors the Niman. The five Katsina presentations are: Hemis, Heheya, Angak'china, Hemis, and Ma'lo. The Hemis are presented by two of the kivas and so appear twice in the five-year cycle.

5. Earle and Kennard (1971, 42) wrote of the Niman: "when the kachinas come to the plaza to dance for the first time, just after sunrise they bring armsful of corn. On this occasion the whole plant is uprooted and bundles of them—ears, leaves, stalks are distributed to the people."

6. David (1993, 142) differentiates between *Kutca Mana*, or "White Maiden," who comes during the Home dance and *Nuvak'chin Mana,* the "Snow Maiden," who appears in winter. Colton (1959, #100) identifies this Katsina as *Qucha* or *Nuvak-chin-mana*.

7. Blue Corn Boy compares to Avatc Hoya described by Fewkes (1903, plate XXI). Fewkes' description notes: "He wears cones made of corn husks in his ears and curved feathers on his head. He accompanies the Hemis Katsina and he has painted rings on his body and legs."

8. Earle and Kennard (1971, 42) wrote, "Kachina Chief...is barefooted, dressed in just kilt and sash, his hair down his back."

9. More than one hundred years later, several Hopi, who had lived through more needy times, noted a number of Katsinam wore new handmade moccasins during a dance, when the plaza was muddied following a rain and the spring thaw. They believed older moccasins should have been used, thus sparing permanent damage to the valued hand sewn leather footwear.

10. Stephen (1936, 531) described the Hüm´is (Hemis) in the 1893 ceremony as wearing a mask and headpiece with spruce at the base of the mask; hawk feathers at the rear. A hank of yarn is worn as bandolier over the right shoulder. Blue armlets are on each arm. The kilt

is circled over with a yarn belt. There is a fox skin at the loins, and about ten or twelve spruce boughs are fastened with a rope around the kilt.

11. *Omauüh*, or "cloud design," includes three semicircles colored white, red, and blue. Rain is drawn as vertical lines under them.

12. The Hemis Katsina and the Sio Hemis Katsina are described and each is portrayed in paintings by Cliff Bahnimptewa (Wright, 1973, 214-216).

13. Outsiders often appear as spectators at the public dances. In the past, Anglo visitors have generally been welcome. More recently, some villages have posted signs at the time of the public Katsina dances that say the village is closed to non-Native Americans on the day of the dance.

14. Federal law exempts Native Americans from hunting restrictions and allows using eagles in religious ceremonies. However, recently the Hopis have not been allowed to hunt eagles in the Wupatki National Monument, one of their traditional eagle nesting areas.

15. The number of birds, thus captured, varies very much in different years. Voth (1905, 107) observed, "One year there were thirty-five eagles and hawks in the village of Oraibi alone."

16. See (Titiev, 1944, 233), (Earle and Kennard, 1971, 38), and (Simmons, 1942, 232).

CHAPTER 10

1, In 1881, Bourke (1984, 131) bought several flat wooden dolls while in Tewa. He mistakenly noted after they completed their duty as a god, the worn wooden images were given to the children to complete their destruction. He wrote, "These gods are nothing but coarse monstrosities, painted in high colours, generally green."

2. Bromberg (1986, 79-85) lists more than three hundred fifty Katsinam with the forewarning this listing was not to be taken as complete.

3. Kachina dolls carved in the image of the early *tithu* remain a separate topic and have evolved into a separate field of collectibles and deserve further study. *Traditional Hopi Kachinas, A New Generation of Carvers*, by Jonathan S. Day, is an excellent resource on the new artistic carvings that follow the characteristics of the traditional *tihu* carvings. Major Native American art shows now recognize this distinct style as a separate category in kachina art.

CHAPTER 11

1. Barton Wrights' *Clowns of the Hopi* is a detailed and definitive publication on the sacred and comic clowns. Of the clowns in general he writes, "Each of these groups is further divided by recognizable variations in color, costume, and attributes. Although some of the differences may appear to be insignificant to the casual observer, they identify distinct individuals easily recognized by the Hopi." The reader is urged to study his text for greater breadth and depth of this topic.

2. Fred Kabotie (1977, 65-66) wrote of his work to revise the Salako at Shungopavi in 1937. After the Niman Katsinam left the plaza, the towering Salako performed. In his account he relates the difficulty in recovering essential details to produce the dance. From Corn Maiden masks and *tablita* he discovered in museum storage, he painted two Salako. Kabotie showed the painting to his grandfather who recalled he took part in it as a young man, and noted it had not been performed since. His grandfather and uncle pieced together enough of the details and worked as consultants for the artist. In addition, a pictograph on a cliff below the mesa included a drawing of the Salako. It gave enough information to make a new headpiece for the Salako for the planned performance in Shungopavi. Colton (1959, #117) states the Salako Dance was held again in Shungopavi in 1952 and 1957.

3. Wikya'tiwa of Walpi had visited Zuni several years earlier and saw the Katsina dance. The Zuni had borrowed it after seeing it performed at Laguna. Wikya'tiwa learned the Laguna dance song, and when he was chosen as the Dance Chief he taught it to the Hopis who, after three weeks of intensive practice would dance. On dance day,

the Katsinam would dance for ten to twelve periods throughout the day. Wikya'tiwa arranged for the Koshari from Tewa village to appear at the exhibition.

Stephen had a rare opportunity to observe the evolution of a Katsina dance as it moves from pueblo to pueblo. In this case it resulted in a Hopi dance in its passage through three pueblos whose people spoke three different languages: Keres, Zuni, and Hopi. It is a first-hand documented example of cultural exchange that has resulted in one building block of the rich Katsina heritage of the Hopi people.

4. Stephen describes these "grotesques" with white faces and wearing scalloped cloud headdresses. They represent the Cloud deities. His description matches the *Tukwinong* (Wright, 1973, 246) who performs as a messenger to the potential summer thunderstorms and appears in this skit with the Koshari, in one of their many roles, calling for rain.

5. The term "grotesques" was used by Bourke (1984, 306) referring to the *tithu* he saw hanging in the homes in Shungopavi. From their first travels into the Southwest, Spanish missionaries saw the pueblo dwellers as devil worshippers and idolatrous because of their rituals and Katsina culture. Stephen's use of the word grotesques followed the white man's not uncommon usage in reference to the Katsina and the Pueblo clowns.

CHAPTER 12

1. Collectors have used Barton Wright's 1973 publication *Kachinas: A Hopi Artist's Documentary* and Wright's 1977 *Hopi Kachinas: The Complete Guide to Collecting Kachina Dolls* to identify dolls and as an information bank and reference when commissioning Hopi carvers to make specific dolls. Since *Kachinas: Spirit Beings of the Hopi* was published in 1991, carvers have added to their repertoire, and collectors seeking distinct pieces have added to the number of kachina dolls on their wish lists. This revitalization could encourage a reappearance of a long absent Katsina in the ceremonial performances.

2. Oswald "White Bear" Fredericks is known for his artwork and produced the drawings for Frank Waters' *Book of the Hopi*. Fredericks was born years after the Fewkes' reports were written.

3. Cottonwood trees grow along the washes and river edges. In the high desert of Hopi, aged roots are scarce and have been over-harvested by carvers. Seasoned logs are generally purchased from dealers who bring in cottonwood root logs from outside the Hopi Reservation. Top carvers who invest many hours of labor carving delicate or complex figures will pay a premium for select wood.

4. Previous Hopi recipients of the Living Treasure Award include: Charles Loloma, jewelry design, painter, and potter; Joy Navasie and Dextra Quotskuyva, potters; Paul Saufkie Sr., silversmith; and Michael Kabotie, painter and cofounder of Artist Hopid.

5. Keams Canyon Arts and Crafts is now McGee's Indian Art Gallery. The gallery has been owned and operated by the McGee family since 1938. Following the traditions of previous owners, Thomas Keam and Lorenzo Hubbell, the McGees serve the Hopi community well, and are among the most respected traders to both the Hopis and the collectors of Native American art.

6. Just one year after leaving the Marine Corps in 1960, Alvin James won first prize for one of his lifelike action carvings in the Hopi Artist Exhibition at the Museum of Northern Arizona in Flagstaff. Up to that time, he made his living as a carpenter and he carved kachina dolls only for traditional purposes. While still working as a carpenter, he began to carve professionally, and within a year won a first prize. This was followed by three successive wins at the Gallup Ceremonial and also at the Arizona State Fair. James was born in 1936 in Oraibi and was a member of the Corn Clan, he died in 2003.

James is credited as one of the leaders in raising the craft of kachina carving to an art form. Along with Wilfred Tewawina, James is one of the originators of the "action" style of

kachina doll carvings. The article in *Arizona Highways* includes fifteen photographs of his carvings. Ray Manley's article states, "Collectors have paid four figure prices for the few rare specimens now regarded as museum pieces." (*Arizona Highways*, June, 1973, 3-17).

7. At the beginning of the last quarter of the twentieth century, the road branching from Arizona State Highway 264 was paved only a short distance into Hotevilla. The village water tank, an incomplete open shell rising over fifty feet above the village, stood idle. The village's conservative citizens opposed government plans for paved streets and a community water system. Today many homes remain with only outside faucets, many of the roads remain unpaved, and electricity is not completely available in the village.

8. At a public hearing (Kykotsmovi, August 9, 1989) held on the renewal of the Black Mesa mine permits, Dennis Tewa said, "We do Kachina dances in the summer, just to get a drop of rain.... Maybe we cannot stop the mining of the coal, but we sure would like to stop the use of water." (Whiteley, 1998, 188-89).

9. Two publications extending the description of Katsinam to include the differences as they appear on the three Hopi mesas are: *Hopi Kachina Dolls* by H. Colton and *Kachinas Spirit Beings of the Hopi* by N. David. The second source even cites disagreements from Hopi individuals who were consulted to review the artist's paintings and the written descriptions.

Chapter 13

1. It is customary for the bride's family to reciprocate and give gifts to the groom's family members who have contributed to the wedding ceremony and those who have made the bride's wedding outfit. These gifts, termed payback, are traditionally handmade baskets and plaques as well as foods that generously balance the quantity of gifts from the groom's family.

Glossary

Angktiwa: Time of Repeat kiva Night Dances.

Bohanna: White man.

Codex Hopi: A manuscript including illustrations of all the known Katsinam.

Hopitu: The peaceful people.

Hoya: Child who has completed their initiation and approaching maturity.

Kachina: Hopi wood carvings of Katsina performers or the Spirit Beings of the Hopi.

Ka-Hopi: Poor, un-Hopi behavior, improper.

Katsina: Hopi spirit ancestors or the impersonators in Hopi ceremonies. Katsina is capitalized in this text.

Katsinam: Plural of Katsina.

Kikmongwi: Village chief.

Kiva: Underground ceremonial chamber where religious celebrations are planned, practiced, and conducted.

Mong: Chief or more important.

Mongkoho: Chief's badge of office.

Mongwikuru: Chief's netted water gourd.

Muyawu: Moon.

Ösömuya: March moon.

Pahos: Prayer sticks.

Phratry: Clan groups.

Piki: Thin wafer like cornmeal sheet bread.

Putsqatihi: Flat kachina cradle dolls, two dimensional *tihu*.

Sipapu: Mythical opening, the place of emergence into the Fourth World. Emergence opening found in all kiva floors.

Soo'so'yoktu: The collective name for the ogre group or family.

Tihu: Kachina doll.

Tithu: Plural of *tihu*.

Tiikive: The Dance Day.

Tusayan: Derived from a Spanish term referring to the province of the Hopi Indians.

Two-Hearts: Witches.

Wuya: Clan ancient.

Bibliography

Adams, E. Charles. *The Origin and Development of the Pueblo Katsina Cult.* (Tucson, AZ: University of Arizona Press, 1991).

Black, Robert A. editor: *Standing Flower, The Life of Irving Pabanale, an Arizona Tewa.* (Salt Lake City, UT: The University of Utah Press, 2001).

Bolton, Herbert E. *Spanish Explorations in the Southwest, 1542-1706.* The Espejo Expedition, 1582-1583. (New York, NY: Scribner and Son, 1916).

Bourke, John G. *Snake Dance of the Moqui.* (Tucson, AZ: University of Arizona Press, 1984).

Broder, Patricia Janis. *Hopi Painting The World of the Hopis.* (New York, NY: The Brandywine Press, E.P. Dutton, 1978).

Bromberg, Eric. *The Hopi Approach to the Art of Kachina Doll Carving.* (Atglen, PA: Schiffer Publishing, Ltd., 1986).

Bureau of Indian Affairs, B.I.A. *Hopi Hearings July 15-30, 1955.* (B.I.A. Phoenix Area Office, Hopi Agency, Keams Canyon, AZ., 1955).

Casteñada, Pedro. *The Journey of Coronado.* (New York, NY: Dover Publications, Inc., 1990).

Colton, Harold S. *Hopi Kachina Dolls with a Key to their Identification.* (Albuquerque, NM: University of New Mexico Press. Revised Ed., 1959).

Coze, Paul. "Living Spirits of Kachina.*" Arizona Highways.* (Phoenix, AZ: *Arizona Highways*, June 1971).

Courlander, Harold. *People of the Short Blue Corn.* (New York, NY: Henry Holt and Company, 1970).

_____. *The Fourth World of the Hopis.* (New York, NY: Crown Publishers, Inc., 1971).

Crane, Leo. *Indians of the Enchanted Desert.* (Boston, MA: Little, Brown, and Co., 1925).

David, Neil R.; descriptions by J. Brent Ricks and Alexander E. Anthony, *Kachinas Spirit Beings of the Hopi.* (Albuquerque, NM: Avanyu Publishing, Inc., 1993).

Diaz Del Castillo, Bernal. *The Conquest of New Spain.* (New York, NY: Penguin Books, 1963).

Dockstader, Fredrick J. *The Kachina and the White Man:The Influences of White Culture on Hopi Kachina Religion.* (Albuquerque, NM: University of New Mexico Press, 1985).

Eggan, Fred. *Social Organization of the Western Pueblo.* (Chicago, IL: University of Chicago Press, 1950).

Earle, E. and Kennard, E. *Hopi Kachinas.* (New York, NY: Museum of the American Indian, Heye Foundation, 1971).

Fewkes, Jesse W. *A Few Summer Ceremonials at the Tusayan Pueblos.* (Washington, D.C.: A Journal of American Ethnology Vol II:1-161, 1892).

_____. *Tusayan Snake Ceremonials.* (Washington, D.C.: Bureau of American Ethnology Annual report No. 16 pp. 267-312, 1894).

_____. *The Group of Tusayan Ceremonials Called Katcinas.* (Washington, D.C.: The Smithsonian Institution, Bureau of American Ethnology Annual Report No. 15 pp. 245-313, 1897).

_____. *A Theatrical performance at Walpi.* (Washington, D.C.: Washington Academy of Sciences Vol II, 605-629, 1900).

_____. *Hopi Katcinas Drawn by Native Artists.* (Washington, D.C.: The Smithsonian Institution, Bureau of American Ethnology Annual Report No. 21 pp. 3-126, 1903).

_____. *The Use of Idols in Hopi Worship.* (Washington, D.C.: The Smithsonian Institution Annual Report pp377-397, 1922).

Gaede, Marnie, and Barton Wright. *The Hopi Photographs, Kate Cory: 1905-1912.* (LaCanada, CA: Chaco Press, 1986).

Geertz, A, and M. Lomatuway'ma *Children of Cottonwood: Piety and Ceremonialism in Hopi Indian Puppetry.* (Lincoln, NE: University of Nebraska Press, 1987).

Graves, Laura. *Thomas Varker Keam Indian Trader.* (Norman, OK: University of Oklahoma Press, 1998).

Green, Jesse. *Cushing at Zuni: The Correspondence and Journals of Frank Hamilton Cushing, 1879-1884*. (Albuquerque, NM: University of New Mexico Press, 1990).

Hice, Michael. *Artists of Change*; *Native Peoples Arts and Lifeways.* (Santa Fe, NM: February/March 2000: 54-59).

Hopi Hearings. Bureau of Indian Affairs. (United States Department of the Interior; Bureau of Indian Affairs. Phoenix Area Office, Hopi Agency, Keams Canyon., 1955).

Hough, Walter. *The Hopi Indians.* Curator Division of Ethnology, United States National Museum, Washington, D.C. (Cedar Rapids, IA: Torch Press, 1915).

James, Harry C. *Pages From Hopi History*. (Tucson AZ: University of Arizona Press, 1974).

Kabotie, Fred and Bill Belknap. *Fred Kabotie Hopi Indian Artist.* (Flagstaff, AZ: Museum of Northern Arizona with Northland Press, 1977).

Kealiinohomoku, Joann. "The Drama of the Hopi Ogres*,*" *Southwestern Indian Ritual Drama*, Edited by C. Frisbie; A School of America Research Book. (Albuquerque, NM: Univ. of New Mexico Press, 1980).

Loftin, John D. *Religion and Hopi Life in the Twentieth Century*. (Bloomington, IN: Indiana University Press, Midland Book Edition, 1994).

Manley, Ray and Joseph Stacy. "Hopi Kachina Artist Alvin James Makya*.*" (Phoenix, AZ: *Arizona Highways*, June 1973).

Malotki, Ekkehart, and Michael Lomatuway'ma. *Maasaw: Profile of a Hopi God*, (Lincoln, NE: University of Nebraska Press, 1987).

McManis, Kent. *A Guide To Hopi Katsina Dolls*. (Tucson, AZ: Rio Nuevo Publishers, 2000).

Munson, Marit K. "Creating the Codex Hopiensis." pp70-83. (Scottsdale, AZ: *American Indian Art*, Autumn 2006).

Nabokov & Easton. *Native American Architecture*. (New York, NY: Oxford University Press, 1989).

Nequatewa, Edmund. *Truth of a Hopi*. Flagstaff, AZ: Museum of Northern Arizona with Northland Press, 1967).

Parsons, E. C. *Pueblo Indian Religion*. 2 vol. (Lincoln, NE: Bison Books Edition, University of Nebraska Press, 1996).

Pearlstone, Zena. *Katsina: Commodified and Appropriated Images of Hopi Supernaturals*. (Los Angeles, CA: UCLA Fowler Museum of Cultural History, 2001).

Pearlstone, Zena and Allan J. Ryan. *About Face, Self-Portraits by Native American First Nations and Inuit Artists*, Edited by Joan K. O'Donnell and Jonathan Batkin. (Santa Fe, NM: Wheelwright Museum of the American Indian, 2005).

Pecina, Ron. "Painter and Kachina Doll Carver Neil David." *Native Artists Magazine;* (Santa Fe, NM: Fall 1999:26-29).

Pecina, Ron and Bob Pecina; Neil David. *Neil David's Hopi World*. (Atglen, PA: Schiffer Publishing Ltd., 2011).

Plog, Stephen. *Ancient Peoples of the Southwest*. (London, England: Thames and Hudson, 1998).

Powell, John W. *The Hopi Villages: The Ancient Province of Tusayan*. (Palmer Lake, CO: Filter Press, 1972. Reprinted from *Scribner's Monthly*, Dec. 1875; 1972).

Roosevelt, Theodore. "The Hopi Snake Dance" *Outlook Magazine,* October 19, 1913.

Schaafsma, Polly, Editor. *Kachinas in the Pueblo World*. (Albuquerque, NM: University of New Mexico Press, 1974).

Secakuku, Alph. *Following the Sun and Moon: Hopi Kachina Tradition*. (Flagstaff, AZ: Northland Publishing, 1995).

Sevillano, M. *The Hopi Way.* (Flagstaff, AZ: Northland Publishing, 1992).

Simmons, L. F. (editor) and Talayesva, Don. *Sun Chief, The Autobiography of a Hopi Indian*. (Clinton, MA: Yale University Press, 1942).

Smith, White Mountain. *Desert Magazine*, pp 4-6. "Tom Pavatea, Hopi Trader." (El Centro, California: Desert Publishing Co., February, 1938).

Stephen, Alexander M. *Hopi Tales. Journal of American Folklore* vol. 42:1-72. (Champaign, IL: University of Illinois Press, 1929).

_____. *Hopi Journal of Alexander M. Stephen*. Edited by E. C. Parsons. (New York, NY: Columbia University Contributions to Anthropology 23 [2 vols.], 1936).

Stoddard, John L. *Stoddard's Lectures;* vol. 10. (Norwood, MA: Norwood Press, 1898).

Teiwes, Helga. *Kachina Dolls. The Art of Hopi Carvers*. (Tucson, AZ: University of Arizona Press, 1991).

Terrell, John. *Pueblo Gods and Spaniards*. (New York, NY: Dial Press, 1973).

Titiev, Mischa. *Old Oraibi, A Study of the Hopi Indians of Third Mesa*. (Albuquerque, NM: Peabody Museum of American Archaeology and Ethnology, Harvard University; vol. 22, no. 1. University of New Mexico Press 1992 edition, 1944).

_____. *The Hopi Indians of Old Oraibi, Change and Continuity*. (Ann Arbor, MI: The University

of Michigan, 1972).

Voth, H. R. *The Oraibi Powamu Ceremony*. The Stanley McCormick Hopi Expedition. Field Columbian Museum, Anthropological series, vol. 3, no. 2. (Chicago, IL: Field Columbian Museum, 1901).

_____. *The Traditions of the Hopi*. Field Columbian Museum, Anthropological series, vol. 11, no.1. (Chicago, IL: Field Columbian Museum, 1905).

_____. *Brief Miscellaneous Hopi Papers. Notes on the Eagle Cult Among the Hopi Indians.* The Stanley McCormick Hopi Expedition, (Chicago, IL: 1912).

_____. *Historical Notes of the First Decade of the Mennonite Mission Work Among the Hopi of Arizona, 1893-1902*. The Mennonite Missionary Reports From Our Stations in Arizona, April 12, 1923.

Waters, Frank. *Book of the Hopi*. (New York, NY: Viking Press, 1961).

Weber, David, J. *What Caused the Pueblo Revolt of 1680?* (Boston, MA: Bedford/St. Martin, 1999).

Whiteley, Peter M. *Rethinking Hopi Ethnography*. (Washington, DC: Smithsonian Press, 1998).

Wright, Barton. *Kachinas, A Hopi Artist's Documentary*, illustrated by Cliff Bahnimptewa. (Flagstaff, AZ: Northland Press, 1973).

_____*Hopi Kachinas, The Complete Guide to Collecting Kachina Dolls*. (Flagstaff, AZ: Northland Press, 1977).

_____*Hopi Material Culture: Artifact Gathered by H. R. Voth in the Fred Harvey Collection*. (Flagstaff, AZ: Northland Press and Heard Museum, 1979).

_____*Clowns of the Hopi*. (Flagstaff, AZ: Northland Publishing, 1994).

Yava, Albert. *Big Falling Snow*, Edited by Harold Courlander. (New York, NY: Crown Publishers, Inc. 1988).

Index